DEGAS AND AMERICA

The Early Collectors

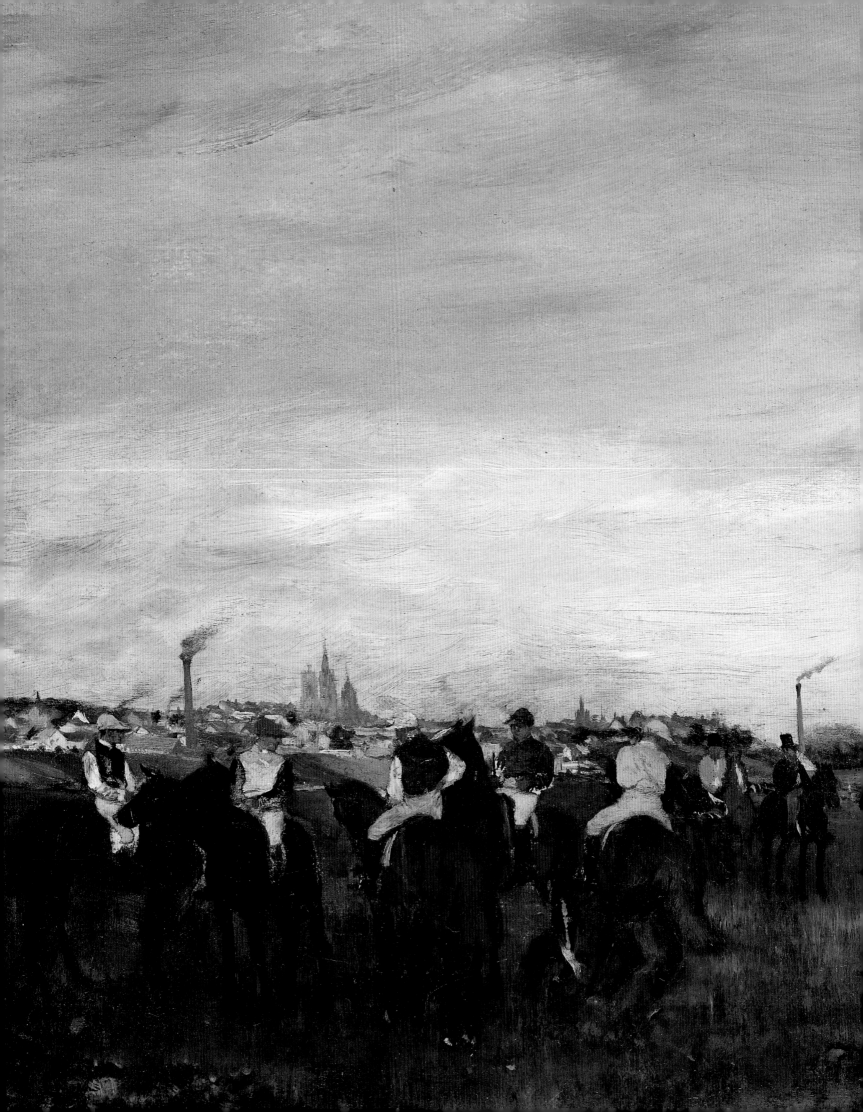

Degas and America

America

The Early Collectors

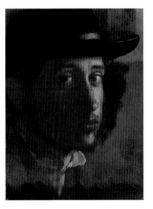

Ann Dumas

David A. Brenneman

HIGH MUSEUM OF ART
THE MINNEAPOLIS INSTITUTE OF ARTS

distributed by
RIZZOLI INTERNATIONAL PUBLICATIONS

Degas and America: The Early Collectors was on view at the High Museum of Art, Atlanta, from March 3 to May 27, 2001; and at The Minneapolis Institute of Arts, from June 16 to September 9, 2001.

This exhibition is organized by the High Museum of Art in collaboration with The Minneapolis Institute of Arts.

In Atlanta, this exhibition is made possible by the Forward Arts Foundation.

Additional support provided by the Rich Foundation and Bank of America.

Support for education programs is provided by the Glenn and Jean Verrill Foundation.

In Minneapolis, generous support for this exhibition is provided by Dayton's Project Imagine and Dain Rauscher. Promotional support is provided by StarTribune.

Library of Congress Cataloging-in-Publication Data
Dumas, Ann.
 Degas and America : the early collectors / Ann Dumas, David A. Brenneman ; [organized by the High Museum of Art in collaboration with the Minneapolis Institute of Arts].
 p. cm.
 Exhibition at the High Museum of Art from March 3 to May 27, 2000 and at the Minneapolis Institute of Arts from June 16 to Sept. 9, 2000.
 ISBN: 0-8478-2340-7 (cloth : alk. paper)
 1. Degas, Edgar, 1834–1917—Appreciation—United States—Exhibitions. 2. Art—Collectors and collecting—United States—Exhibitions. I. Brenneman, David A. II. High Museum of Art. III. Minneapolis Institute of Arts. IV. Title.
 N6853.D33 A4 2001
 759.4—dc21 00-46185

Distributed in 2001 by
Rizzoli International Publications, Inc.
300 Park Avenue South
New York, NY 10010

Jacket front: *The Ballet Class* (detail, cat. 49)
Jacket back: *Self-Portrait* (cat. 7)
Pages 2–3: *The Races* (detail, cat. 25)
Page 3: *Self-Portrait* (cat. 8)
Page 6: *Women Combing Their Hair* (detail, cat. 30)
Page 12: *Race Horses at Longchamp* (detail, cat. 29)
Page 13: *Mary Cassatt* (detail, fig. 1, p. 16)
Page 34: *A Woman Seated Beside a Vase of Flowers* (detail, cat. 18)
Page 35: *Sulking* (detail, fig. 5, p. 38)
Page 46: *The Morning Bath* (detail, cat. 68)
Page 47: *James-Jacques-Joseph Tissot* (detail, cat. 22)
Page 60: *The Dance Examination* (detail, cat. 48)
Page 61: *Orchestra Musicians* (detail, fig. 6, p. 67)
Page 76: *Woman Drying Herself* (detail, cat. 74)
Page 77: *Little Dancer of Fourteen Years* (detail, cat. 78)
Pages 82–83: *Portrait of Mlle. Hortense Valpinçon* (detail, cat. 24)

FOR THE HIGH MUSEUM OF ART
Kelly Morris, Manager of Publications
Nora E. Poling, Associate Editor
Janet S. Rauscher, Assistant Editor

Designed by Susan E. Kelly with assistance by Vivian Larkins
Produced by Marquand Books, Inc., Seattle
 www.marquand.com
Printed by SDZ, Ghent, Belgium

Lenders to the Exhibition

Albright-Knox Art Gallery, Buffalo, New York

Art Gallery of Ontario, Toronto

The Art Institute of Chicago

The Art Museum, Princeton University

The Baltimore Museum of Art

Cincinnati Art Museum

Columbus Museum of Art

The Corcoran Gallery of Art

The Dayton Art Institute

Denver Art Museum

The Detroit Institute of Arts

Dumbarton Oaks Research Library and Collection,
 Washington, D.C.

Fogg Art Museum, Harvard University Art Museums

High Museum of Art, Atlanta

Hirshhorn Museum and Sculpture Garden,
 Smithsonian Institution

The Hyde Collection, Glens Falls, New York

The J. Paul Getty Museum, Los Angeles

Los Angeles County Museum of Art

Mr. Stephen Mazoh

The Metropolitan Museum of Art, New York

The Minneapolis Institute of Arts

The Montreal Museum of Fine Arts

Museum of Art, Rhode Island School of Design

Museum of Fine Arts, Boston

The Museum of Fine Arts, Houston

Museum of Fine Arts, Springfield, Massachusetts

The Museum of Modern Art, New York

National Gallery of Art, Washington, D.C.

New Orleans Museum of Art

Philadelphia Museum of Art

The Phillips Collection, Washington, D.C.

The Pierpont Morgan Library, New York

Reading Public Museum, Reading, Pennsylvania

Mr. and Mrs. Leonard Riggio

Irene and Howard Stein, Atlanta

Sterling and Francine Clark Art Institute,
 Williamstown, Massachusetts

Toledo Museum of Art

UCLA Hammer Museum, Los Angeles

Virginia Museum of Fine Arts, Richmond

Wadsworth Atheneum, Hartford, Connecticut

Yale University Art Gallery

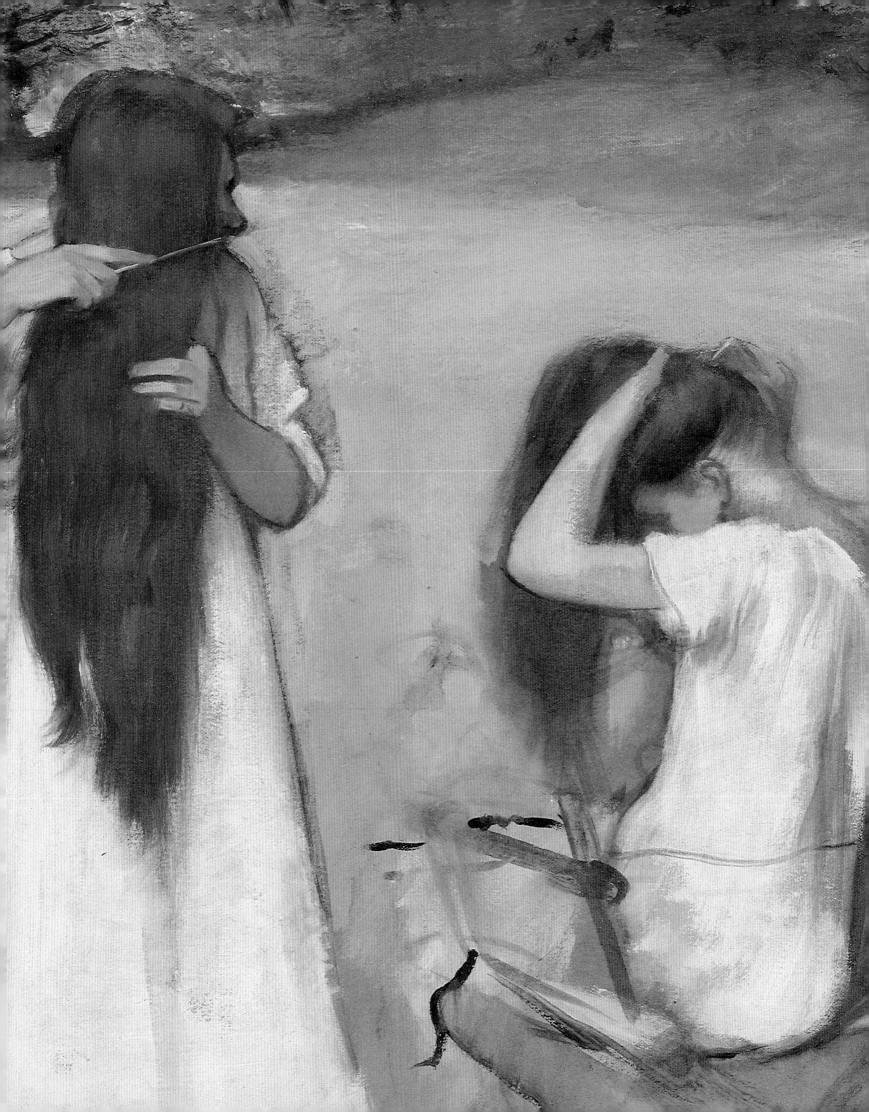

Contents

Acknowledgments

MANY INDIVIDUALS, both in Atlanta and in Minneapolis, deserve thanks for their important work on this exhibition. At the High Museum of Art, we would especially like to thank Michael E. Shapiro, Nancy and Holcombe T. Green, Jr. Director, for his enthusiastic support. Marjorie Harvey, Acting Director of Museum Programs, Rhonda Matheison, Director of Finance and Operations, and Sheldon Wolf, Director of Museum Advancement, played key roles in the planning of this exhibition. Other key staff included Kevin Streiter, Manager of Museum Facilities, Charles Wilcoxson, Chief of Security, Linda Boyte, Acting Manager of Exhibitions and Design, Jim Waters, Chief Preparator, Angela Jaeger, Head of Graphics, Frances Francis, Registrar, Jody Cohen, Associate Registrar, Kelly Ziegler, Exhibitions Assistant, Kim Collins, Museum Librarian, H. Nichols B. Clark, Eleanor McDonald Storza Chair of Education, Joy Patty, Head of Adult Programs, Shantras Lakes, Head of Family and Community Programs, Patricia Cain Rodewald, Head of School Programs, Beth Knowles, former Manager of Individual Support, Nancy Gaddy, Manager of Corporate Support, Jennifer Messer, former Manager of Foundation and Government Support, Roanne Katcher, Manager of Membership, Dorie Wirtz, Manager of Volunteer Services, Sally Corbett, Manager of Communications, and Marie Landis, Manager of Special Events. Under the command of Kelly Morris, the editorial staff of Nora Poling and Janet Rauscher guided the production of the catalogue with poise and precision. Linnea Harwell, Exhibition Coordinator, kept exhibition planning on track, and Phaedra Siebert, Curatorial Assistant in European Art, made outstanding contributions both to the planning of the exhibition and the production of the catalogue.

At The Minneapolis Institute of Arts, we would like to acknowledge the leadership of Evan M. Maurer, Director and President. Patrick Noon, Patrick and Aimée Butler Curator of Paintings, was an important advocate for the exhibition and an effective ally in securing loans for the exhibition. He was ably assisted by Patricia Sue Canterbury, Assistant Curator, and Erika Holmquist-Wall, Administrative Assistant, in the Department of Paintings and Modern Sculpture. Other colleagues who provided critical support were Richard Campbell, J. E. Andrus III Curator of Prints and Drawings, Dennis Jon, Assistant Curator of Prints and Drawings, Laura DeBiaso, Administrator of the Exhibitions Department, Deb LaBatte, Administrative Assistant, Brian Kraft, Registrar,

Tanya Fisher, Associate Registrar, DeAnn Dankowski, Permissions, John Easley, Director of Development and External Affairs, Joan Grathwol Olson, Director of Corporate and Foundation Support, and Kaylen Whitmore, Director of Marketing.

This exhibition resulted from the help and generosity of many individuals. We would like to take this opportunity to thank the following individuals for their invaluable assistance with loans for the exhibition: Douglas G. Schultz, Director, Kenneth Wayne, Curator, Laura Fleischmann, Registrar, Albright-Knox Art Gallery, Buffalo, New York; Matthew Teitelbaum, Director, Michael Parke-Taylor, Acting Head of European Art, Katharine Lochnan, Senior Curator, Prints and Drawings, Brenda Rix, Assistant Curator, Prints and Drawings, Tim Hardacre, Loans Coordinator/Registration Assistant, Faye van Horne, Photographic Resources Coordinator, Art Gallery of Ontario, Toronto; James N. Wood, Director and President, Douglas Druick, Searle Curator of European Paintings and Prince Trust Curator of Prints and Drawings, Suzanne F. McCullagh, Curator of Earlier Prints and Drawings, Gloria Groom, David and Mary Winton Green Curator, Department of European Painting, Judith Barter, Field-McCormick Curator of American Art, Bart Ryckbosh, Archivist, Mary K. Solt, Executive Director of Museum Registration, Hsiu-ling Huang, Photographic Rights Coordinator, The Art Institute of Chicago; Susan Taylor, Director, Peter Bunnell, former Acting Director, Betsy Rosasco, Associate Curator of Later Western Art, Eliza Frecon, Assistant Registrar, Karen Richter, Assistant Registrar, Photo Services, Art Museum, Princeton University; Doreen Bolger, Director, Jay Fisher, Senior Curator for Prints, Drawings, and Photographs, Sona Johnston, Senior Curator, Painting, and Sculpture, Susan Dackerman, Curator for Prints, Drawings, and Photographs, Erin Donovan, Associate Registrar, Nancy Press, Manager, Rights and Reproductions, The Baltimore Museum of Art; Janet Brook, Montreal; Franck Giraud, Senior Vice-President for International Nineteenth and Twentieth-Century Art, Leta Ming, Assistant to the Senior Vice-President for International Nineteenth and Twentieth-Century Art, Christie's, New York; Timothy Rub, Director, Anita J. Ellis, Chief Curator and Curator of Decorative Arts, Kristin Spangenberg, Curator of Prints and Drawings, Kathryn M. Haigh, Registrar, Jennifer Reis, Photo Services Coordinator, Cincinnati Art Museum; Irvin M. Lippman, Executive Director, Nannette Maciejunes, Senior Curator, Rod Bouc, Registrar,

Elizabeth Hopkin, Associate Registrar, Columbus Museum of Art; David Levy, President and Director, Eric Denker, Curator of Prints and Drawings, Kimberly Davis, Assistant Registrar, The Corcoran Gallery of Art; Alexander Lee Nyerges, Director and CEO, Richard Townsend, Deputy for Collections and Public Programs and Curator of European Art; Dominique Vasseur, former Senior Curator; Barbara Siwecki, Registrar, Dayton Art Institute; Lewis I. Sharp, Director, Timothy Standring, Curator of Painting and Sculpture, Lori Iliff, Registrar, Denver Art Museum; Mr. Graham W. J. Beal, Director, George Keyes, Elizabeth and Allan Shelden Curator of European Paintings, Michelle Peplin, Associate Registrar, Sylvia Inwood, Photographic Resources Assistant, The Detroit Institute of Arts; Edward L. Keenan, Director, James N. Carder, Archivist and House Collections Manager, Glenn Ruby, Publishing Manager, Dumbarton Oaks Research Library and Collection, Washington, D.C.; James Cuno, Elizabeth and John Moors Cabot Director, Ivan Gaskell, Curator of Paintings, Sculpture, and Decorative Arts, William Robinson, George and Maida Abrams Curator of Drawings, Maureen Donovan, Registrar for Loans and Exhibitions, David Carpenter, Rights and Reproductions, Fogg Art Museum, Harvard University Art Museums; James T. Demetrion, Director, Valerie Fletcher, Curator of Sculpture, Brian Kavanagh, Registrar, Amy Densford, Photo Technician, Hirshhorn Museum and Sculpture Garden, Smithsonian Institution; Randall Suffolk, Director, Erin M. Budis, Curator, Robin Blakney-Carlson, Collections Manager, The Hyde Collection; John Walsh, Director, Scott Schaefer, Curator of Paintings, Lee Hendrix, Curator of Drawings, Jennifer Walchli, Assistant Registrar, The J. Paul Getty Museum; Suzanne Lindsay, Philadelphia; Andrea L. Rich, President and Director, Sharon Goodman, Curatorial Assistant, Department of Prints and Drawings, Christine Vigiletti, Assistant Registrar, Shaula Coyl, Rights and Reproductions Assistant, Los Angeles County Museum of Art; Stephen Mazoh; Philippe de Montebello, Director, Gary Tinterow, Engelhard Curator of Nineteenth-Century European Painting, Colta Ives, Curator, Department of Prints and Drawings, Marceline McKee, Loans Coordinator, Mary F. Doherty, Museum Librarian, The Metropolitan Museum of Art, New York; Guy Cogeval, Director, Nathalie Bondil-Poupard, Curator of European Art after 1800, Daniele Archambault, Registrar, Marie-Claude Saia, Photographic Services, The Montreal Museum of Fine Arts; Phillip M. Johnston, Director, Lora Urbanelli, Deputy Director, Maureen O'Brien, Curator of Painting and Sculpture, Tara Emsley, Associate Registrar, Melody Ennis, Coordinator of Photographic Services, Museum of Art, Rhode Island School of Design; Malcolm Rogers, Ann and Graham Gunn Director, George T. M. Shackelford, Chair, Art of Europe, Sue Reed, Associate Curator of Prints and Drawings, Erica E. Hirshler, John Moors Cabot Curator of Paintings, Art of the Americas, Kim Pashko, Assistant Registrar for Loans,

Museum of Fine Arts, Boston; Peter Marzio, Director, Peter Bowron, Curator of European Arts, Mary Morton, Assistant Curator of European Arts, Charles Carroll, Registrar, George Zombakis, Rights and Reproductions Administrator, The Museum of Fine Arts, Houston; Heather Haskell, Director and Curator, Stephen Fisher, Registrar, Barbara Plante, Rights and Reproductions, Museum of Fine Arts, Springfield, Massachusetts; Glenn Lowry, Director, Kirk Varnedoe, Chief Curator of Painting and Sculpture, Deborah Wye, Curator of Prints and Illustrated Books, Kathy Curry, Assistant Curator of Drawings, Diane Farynyk, Registrar, Mikki Carpenter, Photo Services and Permissions, The Museum of Modern Art, New York; Earl A. Powell III, Director, Philip Conisbee, Senior Curator of European Paintings, Andrew Robison, Mellon Senior Curator of Prints and Drawings, Douglas Lewis, Curator of Sculpture and Decorative Arts, Judith Cline, Associate Registrar for Loans, Barbara Bernard, Office of Visual Services, National Gallery of Art, Washington, D.C.; Michael Pantazzi, Curator, European Art, National Gallery of Art, Ottawa; E. John Bullard, Montine McDaniel Freeman Director, Gail Feigenbaum, Curator of Paintings, Paul Tarver, Registrar, Jennifer Ickes, Associate Registrar, New Orleans Museum of Art; Anne d'Harnoncourt, George Widener Director and CEO, Joseph Rishel, Gisela and Dennis Alter Senior Curator of European Painting before 1900, Ann Percy, Curator of Drawings, John Ittmann, Curator of Prints, Susan Anderson, Archivist, Nancy Wulbrecht, Registrar for Outgoing Loans, Conna Clark, Photographic Rights and Reproductions, Philadelphia Museum of Art; Jay Gates, Director, Eliza Rathbone, Chief Curator, Joseph Holbach, Chief Registrar, The Phillips Collection, Washington, D.C.; Charles E. Pierce Jr., Director, William M. Griswold, Charles W. Engelhard Curator of Prints and Drawings, Lucy Eldridge, Registrar, Debbie Coutavas, Deptartment of Rights and Reproduction, The Pierpont Morgan Library, New York; Robert P. Metzger, Director and CEO, Deborah Winkler, Assistant Director and Registrar, Reading Public Museum, Reading, Pennsylvania; Mr. and Mrs. Leonard Riggio, New York; Irene and Howard Stein, Atlanta; Michael Conforti, Director, Richard Rand, Senior Curator, James Ganz, Associate Curator of Prints, Drawings, and Photographs, Mattie Kelley, Registrar, Sterling and Francine Clark Art Institute, Williamstown, Massachusetts; Roger Berkowitz, Director, Larry Nichols, Curator of Painting and Sculpture before 1900, Patricia Whitesides, Registrar, Toledo Museum of Art; Ann Philbin, Director, Cynthia Burlingham, Chief Curator, Susan Lockhart, Registrar, Claudine Dixon, Administrative and Editorial Coordinator, UCLA Hammer Museum; Michael A. Brand, Director, Richard B. Woodward, former Interim Director, Malcolm Cormack, Paul Mellon Curator and Curator of European Art, Mary Sullivan, Associate Registrar, Howell Perkins, Manager of Photographic Services, Virginia Museum of Fine Arts, Richmond; Elizabeth Kornhauser, Acting Director, Eric

Zafran, Curator of European Painting and Sculpture, Cindy Roman, Associate Curator of European Painting and Sculpture, Mary Busick, Assistant Registrar, Lynn Mervosh, Rights and Reproductions Coordinator, Wadsworth Atheneum, Hartford, Connecticut; Jock Reynolds, Director, Lisa Hodermarsky, Acting Curator of Prints, Drawings, and Photographs, Lynne Addison, Associate Registrar, Suzanne Warner, Rights and Reproductions, Yale University Art Gallery.

For assistance in obtaining photography for the catalogue, we would like to thank: Cynthia Bird, Photo Editor, Adelson Galleries; Mr. and Mrs. Arthur G. Altschul and their curator, Claire A. Conway; Anne Sullivan, Registrar, Arizona State University Art Museum; J. Hindrichs, Artothek, Germany; Jean Rainwater, Coordinator of Reader Services, John Hay Library, Brown University; Charles Scribner's Sons Archive; Matthew Cook, Coordinator, Rights and Reproductions, Chicago Historical Society; Christie's, New York; Ms. Caroline Durand-Ruel-Godfroy, Collection Durand-Ruel; Erika Lindt, Administrative Assistant, Foundation E. G. Bührle Collection; Winnie Tyrrell, Manager, Photo Library, Glasgow Art Gallery and Museums; Priscilla Caldwell, James Graham and Sons; Cynthia Cormier, Director of Education and Curatorial Services, and Sharon Stotz, Education Coordinator, Hill-Stead Museum; Madame Frédérique Kartouby, Musée d'Orsay; Heather Egan, Manager of Rights and Reproductions, National Portrait Gallery; Stacey Sherman, Rights and Reproductions Coordinator, The Nelson-Atkins Museum of Art; Tara McDonnell, Curatorial Assistant, Norton Museum of Art; Michael Owen, Director, Michael Owen Gallery; Monique Nonne, Documentaliste, and Anne Pingeot, Musée d'Orsay, Paris; Rhonda Mottin, Assistant Registrar, Portland Museum of Art; Ben Primer, University Archivist and Acting Associate University Librarian, and Anna Lee Pauls, Photoduplication Coordinator, Princeton University; Meredith Ward, Richard York Gallery; Sotheby's, New York; Anita Duquette, Manager, Rights and Reproductions, Whitney Museum of American Art; and Tim Zorach, Georgetown, Maine.

For their assistance with research for the exhibition, we would like to thank the following individuals: Barry Simpson, Registrar, Art Gallery of Ontario, Toronto; Gil Pietrzak, Pennsylvania Department, Carnegie Library of Pittsburgh; Bridget M. O'Toole, Curatorial Assistant for Painting and Sculpture, Denver Art Museum; Lee R. Sorensen, Art Selector, Lilly Library, Duke University; Marjorie B. Cohn, Carl A. Weyerhaeuser Curator of Prints, Michael T. Dumas, Agnes Mongan Center, Abigail Smith, Archivist, and Miriam Stewart, Assistant Curator, Drawings Department, Fogg Art Museum, Harvard University Art Museums; Caroline Durand-Ruel Godfroy, Paris; Matthew Drutt, Associate Curator for Research, and Michelle Foa, Project Curatorial Assistant, Solomon R. Guggenheim Museum; Amy N. Dove, Curatorial Assistant, UCLA Hammer Museum, Los Angeles; Melissa Greven, Faculty Assistant, Harvard Law School, Alexandra Ames Lawrence, Research Assistant, Art of Europe, Museum of Fine Arts, Boston; Jennifer Culvert, Registrar's Office, and Laura Rosenstock, Assistant Curator, Photography and Sculpture, The Museum of Modern Art; Valerie Zell, Assistant Curator of European Art, Nelson-Atkins Museum of Art; Robert McD. Parker; Susan Anderson, Archivist, and Jennifer Vanim, Administrative Assistant in the Department of European Paintings and Sculpture before 1900, Philadelphia Museum of Art; Kathleen Stuart, Frank Strasser Administrator, Department of Drawings and Prints, The Pierpont Morgan Library, New York; Norma Sindelar, Archivist, Saint Louis Art Museum; Anne O. Morris, Head Librarian, Toledo Museum of Art.

Finally, we would like to thank those individuals who wrote for the catalogue. We especially thank essayists Richard Kendall and Rebecca A. Rabinow for their outstanding and original contributions. We would also like to thank the following scholars for their insightful discussions of objects in the exhibition: Patricia Sue Canterbury, Assistant Curator of Paintings and Modern Sculpture, The Minneapolis Institute of Arts; James Carder, Archivist and House Collection Manager, Dumbarton Oaks Research Library and Collection, Washington, D.C.; Valerie Fletcher, Curator of Sculpture, Hirshhorn Museum and Sculpture Gardens; Frances Fowle, Honorary Research Fellow, Department of Fine Art, University of Edinburgh, Scotland; Mary Morton, Assistant Curator of European Art, The Museum of Fine Arts, Houston; David Ogawa, Visiting Assistant Professor, Union College; Claire I. R. O'Mahony, Curator of Nineteenth- to Early Twentieth-Century Painting, Richard Green Gallery, London; Phaedra Siebert, Curatorial Assistant in European Art, and Gudmund Vigtel, Director Emeritus, High Museum of Art.

Ann Dumas and David A. Brenneman

Directors' Preface

THE DECISION TO MOUNT AN EXHIBITION of the work of Edgar Degas stemmed in part from the High's successful 1999 exhibition, *Impressionism: Paintings Collected by European Museums*. That exhibition aimed to show how Impressionist paintings made their way into European museums, and it revealed the initial difficulties and later triumph of the Impressionist movement. Similarly, we hoped to approach Degas's early American reception with a comprehensive view to understanding this complex art historical phenomenon.

Degas's work, like that of fellow Impressionists, was not immediately embraced by Americans. Critics were shocked by Degas's strange use of color, and they were troubled by his depictions of what were deemed to be vulgar subjects of everyday urban life. Finally, his later works sparked controversy because they appeared to be unfinished.

Nevertheless, many of Degas's works left France because certain American collectors had a keen appetite for his art. Among the early collectors were Louisine Havemeyer in New York, Berthe Honoré Palmer in Chicago, and Alexander Cassatt in Philadelphia. Following Degas's warm reception by private collectors, important institutional acquisitions were made by the Museum of Fine Arts, Boston, The Metropolitan Museum of Art, New York, The Art Institute of Chicago, and other museums that had the foresight to acquire Degas's work at an early date. For these private and institutional collectors, Degas represented a modern innovator, a master draftsman, and a painter whose genius placed him in the same rank as the old masters.

Crucial to the dissemination of Degas's reputation and work was the American artist Mary Cassatt, who encouraged Mrs. Havemeyer and others to buy Degas's work. Equally important was the initiative of the Paris art dealer Paul Durand-Ruel: the Impressionist exhibition he held in New York in 1886 was the first major public showing of Degas's work in America. Another significant indicator of growing American enthusiasm for Degas was the first museum exhibition of his work, held in 1911 at the Fogg Art Museum of Harvard University. Then in 1936, the first major retrospective of his work was held at the Pennsylvania Museum of Art (now the Philadelphia Museum of Art).

The works assembled in this exhibition demonstrate how Degas has become one of the most cherished of nineteenth-century masters in America. This project is the result of a collaboration between the High Museum of Art and The Minneapolis Institute of Arts. We would like to thank Ann Dumas and David A. Brenneman, Frances B. Bunzl Family Curator of European Art at the High, who co-organized the exhibition. They worked closely with Patrick Noon, the Patrick and Aimée Butler Curator of Paintings at The Minneapolis Institute of Arts.

In Atlanta, the High Museum of Art is privileged to have the Forward Arts Foundation as lead sponsors for the Degas exhibition. The Forward Arts Foundation, an association of Atlanta women volunteers, emerged over three decades ago from the Museum's Women's Committee. Focused on supporting visual arts in Atlanta, the foundation continues to purchase of works of art, sponsor exhibitions, and provide endowment support for the Museum. We are also grateful to the Rich Foundation for their critical funding of Degas and their legacy of leadership at the Museum. Support for this exhibition is also made possible by the High's corporate sponsor, Bank of America.

Presentation of *Degas and America* at The Minneapolis Institute of Arts has been made possible with the generous support of Dayton's Project Imagine, a program of the Department Store Division of Target Corporation, which embodies its corporate commitment to the art of giving by donating five percent of the company's federally taxable income to the community. The Institute is also grateful for major support from Dain Rauscher, one of the nation's largest full-service securities firms, likewise known for its outstanding philanthropy in the communities where it does business.

Michael E. Shapiro
Nancy and Holcombe T. Green, Jr. Director
High Museum of Art

Evan M. Maurer
Director and President
The Minneapolis Institute of Arts

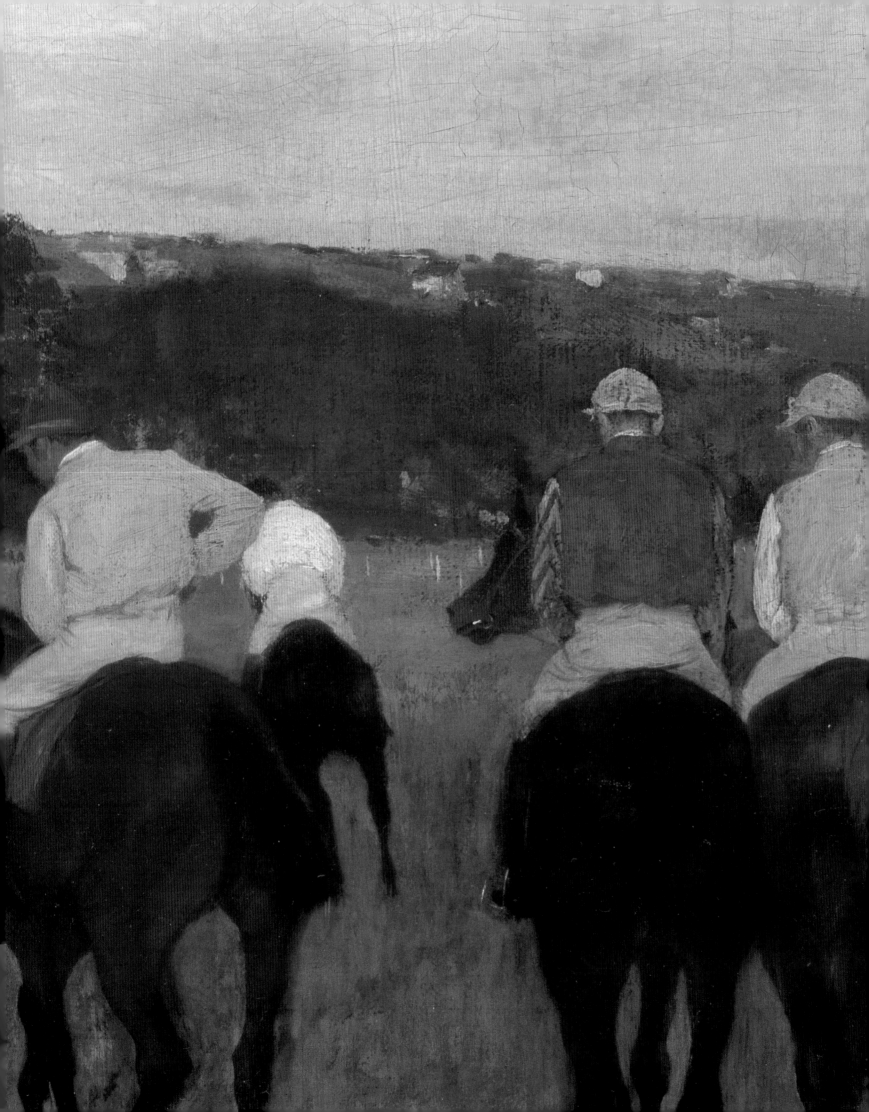

Degas in America

Ann Dumas

"ANYONE WHO WISHES to make a serious study of French painting must cross the Atlantic," asserted the critic of the British periodical *The Burlington Magazine* in 1910. "One can get to know Degas from all sides in America," he continued. "Examples, and many, of jockeys, ballet scenes, of interiors and single figures are to be found."[1] It remains a remarkable fact today that the majority of the world's outstanding collections of works by Degas are in America. The superb collections at The Metropolitan Museum of Art, New York, The Art Institute of Chicago, the National Gallery of Art, Washington, D.C., and the Norton Simon Museum of Art, Pasadena, are surpassed only by the Degas holdings at the Musée d'Orsay in Paris. And in addition to these substantial collections, many museums throughout the United States possess smaller groups or individual examples of Degas's work.

How did America discover Degas? Who were the pioneer American collectors, museum directors, and curators who responded to this challenging French artist? When was Degas first exhibited, appreciated, or misunderstood in the United States? What kinds of works, if any, were favored above others? Did Americans have a particular taste for Degas that was distinct from their enthusiasm for the Impressionists in general? What was his impact on contemporary American artists? These are some of the questions that this exhibition and catalogue set out to address.

Certainly, the phenomenon of Degas's reception in America owes a good deal to a general open-mindedness and lack of prejudice on the part of adventurous American collectors that allowed them to respond to Impressionism in the 1890s. This was in marked contrast to the largely hostile public reaction that

had greeted the movement in Paris twenty years before, when the Impressionists had first exhibited as a group in 1874. It is worth remembering that it was not until 1896 that the French state grudgingly, and after several delays, accepted seven works by Degas as part of Gustave Caillebotte's magnificent bequest of Impressionist paintings. Only seven years later, the enthusiastic purchase of *Race Horses at Longchamp* (cat. 29) by the Boston Museum of Fine Arts marked the first acquisition by an American institution of a work by Degas.

Degas has the distinction of being the only French Impressionist ever to visit America. In the fall and winter of 1872 to 1873, he spent about four months with his American relatives on his mother's side of the family, the Mussons, in their native New Orleans.[2] Although this trip produced a number of portraits of Degas's American relatives, it had no impact on the market for Degas's work on this side of the Atlantic.

It was not until a few years later, in 1878, that the first work by Degas would be publicly displayed in America. This was *Rehearsal of the Ballet* (page 36, fig. 1), a magical little monotype overlaid with layers of gouache and pastel that displays the oblique composition, carefully orchestrated spontaneity, and experimental technique that exemplified Degas's art in the 1870s. When this work was included in the Eleventh Annual Exhibition of the American Watercolor Society in New York in 1878, an anonymous critic wrote, "It gave us an opportunity of seeing the work of one of the strongest members of the French Impressionist School, so called: though light and in parts vague in touch, this is the assured work of a man who can, if he wishes, draw with the sharpness and firmness of Holbein."[3]

MARY CASSATT AND THE FIRST AMERICAN COLLECTORS
Rehearsal of the Ballet is generally accepted to be the first work by Degas to be bought by an American collector. It was the purchase of a well-to-do American girl, Louisine Elder (1855–1929), who had never bought a work of art before. She was captivated by this pastel in 1877, when she saw it in a picture dealer's window during one of her first visits to Paris. On the advice of her new friend, the American Impressionist painter Mary Cassatt (1844–1926), Louisine raised the 500 francs (then worth about $100) required to buy the work from her own and her two sisters' allowances. Cassatt, who was ten years older than Louisine, was to become her friend, mentor, and tutor in matters of art. In

her memoirs, Louisine recalled, "Mary Cassatt and I have been lifelong friends. She has been my inspiration and my guide. I call her the fairy godmother of my collection, for the best things I own have been bought on her judgement and advice."[4] Guided by Cassatt, Louisine and her husband Henry O. Havemeyer (1847–1907), whom she married in 1883, would put together one of the most spectacular collections ever created—encompassing furniture and decorative arts as well as old-master and nineteenth-century French painting.[5]

Louisine Havemeyer never lost her passion for Degas. She was the first to demonstrate that particular obsession with Degas that, as we shall see, was to characterize a succession of American collectors. In her memoirs she leaves an endearingly fresh and candid account of her enthusiasm along with the story of her acquisitions of his work over a period of forty years. She recalls the several visits she and Henry made to Degas's studio with Cassatt, describing Degas as "a dignified looking man of medium height, a compact figure, well dressed, rather dark and with fine eyes. There was nothing of the artist *négligé* about him, on the contrary he rather impressed me as a man of the world."[6] One occasion that particularly stuck in her memory was when Degas unexpectedly gave her and Henry three drawings, which she always treasured and kept in a box under the sofa in her New York mansion.[7] In 1891 she bought *The Collector of Prints* (page 38, fig. 4) and in 1895 acquired about a half-dozen pictures from the dealer Paul Durand-Ruel. The enigmatic genre painting *Sulking* (page 38, fig. 5) was acquired in 1896 and five more ballet scenes in 1899. In 1898 Mrs. Havemeyer overcame the misgivings about Degas of her friend and New York neighbor, Colonel Oliver H. Payne, and persuaded him to buy the wonderfully luminous and complex *The Dance Class* (1874, Metropolitan Museum of Art).

Further acquisitions of works by Degas followed thick and fast. In 1912, Mrs. Havemeyer paid the highest price ever for a work by a living artist when she bought Degas's *Dancers Practicing at the Bar* (page 41, fig. 11) for 430,000 francs at the sale of the collection of Degas's old friend Henri Rouart in December 1912. Her last purchase was the hauntingly beautiful painting *A Woman Seated Beside a Vase of Flowers* (cat. 18), which she bought from Durand-Ruel in 1921. In that year she also acquired seventy-two bronzes—the first casts ("A" set) of the small wax sculptures found in Degas's studio after his death, produced by

the Paris foundry A. A. Hébrard from 1918 to 1921. This went some way toward compensating Louisine for her disappointment at failing to purchase from the artist's heirs the wax sculpture of *The Little Dancer of Fourteen Years* (National Gallery of Art, Washington, D.C.). She had admired this "graceful figure [that] was as classic as an Egyptian statue and as modern as Degas" on several visits to his studio, and had tried to buy it as early as 1903.[8] Perhaps the greatest tribute Mrs. Havemeyer paid Degas was to include twenty-four of his works in the exhibition she organized in New York in 1915 in support of woman suffrage (see page 42). In her speech at the opening event, "Remarks on Edgar Degas and Mary Cassatt," she combined personal anecdotes of her long acquaintance with Degas with observations on his working methods.

In all, the Havemeyers acquired no fewer than sixty-four works by Degas in all media. Their adventurous taste was combined with a capacity to learn and was supported by significant wealth, which enabled them to assemble the greatest collection of Degas's work ever formed in private hands. "All the pictures privately bought by rich Americans will eventually find their way into public collections and [will] enrich the nations and national taste," Cassatt remarked in 1911.[9] True to that particularly public American spirit, the Havemeyers' collection was formed not only for their personal enjoyment but also for the benefit of a great public institution. In 1929, the year of Louisine's death, fourteen paintings, twenty-five pastels and drawings, six prints, and sixty-eight bronzes by Degas were bequeathed to The Metropolitan Museum of Art in New York. This pattern of private donations and bequests lies behind the formation of so many American museum collections. The Havemeyers thus exemplify, on a grand scale, the munificent collectors of the Golden Age of American collecting at the end of the nineteenth and the beginning of the twentieth centuries.

Nobody played a more crucial role in promoting Degas's work among American collectors than Mary Cassatt. She was undoubtedly the single most important influence in shaping the Havemeyers' collection, especially their acquisitions of Degas's work, but she also acted as an informal counselor to a wide range of her acquaintances among the American social elite.[10] She became a focus for wealthy Americans who were captivated by Paris and the allure of French culture. As an artist living and working in the contemporary art world in Paris—but

also the daughter of a wealthy, patrician Philadelphia family—she was uniquely placed to act as an ambassador between avant-garde French artists and American millionaires. She became an advisor to fabulously wealthy Americans who were keen to emulate European aristocrats and endorse their newly acquired fortunes in coal, steel, and railroads with a cachet of culture. Works by Degas and the other Impressionists were not easily accessible to American visitors to Paris. They would not have seen Degas's works at the official Salon but only at the Impressionist exhibitions (which came to an end in 1886), at Durand-Ruel and a few more modest dealers such as Alphonse Portier, and in the artist's studio—venues to which Cassatt had a special entrée.

Cassatt's independent character enabled her to transcend the traditional restrictions that bound a young woman of her social class. In June 1874, at the age of thirty, she settled in Paris, determined to pursue her career as an artist. Apart from two trips back to the States late in life, she was to remain in France until her death in 1926. Cassatt's determination to persuade her wealthy compatriots to acquire modern French painting (although, sometimes, she also advised them on purchases of the old masters) stemmed from a belief in the educative value of art and its power to touch people's lives. She felt that America should be enriched with art collections equal to those of Europe. Her own immigration to Paris had been partly motivated by the fact that there was not enough great art for a young student to study at home. Her private fortune meant that money was not a motive in advising collectors.[11] Cassatt succeeded brilliantly in igniting the many American collectors who visited her in Paris with her own passionate conviction about the work of her Impressionist colleagues. She herself formed a small but impressive collection of their work that, in addition to Degas, included paintings by Monet, Manet, Morisot, and Courbet (whom she especially admired), as well as Japanese prints.[12] Her example inspired confidence among the wealthy elite in her circle to do the same. As Erica Hirshler has explained, "In effect, her recommendation made radical art respectable."[13] Although she managed to persuade her friends to buy works by nearly all of the Impressionists, it was unquestionably Degas for whom her greatest admiration was reserved.

By the time Cassatt first met Degas in 1877, she had for some time been a devoted admirer of his art. Much later, in a letter to

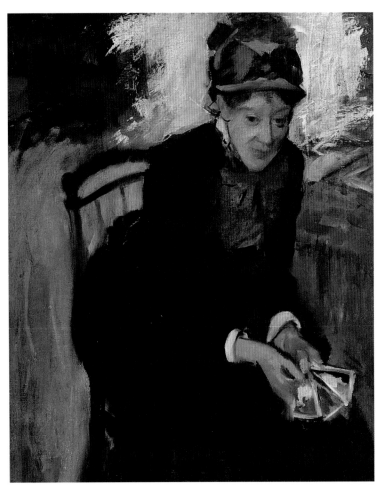

Fig. 1. Edgar Degas, *Mary Cassatt,* ca. 1880–84, oil on canvas, 28⅛ × 23⅛ inches, The National Portrait Gallery, Smithsonian Institution, gift of Morris and Gwendolyn Cafritz Foundation and the Regents' Major Acquisitions Fund, Smithsonian Institution, NPG.84.34.

tured by a number of shared attitudes. To begin with, they came from similar haute-bourgeois backgrounds and were thus socially at ease with one another. Moreover, their approaches to making art coincided in many respects. They both, to a large extent, concentrated on the human figure, although Cassatt's status as a woman artist in the nineteenth century meant that her range of subjects was more limited than was Degas's. They also both loved experimenting with different techniques, especially in pastel and printmaking. Although Cassatt was never the mentor for Degas that he was for her, he respected her work.

That Degas liked and respected this strong-willed, independent woman is clear from his portrait of her in a forceful—almost masculine—pose, leaning forward with her elbows on her knees (fig. 1). Later in life, Cassatt came to detest this portrait and requested that her family not keep it, asking the dealer Durand-Ruel to find a non-American buyer for it so that she would not be recognized at home. The portrait is in fact strikingly similar to that of another woman artist whom Degas painted, Victoria Dubourg, the wife of the still-life painter Henri Fantin-Latour (cat. 20), whom he portrayed in a direct pose that is equally at odds with the conventions of nineteenth-century female portraiture. Although neither of these women is depicted with the attributes of artists, the rather workmanlike poses that Degas has chosen suggest the respect he had for them as professionals.

Cassatt was Degas's model on a number of other occasions. She posed for his telling vignette of a Parisian *femme du monde* weighing the effect of a new hat in two pastels entitled *At the Milliner's* (Metropolitan Museum of Art and Museum of Modern Art). It is possible that she was also the model for the young milliner surveying her latest creation in *The Millinery Shop* (cat. 54). She is possibly one, if not two, of the modish women in *Portraits in a Frieze,* 1870 (cat. 40).[15] Cassatt is also the elegant silhouette leaning on an umbrella in Degas's print *Mary Cassatt at the Louvre: The Paintings Gallery* (cats. 45, 46, 47). One of Degas's most complex prints, the work evolved through twenty states, combining aquatint, etching, and drypoint. It is, in a sense, an homage to Degas and Cassatt's shared love of the Louvre and the art of the past as well as to their intense collaboration in an experimental printmaking venture. *Mary Cassatt at the Louvre* was produced in 1879, the year in which Degas and Cassatt, together with Pissarro, plunged into the alchemy of printmaking for a never-realized publication of original prints

Louisine Havemeyer, she touchingly remembered the deep impact that Degas's work had first made on her. "How well I remember nearly forty years ago seeing for the first time Degas' pastels in the window of a picture dealer, in the Boulevard Haussmann. I would go there and flatten my nose against that window and absorb all I could of his art. It changed my life. I saw art then, as I wanted to see it."[14] Her commitment to Degas was the most important and enduring element of her artistic career. Degas invited Cassatt to exhibit with the Impressionist group, and she made her debut at the Fourth Impressionist exhibition in 1879. With her share of the proceeds from the 1879 exhibition, she bought a painting by Monet and one by Degas.

The lifelong friendship between Degas and Cassatt was nur-

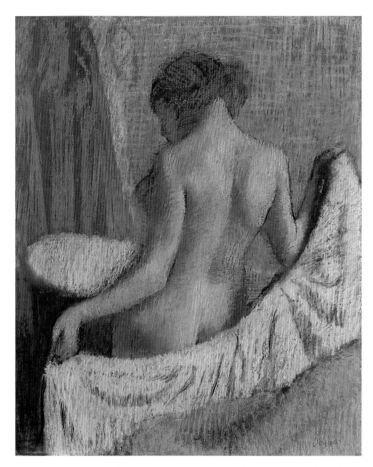

Fig. 2. Edgar Degas, *After the Bath,* 1985–98, pastel on brown cardboard, 27½ × 22⅜ inches, Fogg Art Museum, Harvard University Art Museums, gift of Mrs. J. Montgomery Sears.

that was to have been titled *Le jour et la nuit (Day and Night).* Inventing new techniques and using old ones in new ways, they manipulated light and dark, texture and surface, to bring a new visual variety and expressive language to the print.

At the close of the last Impressionist exhibition in 1886, Degas and Cassatt exchanged works, no doubt as a gesture of friendship. Degas received Cassatt's portrait *Girl Arranging Her Hair* (1886, National Gallery of Art, Washington, D.C.) and Cassatt acquired *Woman Bathing in a Shallow Tub* (1885, Metropolitan Museum of Art), one of the suite of eight richly textured and colorful pastels of women bathing that the critic Huysmans memorably described as "the marriage and adultery of colour."[16] Although Cassatt thought that the work was not readily appealing—"I cannot believe that many would care for the nude I have. These things are for painters and connoisseurs"[17]—in fact, it

was probably the presence of this beautiful pastel in Cassatt's collection that inspired three American women to acquire similar examples of Degas's late female nudes, works that are often considered among Degas's tougher, more difficult work. Louisine Havemeyer bought *Woman Bathing in a Shallow Tub* from Cassatt in 1917; it is one of several late nudes that she eventually owned. One of Degas's most sumptuous late nudes, *After the Bath* (fig. 2) was acquired, probably at the sale of the Parisian dentist and distinguished collector Dr. Viau in 1907, by Sarah Choate Sears, wife of the Boston real estate millionaire Montgomery Sears. Sarah Sears was a leading light in the Boston art community at the turn of the last century who, in addition to collecting art, was herself a gifted amateur painter and photographer.[18] She eventually owned five works by Degas: in addition to *After the Bath,* she bought *The Washbasin,* two unidentified pastels of a nude woman reading, and *The Mante Family,* ca. 1884 (Private Collection)—another version of the work now in the Philadelphia Museum of Art (fig. 4), which was originally owned by Mrs. Potter Palmer, doyenne of Chicago society.[19]

The redoubtable Berthe Honoré Palmer purchased the luminous *Morning Bath* (cat. 68) from Durand-Ruel in Paris in 1896, probably on Cassatt's advice. One of the most beautiful of all Degas's nudes, *The Tub* (fig. 3) was acquired by the Cleveland iron magnate Alfred Pope and was one of the works kept by his daughter, the first American woman architect, Theodate Pope, when she pruned her father's collection after his death. It is surprising, but perhaps not accidental, that these women collectors should have been drawn to these uningratiating pictures. As both Erica Hirshler and Richard Kendall have proposed, these free-spirited female patrons at the turn of last century evidently saw these images as sympathetic renderings of the commonplace rituals of a woman's daily life, and not the displays of misogynist voyeurism that they are sometimes taken to be.[20]

Sarah Choate Sears, the Potter Palmers, and Alfred Pope were all part of the network of wealthy collectors that revolved in Cassatt's orbit. By the 1890s, when these collectors were gravitating to Paris, captivated by the sophisticated allure of the city and of French culture, the market for modern French art was already shifting from Paris to New York. Escalating demand had an effect on prices, and the value of Degas's work shot up at the turn of the century. Noting this new trend, the New Yorker Alfred

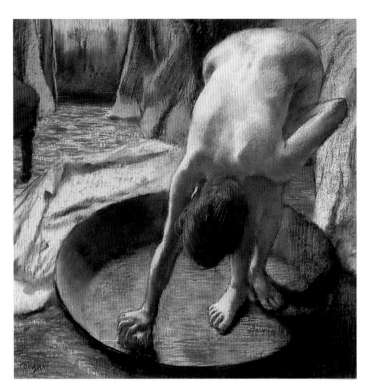

Fig. 3. Edgar Degas, *The Tub*, ca. 1886, pastel on paper, 27½ × 27½ inches, Hill-Stead Museum, Farmington, Connecticut.

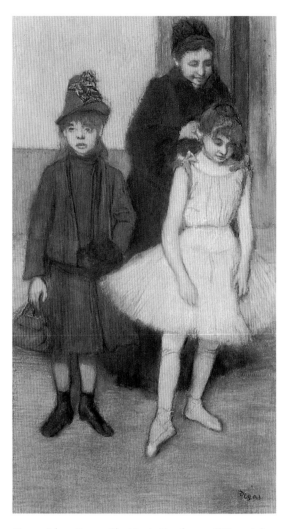

Fig. 4. Edgar Degas, *The Mante Family*, ca. 1886, pastel on paper, 34¾ × 19⅛ inches, Philadelphia Museum of Art, given by Mrs. John Wintersteen.

Trumble began in 1889 to publish a journal entitled *The Collector*, which contained articles on sales and exhibitions in Europe and America. However, on the other side of the Atlantic, many Frenchmen were dismayed at what they saw as the dissipation of their patrimony. When the French painter and writer Jacques-Emile Blanche regretfully compared the old-school French connoisseur with "the stampede of irresponsible American millionaires," he summed up a general French attitude (shared by Degas himself).[21]

Mary Cassatt had begun her evangelizing campaign on behalf of modern French art on her own home territory in Philadelphia. After Louisine Elder's purchase of *Rehearsal of the Ballet,* Cassatt turned her attention to her brother Alexander Cassatt, vice president of the Pennsylvania Railroad Company, and tried to convince him that he should own a Degas. She started off by tactfully suggesting a jockey picture, *Scene from the Steeplechase: The Fallen Jockey* (subsequently acquired by Mr. and Mrs. Paul Mellon and now in the collection of the National Gallery of Art, Washington, D.C.), no doubt assuming that this would be more in line with the tastes of a patrician East Coast gentleman who

loved horses than some of Degas's other subjects. She sent her brother photographs of three of Degas's works, including *The Ballet Class* (cat. 49). Robert Cassatt, the father of Mary and Alexander, commented to his daughter: "I do not know what he will think of the horses, but the dancers are wonderful."[22] Apparently Alexander thought so too, for he decided to buy what remains one of Degas's most spatially complex and compelling dance compositions. Although the first version of this painting was complete by the end of 1880, Degas was unable to resist the urge to revise, painting over a foreground figure of a dancer, adjusting her shoe, and replacing her with the seated woman reading a newspaper. Finally, *The Ballet Class,* the second work

by Degas to cross the Atlantic, was delivered to Philadelphia in September 1881. This was to be the first of three works by Degas that Alexander Cassatt would acquire on his sister's advice. In 1889 he bought *The Jockey,* ca. 1886, now also in the Philadelphia Museum of Art, and a pastel over monotype of a café-concert.[23]

Another prominent Philadelphia collector in this first phase of the American response to Degas was John G. Johnson. A lawyer who advised Alexander Cassatt, Johnson was also a friend of the Havemeyers. Although principally a collector of Renaissance and Baroque art, he acquired three Degas works that were eventually bequeathed to the Philadelphia Museum of Art: the beautiful pastel *Ballet from an Opera Box,* ca. 1884, which was bought from Paul Durand-Ruel in 1891 on Mary Cassatt's recommendation; the drawing of a dancer *A Coryphée Resting,* which came from the Dutch dealer Van Wisselingh; and an amusing and unlikely oil study of a cow.

Mention should also be made of Johnson's friend, the streetcar millionaire Peter A. B. Widener of Elkins Park, Pennsylvania, who was escorted around the Paris galleries by Johnson. Widener became one of the earliest American collectors of Degas when he bought *The Races* (cat. 25), which had previously belonged to the New York businessman Erwin Davis.

Although, as we shall see, Boston was to play a leading role in fostering the appreciation of Degas after the first decade of the twentieth century, in the 1880s and 1890s Bostonians were passionate about Monet above all the other Impressionists. This seems to have been a natural development from their enthusiasm for French landscapes of the Barbizon School and the fact that a number of Boston artists traveled to Giverny to paint with Monet on his home territory. Throughout the nineteenth century, landscape was the dominant subject for American painting, which accounts for the American understanding of Impressionism as primarily a landscape style. The *Foreign Exhibition* held at the enterprising St. Botolph Club in 1883 contained three works by Monet but none by Degas. An exhibition devoted entirely to Monet in 1892 contained twenty-one landscapes, all borrowed from local Boston collections. But a taste for Degas was slower to develop. Another famous Boston collector, Isabella Stewart Gardner, acquired Degas's fine, sharply focused, Ingresque portrait of Mademoiselle Gaujelin from the New York dealer Eugene Glaenzer on the advice of Bernard Berenson, who found the work "mysterious, fascinating, inexhaustibly beautiful."[24] One

of three works by Degas acquired by Mrs. Gardner, it is perhaps a predictable choice for a collector renowned for her magnificent collection of old masters.

Determined not to lag behind these East Coast centers of culture, the great new industrial cities of the Midwest, notably Chicago ("Paris of the Prairies"), also began to collect Impressionist pictures on a grand scale. The most important collectors in Chicago in the 1890s were Mr. and Mrs. Potter Palmer. Palmer had made a fortune in the dry goods business and then built the opulent Palmer House Hotel, rebuilding it after it was destroyed by fire in 1871. Typical of the generation of American collectors who bought Impressionism, Berthe Honoré and Potter Palmer had throughout the 1890s amassed an extensive collection of paintings by the Barbizon School that lined the walls of the seventy-five-foot-long salon in their lavish neo-Gothic mansion on the Lake Shore Drive. Possibly as a result of their acquaintance with Mary Cassatt, they began to turn their attention to the more avant-garde art of the Impressionists. Like Louisine Havemeyer, Mrs. Palmer's first acquisition of a modern French painting was a Degas dance pastel, *On the Stage* (Art Institute of Chicago), which she bought from the dealer Durand-Ruel for 600 francs in September 1889. But whereas the Havemeyers disliked Renoir and were not keen on Pissarro or Sisley, but loved Degas, the Potter Palmers' passion for Monet and Renoir outweighed their enthusiasm for Degas. Nevertheless, in 1891 they bought Degas's *Dancers Preparing for the Ballet* (ca. 1872–76, Art Institute of Chicago).

The following year, the Palmers indulged in a flurry of art-buying, perhaps hoping to enlarge their collection in time for the great Chicago World's Fair, the Columbian Exposition in 1893, when their home would become the setting for many a glittering social gathering. From Durand-Ruel alone they bought twelve Monets, ten Renoirs, eight Pissarros, two Sisleys, and two Cassatts. Later they bought five more works by Degas, including *The Mante Family* (fig. 4) and *The Morning Bath* (cat. 68) in 1896. The bulk of their collection was, however, complete by the time the Exposition opened in May 1893. Berthe Honoré Palmer played a central role in the organization of the Fair, since she was chairwoman of the Board of Lady Managers. The fashionable Swedish society portraitist Anders Zorn captured the "Queen of Chicago" in her moment of glory, resplendent in her "crown jewels" for the opening of the Fair (fig. 5). As in the case

of the Havemeyers, the Palmers' private collection was destined to enrich a great public institution, The Art Institute of Chicago.

The Palmers were almost certainly advised in their Impressionist purchases by Mary Cassatt, but they were also guided by another more elusive personality who, like Cassatt, played a vital role as a contact between avant-garde French artists and American collectors, especially in Chicago. Like Cassatt, Sara Tyson Hallowell came from Philadelphia, but she had settled in Chicago in 1873, when she came to organize the art display for the Interstate Industrial Exposition in order to "solve the problem of self support."[25] Although she was not herself a painter, she established a wide network of friends and acquaintances among avant-garde artists in Paris, dealers, and American collectors, developing a successful career as an art agent and advising Chicago collectors on their purchases. As John Kysela described her, "Sara circulated among the Impressionists. She looked them up in their studios, and visited them in their forest retreats. She staked them at times, appraised their work, cheered them in dark moments, established American links and worked smoothly with Durand-Ruel."[26] Hallowell rose to prominence at the time of the Columbian Exposition, when she was responsible for the *Loan Exhibition of Foreign Masterpieces* shown in the Palace of Fine Arts. All the works were gathered from American collections. Although it cannot be said that the exhibition featured French avant-garde art—since much of the work on view was from the Romantic and Barbizon schools—it nevertheless acted as a showcase for a small group of Impressionist works, including Degas's *The Ballet Class* (cat. 49), lent by Alexander Cassatt. An anonymous critic reported that he could not "find any pictures in the entire French section that surpass in dexterity of execution those of Degas."[27]

Mary Cassatt, and quite possibly Sara Hallowell as well, advised two other significant early collectors of Degas, Harris Whittemore (fig. 6) and Alfred Atmore Pope, who were both iron barons. Alfred Pope's company was based in Cleveland, Ohio, while Harris Whittemore followed his father as president of the Naugatuck Malleable Iron Company in Connecticut. In the winter of 1888–89, the Popes embarked on a European tour, accompanied for much of it by their young friend Harris Whittemore. In Paris the Popes, like many Americans, were drawn first to Monet and bought several paintings from Durand-Ruel. But in 1892 they discovered Degas—his pastel *Jockeys* (1886, Hill-Stead

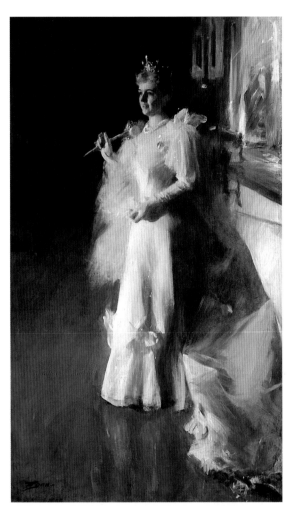

Fig. 5. Anders Zorn (Swedish, 1860–1920), *Mrs. Potter Palmer*, 1893, oil on canvas, 101⅝ × 55⅝ inches, The Art Institute of Chicago, Potter Palmer Collection, 1922.450.

Museum, Farmingon, Connecticut), and his brilliantly hued *Dancers in Pink* (page 48, fig. 1), which had previously been owned by Erwin Davis. An unsigned article about the Pope collection that appeared in the Cleveland *Plain Dealer* on January 7, 1894, mentions Degas's "Ballet Girls," concluding, "The Impressionist school is poorly understood by the people in general and yet it is a strong, vigorous institution and a formidable rival to the realistic one. There are several fine examples on exhibition and, as may be imagined, are misunderstood to a great extent. They are not for casual glances, but for deep study. The oftener you study them the better acquainted you become with the efforts of the artist and his aims."[28] Alfred Pope went on to acquire two spectacular works by Degas, probably on Cassatt's

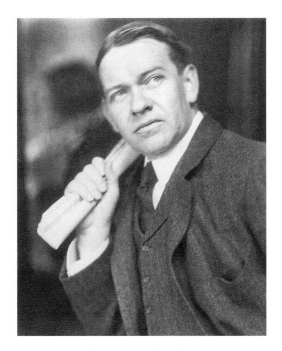

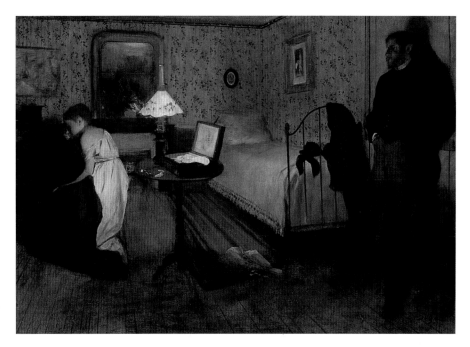

Fig. 6. Harris Whittemore, Hill-Stead Museum, Farmington, Connecticut.

Fig. 7. Edgar Degas, *The Interior*, 1868–69, oil on canvas, 32 × 45 inches, Philadelphia Museum of Art, The Henry P. McIlhenny Collection in memory of Frances P. McIlhenny.

advice, *The Tub* (fig. 3) and the enigmatic *The Interior* (fig. 7). In 1907, Pope had considered buying *The Interior* but had decided against it, perhaps because of the work's highly charged and obviously sexual subject.[29] However, in October 1909 his friend Harris Whittemore bought it for him as a Christmas gift. Whittemore would later inherit the work from Pope, but this, as we shall see, was not the end of the picture's migration through important American collections.

The Whittemores, probably as a result of Cassatt's encouragement, had a particular fondness for the work of Degas. Cassatt met the Whittemores in Paris by 1893 and corresponded regularly with them until her death in 1926, often recommending acquisitions of Degases. In November 1893 she suggested they visit the private dealer Alphonse Portier, who "will show you some drawings of Degas and other things that might interest you."[30] In that year Whittemore bought from Durand-Ruel *Four Dancers in the Rehearsal Room,* ca. 1890,[31] and *On the Stage,* ca. 1881.[32] A letter from Cassatt to Whittemore, written in November 1893, reveals that Degas was a topic that came up regularly in their exchanges: "Did you see my brothers Degas at the Loan Exhibition in Chicago? Some one wrote to me it was the finest thing there. I hear that a Mr. Yerkes objected to the Degas, saying

no one ever heard of him, that Bougereau represented the French school. If I do hear of a Degas I will write at once. There is a splendid pastel of his belonging to a friend of mine in New York, which I got her to buy 15 years ago for 500 francs. I always knew Degas was one of the great artists of the century, although I was laughed at for saying so."[33] Whittemore bought the luminous *The Rehearsal* (Fogg Art Museum, Harvard University) from the New York dealer Eugène Glaenzer in March 1907. Whittemore also purchased another early Degas, *Violinist and Young Woman Holding Sheet Music* (fig. 8), for $7,000 in 1921. In addition to these important paintings, his collection eventually included a number of works on paper, among them two horse-racing pastels and seven ballet scenes. A few years later, just after Degas's death, Whittemore bought a preparatory sketch on bright green paper (British Museum, London) for Louisine Havemeyer's *Dancers Practicing at the Bar* (page 41, fig. 11).

The excitement—the thrill of the chase—that these early Impressionist collectors experienced as they hunted for pictures emerges from their delightfully impromptu letters. Writing to Whittemore from Paris, Pope describes visits to the celebrated collections of the baritone Jean-Baptiste Faure and Count Isaac de Camondo:

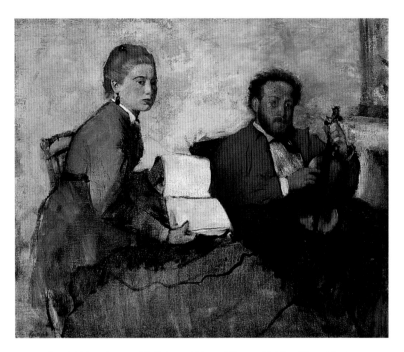

Fig. 8. Edgar Degas, *Violinist and Young Woman Holding Sheet Music,*
ca. 1871, oil on canvas, 18¼ × 22 inches, The Detroit Institute of Arts,
Bequest of Robert H. Tannahill.

When we first came to Paris I wired Clinton Peters & we went
up to Camenthorns [Paris dealer], there was the Degas horse
picture, its fine *best worked* horse picture I have ever seen, its
beyond criticism except being in pastel. It is well represented
by the photograph. I didn't "rise to it," although I know its
good. C. also had indifferent ballet girl picture in oil. C then
proposed going to see Fares & Count Comondor collections
which we did. The former has *five* Manets, the one fine Degas,
other fine things, lots you *cant see.* Count C has many Degas,
one the Ballet Master & girls, interior green side walls, *air
every thing.* It's the great Degas here. His little one bought
lately for 60,000frs, is dry & fine like a Messonier, wouldn't
care for it. The first one I spoke of would be cheap at any
price. I have seen Manzies since & its just "out of sight" of
his. I *would not* exchange mine for Faures or any of Manzies.
Durand-Ruel has the opera, its good, but I don't "rise to it" as
I am bound to do to any & every picture before I purchase it,
unless of course I loose my head.[34]

PAUL DURAND-RUEL

Paul Durand-Ruel, the brilliant dealer and great champion of
the Impressionists, no less than Mary Cassatt, played a vital
role in bringing French Impressionism to America. Like Cassatt,
Durand-Ruel claimed an altruistic motive, believing that he was
contributing to the development of American culture: "A good
dealer must be an enlightened *amateur,* ready—if need be—to
sacrifice his own interest to his artistic convictions."[35] All of the
American collectors who went to Paris made the pilgrimage to
"the Louvre on la rue Laffitte," as Durand-Ruel's gallery came to
be known. Cassatt regularly directed her friends there and, at
one stage, Sara Hallowell wrote to Durand-Ruel suggesting that
the firm might find it advantageous to employ her and, on an-
other occasion, that she should run a Chicago branch of the
gallery that he was thinking of opening. The 1882 economic
depression in France that brought Durand-Ruel close to bank-
ruptcy propelled him into exploring markets abroad. An ambi-
tious exhibition of Impressionist paintings that he organized
at Dowdeswell's Galleries in London in 1883 was a commercial
flop but, undaunted, the dealer decided to try his luck in the
United States. "One must try to revolutionize the New World at
the same time as the Old," he explained to Pissarro.[36] Durand-
Ruel was in fact rescued from his financial predicament by a
proposal from James Sutton, the representative of the Ameri-
can Art Association of New York. Having been satisfied about
the financial viability of the scheme and encouraged by the
Association's luxurious premises, Durand-Ruel shipped about
three hundred paintings to New York. These included forty-eight
Monets, seventeen Manets, forty-two Pissarros, thirty-eight
Renoirs, fifteen Sisleys, three Seurats, and twenty-three by
Degas. As a safeguard, he also included about fifty works by
more conservative artists.

Works in Oil and Pastel by the Impressionists of Paris opened
in New York on April 10, 1886. Although, as we have seen, indi-
vidual works by Degas had been exhibited in America on a few
isolated occasions before this—Mrs. Havemeyer's pastel at the
American Watercolor Society in 1878 and Erwin Davis's *Dancers
in Pink* (page 48, fig. 1) in the Pedestal Exhibition organized by
the American artists William Merritt Chase and J. Alden Weir in
1883—but this was the first occasion on which such a substan-
tial group of works by Degas had ever been presented to the

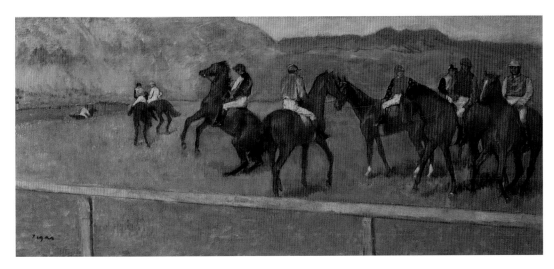

Fig. 9. Edgar Degas, *Race Horses,* ca. 1878–80, oil on canvas, 15½ × 35 inches, E. G. Bührle Foundation Collection.

American public. Although some critics were puzzled, most responded favorably to the exhibition. Certainly, there was nothing like the blind hostility that had greeted the First Impressionist exhibition in Paris twelve years before. For tax reasons the exhibition moved to the National Academy of Design on May 25, with twenty-one additional Impressionist paintings. This expanded version included twenty-five works by Degas. It is difficult to identify many of the works with certainty because there is little precise evidence in the catalogue. Thirteen were lent by private collectors. Alexander Cassatt lent *The Ballet Class* (cat. 49) and Erwin Davis lent his *Dancers in Pink* (page 48, fig. 1). Durand-Ruel was encouraged by the moderately successful sales. "Do not think that Americans are savages," he wrote from New York to Fantin-Latour. "On the contrary, they are less ignorant, less close-minded than our French collectors."[37] Two years later he opened the New York branch of his gallery at 389 Fifth Avenue and, from that point, he dominated sales of Degas in America for several years.

Durand-Ruel's entrepreneurial tactics in America extended well beyond New York. One of his strategies was to place Impressionist works in the various international exhibitions that were held in major American cities throughout the 1890s. Following the World's Columbian Exposition in Chicago in 1893, the *Art Loan Exhibition* was presented in Cleveland in 1894, the St. Louis Exposition in 1895, and an exhibition was put on by the Carnegie Institute, Pittsburgh, in 1896. These exhibitions were immense

surveys of contemporary art throughout the world and were designed to place American art in an international context. Degas was represented in this exhibition by two of his subjects that were the most popular with American audiences at the time, a horseracing scene and a ballet subject, *Race Horses* (fig. 9) and an unidentified *Dance Rehearsal.* The following year Durand-Ruel sent Degas's *The Ballet from "Robert le Diable,"* (1871, Metropolitan Museum of Art) to the *Second Carnegie International;* it was bought by the Havemeyers at the beginning of 1898. He continued to send a single work by Degas to the Pittsburgh exhibition over the next few years: *Dancing Girls* in 1898, *Ballet Dancers* in 1899, *Orchestra Musicians* (page 67, fig. 6) in 1900, *On the Race Course* in 1901, and *Dancers* (now titled *The Ballet Rehearsal,* page 191) in 1902. It must be noted, however, that the Impressionist works at these fairs were far outnumbered by the official art on view. For example, we can see Alexander Cassatt's *The Ballet Class,* surrounded by Salon paintings in the *Loan Exhibition of 1902* in Pittsburgh (fig. 10).

Durand-Ruel went on to mount a series of international exhibitions—in Toledo in 1905, St. Louis in 1907, and Pittsburgh in 1908 (which included *La Savoisienne,* cat. 11). Though not many Impressionist works were sold from these exhibitions, they were effective in bringing avant-garde art to the attention of audiences in the cities where there were new museums. As Richard Brettell has observed, "Durand-Ruel's vision of the American museum is most perfectly embodied

Fig. 10. *Loan Exhibition of 1902*, Carnegie Museum, Pittsburgh.

in Chicago, where the Durand-Ruel stock of late nineteenth and early twentieth-century dominates the museum."[38]

Durand-Ruel's dealings with the Museum of Fine Arts, Boston, offer an insight into the methods he employed to sell modern French art to American museums. He often sought to create an impression of scarcity. In a letter addressed to the director, General Charles G. Loring, in December 1898, when Durand-Ruel was trying to interest Boston in Manet's *Déjeuner sur l'herbe,* he noted, "The trouble now is not in selling, but finding paintings by Manet and Degas."[39] In 1903, Durand-Ruel sent two works on approval to the Museum of Fine Arts, *Race Horses at Longchamp* (cat. 29) and *Orchestra Musicians* (page 67, fig. 6), which he had already circulated in some of the exhibitions mentioned above. In trying to decide between the two works, the museum sought the opinions of distinguished local artists including Edmund C. Tarbell (1862–1938) and Frank W. Benson (1862–1951). The fact that the price for the jockeys was $9,000 and the musicians $13,500 does not seem to have colored the opinions put forward.[40] Benson's opinion is given: "There are things in the heads of the *Musicians* which would be helpful to our students who are on heads, but on the whole regards the Jockeys as the more beautiful picture, and would recommend the Museum to buy it."[41] John Briggs Potter (1864–1951), an artist who later became a curator at the Museum, "fears that technically the [*Musicians*] is not so sound as the jockey picture, and not likely to last as long in good condition."[42]

Tarbell, on the other hand, "has no question that the *Musicians* is the better picture for the Museum. Thinks the *Jockey* picture has the best drawing of horses he has ever seen. Admires the picture greatly, but thinks the students can get more out of the other."[43] In the end, the weight of popular opinion favored the *Race Horses,* which thus became the first work by Degas to be acquired by an American museum.

Perhaps because it is one of Degas's most innovative compositions of the early 1870s, Durand-Ruel seems to have had difficulty in finding a buyer for *Orchestra Musicians.* In 1906, Durand-Ruel sent the painting for consideration to The Metropolitan Museum of Art, New York, during the British critic and art historian Roger Fry's brief tenure as curator there, but no sale ensued.[44] And, at one point, it was on approval at the National Gallery of Canada in Ottawa.[45] Eventually, the Städtische Galerie, Frankfurt, bought the work in 1913.

Although Degas never achieved the popularity with Boston collectors enjoyed by Monet, it was in the Boston area that the most significant landmark in this history of Degas's exposure in America occurred: the one-man exhibition of his work held at the Fogg Art Museum in 1911. The first museum exhibition devoted to Degas, the Fogg show was the initiative of a small group of scholars and collectors, led by Arthur Pope, a Harvard professor and nephew of the collector Alfred Pope, and including Denman Ross, who also taught at Harvard and was a distinguished collector. The exhibition contained only twelve works, but each was a masterpiece. Pope lent three works from his collection, *The Interior* (fig. 7), the vivid *Dancers in Pink* (page 48, fig. 1), and the *The Tub* (fig. 3). Harris Whittemore lent *The Rehearsal* (Fogg Art Museum, Harvard University Art Museums). The Boston Museum of Fine Arts lent *Race Horses at Longchamp* (cat. 29) and two pastel over monotype landscapes (fig. 11 and page 53, fig. 8), which Denman Ross had given the Museum in 1908. It is no accident, perhaps, that this great collector of Asian art should have been drawn to these dreamy landscape evocations that suggest the insubstantiality of Chinese landscape paintings. Durand-Ruel lent three works, including *La Savoisienne* (cat. 11). Sarah Sears declined to lend her pastel *After the Bath* (fig. 2) on grounds of fragility. But, in all, it must have been a splendid exhibition. The paintings were hung on screens draped with white wall hangings placed under the skylight in the

picture gallery.[46] And the works of art were amplified by a display of photographs of paintings and pastels in order, as Arthur Pope explained, "to show a greater range of work and also indicate the place occupied by the originals in the main gallery in relation to his work as a whole."[47] It is noteworthy that, in his introductory text published in the pamphlet that accompanied the exhibition, Pope singled out qualities in Degas that are in direct opposition to those usually associated with Impressionism: "In his work there is no slighting of the exact definition of form, no slurring to conceal his ignorance, no effect of haze or smoke to reproduce an illusion of atmosphere. The expression is of clear air. There is no trick. It is as straightforward painting as that of Velasquez."[48]

The famous Armory Show held in New York and Chicago two years later reflected the avant-garde inclinations of its organizers, the painter and critic Walt Kuhn and the artist Arthur B. Davies. It encompassed the latest developments in European art but included only three works by Degas: *Jockeys on Horseback before Distant Hills* (1884, Detroit Institute of Arts), *After the Bath* (ca. 1890, Norton Simon Museum), and *The Repose* (ca. 1893, North Carolina Museum of Art).

The next substantial showing of Degas's work occurred at the Knoedler Galleries in New York in 1915 at the exhibition in support of woman suffrage organized by Mrs. Havemeyer with the help of Mary Cassatt. Of the sixty-four paintings on view, twenty-seven were by Degas and the rest by Cassatt, together with a selection of old master paintings. In addition to the large number of works lent by Mrs. Havemeyer, Harris Whittemore lent *The Rehearsal* (ca. 1873, Fogg Art Museum). The Boston Museum of Fine Arts lent *Race Horses at Longchamp* (cat. 29), and Sara Sears lent *After the Bath* (fig. 2). Like Alfred Pope, Cassatt and Havemeyer appreciated the connections between Degas and the art of the old masters, a point they brought out in the hanging of the exhibition. As George T. M. Shackelford has observed, Cassatt selected her own most recent work, but only early examples of Degas, possibly because she was uncertain whether she could withstand comparison with Degas's powerful late works.[49]

In 1916, Durand-Ruel mounted a significant exhibition of the work of Degas and Manet.[50] In 1918, the year after Degas's death, he staged a memorial exhibition in his New York gallery.[51] In 1920 he put on an exhibition of Degas's drawings.[52]

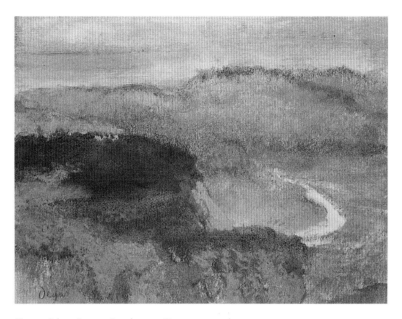

Fig. 11. Edgar Degas, *Landscape*, 1890–93, pastel over monotype on paper, 10½ × 14 inches, Museum of Fine Arts, Boston, Denman Waldo Ross Collection.

By far the largest early showing of Degas's works in the United States took place in New York in 1921. The occasion was the sale of the magnificent group of pastels and paintings by Degas that the French collector Jacques Seligmann had acquired only three years before at the studio sales following Degas's death.[53] Among the seventy-one works on display in the Plaza Hotel were some masterpieces, especially from Degas's early career, including *The Daughter of Jephthah* (see cat. 10), *Portrait of Mme. René De Gas, née Estelle Musson* (cat. 27), *Portrait of a Woman* (cat. 33), and *At the Theatre: Woman Seated in the Balcony* (cat. 37). Although the public and several critics were puzzled by what seemed to be the "unfinished" state of many of the works, significant purchases were made by American collectors and some museums. One of Degas's most important early paintings, *Mlle. Fiocre in the Ballet "La Source"* (fig. 12), was bought by the Brooklyn Museum.

January of 1922 saw the first exhibition of Degas's sculptures and prints at the Grolier Club in New York. Mrs. Havemeyer lent the "A" set of seventy-two bronzes that she had bought the year before. It is worth mentioning here that in parallel with the acquisition of Degas's paintings, pastels, and sculptures, a few American collectors had begun to show an interest in one of the most private and experimental areas of Degas's *oeuvre*, his prints.

Fig. 12. Edgar Degas, *Mlle. Fiocre in the Ballet "La Source,"* 1867–68, oil on canvas, 51⅛ × 57⅛ inches, The Brooklyn Museum, New York, Gift of A. Augustus Healy, James H. Post, and John T. Underwood.

Mrs. Havemeyer owned a few. Mrs. Abby Aldrich Rockefeller acquired a fine impression of the lithograph of *Mlle. Bécat at the Ambassadeurs* (cat. 35) from the New York print dealer Keppel. Samuel Avery, the New York dealer and collector, aided by George Lucas (an American agent in Paris), acquired a few prints by Degas, including a fine impression of *Mary Cassatt at the Louvre: The Paintings Gallery* (New York Public Library). But by far the most outstanding of the early collectors to buy Degas prints were W. G. Russell Allen of Boston and Lessing J. Rosenwald of Philadelphia. Rosenwald's collection of prints, acquired from the 1920s through the 1950s, including many by Degas, eventually enriched the collections of the National Gallery in Washington, D.C. During the same years, Allen amassed a magnificent collection of prints ranging from the old masters to the moderns, including many prints and some early academic drawings by Degas—*Song of the Dog* (cat. 32) and *Academic Study of a Nude Man* (cat. 5)—that became part of his bequest to the Museum of Fine Arts in 1963.

PAUL J. SACHS AND THE FOGG ART MUSEUM

Paul J. Sachs (fig. 13), who was to become one of the most influential figures in the American appreciation of Degas, brought a new flavor of scholastic connoisseurship to Degas collecting. When his father released him from his position as senior partner in the family banking firm Goldman Sachs, he entered the Fogg Art Museum at Harvard University in 1915.

Degas was Sachs's favorite artist. He particularly admired and loved the artist's drawings and acquired about twenty examples, most of which he left to the Fogg. These included the Ingresque *Head of a Woman* (cat. 17) and *A Nude Figure Bathing* (cat. 64). As Agnes Mongan, one of Sachs's most gifted students, and to this day one of the most eloquent writers on Degas, who later became director of the Fogg, once remarked: "Every drawing that entered the Sachs collection was individually and lovingly chosen, and selected with such passion and enthusiasm that a whole generation of private collectors and curators caught the infection and began to follow his example."[54]

For Sachs and his students, the appeal of Degas lay not so much in his modernity as in his continuity with the great draftsmen of the past—Botticelli, Piero della Francesca, Holbein, and, more recently, Ingres—all artists noted for the precision and refinement of their line. Not surprisingly, these new connoisseur collectors tended toward Degas's early drawings, in which linear

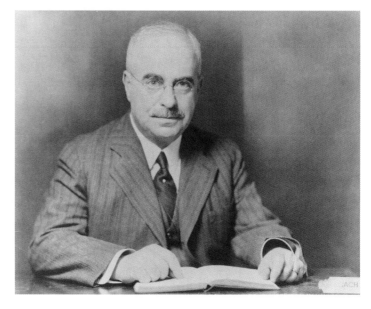

Fig. 13. Paul J. Sachs (1878–1965), Harvard University Art Museums.

finesse is most apparent. This is exemplified in the twenty or so Fogg drawings that formerly belonged to Sachs. It is this association with the past and connoisseurship that distinguishes the taste of these connoisseur collectors for Degas from the broader-based enthusiasm for Impressionism in general, especially the plein-air painterliness of Monet and Renoir. More particularly, their historical approach separated them from the first generation of Degas collectors, who tended to favor his modern, realist works of the 1870s and 1880s, with ballet and racehorse subjects being the most popular.

Sachs was not only a discerning collector but also an inspiring teacher. He succeeded in translating what had been the private rituals of the gentleman connoisseur into a self-conscious academic method.[55] He believed passionately that study should always be rooted in original objects and the visual delight they afforded. In the 1920s and 1930s his legendary courses were attended by a generation of future connoisseurs, museum curators, and directors, who staffed most of the newly created museums in America.[56]

In his teaching, Sachs employed techniques Bernard Berenson had developed in his study of the old masters—concentrating on the object, especially drawings, to develop a visual memory and relying on photographs for comparison. It was natural, therefore, that he should see the vast wealth of more than three thousand works by Degas that was revealed when his studio was put up for auction in 1918 and 1919 as a wonderful potential teaching tool for his Harvard students.[57] When negotiations with Durand-Ruel to purchase photographs of all the works foundered because funds from a benefactor did not materialize, Sachs lamented that "we shall very reluctantly have to miss the opportunity, which will be a matter of real regret, for the value of such a collection of photographs for teaching purposes here would be very great indeed."[58]

Sachs made at least two further attempts to buy works by Degas for the Fogg. In 1923 he was considering buying a set of the bronzes. Although Degas's sculptures were conceived as a private artistic process, when they were cast in bronze after his death, they became a lucrative product for the art market. Durand-Ruel's correspondence with Sachs reveals that not only the Fogg but other American museums—including Cleveland, the Rhode Island School of Design, The Minneapolis Institute of Arts, the Cincinnati Art Museum, and the Art Association of Montreal—

were eager to acquire examples of the bronzes. In 1926, Sachs was again disappointed when he was unable to raise the funds for *At the Races in the Countryside,* 1869, which went to the Museum of Fine Arts, Boston, instead.

Sachs was one of the few American collectors to attend the Degas atelier sales in Paris, where he was amused by the French soldiers, on leave from the front in the First World War, bidding in the sale-room.[59] Among the other American bidders was Robert Sterling Clark. He bought one painting and eleven drawings via Knoedler from the fourth atelier sale in July 1919. Isabella Stewart Gardner of Boston also bought several drawings at the sales. Mildred and Robert Woods Bliss of Washington acquired *The Song Rehearsal* (cat. 28) from the sale.

The Metropolitan Museum, acutely conscious of having no works by Degas, was keen to acquire at the sale. Mary Cassatt had proposed two major paintings, *Scene from the Steeplechase: The Fallen Jockey* (National Gallery of Art, Washington, D.C., ex-Mellon) and *The Bellelli Family* (see cat. 9), known then as *Family Portrait.* Just as the funds were approved for *Family Portrait,* The Metropolitan Museum discovered that the Louvre had bought it the day before.[60] The curator Bryson Burroughs, a devotee of Degas, who (in the company of Roger Fry) had visited Degas in his studio in 1907,[61] lamented, "Degas is the most cultivated and intellectual artist of the century. The Museum owns no works by him."[62] The situation was remedied, through the dealer Jacques Seligmann, when the Museum acquired ten portrait and figure drawings and pastels (see cats. 14, 41) at the second atelier sale. Several of the works were of the highest quality, including three portrait drawings of Manet.

Although few American collectors were present at the sales, the vast quantity of works that suddenly became available would have a noticeable impact on the American market. Astute international dealers such as Knoedler bought heavily in consortium to ensure that they would have plenty of stock to sell to American collectors after the war. These later purchases from dealers—as opposed to purchases made directly from the sales—account for the large number of works from the atelier sales that are now in American collections.

Of all of Sachs's students, the one who had the greatest impact on the history of Degas in America was Henry P. McIlhenny. The son of a wealthy Philadelphia family, McIlhenny was able to indulge his passion for collecting while still a student at

Harvard, acquiring works by Chardin, Corot, Seurat, and Matisse. In the fall of 1933, McIlhenny acquired Degas's great pastel drawing *The Ballet Master* (1875, Philadelphia Museum of Art) from the dealer César de Hauke. He recalled having seen the work "in that group of facsimiles which Sachs went over in detail one night I was there for dinner. I remember distinctly his anger at not having bought it when he had the chance because he considers it one of the top-notch drawings."[63] In 1934, McIlhenny became decorative arts curator (although his duties encompassed paintings as well) at the Philadelphia Museum of Art, a post he would hold for the next thirty years.

In parallel with his museum career, McIlhenny actively expanded his personal collection of nineteenth-century French art, which became famous. In the summer of 1935 he was delighted to find in Paris Degas's celebrated sculpture *Little Dancer of Fourteen Years* (see cats. 78, 79). The original wax model was the only sculpture Degas had exhibited in his lifetime and its uncanny naturalism had caused a sensation at the Sixth Impressionist exhibition in 1881. The following January, McIlhenny bought *The Interior* (fig. 7), and, true to his finely tuned sense of curatorial connoisseurship, he wrote to Knoedler to ask if he could trace the original frame.[64]

Like *Orchestra Musicians*, *The Interior* has a complex history in relation to American collecting. As we have seen, this painting had been in the collection of Alfred Pope. An entry in René Gimpel's *Diary of an Art Dealer,* headed "They're prudes in Boston," recounts that "the painting was shown to the purchase committee of the Boston Museum, which was going to buy it, but some women were against it saying the picture was immoral: this couple weren't married, as there was a single bed."[65] It was then on approval from Durand-Ruel in Paul Sachs's office at Harvard; Sachs failed to raise the money to secure it for the Fogg. When Henry McIlhenny snapped it up, he was congratulated by his friend Carl Pickhardt, Sachs's son-in-law: "It seems to me that you have made perhaps the most interesting acquisition that it will ever be your privilege to make. To me that picture is absolutely unique in the history of art because it is the only time that subject has ever been dealt with and by the only man who could possibly have done it. Whatever hopes you may have in collecting and to whatever extent you intend to expand, you have at least a unique collection, which on its quality alone, it

seems to me will fill a most impressive place. You certainly have done yourself proud!"[66]

As for his mentor Sachs, McIlhenny's favorite artist was Degas. When he bought the pastel *Mary Cassatt at the Louvre* from Jacques Seligmann in 1935, he was delighted by the subject's Philadelphia connection and thrilled, the following year, when the Museum was able to buy *The Ballet Class* (cat. 49) from the heirs of Alexander Cassatt. McIlhenny was responsible for the largest exhibition of Degas's work ever held at the time, the 1936 retrospective at the Pennsylvania Academy of Art (now the Philadelphia Museum of Art). The show contained 105 works, including such masterpieces as *The Daughter of Jephthah* (Smith College Art Museum, Northhampton, Massachusetts, see cat. 10), *A Woman Seated Beside a Vase of Flowers* (cat. 18), *Carriage at the Races* (Museum of Fine Arts, Boston), *At the Races* (Museum of Fine Arts, Boston), *The Millinery Shop* (cat. 54), *Head of a Woman* (cat. 17), lent by Paul Sachs, and *Portrait of Edmondo Morbilli* (cat. 16). Remarkably, the exhibition included four of Degas's rare photographs, including the only two known landscapes, lent by the French collector Marcel Guérin. These were subsequently acquired by Sachs and are now in the Fogg Art Museum.[67] The exhibition met with international praise. During the planning, McIlhenny discovered that the Louvre was also mounting a Degas exhibition at the same time. Not only did McIlhenny persuade them to lend six paintings, but he was also able to get them to postpone their exhibition by three months by diplomatically proposing that the Philadelphia show travel to France to act as a focus for American loans.

McIlhenny was a leading figure in an expanding group of American collectors who were buying French nineteenth- and early twentieth-century art during the interwar years. Writing in 1958 in his unpublished memoir, Sachs praised the new generation of collectors: "The heroic age of art collecting is long over; the last of the giants is gone; but the American public, recipients of their largesse, is still stunned by the very magnitude of their gifts. This has delayed us in recognizing the no less significant accomplishments of more recent collectors."[68] One reason for the increased popularity of French Impressionist paintings was the change in the "dwelling units of the Collector Class," according to Aline B. Saarinen, who explained that "the exodus from mansions to townhouses and to apartments meant smaller

rooms and lower ceilings" in which "the French paintings—right in scale, light in hue and charming in Louis XV good frames—seemed appropriate."[69] Another factor was that "the old-master market was dwindling. Their prices were high. The French 'modern' paintings were plentiful and just expensive enough to be trustworthy."[70] In line with the increased demand, the number of American dealers also expanded. Although Durand-Ruel was not the only dealer handling Degas at the turn of the century—Knoedler was also very active and there were other smaller dealers such as Glaenzer—he had dominated the market. By the twenties, however, other dealers such as Wildenstein, César de Hauke, and Carroll Carstairs had entered the field.

A detailed examination of the great American collectors of the twenties and thirties is beyond the scope of this essay, but a few may be cited in the consolidation of the taste for Degas: Robert Sterling Clark, Stephen C. Clark, Maud and Chester Dale, Sam A. Lewisohn, Duncan Phillips, Mrs. Larned Coburn, Edward G. Robinson, John T. Spaulding, Robert Treat Paine II, John Hay Whitney, and Maurice Wertheim.

By the 1920s the Impressionists were no longer modern. More avant-garde taste had turned toward Matisse and Picasso. After all, the Chicago collector and art commentator Arthur Jerome Eddy had published the first American book on the Cubists in 1914.[71] The ongoing debate as to whether Degas was a modernist or a traditionalist—so succinctly summarized by Agnes Mongan: "Degas is a modern and yet an ancient,"[72]—continued, although it is perhaps Degas the traditionalist who seems to have prevailed with both critics and collectors. In contrast to the view that Degas was accepted as a modern old master, Renoir was at this time revered by the avant-garde as an influential modernist.[73] But, as always, Degas resists facile categorization. It is no surprise, therefore, to find that Degas (like Renoir) was aligned with a modernist taste for the human figure—in the works of Robert Henri and other members of The Eight—that supplanted the emphasis on landscape by earlier appreciators of Impressionism.[74] Sachs and his disciples admired Degas for his link with tradition, and their cultivated taste was primarily for Degas drawings. But this generally conservative view of Degas was shared by other collectors, who also embraced Renoir in their pantheon of late nineteenth-century modern masters.

In Boston, John T. Spaulding, the son of the founder of the

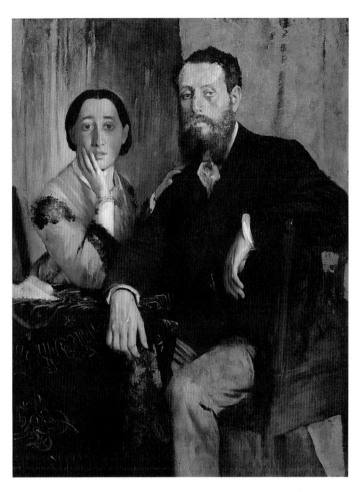

Fig. 14. Edgar Degas, *Edmondo and Thérèse Morbilli,* ca. 1867, oil on canvas, 45⅞ × 34¹³⁄₁₆ inches, Museum of Fine Arts, Boston, gift of Robert Treat Paine II.

Revere Sugar Refinery, gathered a famous collection of Japanese prints that today forms part of the Museum of Fine Arts's holdings in Asiatic art. But in the 1920s his interests expanded to include French nineteenth-century painting. He acquired three works by Degas: *Father Listening to Pagans*, 1869–72, *Dancer with Crossed Arms,* and *Three Dancers* (all now Museum of Fine Arts, Boston). Another Boston collector of this period was Robert Treat Paine II, who purchased the sensitive portrait of Degas's sister and her husband, *Edmondo and Thérèse Morbilli* (fig. 14), in the late 1920s. His gift of this work to the Museum of Fine Arts in 1931 encouraged the Museum to buy from the New York dealer Wildenstein the elegant autonomous preparatory drawing of Edmondo (cat. 16).

In Chicago, Martin Ryerson, a reserved and scholarly lawyer who managed his family's lumber business, was one of The Art Institute of Chicago's greatest benefactors. At his death in 1932 he bequeathed his great collection of works by old masters, in addition to his thirteen Monets, six Renoirs, and several Degases (including two great pastels, *Preparation for the Class* and *Woman at Her Toilette*). The following year the Art Institute benefited from another outstanding bequest, the collection of a dignified and lonely widow, Annie Swan Coburn, which included three works by Degas—the early portrait *Uncle and Niece*, 1875–78, *The Millinery Shop* (cat. 54), and *Four Studies of a Jockey,* 1866. Legend has it that the first of these paintings served as a fire-screen in Mrs. Coburn's suite of gloomy rooms in the Blackstone Hotel, which was crammed with French nineteenth-century paintings.[75] Although the bulk of Mrs. Coburn's collection went to the Art Institute, ten pictures (including Degas's *At the Races: The Start,* 1860–61) were bequeathed to the Fogg in memory of her husband, much to the surprise and delight of Paul Sachs.[76]

Another major collection that enriched the Fogg was that formed by the banker Maurice Wertheim. From the outset, Wertheim intended to leave an art collection, in memoriam, to his former college. Beginning in 1936, he amassed a major collection of French nineteenth-century and early twentieth-century paintings that included Degas's early dance picture *The Rehearsal,* ca. 1873–78, and the pastel *Singer with a Glove,* ca. 1878.

The Sterling and Francine Clark Institute in Williamstown, Massachusetts, is another famous American repository of works by Degas, formed by Robert Sterling Clark and his wife Francine. Clark, like other connoisseurs of his generation, particularly admired Degas's early drawings. When he bought *Two Studies of the Head of a Man* (cat. 3) at Durand-Ruel in 1938, he noted that it was "a magnificent drawing, as fine as a da Vinci or Holbein."[77] Clark was one of the few American collectors who bought directly from the Degas atelier sales in Paris in 1918 and 1919. Later he recalled, "I well remember the Degas sale after the First World War. I bought a few things like the portrait and some drawings; my only regret is that I did not buy more."[78] Clark bought his bronze cast of *Little Dancer of Fourteen Years* (cat. 78) in Paris, in the early 1920s, shortly after the Hébrard foundry produced editions from Degas's original waxes. An

Fig. 15. Mr. and Mrs. Robert Woods Bliss, Harvard University Archives.

entry in his journal records his impression that the sculpture resembled "a Spanish polychrome figure in color."[79] He continued to buy works by Degas throughout his life, concluding in 1948 with an early *Self-Portrait* of 1857–58. In all, he purchased more than sixty works by Degas in all media that, with the exception of a group of lithographs of bathers dating from the 1890s, span the artist's early and middle career.

The Degas holdings of a number of Washington, D.C., museums have been greatly enhanced by bequests from distinguished collectors. At Dumbarton Oaks, the Blisses (fig. 15), who were primarily collectors of Byzantine art, strayed into the realm of Degas with their acquisitions of the *essence* drawing of Giulia Bellelli (cat. 9) and *The Song Rehearsal* (cat. 28). William A. Clark, who made a fortune mining copper in Montana and later became a United States senator, left most of his collection to the Corcoran Gallery of Art, including a number of works by Degas (see cat. 39). Clark's collection of Degases was not, however, comparable to that formed by the financier Chester Dale (1883–1962). Beginning in the mid-1920s, Dale collected French nineteenth-century art, acquiring many superb examples now in the National Gallery of Art, Washington, D.C.

Washington, D.C., also benefited from the collecting of Duncan Phillips, who assembled an outstanding collection of

American and European art of the nineteenth and twentieth centuries. In 1918 he founded the Phillips Collection in memory of his father and brother. Phillips liked to assemble in-depth groups of the work of the artists he loved. He was particularly fond of Renoir, but also acquired several outstanding works by Degas (see cat. 30).

No account of the collecting of Degas in America would be complete without at least a reference to the major collections formed in more recent years. David Daniels, a collector and connoisseur, began collecting in the 1950s and pursued a life-long passion for Degas. He has found early drawings especially appealing, such as the splendid preparatory study for *The Daughter of Jephthah* (cat. 10), and these dominated his collection, although his taste also encompassed one of the boldest of the artist's late pastel nudes, *Woman Drying Herself* (Achenbach Foundation for Graphic Arts, the Fine Arts Museums of San Francisco).

The financier Norton Simon (1907–1993) and the banker Paul Mellon (1907–1998) formed the two collections that have ensured a major presence for Degas in America in more recent times. Norton Simon amassed a large, eclectic collection that included old masters and Asiatic art, but at the same time he demonstrated a particular enthusiasm for Degas, especially for figure subjects and challenging compositions. At one time, he owned *Rehearsal of the Ballet* (page 36, fig. 1), which had been Louisine Havemeyer's first purchase. Simon had a keen interest in Degas's sculptures, buying and selling several examples over the years. His most spectacular acquisition occurred in 1977, when he bought (from The Lefevre Gallery in London) the seventy-two "modèle" casts.[80] In addition to these sculptures, the Norton Simon Museum houses about thirty paintings, pastels, and drawings by Degas.

Paul Mellon's passion was for British painting of the eighteenth and nineteenth centuries and, owing to the influence of his second wife, French Impressionism, which he started to buy in the 1950s. Mellon was chairman of the National Gallery of Art, Washington, D.C., and bequeathed his outstanding collection of Impressionist and Post-Impressionist painting to that institution. Like other aristocratic collectors of Degas—John Hay Whitney, for example, who in the late 1920s bought two racing pictures, *The False Start* (fig. 16) and *Before the Races*, 1881–85— Mellon found a happy conjunction of his love of art and of horses

in Degas's equestrian pictures. His most noteworthy acquisitions were the great *Scene from the Steeplechase: The Fallen Jockey*, 1866 (reworked ca. 1897, National Gallery of Art, Washington, D.C.) and a substantial group of the remarkable wax sculptures that had been found in Degas's studio at his death. These he bought from Knoedler in 1955, leaving them to the National Gallery of Art and to the Virginia Museum of Art. An interesting footnote to the history of Degas's sculpture in America is documented by a painting by Raphael Soyer (fig. 17), showing the distinguished art historian John Rewald and his wife seated in front of the plaster of Degas's *Little Dancer of Fourteen Years*. The plaster was a gift from Knoedler to Rewald in 1956.[81] Rewald's *History of Impressionism,* which appeared in 1946, marked a landmark in the history of French modernism in America.

In keeping with the great tradition of American collecting, each of these Degas enthusiasts was eager to build a national heritage. Each collected not only for pleasure, but with the ultimate goal of leaving works of art to a museum. They thus played a vital role in contributing to the astonishing range of works by Degas that are available to public view in America. As Daniel Catton Rich asked on the occasion of Mrs. Coburn's bequest

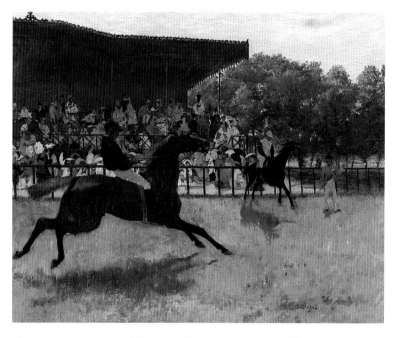

Fig. 16. Edgar Degas, *The False Start*, 1869–72, oil on panel, 12½ × 15⅞ inches, Yale University Art Gallery, gift of John Hay Whitney.

Fig. 17. Raphael Soyer (American, 1899–1987), *Mr. and Mrs. John Rewald*, oil on canvas, 38 × 32 inches, The Minneapolis Institute of Arts, gift of Mrs. Patrick Butler.

to The Art Institute of Chicago in 1933, "Can a museum ever acquire enough works by Degas?" Paul Sachs, in his personal reminiscence of this event, added: "I personally have no doubt whatsoever . . . for I am convinced that he was one of the greatest nineteenth-century French artists."[82]

NOTES

1. Waldman 1910, p. 62. He went on to list several collections of note, such as those of the Havemeyers, Alfred Pope, and Harris Whittemore.
2. See Feigenbaum et al. 1999.
3. *Scribner's Monthly* 15 (April 1878), pp. 888–89, cited in Weitzenhoffer 1986, p. 26.
4. Havemeyer 1993, p. 249.
5. See Frelinghuysen et al. 1993.
6. Havemeyer 1993, p. 251.
7. Louisine Havemeyer, "Notes to my Children," p. 31, courtesy of J. Watson Webb Jr., cited in Weitzenhoffer 1986, p. 116.
8. Havemeyer 1993, p. 254.
9. Philadelphia *Public Ledger,* May 7, 1911, cited in Barter et al. 1998, p. 181.
10. The following discussion of Mary Cassatt's role in guiding American collectors to acquire works by Degas is indebted to Erica Hirshler's excellent essay "Helping 'Fine Things Across the Atlantic,' Mary Cassatt and Art Collecting in the United States," in Barter et al. 1998, pp. 177–212.
11. Not much is known about the details of how Cassatt worked as an advisor and whether or not she ever took commissions from dealers such as Durand-Ruel. See ibid., p. 179.
12. See ibid. for Cassatt's collection.
13. Ibid., p. 179.
14. Cassatt to Havemeyer, quoted in Weitzenhoffer 1986, p. 21 and p. 259, n. 7.
15. Boggs et al. 1988, pp. 3118–20.
16. Huysmans 1883, pp. 119–20.
17. Hirshler in Barter et al. 1998, p. 183.
18. Conversation with Erica Hirshler, curator of American painting, Museum of Fine Arts, Boston, March 15, 2000.
19. See Hirshler in Barter et al. 1998, p. 195 and p. 209, n. 67.
20. Ibid., p. 184; and Kendall 1996, pp. 143, 155–56.
21. Blanche 1919, p. 253.
22. Weitzenhoffer 1986, p. 27.
23. See Hirshler in Barter et al. 1998, p. 188 and p. 208, n. 28.
24. Berenson to Isabella Stewart Gardner, March 3, 1914, in Van Hadley 1987, p. 331, quoted in Sutton 1990, p. 36.
25. Quoted in Faulkner 1972, p. 14.
26. Kysela 1964, pp. 159–60.
27. Quoted in *The Chicago Herald* (May 28, 1893) in *Chicago Historical Society Scrapbook,* vol. 24, n.p., The Art Institute of Chicago, Department of American Art Archives.
28. Cleveland *Plain Dealer,* January 7, 1894, p. 7, H. Whittemore Trust, Naugatuck, Connecticut, courtesy of Hill-Stead Museum, Farmington, Connecticut.
29. Paul-André Lemoisne was the first to give the work the title *The Rape (Le Viol)* in his catalogue raisonné, first published 1946–49. See Lemoisne 348.
30. Cassatt to Harris Whittemore, November 14, 1893, H. Whittemore Trust, Naugatuck, Connecticut, courtesy of Hill-Stead Museum, Farmington, Connecticut.
31. Private collection. Lemoisne supplement 148.
32. Location unknown. Lemoisne 650. See also Hirshler in Barter et al. 1998, p. 198.

33. Cassatt to Harris Whittemore, November 14, 1893, H. Whittemore Trust, Naugatuck, Connecticut, courtesy of Hill-Stead Museum, Farmington, Connecticut. "Mr. Yerkes" was a fabulously wealthy collector, originally from Chicago, who displayed a vast collection of Barbizon and French academic painting in his New York mansion.

34. Pope to Whittemore, August 26, 1894, H. Whittemore Trust, Naugatuck, Connecticut, courtesy of Hill-Stead Museum, Farmington, Connecticut. "Fare" is Jean-Baptiste Faure, the famous French baritone and collector. "Count Camondor" is Count Isaac de Camondo, who assembled a great collection of Impressionist works, including several by Degas, many of which were given to the Louvre in 1911. "Ballet Master & girls" is *The Dance Class*, 1873–76, Musée d'Orsay, Paris. "Manzie" is Michel Manzi, who produced a chromotypogravure facsimile of Degas's drawings (1896–98). He was also a collector and owned a number of works by Degas that were auctioned in the sale of his estate, Galerie Manzi, Joyant & Cie, Paris, March 13–14, 1919.

35. Paul Durand-Ruel, *Revue internationale de l'art et de la curiosité* in Venturi 1939, pp. 17–18.

36. Camille Pissarro, *Lettres à son fils Lucien,* ed. John Rewald (Paris: Albin Michel, 1950), p. 47, quoted in Weitzenhoffer 1986, p. 38.

37. Ibid., p. 42 and p. 261, n. 15.

38. Richard Brettell, introduction to Gerstein 1989, p. 18.

39. Quoted in ibid., p. 18.

40. Durand-Ruel to Gen. Charles C. Loring, December 24, 1898, Museum of Fine Arts, Boston, Department of the Art of Europe Archives.

41. Statement from Frank W. Benson, April 27, 1903, Museum of Fine Arts Boston, Department of the Art of Europe Archives.

42. Statement from John Briggs Potter, April 24, 1903, Museum of Fine Arts Boston, Department of the Art of Europe Archives.

43. Statement from Edmund C. Tarbell, April 28, 1903, Museum of Fine Arts Boston, Department of the Art of Europe Archives.

44. Susan Alyson Stein, "The Metropolitan Museum's Purchases from the Degas Sales: New Acquisitions and Lost Opportunities," in Dumas et al. 1997, p. 271.

45. Conversation with Michael Pantazzi, Curator at the National Gallery of Canada, Ottawa, March 15, 2000.

46. Boston *Transcript,* April 7, 1911, Harvard Art Museums Archives, Degas 1911 Exhibition Files.

47. Arthur Pope, "Paintings by Degas in the Fogg Art Museum," *Advertiser,* April 6, 1911. Harvard University Art Museums, Arthur Pope Files.

48. Arthur Pope, "A Loan Exhibition of Paintings and Pastels by H.G.E. Degas," Fogg Art Museum, April 1911, n.p., Harvard University Art Museums Archives, Arthur Pope Files.

49. George T. M. Shackelford, "*Pas de Deux*: Mary Cassatt and Edgar Degas," in Barter et al. 1998, p. 110.

50. *Exposition Edouard Manet et Edgar Degas,* April 5–29, 1916.

51. *Exposition Degas,* January 9–26, 1918.

52. *Exposition Degas,* March 11–27, 1920.

53. Seligmann was obliged to sell his Degas collection because scarcity of labor and materials prevented him from building a gallery in which to display it.

54. Mongan 1965, p. 10.

55. See Smyth and Lukehart 1993, p. 146.

56. For example, Theodore Rousseau at The Metropolitan Museum of Art, Henry P. McIlhenny at Philadelphia, and Perry Rathbone at Boston.

57. See *Vente* 1989.

58. Sachs to Durand-Ruel, January 2, 1923, Harvard University Art Museums Archives, Paul J. Sachs Files.

59. Mongan 1965, p. 110.

60. See Stein in Dumas et al. 1997, p. 281.

61. Ibid., p. 288.

62. B. B. [Bryson Burroughs], "Nineteenth-Century French Painting," *Metropolitan Museum of Art Bulletin* 13, no. 8 (August 1918), p. 180, quoted in ibid., p. 281.

63. Quoted in Rishel 1987, pp. 36–37.

64. McIlhenny to Knoedler, December 29, 1936, Philadelphia Museum of Art Archives, McIlhenny Files.

65. Gimpel 1966, p. 164.

66. Pickhardty to McIlhenny, January 25, 1936, Philadelphia Art Museum Archives, McIlhenny Files.

67. Daniel, Parry, and Reff 1998, p. 38.

68. Paul J. Sachs, *Tales of an Epoch,* 1958, p. 250, unpublished typescript, Harvard University Art Museum Archives, Paul J. Sachs Files.

69. Saarinen 1958, p. 376.

70. Ibid., pp. 375–76.

71. Arthur Jerome Eddy, *Cubists and Post-Impressionism* (Chicago: McClurg, 1914).

72. Agnes Mongan, "Portrait Studies by Degas in American Collections," *The Bulletin of the Fogg Art Museum* (May 1932), p. 62.

73. Anne E. Dawson, "The Renoir Acquired in 1945 by the Rhode Island School of Design Museum: A Significant Choice," *Gazette des Beaux-Arts* (6ᶜ période, vol. LXXXI, 1998), p. 183.

74. Ibid., p. 186.

75. Erens 1979, p. 51.

76. Paul J. Sachs, *Tales of an Epoch,* 1958, p. 252, unpublished typescript, Harvard University Art Museum Archives, Paul J. Sachs Files.

77. Quoted in Fernandez and Murphy 1987, p. 5.

78. Ibid. "The portrait" is *Portrait of a Man,* ca. 1875–80, oil on canvas, the Sterling and Francine Clark Collection, Williamstown, Massachusetts.

79. Unpublished manuscript of Clark's journal, entry dated April 19, 1923, pp. 1–3, Archives of the Sterling and Francine Clark Art Institute, Williamstown, Massachusetts.

80. The "modèle" casts are the set of master bronzes cast between 1918 and 1921 by the Hébrard foundry in Paris directly from Degas's original waxes. I am grateful to Sara Campbell, director of art at the Norton Simon Museum of Art, Pasadena, California, and to Richard Kendall for information on Simon's collecting.

81. Rewald sold it to Paul Mellon in 1968.

82. Paul J. Sachs, *Tales of an Epoch,* 1958, p. 36, unpublished typescript, Harvard University Art Museum Archives, Paul J. Sachs Files.

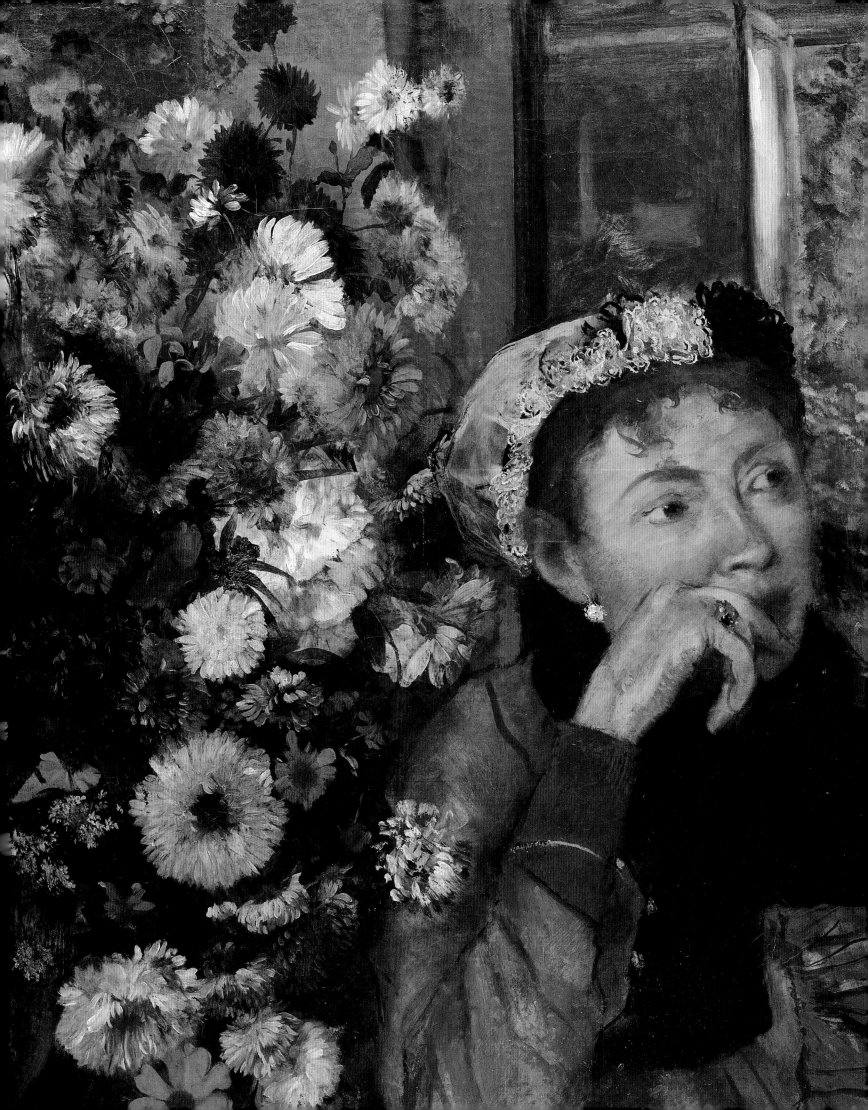

LOUISINE HAVEMEYER
AND EDGAR DEGAS

Rebecca A. Rabinow

I believe it takes special brain cells to understand Degas.

LOUISINE WALDRON HAVEMEYER, CA. 1917

LOUISINE WALDRON ELDER (later Havemeyer, 1855–1929) was about twenty-two years old when she walked into a Parisian color shop and spent $100, money she had saved from her allowance, on a pastel by Edgar Degas (fig. 1).[1] She may well have been the first American to purchase a work by the artist. Over the next five decades she acquired another sixty-four of Degas's paintings, pastels, and drawings, as well as prints and posthumous casts of his sculpture. Incredibly, these pieces represented only a fraction of the treasures that filled Mrs. Havemeyer's Fifth Avenue mansion. She owned forty-five Courbets, thirty Monets, twenty-five Manets, twenty-five Corots, seventeen Cassatts, fifteen Rembrandts, thirteen Cézannes, twelve Goyas, three El Grecos, a Bronzino, superb Asian art, and Tiffany masterpieces, to list but the highlights.[2] Louisine Havemeyer's interest in Degas deserves special mention. She was among the first Americans to recognize his importance, and although she found his work challenging, she collected it steadily, even during moments of financial uncertainty and after prices for the artist's work had soared. For much of her lifetime, Degas's paintings were not to be found in the permanent collection of any New York museum.[3] Enthusiasts had to content themselves with temporary gallery displays and the special loan exhibitions to which Mrs. Havemeyer occasionally (and anonymously) lent her pictures. This situation changed after Louisine Havemeyer's death in 1929. Her generous bequest to The Metropolitan Museum of Art included many of her best Degas works, in all media, and to this day, the Havemeyer collection of Degas's art remains one of the most significant in the world.

Louisine Waldron Elder (fig. 2) was born to a prosperous New York family in 1855, just six years before the start of the Civil War.

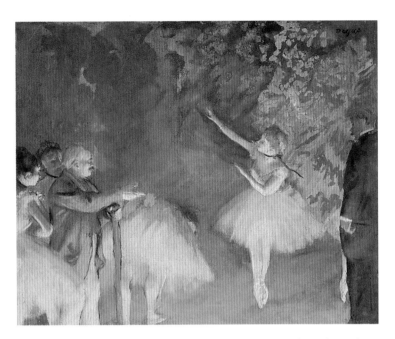

Fig. 1. Edgar Degas, *Rehearsal of the Ballet*, ca. 1876, gouache and pastel over monotype on paper, 21¾ × 26¾ inches, The Nelson-Atkins Museum of Art, Kansas City, Missouri, purchase, Kenneth A. and Helen F. Spencer Foundation Acquisition Fund.

Fig. 2. Louisine Elder, ca. 1882.

When she was eighteen years old, she attended a fashionable boarding school in Paris. Friends there introduced her to the American artist Mary Cassatt (1844–1926), who was ten years her senior. The two immediately established a rapport, and Cassatt delighted in showing the cultural sights of the city to the young woman. In her memoirs, Mrs. Havemeyer recalls how impressed she was by both Cassatt's intelligence and her resourcefulness at procuring inexpensive tickets to the Opéra, where they enjoyed "the fine ballets that were attracting Degas's attention at that very time."[4]

It was during a subsequent trip to Paris, most likely in 1877, that Cassatt suggested she purchase one of Degas's pastel-enhanced monotypes. Cassatt had long admired the artist's work. Miss Elder, on the other hand, "scarce knew . . . whether [she] liked it or not," but because she implicitly trusted Cassatt's judgment on such matters, she agreed.[5] Louisine Elder would soon learn that Degas considered it an artist's duty to see his pictures properly framed. Her ballet scene was sold in the gray and green frame Degas had specifically chosen for it.[6]

Degas wrote a note thanking Cassatt for her role in the transaction. It was at about this time that Degas invited Cassatt to

participate in the Fourth Impressionist exhibition.[7] When she steered Louisine Elder toward the pastel, Cassatt may have been aware of Degas's financial difficulties. He was overwhelmed by debts owed by the firm of his recently deceased father. In order to save the family name, Degas was forced to sell a number of paintings, a "hellish adventure" that was compounded by his younger brother René's refusal to pay his own personal debts.[8] During this period the forty-three-year-old artist often complained to his friends about his poor health and near-penniless state, and he much appreciated any additional income from the sale of his art.

After returning to New York, Louisine Elder lent her new picture to the eleventh annual exhibition of the American Water Color Society in 1878.[9] It was the first work by Degas ever exhibited in the United States. Miss Elder was disappointed to find *Rehearsal of the Ballet* hung high in a small room at the National Academy of Design and horrified to discover that the frame had been bronzed, ostensibly in accordance with the display policy.[10] Despite its less-than-prominent location, the picture caught the eye of the *New York Times* critic, who felt that "the ballet dancers are in their natural but no means their prettiest positions. The

Fig. 3. Rembrandt, *Herman Doomer*, 1640, oil on wood, 29⅝ × 21¾ inches, The Metropolitan Museum of Art, New York, H. O. Havemeyer Collection, Bequest of Mrs. H. O. Havemeyer, 1929.

painting goes only just far enough to tell the story and no more." He went on to describe the relatively unknown artist as "a real 'impressionist,' and a man whose name will readily lend itself to the wicked puns of the detesters of that school. He is uncompromisingly realistic; in fact, he rather prefers the ugly to the beautiful."[11]

Over the next few years Louisine Elder continued to allocate her allowance for contemporary art: a Monet painting of a Dutch drawbridge, a Pissarro fan painting, one of Cassatt's few self-portraits, a Raffaëlli watercolor, and five Whistler pastels. Toward the end of her life, she mused that these early acquisitions formed "the cornerstone of what later developed into a more important affair."[12]

When she was twenty-eight years old, Louisine Elder wed her older cousin by marriage, Henry Osborne Havemeyer (known as Harry or H. O., 1847–1907). The two had been acquainted since childhood, as Harry Havemeyer had been sent to live with the Elders after the deaths of his mother and, later, his older sister. Moreover, when he was in his early twenties, he had been married to Louisine Elder's aunt.[13] They divorced, and in 1883 he and Louisine were quietly married in Greenwich, Connecticut. H. O. Havemeyer's personal fortune increased as he expanded the family's sugar-refining business. His taste, which governed the couple's early acquisitions, was typical of wealthy New Yorkers of the time: Japanese decorative art, including lacquer boxes, sword guards, and textiles; pictures by fashionable Salon artists, such as Jean-Jacques Henner and Félix Ziem; Barbizon paintings by Jean-Baptiste-Camille Corot, Narcisse Diaz de la Peña, Jean-François Millet, and Théodore Rousseau; and Dutch old masters. H. O. Havemeyer's passion for Rembrandt portraits, for example, fueled the couple's most notable early acquisition, a remarkable painting of the ebony worker Herman Doomer (fig. 3), which they purchased in 1889 for a staggering sum, somewhere between $70,000 and $100,000.

Although Mr. Havemeyer presented his wife with a Manet still life in 1886, the couple did not begin collecting contemporary French art on a grand scale until the 1890s.[14] Cassatt was constant in her endorsement of Degas. In 1889 she presented Louisine Havemeyer with a Degas monotype, *A Girl Putting on Her Stocking*. Two years later, during one of the Havemeyers' visits to Paris, Cassatt brought them to the artist's studio on the rue Victor-Massé.[15] Mrs. Havemeyer recalled him as "a dignified-looking man of medium height, a compact figure, well dressed, rather dark and with fine eyes. There was nothing of the artist *négligé* about him, on the contrary he rather impressed me as a man of the world."[16] The Havemeyers purchased an oil painting, *The Collector of Prints* (fig. 4), directly from Degas for about $1,000.[17] He asked to keep it in order to make a few revisions. It was finally sent to the Havemeyers three years later, an inconvenience aggravated by Degas's insistence on tripling the original sale price.[18]

Learning from the experience, the Havemeyers' next Degas purchases were made a safe distance from the artist himself. On January 16, 1894, they visited the art dealer Paul Durand-Ruel's New York gallery, where they splurged on a cache of

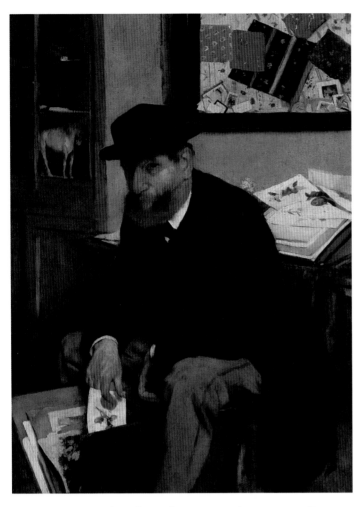

Fig. 4. Edgar Degas, *The Collector of Prints*, 1866, oil on canvas, 20⅞ × 15¾ inches, The Metropolitan Museum of Art, New York, H. O. Havemeyer Collection, Bequest of Mrs. H. O. Havemeyer, 1929.

Fig. 5. Edgar Degas, *Sulking*, ca. 1869–71, oil on canvas, 12¾ × 18¼ inches, The Metropolitan Museum of Art, New York, H. O. Havemeyer Collection, Bequest of Mrs. H. O. Havemeyer, 1929.

Impressionist treasures that included Manet's controversial *Masked Ball at the Opéra* (National Gallery of Art, Washington, D.C.), as well as landscapes by Degas, Monet, and Sisley. The Degas landscapes—pastel-enhanced monotypes—were fairly recent creations and had been the subject of the artist's first one-man show at Durand-Ruel's Parisian gallery in the fall of 1892.[19] In February 1894 the Havemeyers purchased three additional Degas landscapes and returned one from the previous group; in March they bought yet another.

The following year, in September 1895, the Havemeyers selected eleven more Impressionist pictures from Durand-Ruel. Six were by Degas, and of these all but two were ballet scenes. Degas was well aware of the subject's popularity with collectors;

a decade earlier he had bitterly complained that ballet scenes were "the only thing people want."[20] Nonetheless he continued to depict dancers, at one point explaining to Louisine Havemeyer that, in his eyes, they were the modern equivalents of a classical theme, embodying "all that is left . . . of the combined movements of the Greeks."[21]

Over the next few years the Havemeyers purchased several more works by Degas, including an intriguing small painting, *Sulking* (fig. 5). They acquired another five of Degas's ballet scenes during the first two months of 1899. One of these, *The Dance Lesson* (fig. 6), had previously belonged to the artists Gustave Caillebotte and Pierre-Auguste Renoir. Renoir had deposited the pastel with Durand-Ruel a few years earlier because he had supposedly "tired of seeing the musician forever bending over his violin, while the dancer, one leg in the air, awaited the chord that would give the signal for her pirouette."[22] The Havemeyers had no such objection, and in January 1899 they paid Durand-Ruel roughly $5,550 for the picture. The following month they spent nearly twice as much for a similarly sized pastel, *The Rehearsal Onstage* (fig. 7), which had failed to sell a decade earlier at the auction of the French financier Ernest May. The picture's off-center perspective affords simultaneous views of ballerinas dancing and stretching onstage, the scroll of a cello protruding from the orchestra pit, and oblique glimpses of scenery flats. This pastel recalls Mrs. Havemeyer's first Degas;

indeed, the principal dancers are mirror images of one another. In 1902 the Havemeyers purchased another nearly identical oil painting (fig. 8) from the gallery Boussod & Valadon.

Degas's prices escalated at the turn of the century as international collectors, including the Havemeyers, vied for his work. Another Havemeyer purchase from 1899, Degas's *At the Milliner's* (fig. 9), cost them approximately $10,000, twenty-five times the amount Durand-Ruel had paid the artist for it in 1882. The Havemeyers may have splurged on the startlingly modern pastel for sentimental reasons: the woman depicted trying on hats is their good friend and longtime art advisor Mary Cassatt.

One of the few paintings that eluded the Havemeyers during this period was *The Pedicure* (Musée d'Orsay), a scene supposedly inspired by the artist's 1872–73 trip to New Orleans. Much to the Havemeyers' annoyance, Durand-Ruel sold the extraordinary

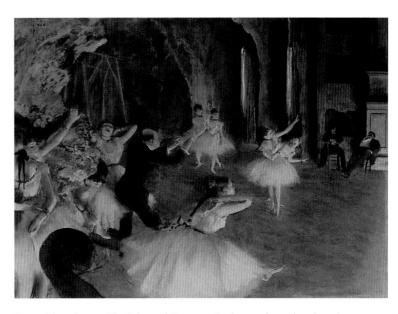

Fig. 7. Edgar Degas, *The Rehearsal Onstage*, 1874?, pastel over brush-and-ink drawing on paper mounted on canvas, 21 × 28½ inches, The Metropolitan Museum of Art, New York, H. O. Havemeyer Collection, Bequest of Mrs. H. O. Havemeyer, 1929.

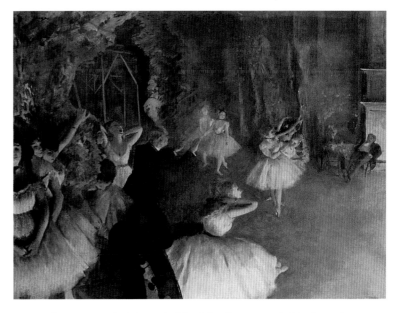

Fig. 8. Edgar Degas, *The Rehearsal of the Ballet Onstage*, probably 1874, oil colors freely mixed with turpentine, with traces of watercolor and pastel over pen-and-ink drawing on paper mounted on canvas, 21⅜ × 28¾ inches, The Metropolitan Museum of Art, New York, Bequest of Mrs. H. O. Havemeyer, 1929.

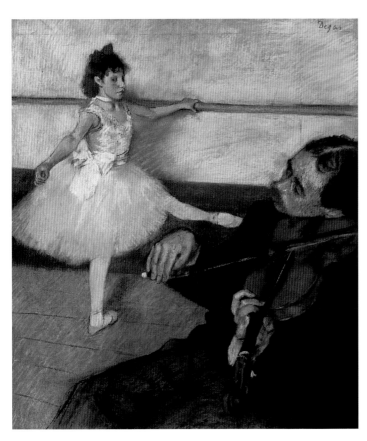

Fig. 6. Edgar Degas, *The Dance Lesson*, ca. 1879, pastel and black chalk on paper, 25⅜ × 22⅛ inches, The Metropolitan Museum of Art, New York, H. O. Havemeyer Collection, gift of Adaline Havemeyer Perkins, in memory of her father, Horace Havemeyer, 1971.

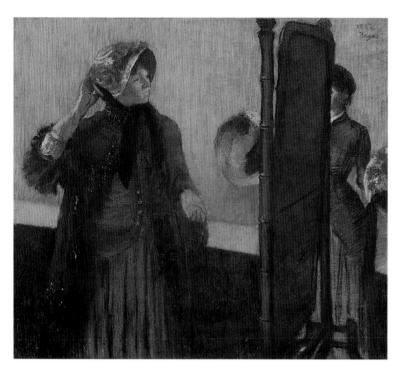

Fig. 9. Edgar Degas, *At the Milliner's*, 1882, pastel on paper, 30 × 34 inches, The Metropolitan Museum of Art, New York, H. O. Havemeyer Collection, Bequest of Mrs. H. O. Havemeyer, 1929.

Fig. 10. Louisine Havemeyer, ca. 1906.

painting to the banker Comte Isaac de Camondo on January 11, 1899.[23] Frustrated, the Havemeyers settled for a picture of two ballerinas at rest (one dancer, seen from the back, is seated on a piano; the other, fixing her shoe, leans against it). Mr. Havemeyer complained that the prices of Degas's art were inconsistent, and that the smaller painting's $7,000 price was extreme.[24] Nonetheless, his willingness to pay significant sums for contemporary French art suggests that his tastes were evolving to reflect those of his wife. Indeed, gallery records indicate that he was selling back Barbizon pictures in order to acquire new, more modern works.

Although the Havemeyers frequently made purchases from Durand-Ruel's gallery (and on occasion from Paul Durand-Ruel's personal collection),[25] they did return to Degas's studio from time to time. In her memoirs Louisine Havemeyer recalls a visit during which the artist showed them some of his most recent pastels:

> Mr. Havemeyer requested Degas to let him have some of them, but he seemed reluctant to give them up. . . . Miss

Cassatt took up one drawing and called my husband's attention to it. It was the sketch for "Les Danseuses à la Barre." . . . Suddenly [Degas] selected two others, signed them all and handed them to Mr. Havemeyer. We realized we were the fortunate possessors, not only of his best drawings, but of those he wished us to have.[26]

Meanwhile the "Sugar King"—as the newspapers had dubbed H. O. Havemeyer—was experiencing serious business problems. In May 1897 he was brought to trial for refusing to provide the U.S. Senate Sugar Investigating Committee with information concerning campaign contributions. He was successfully defended by a team of lawyers led by John G. Johnson of Philadelphia, who supposedly asked for $3,000 and a picture from the Havemeyer collection as his fee. (He was paid $100,000 in cash instead.[27]) Ongoing difficulties with their sugar business—foremost among them a thirty-million-dollar antitrust suit brought by the Pennsylvania Sugar Refining Company—continued to plague the family. On December 4, 1907, two weeks after his company was charged with systematic

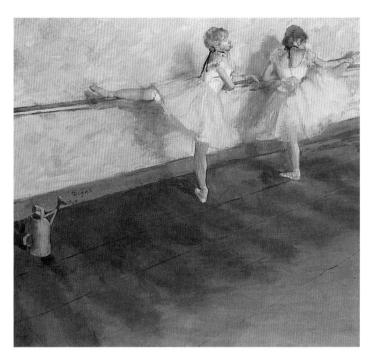

Fig. 11. Edgar Degas, *Dancers Practicing at the Bar*, 1876–77, mixed media on canvas, 29¾ × 32 inches, The Metropolitan Museum of Art, New York, H. O. Havemeyer Collection, Bequest of Mrs. H. O. Havemeyer, 1929.

watering can, a common feature of rehearsal studios, where they were used to dampen the floors in order to suppress dust. Some art world insiders estimated that bidding on this picture would top $10,000, but it came as something of a shock when the picture sold for $87,000. Louisine Havemeyer had set a record, paying the highest amount to date for the work of a living artist.[30] An assiduously private person, she tried to keep her identity secret, but rumors immediately circulated in newspapers and art journals.[31] This purchase reconfirmed her status as one of the world's most important collectors of Degas's art and simultaneously elevated Degas's prices to a new level. Months later, Cassatt shrewdly noted that the price Mrs. Havemeyer paid "has temporarily stopped the sales of Degas pictures. No matter what you ask, amateurs say, 'Oh of course you want a big price after the Rouart sale.'"[32]

Just a few weeks later, in early January 1913, Louisine Havemeyer purchased a bather (fig. 12) from the posthumous sale of

fraud (the dockside scales used to measure sugar were found to be miscalibrated), Mr. Havemeyer died of kidney failure.

These were difficult times for his widow. Her mother died soon after, on the very day of H. O. Havemeyer's funeral, and in early January, her eldest daughter Adaline's newborn twins died as well. The antitrust suit dragged on until June 1909, when the family firm, the American Sugar Refining Company, agreed to pay an out-of-court settlement of $10 million. Not surprisingly, Mrs. Havemeyer paused in her collecting. Feeling financially insecure, she sold some pictures—although none by Degas— in order to purchase works by Courbet, Goya, and El Greco.

A momentous turning point both for Louisine Havemeyer personally and for the modern art market was the 1912 posthumous collection sales of Degas's good friend Henri Rouart. Rouart had been an industrialist and amateur artist who had participated in seven of the eight Impressionist exhibitions.[28] The sales of his collection, which included pictures by "every French artist of note in the past century," were much anticipated by the art community.[29] One of the many Degas paintings in the sale depicted two dancers (fig. 11) stretching at a bar next to a

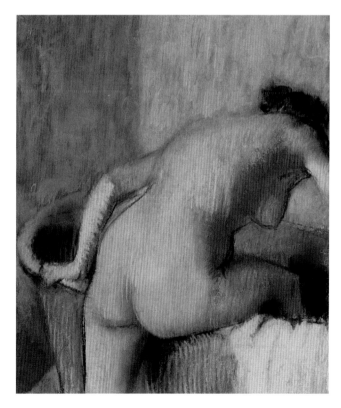

Fig. 12. Edgar Degas, *Bather Stepping into a Tub*, ca. 1890, pastel and charcoal on paper, 22 × 18¾ inches, The Metropolitan Museum of Art, New York, H. O. Havemeyer Collection, Bequest of Mrs. H. O. Havemeyer, 1929.

Tadamasa Hayashi, a Japanese art dealer who had worked in Paris during the 1880s and 1890s. Cassatt was delighted to learn the news: "I am glad you bought the Degas nude. . . . How few people care for Art, but then few care for things outside of the run."[33] Louisine Havemeyer had, by and large, eschewed Degas's nudes up to this point. Early on, she and her husband seem to have considered the artist a bit too brutal and frank in his representation of the unclothed human body and had preferred the more sensuous nudes of artists such as Courbet.[34] However, as the years progressed, Louisine Havemeyer developed a taste for Degas's elegant pastel renditions of bathers.

Mrs. Havemeyer's most significant Degas nude, and the one she considered her best, depicts a seated woman, whose long hair is being combed by her maid (fig. 13). H. O. Havemeyer had

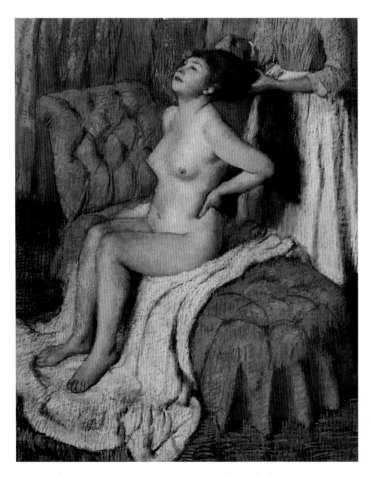

Fig. 13. Edgar Degas, *A Woman Having Her Hair Combed*, ca. 1868–88, pastel on paper, 29⅛ × 23⅞ inches, The Metropolitan Museum of Art, New York, H. O. Havemeyer Collection, Bequest of Mrs. H. O. Havemeyer, 1929.

greatly admired the pastel, which may partly explain why, on the eve of World War I, his widow willingly paid some $20,000 for it at the posthumous sale of the art critic and author Claude Roger-Marx.[35] The composition is startling; Degas includes only what is necessary; he crops the maid, pictorially decapitating her. As with so many of the Havemeyer Degases, this pastel came recommended by Cassatt, who firmly believed that the artist's nudes could be appreciated only by "painters and connoisseurs."[36] Cassatt herself owned one. After the 1886 Impressionist exhibition, she and Degas had exchanged paintings: her *Girl Arranging Her Hair* (National Gallery of Art, Washington, D.C.) for Degas's *Woman Bathing in a Shallow Tub*. Three decades later, convinced that her family would not "care in the least for them," Cassatt sold the Degas pastel, along with two of his other pictures (a fan painting and a small portrait), to her "dearest Louie."[37]

Meanwhile, Louisine Havemeyer was becoming increasingly involved in the American woman suffrage movement and searched for ways to further the cause. She decided to unite two of her passions by organizing an exhibition of Degas's art; the modest one-dollar admission fee would go to the Woman Suffrage Campaign Fund. Cassatt found the idea "piquant" in view of Degas's opinions of women.[38] During the spring of 1914, while vacationing with Cassatt, Mrs. Havemeyer decided to broaden the scope to include works by her friend; later she added some old-master paintings. When the show opened at M. Knoedler and Co.'s New York gallery in April 1915, it contained sixty-four pictures, of which twenty-seven were by Degas. All were lent anonymously, some by Louisine Havemeyer, some by Durand-Ruel, and others by Henry Clay Frick, Mrs. J. Montgomery Sears, Harris Whittemore, and Joseph Widener. On the opening day, Louisine Havemeyer presented a special lecture on Degas and Cassatt, which generated much publicity; the exhibition ultimately earned $2,283 for her cause.[39]

In organizing the exhibition, Mrs. Havemeyer intentionally juxtaposed Degas with the old masters. She had first appreciated the comparison in her own home, when she displayed Degas's portrait of M. Altes (a flutist and concert master of the Paris Opéra) between two sixteenth-century panels thought to be by Clouet and Corneille de Lyon. When she mentioned the idea to Cassatt, the artist urged her to hang a Vermeer next to a Degas "and let the public look first at the one and then at the other. It may give them something to think about."[40] Thanks to Joseph

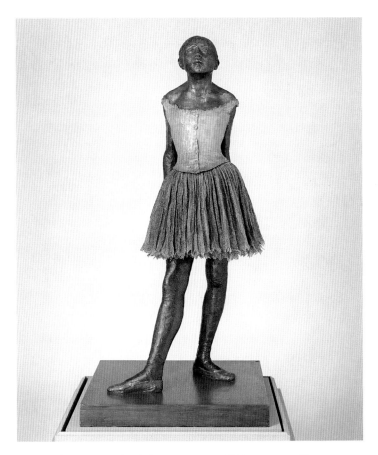

Fig. 14. Edgar Degas, *The Little Fourteen-Year-Old Dancer*, ca. 1880, cast 1922, bronze, slightly tinted, with cotton skirt and satin hair ribbon, 41¼ inches high, The Metropolitan Museum of Art, New York, H. O. Havemeyer Collection, Bequest of Mrs. H. O. Havemeyer, 1929.

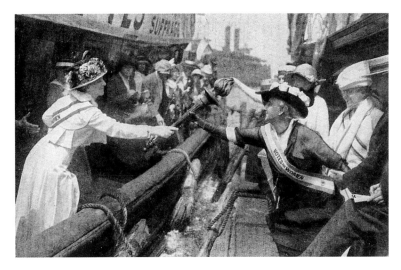

Fig. 15. Louisine Havemeyer passing the Torch of Liberty to the New Jersey branch of the Woman's Political Union. From Louisine W. Havemeyer, "The Suffrage Torch, Memories of a Militant," *Scribner's Magazine* 71 (May 1922), p. 537.

Widener's loan of Vermeer's *Woman Holding a Balance* (National Gallery of Art, Washington, D.C.), Louisine Havemeyer was able to follow Cassatt's suggestion and was delighted with the result.

Degas's status as a modern master was confirmed after his death on September 27, 1917, when his works were auctioned in a series of sales with much hype and high prices. Amazed, Cassatt provided Louisine Havemeyer with an account of the first sale: "When one thinks of how nobody would buy when you first began! But that is the way with everything." She later wrote, "even pictures with half the painting scratched out sold for high prices! The explanation is in part speculation by dealers . . . and also amateurs, & the revelation of Degas as an artist of not only great talent but great variety."[41]

Although Mrs. Havemeyer made no purchases from the Degas studio sales, she pursued her desire to acquire a wax

sculpture from the artist's heirs.[42] *The Little Fourteen-Year-Old Dancer,* the only sculpture Degas publicly exhibited during his lifetime, had been much admired by the Havemeyers. Mrs. Havemeyer first expressed her interest in purchasing it during a 1903 visit to Degas's studio. Years later, during another visit, she spotted the statue's remains—replete with its wooly dark hair and faded gauze tutu—in a vitrine and asked Durand-Ruel to find out whether the artist would reassemble it for her.[43] Degas agreed to look into the matter. After his death Mrs. Havemeyer attempted yet again to acquire the sculpture, this time with the aid of the dealer Ambroise Vollard, who had helped prepare the posthumous inventory of the artist's studio. Degas had estimated the purchase price at $8,000, but when the subject was broached with his heirs, they valued it first at $100,000 and then doubled the figure. Mrs. Havemeyer ultimately settled for a posthumous bronze cast of *The Little Fourteen-Year-Old Dancer* (fig. 14), as well as for the first casts (series "A") of seventy-two smaller wax sculptures—mostly racehorses, bathers, and dancers (see cat. 82).[44]

During the final decade of her life, Louisine Havemeyer devoted much of her time to the campaign for woman suffrage (fig. 15). She traveled around the country promoting the cause (which finally became a constitutional right in 1920) and even spent three nights in jail after an effigy of President Wilson was

burned during a demonstration she attended in Washington, D.C. She began planning her legacy and writing her memoirs. She also purchased a few more works by Degas, among them a remarkable canvas, *A Woman Seated Beside a Vase of Flowers* (cat. 18). By this point, Degas was generally accepted as "the most significant painter of his complex and fascinating period."[45] Rather than be diverted by the younger, more controversial generation of French artists who were gaining popularity in the United States—notably Derain, Matisse, and Picasso—Mrs. Havemeyer remained faithful to her favorites.[46]

For years Louisine Havemeyer had been a generous, albeit anonymous, lender to The Metropolitan Museum of Art. In 1919 a few months after the museum's curator of paintings, Bryson Burroughs, publicly lamented the Metropolitan's lack of paintings by Degas, Mrs. Havemeyer drafted a codicil to her will, in which she bequeathed one hundred and thirteen works of art—including six paintings and seven pastels by Degas—to the Metropolitan.[47] She and her heirs subsequently added to the bequest, so that it ultimately numbered nearly two thousand objects, of which fifteen paintings, fifteen pastels, six prints, four drawings, two fan mounts, a watercolor, and a series of sculpture were by Degas.[48] In 1878, Louisine Elder had introduced Degas to New York. More than fifty years later, her bequest ensured that his work was there to stay. At long last New Yorkers and visitors to the city could permanently enjoy a spectacular group of works by an artist many considered "the most cultivated and intellectual . . . of the century."[49]

NOTES

1. It was probably in 1877 that Louisine Elder purchased *Rehearsal of the Ballet* for 500 francs. At this time, and until World War I, the rate of exchange was approximately five French francs to the American dollar. The work was inherited by her daughter, Adaline Havemeyer Frelinghuysen. It was purchased from her estate in 1965 by Norton Simon, who sold it at auction in 1973 to the Marlborough Gallery. The Nelson-Atkins Museum in Kansas City puchased the work later that year.

2. Descriptions of the collection may be found in both Weitzenhoffer 1986 and Frelinghuysen et al. 1993. Several of the Havemeyer Courbets, Goyas, and Rembrandts, as well as one El Greco, have since been de-attributed. For specific identifications of these and all other Havemeyer-owned pictures, see ibid., pp. 291–384. Unless otherwise noted, all pictures mentioned in this essay are in the collection of The Metropolitan Museum of Art, New York.

3. The Brooklyn Museum of Art acquired two Degas paintings in 1921: *Mlle. Fiocre in the Ballet "La Source"* (page 26, fig. 12) and *Portrait of a Man*. The Metropolitan Museum of Art's curators were less successful in attempts to convince their trustees to purchase a Degas painting. See Susan Alyson

Stein, "The Metropolitan Museum's Purchases from the Degas Sales: New Acquisitions and Lost Opportunities," in Dumas et al. 1997, pp. 271–91. At the time of Louisine Havemeyer's death, the only painting by Degas hanging in the Metropolitan was *The Interior* (page 21, fig. 7), an anonymous long-term loan from the J. H. Whittemore Company.

4. Havemeyer 1993, p. 270. The memoirs first appeared in 1961 in a private printing for the Havemeyer family and The Metropolitan Museum of Art.

5. Ibid., p. 249.

6. In her memoirs, Louisine Havemeyer recounts that Degas "wished the frame to harmonize and to support his pictures and not to crush them as an elaborate gold frame would do. . . . The first thing I did to many a Degas that we purchased from amateurs was to remove the atrocious heavy gold frame which the owners probably thought gave the picture more importance, and to restore it to its original frame when possible or provide it with one Degas could approve." Ibid., p. 250.

7. George T. M. Shackelford, "*Pas de deux:* Mary Cassatt and Edgar Degas," in Barter et al. 1998, p. 110.

8. Degas to Charles Deschamps, June 1, 1876, quoted in Boggs et al. 1988, p. 214.

9. Louisine Elder loaned two works to the exhibition, which lasted from February 3 to March 3, 1878: Degas's *Rehearsal of the Ballet* (listed in the exhibition catalogue as *A Ballet*, fig. 1) and Eduardo Tofano's *Reverie* (location unknown).

10. Havemeyer 1993, pp. 250–51.

11. "American Water-Color Society; Eleventh Annual Exhibition—Reception to Artists and the Press—American and Foreign Exhibitors," *New York Times,* February 2, 1878, p. 5.

12. Louisine W. Havemeyer, unpublished draft of the speech given at M. Knoedler and Co., New York, April 6, 1915. Frances Weitzenhoffer archives, The Metropolitan Museum of Art, Department of European Paintings.

13. The marriage had supposedly been strained by Mr. Havemeyer's drinking. Before marrying him, Louisine Elder made him promise to abstain from alcohol. See Gary Tinterow, introduction to Havemeyer 1993, p. xiii.

14. The work in question—Manet's *The Salmon*—is now owned by the Shelburne Museum (Shelburne, Vermont). For more information on the purchase, see Frelinghuysen et al. 1993, p. 206.

15. For information on the address of Degas's studio at this time, see Tinterow, "Degas's Degases," in Dumas et al. 1997, p. 105, n. 9.

16. Havemeyer 1993, p. 251.

17. There is some question as to the original price of this painting; it seems to have been purchased for either 3,000 or 5,000 francs. See Frelinghuysen et al. 1993, p. 235, no. 197; Weitzenhoffer 1986, p. 81; and Havemeyer 1993, p. 253.

18. Degas was notorious for announcing that a picture needed only a small touch-up and then spending years reworking the entire canvas. When Cassatt's brother attempted to acquire *The Steeplechase* (National Gallery of Art, Washington, D.C.), for example, he was informed that the canvas required no more than two hours of revisions. Alexander Cassatt waited in vain, for Degas never completed the painting. Aware of the artist's tendency, Henri Rouart is said to have chained at least one of his Degases to the wall so the artist could not remove it. See Boggs et al. 1988, pp. 375, 561; and Havemeyer 1993, p. 253.

19. For more information on the exhibition and disbursement of these pictures, see Kendall 1993, pp. 183–229.

20. Degas to Ludovic Halévy, September 1880, quoted in Boggs et al. 1988, p. 219.

21. Havemeyer 1993, p. 256. See also Havemeyer 1915.

22. Ambroise Vollard, quoted in Boggs et al. 1988, p. 334.

23. Camondo purchased *The Pedicure* for about $12,000, more than twice the amount the dealer had paid for it just two weeks earlier. Boggs et al. 1998, pp. 191–92; and Frelinghuysen et al. 1993, p. 225.

24. Weitzenhoffer 1986, p. 135. The painting in question is *Dancers at Rest*, 1874 (private collection, Lemoisne 343).

25. Havemeyer 1993, p. 258 and p. 338, n. 383.

26. Ibid., p. 252.

27. See Weitzenhoffer 1986, pp. 96–97, 118–20; and Frelinghuysen et al. 1993, p. 221.

28. For more information on Rouart, see Boggs et al. 1988, p. 249.

29. "600 Works in Rouart Sale; Collection to be Sold in Paris, Strong in Nineteenth Century Paintings," *New York Times*, December 1, 1912, sec. 3, p. 5.

30. The underbidder for the painting was the Comtesse de Béarn, represented at the sale by the artist José Maria Sert. See "Rouart Sale Echoes," *American Art News* 11, no. 12 (December 28, 1912), p. 5.

31. See, for example, "Degas Brings $87,000 at Henri Rouart Sale," *The Sun*, December 11, 1912, p. 2; and R. C., "Modern Pictures at the Sale of the Rouart Collection," *New-York Tribune*, December 15, 1912, part 2, p. 7. Initially there also were rumors that the painting had been purchased by Mrs. Sears of Boston. See *American Art News* 11, no. 12 (December 28, 1912), p. 5.

32. Cassatt to Havemeyer, March 30 [1913], Frances Weitzenhoffer archives, The Metropolitan Museum of Art, Department of European Paintings.

33. Cassatt to Havemeyer, January 30 [1913], Frances Weitzenhoffer archives, The Metropolitan Museum of Art, Department of European Paintings.

34. See Havemeyer 1993, pp. 198, 261.

35. Joseph Durand-Ruel, acting on behalf of Louisine Havemeyer, bid 101,000 francs for the Degas. *Tableaux, Pastels, Dessins, Aquarelles . . . Faisant partie de la collection Roger Marx*, Galerie Manzi-Joyant, Paris, May 11–12, 1914, lot 125.

36. Quoted in Frelinghuysen et al. 1993, p. 274.

37. Cassatt to Havemeyer, December 28 [1917], quoted in Dumas et al. 1997, p. 100. See also Frelinghuysen et al. 1993, pp. 273–74.

38. Cassatt to Havemeyer, February 15, 1914, quoted in Weitzenhoffer 1986, p. 219. Having been subjected to some of Degas's comments concerning the abilities of women painters, Cassatt was amused that his pictures were to be included in a suffrage exhibition.

39. For more information on the exhibition, see Rebecca A. Rabinow, "The Suffrage Exhibition of 1915," in Frelinghuysen et al. 1993, pp. 89–95.

40. Havemeyer 1915. See also Havemeyer 1993, p. 263.

41. Cassatt to Havemeyer, May 9 and June 25, 1918, Frances Weitzenhoffer archives, The Metropolitan Museum of Art, Department of European Paintings. See also Weitzenhoffer 1986, p. 238.

42. Mrs. Havemeyer did, however, purchase one painting at Degas's collection sales: Cassatt's *Girl Arranging Her Hair* (National Gallery of Art, Washington, D.C.). See Stein in Dumas et al. 1997, p. 290, n. 1.

43. Havemeyer 1993, pp. 254–55.

44. The sculptures, cast in bronze by A. A. Hébrard from the original wax models by Degas, were made in Paris ca. 1918–22. For more information, see Pingeot; Clare Vincent, "The Havemeyers and the Degas Bronzes," in Frelinghuysen et al. 1993, pp. 77–80; and Dumas et al. 1997, pp. 99–104. Degas's original sculpture of *The Little Fourteen-Year-Old Dancer* (National Gallery of Art, Washington, D.C.) remained with the artist's heirs for decades before it was finally sold.

45. "'Met' Explains Modernist Show; Asserts Forthcoming Exhibition is to Enable Comparison of New Art with that of Already Accepted Standards," *American Art News* 19, no. 28 (April 23, 1921), p. 5.

46. When in 1923, for example, Mrs. Havemeyer was asked for permission to reproduce one of her Manets in a book on modern art, she responded that she did not wish her pictures to be used to promote the "modern art which certain people are trying to force down the public's throat." Reid 1968, p. 608.

47. Bryson Burroughs, "Drawings by Degas," *Bulletin of the Metropolitan Museum of Art* XIV, no. 5 (May 1919), p. 115; and Stein in Dumas et al. 1997, pp. 286–87.

48. These figures include two works that were not part of Louisine Havemeyer's original bequest: in 1929 her son Horace added *The Rehearsal of the Ballet Onstage* (fig. 8) to the bequest, and in 1971, Havemeyer family members further added the pastel *The Dance Lesson* (fig. 6) in memory of Horace.

49. Bryson Burroughs, "Nineteenth-Century French Painting," *Bulletin of the Metropolitan Museum of Art* XIII, no. 8 (August 1918), p. 180.

Degas and His American Critics

David A. Brenneman

To a large extent, early twentieth-century American critics simply recycled and repeated what was already known about Degas from European sources.[1] Much of the criticism was concerned with categorizing the artist's efforts: whether or not he was an Impressionist; his unforgiving depictions of what were deemed to be low-life subjects; the artist's early study of the old masters and his allegiance to the neo-classical tradition of Ingres; and the modernism of the apparently fragmentary and unfinished appearance of his works and his innovative use of color. None of these issues by themselves were particularly distinctive. However, as a body of writing, American criticism of Degas was strikingly positive and enthusiastic.[2] Although American critics did not quite know what to make of Degas's singular talent, they nevertheless almost universally accepted him as one of the leading masters of late nineteenth- and early twentieth-century art.

The earliest opportunities for American critics to see Degas's work and to comment on it came in 1878 and 1883. The first work exhibited publicly in the United States was a gouache over monotype purchased by Louisine Havemeyer in Paris (page 36, fig. 1) and exhibited at the annual exhibition of the American Watercolor Society in New York in 1878. The work's inclusion elicited a surprising amount of critical curiosity. An anonymous critic for the *New York Times* described Degas as "a real 'impressionist'" and further noted that Degas "is uncompromisingly realistic; in fact, he rather prefers the ugly to the beautiful."[3] The critic for *Scribner's Monthly* wrote, "Among the pictures from abroad, 'A Ballet,' by Degas, gave us an opportunity of seeing the work of one of the strongest members of the French 'Impressionist' school, so called; though light, and in parts vague,

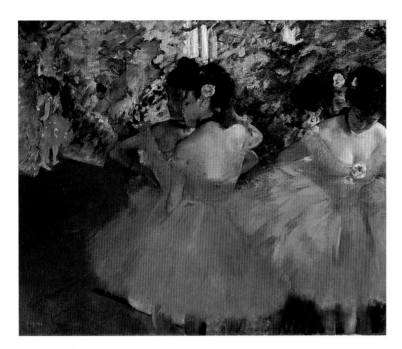

Fig. 1. Edgar Degas, *Dancers in Pink*, ca. 1880, oil on canvas, 23¼ × 29 inches, Hill-Stead Museum, Farmington, Connecticut.

in touch, this is the assured work of a man who can, if he wishes, draw with the sharpness and firmness of Holbein."[4] Albeit brief, these pieces of criticism reveal knowledge about the artist that could not have been gleaned from Degas's ballet scene alone. For example, the reference to Holbein alludes to Degas's close study of the German old masters during the 1850s and 1860s, as signaled by the inclusion of a painting by Lucas Cranach in his portrait of James Tissot (cat. 22). The review also alludes to the question of "finish" in Degas's work, which many French critics—even supporters of the artist—found so vexing. Finally, both critics were also aware that Degas was allied with the Impressionists, who had begun exhibiting together only four years earlier in 1874. Although it is unknown who wrote these pieces, they demonstrate that American critics, even at this very early date, were relatively well informed and were prepared to accept Degas as an important European artist.

In 1883 another ballet scene by Degas, this time an oil painting, was exhibited at the Pedestal Fund Art Loan Exhibition in New York City. The purpose of this exhibition was to raise funds to erect a base to support Bartholdi's titanic sculpture *Liberty Enlightening the World* in the New York harbor, but it also allowed the organizing committee to expose the American public to

advanced European painting. The notoriety of the exhibition (which included works by another radical French artist, Édouard Manet) resulted in increased critical attention for Degas's *Dancers in Pink* (fig. 1), which was loaned to the exhibition by the New York collector Erwin Davis. Several critics who saw the Degas were not as receptive as the *Scribner's Monthly* critic had been in 1878. Mariana Griswold Van Rensselaer wrote, "Degas was represented by a sketch of some ballet-girls in very vivid pink frocks, which was a superb bit of brush-work, but certainly nothing more."[5] Both Degas and Manet were viewed as having depicted "ugly" and even repulsive subjects in their paintings. Although initially deterred by the lack of beauty in their subjects, a more sympathetic critic, John C. Van Dyke, nevertheless recognized the magnetic power of Manet and Degas's bold images: "They are repulsive looking, indeed, but it is strange how often in walking around the room the eye will wander back to study the repulsiveness and admire the ugliness." Van Dyke went on to write encouragingly about Degas's painting: "Degas's 'Le Ballet,' a most pronounced example of the impressionist school, hangs upon the north wall, and must be seen from a distance to be properly appreciated. It is worthy of careful study."[6] Degas's painting was one of the standout works in the exhibition; it was partially reproduced in a cartoon that ran in the *Daily Graphic* of New York (fig. 2).

Fig. 2. Cartoon, *The Opening of the Art Loan Exhibition in Aid of the Bartholdi Pedestal Fund at the Academy of Design Last Monday*, published in *The Daily Graphic*, December 10, 1883, private collection.

By 1886 only two works by Degas had been exhibited publicly in the United States. This was soon to change. Paul Durand-Ruel, the enterprising Parisian dealer and crusader for the Impressionist cause, was persuaded to mount a major exhibition of Impressionist paintings in New York, with the hope that he would be able to sell many of these works to American buyers.[7] He imported around three hundred paintings by all of the artists who had exhibited in the Parisian Impressionist group shows, including works by newcomers Georges Seurat and Paul Signac. Initially held at the galleries of the American Art Association, the exhibition was expanded and moved to the more generous spaces of the National Academy of Design. This latter incarnation of the exhibition included some twenty-two works by Degas, comprising not only works owned by Durand-Ruel but also loans from such notable collectors as Louisine Havemeyer, Erwin Davis, and Alexander Cassatt.

In order to give visitors to the exhibition some frame of reference, the organizers produced a catalogue that featured a number of European newspaper reviews of Impressionist exhibitions held in Paris and London. The critics whose writings were included in the pamphlet held different ideas about what Impressionism was. An 1883 review from the *Evening Standard* of London was particularly complimentary of the work of Degas, basing its view on a conception of Impressionism in which the artist "aims generally to record what the eye actually sees" and addresses himself or herself "with courage and confidence to the artistic problems of our modern life, and of our artificial society."[8] The critic praised the snapshot quality of Degas's compositions, his innovative use of color, and the unusual nature of Degas's look at modern life. However, in describing a composition like *The Lowering of the Curtain* (fig. 3), the critic did not hold out much hope for the public's response to Degas's work: "M. Degas's remaining work—a perfectly original study of the scuttering of ankles of certain ballet girls under the weird and vivid illumination of the stage—is unquestionably clever, but the amateurs are few to whom it will afford unmixed delight."[9]

Some American critics took their cue from the English criticism, but others were not as appreciative. The critic for the *New York Times* delivered the following backhanded compliment: "Degas is an artist much above mediocrity, notwithstanding his passion for ugliness and mediocrity." The *Times* critic was espe-

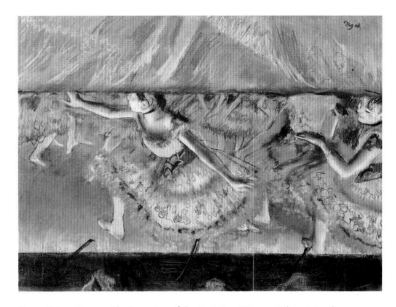

Fig. 3. Edgar Degas, *The Lowering of the Curtain*, 1880, pastel on joined paper, 24¼ × 29⅛ inches, private collection.

cially provoked by the type of ballet scene that had been so warmly praised by the English critic in 1883: "No. 106 'Drawing the Curtain' exhibits all the ugliest points of Ballet dancers just as the curtain drops—their distorted feet, unnatural gestures and lack-luster expressions; moreover, they appear to be female monstrosities who are on the point of being crushed by the falling mass."[10] Yet Degas's work was not entirely without a redeeming quality, according to the critic:

> [Degas does not] depict well-to-do young people as weaklings and depraved in the way that Renoir does in his "Dejeuner a Bougival," nor his nude boys mere bags of boneless outlines, and ugly outlines at that, as Seurat does in his "Bathing." In the small picture of jockeys on horseback clumped together Degas offers rich, somber color and a rude strength that entitles him to respect.[11]

A friendlier reviewer, who was nevertheless still somewhat wary of Degas's innovations, noted briefly:

> The brilliant and startling talent of Degas, who represents the best of the extreme side of the school, may be studied in the ballet of *Robert le Diable,* with its two distinct planes of composition and its weirdness of color and light; in his many ballet subjects, in his "Woman in a café," and in his

café-singer, Degas is abrupt—bizarre—fierce, and almost terribly fascinating.[12]

In addition to the shock of Degas's "weird" lighting, the ugliness of his subjects, and his bizarre compositional techniques, the controversial issue of whether or not his works were finished also appeared in several reviews. This question resulted from such works as *Dancer with Red Stockings* (cat. 53), which seemed to be no more than preparatory studies. The critic for *The Studio* suggested that these works were not fit to be seen by the public and that they should be placed "where only artists, students, or critics would see them, for such persons only do they concern."[13] The perceived masquerading of mere sketches as finished works of art upset the academic notion that only polished works should be viewed by the public. Another American critic, however, was delighted by the snapshot quality of Degas's works:

> One is in a *pays des cocotte*[s], and actresses; the genius of Degas, especially, revels *dans les coulisses.* Here are ballet coryphées in every state of *déshabille,* dancing, dressing, drawing on their stockings, rapidly sketched in charcoal on variously tinted papers, with a dab of occasional color, doubtless *la note qui chante!* The utter homeliness and want of grace of the models console us for the scanty memoranda the artist gives of their charms.[14]

This critic was willing to forgive Degas his "scanty memoranda" because he was able to open such a candid and engaging window on his subjects.

Whereas American critics were taken aback by the unusual subject matter and technical features of the work of Degas and his fellow Impressionists in 1886, the criticism that came in the following years was much more thoughtful and restrained. The primary concern of critics after 1886 was to identify and articulate the nature of Degas's art. It probably occurred to some Americans who saw the Impressionist exhibition at the National Academy of Design in 1886 that the aims of the artists whose work was represented were different and perhaps even conflicting. The year 1886 was pivotal in the history of the Impressionist movement, not only because Americans got their first real look at the art, but also because the last of the Impressionist exhibitions was presented in Paris. By this time the group had already begun to fragment. Monet had ceased to exhibit with

Fig. 4. W. C. Brownell (1851–1928), Charles Scribner's Sons Archive, Manuscripts Division, Princeton University Library.

the group after 1882, and other members—especially Gauguin and Renoir—were undergoing serious ideological and stylistic transformations. Further dividing the group were the Pointillists Seurat and Signac, who espoused a radical scientific approach to Impressionism that alienated other members of the group. After 1886, Impressionism as a French movement effectively disbanded.

The splintering of the Impressionist group in the late 1880s encouraged efforts to extricate Degas from that context and to associate him with other stylistic and ideological tendencies. The journalist W. C. Brownell (fig. 4) was the first American critic to attempt to redefine Degas's achievement. Brownell began his career as a reporter for the New York *World* in 1871. He was on the staff of *The Nation* from 1879 to 1881, and then took a hiatus from journalism to travel to Europe, where he stayed from 1881 to 1884. It was presumably at this time that Brownell first came into contact with the work of Degas as well as other avant-garde French artists. In 1888 he became an editor and literary advisor at the publishing house of Charles Scribner's Sons in New York,

and in 1892 Brownell published a book titled *French Art* with Scribner's, one of the first serious American studies of advanced French art.

Although Brownell was generally supportive of modern art, especially the sculpture of Auguste Rodin, he did not see the future of painting issuing from the example of Monet and the Impressionists. He prophesied, "Whatever the painting of the future is to be, it is certain not to be the painting of Monet."[15] Brownell believed the work of Monet was too automatic, too impersonal, like a photograph. Degas, on the other hand, did not paint what was real, according to Brownell, but "colors and shapes and their decorative arrangements." Degas's use of color could be seen as a link to the Impressionists, but he directed their methods toward art with an expressive or "a personal point of view." Brownell concluded, "Nothing could be more opposed to the elementary crudity of impressionism than his [Degas's] distinction and refinement, which may be said to be carried to a really fin de siècle degree."[16] The ideas that guided Brownell's promotion of Degas and his rejection of Monet were essentially those espoused by symbolist artists like van Gogh, Gauguin, and other Post-Impressionists, who in the late 1880s argued that art must express a deeper, more personal meaning.[17] Although Brownell believed that "the attitude of the painter toward life and the world in general" could be expressed through color and the decorative arrangement of form, he was evidently unfamiliar with the work of either Gauguin or van Gogh. He was only certain that it would not follow from Monet.

The next major piece of "American" criticism of Degas was not that of an American critic, but by Julius Meier-Graefe (1867–1935; fig. 5), an influential German critic and art dealer whose translated book *Modern Art* was published simultaneously in London and New York in 1908. Meier-Graefe had a panoramic and up-to-date view of French avant-garde art at the turn of the century, and he presented Degas as belonging to a collaborative team of modern artists, each with his own job to do in the development of modern art: "Manet set forth the general programme: the new art was to be decoration pure and simple; Cézanne exhibited the texture of the stuff; Renoir painted exquisite fragments for it, the feminine element that must be in all real painting; Degas drew for it."[18] Meier-Graefe did not see Degas as a Realist or as an Impressionist, but as a brilliant colorist and technical innovator who revolutionized drawing. He argued that

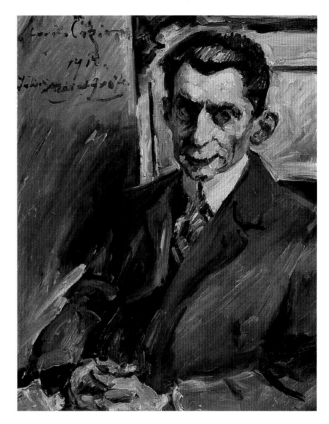

Fig. 5. Lovis Corinth (German, 1858–1935), *Julius Meier-Graefe*, 1914, oil on canvas, 35½ × 27¾ inches, Musée d'Orsay.

Degas's recognition that his earlier old-master-inspired paintings did "not harmonise with our modern nerves, our desires, our passionate delight in colour, our pleasure in the throb and quiver of life" led to an intense obsession with color.[19] Meier-Graefe was particularly impressed by Degas's innovations in pastel: "Over all he sheds an intoxicating splendour of colour, pain bathes in marvellous lights; his stage-settings become Elysian fields, before which all tropical images pale. His planes are like great butterfly-wings; it seems as if every motion of the air must stir this ethereal colour-dust, so carelessly strewn."[20]

In 1923, Meier-Graefe published one of the first monographs on Degas in English, which repeated the message contained in his earlier chapter in *Modern Art*. All aspects of the artist's work were covered, but Meier-Graefe again reserved special praise for Degas's extraordinary pastels: "Degas invented a new kind of pastel drawing as Cézanne invented a new kind of painting."[21] At the conclusion of his book, Meier-Graefe proclaimed, "Degas opened the way for a new era in art. At the foot of the

Fig. 6. Arthur Pope (1880–1974), Harvard University Art Museums.

monument, which should be erected to him, we will find the strange figures of Forain and Lautrec, van Gogh and Gauguin, surrounded by many others. Picasso and other living oddities would be among the crowd."[22] This was a very strong endorsement by one of the leading international critics and historians of modern art.

Aware of Degas's reputation as a modern master, the Fogg Art Museum of Harvard University mounted in 1911 the first museum exhibition of Degas's work to be held anywhere in the world. The exhibition, which included twelve works borrowed from New England collections, was organized by Arthur Pope (fig. 6), a lecturer on fine arts and the protégé of one of the leading design theorists at Harvard, Denman Waldo Ross (fig. 7). Pope's uncle, Alfred Pope of Farmington, Connecticut, lent three important pictures to the exhibition. Also assisting in the organization of the exhibition was the director of the Fogg, Edward Waldo Forbes.

The reviews of the 1911 Fogg exhibition were very favorable. They took at face value the assertion put forward in the exhibi-

tion pamphlet authored by Arthur Pope that Degas was one of the greatest artists living at that time. This was said despite the fact that very few of his works had been available in America for public inspection. Many of the notices that appeared in the newspapers regarding the exhibition were brief and simply repeated what Pope had written in the pamphlet. Blurbs about the exhibition appeared in newspapers ranging from Boston to New York, Springfield (Massachusetts), Pittsburgh, and Providence. The most complex reviews appeared in *The Globe* and *The Boston Transcript*. The former review was signed "A. J. Philpott," while the latter appeared without a byline.

Philpott noted in *The Globe* that although Degas was primarily known for his ballet pictures, the works exhibited in the Fogg installation revealed the full range of his talents and subject matter. Philpott wrote:

> It might be well to say that Degas is one of the very few men
> who could paint a ballet picture that looked decent, because
> as a rule such pictures are apt to be either vulgarly pictur-
> esque or picturesquely vulgar. In the ballet pictures by Degas
> you feel the harmonies of light, color, and movement—they
> are almost musical. The figures are not mere models posed
> for the occasion; each is a note and is in its just place in
> the composition. Degas was always sensitive to the minor
> notes in color and he painted these notes with rare felicity
> and truth.[23]

Philpott then compared Degas and Whistler, saying both painted "with very much the same directness and simplicity," but that Degas could paint movement and his application of color was more vivid. Philpott went on to praise the naturalness of Degas's jockey paintings and the dramatic presentation of the painting titled *The Interior* (page 21, fig. 7).

The unnamed reviewer in *The Boston Transcript* also had only good things to say about the exhibition. The first works to receive treatment were those lent by Alfred Pope. Of particular interest was the painting of ballet dancers that had been lent to the Pedestal Loan Fund Exhibition in New York in 1883. Using terms similar to Philpott's discussion of Degas's ballet scenes, the critic wrote:

> This picture, which is somewhat famous, shows a group of
> dancing-girls at three-quarters length, in rose-pink costumes,

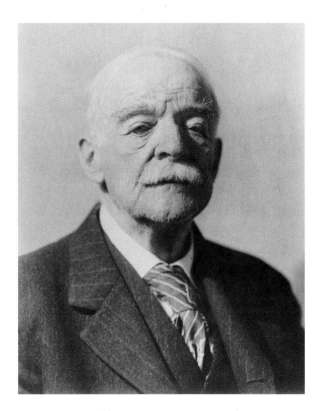

Fig. 7. Denman Waldo Ross (1853–1935), Harvard University Art Museums.

on the stage. The rose-pink tone is the dominant color, and it is managed with admirable effect, its relation with the flesh tones and the background tones giving it a rare quality. Degas is one of the few painters who is able to make rose pink count for its full worth in a color scheme, though we have seen one or two canvases by Alfred Stevens in which it was made to yield up a similar sensation of choiceness.[24]

The focus on the formal qualities—the arrangement of colors and shapes—of Degas's dance scenes in the criticism of the 1911 Fogg showing was probably the result, either directly or indirectly, of the writings and teachings of Harvard's Denman Ross, whose *Theory of Pure Design* appeared in 1909. In that book and in subsequent writings, Ross promoted the notion that "lines and spots of paint can be arranged in forms of Order just as we arrange sounds in Music, for no other reason than to express the Love of Order and the Sense of Beauty."[25] Interestingly, Ross compared the pleasure that results from "pure design" with the pleasure received from the abstracted movements of a dance performance. This did not mean, however, that Ross was a fan

of "abstract" painting. He found the work of certain modern artists, whom he termed generally "Post-Impressionists," to be misguided and too extreme in their application of the principles of pure design.[26] However, Ross particularly admired two aspects of Degas: his excellent draftsmanship and his feeling for "color-values."[27] It was evidently the appreciation of the latter quality that led Ross to purchase two pastelized monotype landscapes (fig. 8 and page 25, fig. 11) in the 1890s, which he gave to the Museum of Fine Arts, Boston, in 1908. These works were included in the Fogg exhibition; the organizer of the exhibition, Arthur Pope, was a close associate who shared Ross's ideas regarding the visual arts.

Whereas Meier-Graefe and the critics in Boston in 1911 had found beauty and significance in Degas's formal innovations, those innovations came under attack in 1915. Willard Huntington Wright (1888–1939; fig. 9) was a journalist from California who first worked as a reporter for the *Los Angeles Times* and later became editor of *The Smart Set* magazine in New York. In March of 1914, Wright, along with his brother, the artist Stanton Macdonald-Wright, embarked on a trip to Europe. When he returned to New York in 1915, he published a book titled *Modern Art: Its Tendency and Meaning,* which was intended to provide a

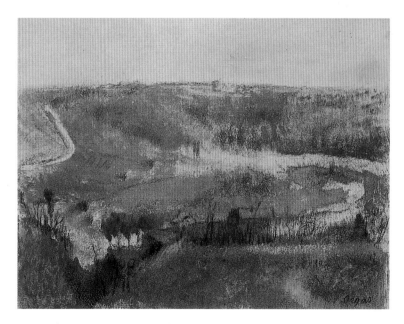

Fig. 8. Edgar Degas, *Autumn Landscape,* 1890–93, pastel over monotype on paper, 12 3/16 × 16 5/16 inches, Museum of Fine Arts, Boston, Denman Waldo Ross Collection.

theoretical basis for the artistic efforts of his brother, who, along with another American artist named Morgan Russell, had established a movement called Synchromism. Clearly inspired by the recent forays into "non-objective" painting by Picabia and Delaunay, the Synchromists established their genealogy in the nineteenth-century work of Cézanne and Renoir. Degas did not fit into the picture of the development of modern art as formulated by Wright and Synchromists, and thus Wright wrote that Degas "was one of those painters who, content to remain stagnant, employ the qualities which have been handed down to them and breathe into old inspirations the flame of individual idiosyncrasy."[28] Wright characterized Degas's work as "artistic," a pejorative term that referred to the appreciation of the sensual textures of decorative arts objects. The term "artistic," according to Wright, "commonly refers to paintings in which the exactitude of drawing is lost in a nonchalant *sensibilité,* and in which the *matière* takes on a seductive interest merely as a stuff or a sub-

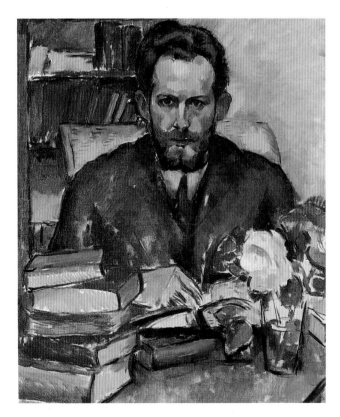

Fig. 9. Stanton Macdonald-Wright (American, 1890–1973), *Portrait of Willard Huntington Wright,* 1913–14, oil on canvas, 30 × 36 inches, National Portrait Gallery, Smithsonian Institution, gift of the James Smithson Society.

stance, the love of which lies deep in the most intellectual of men."[29] Thus Degas's pastels, which so enchanted Meier-Graefe, were simply beautiful surfaces and nothing more. To Wright, this fascination with surfaces "indicated the inherent decadence of his aims." Wright continued, "Nor was it the only sign of his retrogression. There is not even pictorial finality in his work. He never painted subjects as such, but used them only as bases for arabesques."[30] The only work by Degas that Wright chose to reproduce in his book was a beautiful pastel of dancers that belonged to Louisine Havemeyer (cat. 48) and which had been included in her exhibition at Knoedler's gallery in 1915.

Despite Wright's negative criticism, 1915 was a benchmark year in the critical reception of Degas's work in America. Louisine Havemeyer of New York, the greatest American collector of Degas's work, organized a major exhibition of the work of Degas and Mary Cassatt to raise money and awareness for woman suffrage. The exhibition was held at Knoedler's gallery in Manhattan. On April 6, 1915, she delivered a lecture in the exhibition, relating anecdotes about the work of both Cassatt and Degas, including a description of the first time that she saw a work by Degas. Mrs. Havemeyer's reasons for her appreciation of Degas emerge in her discussion of a cabaret scene, which was excerpted from her lecture and published in the *New York Times:* "The 'Café Concert' which you see before you is not, perhaps, the attractive place we Americans recall on the Champs Elysees, but rather a true record of what it really is. . . . Degas, the keen, subtle philosopher, reveals the café concert as it is from its heart and core, from cause to effect."[31] Mrs. Havemeyer's observations were echoed by those of another, anonymous critic in the *New York Times.* Although the critic contended that Degas did not "belong to any group, revolutionary or otherwise," he did compare the artist to a scientist who is "on his mettle to observe and register facts disclosed by his own original research."[32] Both Mrs. Havemeyer and the *New York Times* critic presented Degas's realism as that of an anatomist who cuts open reality in order to reveal the "heart and core" of daily life.

In addition to Mrs. Havemeyer's characterization, we have seen that the American presentation of Degas as a Realist began well before 1915. Some of the first critical comments to appear in 1878 described him as "uncompromisingly realistic." James Gibbons Huneker (fig. 10), an influential critic for the *New York Sun* newspaper, also viewed Degas as an uncompromising Realist.

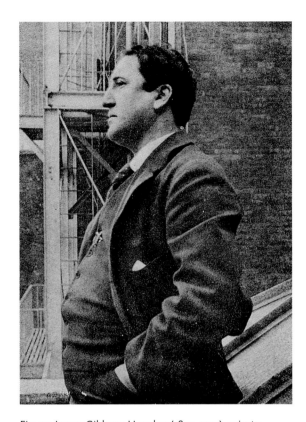

Fig. 10. James Gibbons Huneker (1857–1921), private collection.

In 1910, Huneker expressed his admiration for Degas's draftsmanship and portrayed him as "an Ingres who has studied the Japanese. Only such men as Pallajuolo and Botticelli rank with Degas in the mastery of rhythmic line. He is not academic, yet he stems from the purest academic traditions."[33] Huneker thought Degas particularly brilliant in his straightforward rendering of the female nude: "Degas knew that to grasp the true meaning of the nude it must be represented in postures, movements which are natural, not studio attitudes. As Monet exposed the fallacy of studio lighting, so Degas revealed the inanity of its poses."[34] He was also taken with Degas's ability to capture "the moving line." Because of his remarkable facility as a draftsman, Huneker observed, "He draws movement. He can paint rhythms."[35]

Taking the "Degas as Realist" theme even farther, an article that appeared in the New York Times in 1914 proposed that Degas was an example for the "workman."[36] The critic argued, "His whole career is a deep voiced protest against the curse of modern art; against, that is, the craving for the appearance of an

excellence that has no rent in honest thought." While the critic went on to assert that Degas's work was indeed "modern" in the innovative manner in which the artist went about scrupulously observing and recording modern life, it was also tempered with a classical correctness that resulted from excellent "workmanship." Unlike Willard Huntington Wright, the critic did not see Degas's work as displaying "an inherent decadence," but as being "honest" and "workmanlike." The anonymous author of Degas's New York Times obituary in 1917 also stressed the issue of "work" in relation to the artist:

> Workers were the favorite models of Degas, work was his favorite theme. It was not the work of the fields that meant to Millet weariness or the work of the mines that meant to Meunier despair, but the work of people who lived by the labor they could do best and for which they were chosen by the selection of the fittest. Degas saw them with the eyes of an artist, who himself was doing the hard thing well with a special fitness for triumphing in it.[37]

Although the idea of Degas as a workman did not spread, the realist theme continued into the 1920s, proving to be one of the most popular modes for interpreting Degas's work.

The sale of Jacques Seligmann's recently acquired collection of Degas paintings and pastels in January of 1921 provided another opportunity for critical examination and discussion. The sale preview was open and free to the public for a week beginning on January 22, and was at that time the largest showing of Degas's works ever held in the United States. The showing revived the issue of finish in Degas's work. Indeed, most of the work in the sale appeared to be unfinished, and prospective buyers would have known that the works had recently been purchased from the sales of Degas's studio (cats. 27, 33, 37, 71). In one review, Hamilton Easter Field (fig. 11), the Brooklyn-based artist and critic,[38] assured the public that the work was intentionally left in the state in which they found it and that it was in fact "finished." Field wrote confidently, "Degas is one of the few painters who has deliberately left canvases without giving all portions an equal finish. . . . Everything essential to the full expression of the idea of the painting would be carefully executed. Whatever was unnecessary would be left in the rough. Rodin, in his sculpture, adopted the same method. With Degas, as with Rodin, it was intentional."[39] Steering a slightly different tack, the

Fig. 11. Hamilton Easter Field (American, 1873–1922), *Self-Portrait,* ca. 1890, oil on panel, 23½ × 17½ inches, Portland Museum of Art, Portland, Maine, gift of Barn Gallery Associates, Ogunquit, Maine, 1979.

critic for the *New York Times* argued that "the oil medium was not a sympathetic medium with Degas." Because Degas was above all a draftsman, he used oil paint "despitefully." Nevertheless, the critic concluded:

> If he did hate it, he none the less asked much of it. He asked it to express a side of his genius otherwise not to be suspected; the intense conservatism of his taste that withstood his burning curiosity and pioneer spirit. If he drew with a boldness and individuality, a research into the secret sources of form and movement, that created a new art language and causes him still to resist popular esteem, he painted with a firm, prim finish, a reticence of color, an economy of matter, such as Ingres practiced and Leonardo preached.[40]

This reaction to the issue of Degas's finish was evidently not a result of shock, as it had been in 1886, but rather a result of commercial concerns. Who wanted to buy unfinished pic-

tures? The *Times* writer observed, "The sale of this fine collection of drawings and paintings will test the interest of the picture-buying public in this country in art that makes no compromises."[41] By the time of the sale, any concerns about finish had been allayed, and the sale yielded the phenomenal amount of $226,800.

The January following the Seligmann sale saw the first exhibition of Degas's sculpture and prints at the Grolier Club in New York. Mrs. Havemeyer loaned her recently purchased "A" set of seventy-two bronzes. This elicited the first American criticism of Degas's sculpture. An article in the *New York Times Book Review* praised the exhibition of the "recently discovered" sculptural work and argued that their New York showing "amounts to a profoundly significant event in the exhibition field."[42] The author of the article particularly liked the way in which they allowed access into Degas's creative processes, and he or she noted, "He built his figures solidly in order to reduce them to line." The author also compared Degas's efforts to those of Michelangelo, particularly Degas's efforts to recreate "vital movement" in three dimensions. The author continued, "Not since the Renaissance has any one been quite so interested in such things." Finally, the author compared Degas to Rodin. Whereas Rodin's sculpture demonstrated a traditional approach to the posing of figures, Degas was radically innovative in that "he wanted to observe the poses and gestures in the freedom of a personal solitude, without the artificial constraint that arises unconsciously from knowing one's poses and gestures observed."[43]

In 1925 the sculptures were again exhibited at the Ferargil Gallery in New York. This time it was the "B" set that had originally belonged to the Norwegian dealer Halvorsen and that had been exhibited at the Durand-Ruel Gallery in New York in 1922. The exhibition at the Ferargil Gallery resulted in a negative review by the American modernist sculptor, William Zorach (1887–1966). Whereas the critic for the *New York Times* in 1922 had received Degas's three-dimensional work as a major milestone in the history of sculpture, Zorach argued that "in the strict use of the word they can hardly be considered seriously as sculpture."[44] As a means to a pictorial end, Zorach found them interesting: "But the figures remain modelling, not sculpture. . . . Real sculpture is something monumental, something hewn from a solid mass, something with repose, with inner and outer form; with strength and power—not an outer surface modelled

on a wire frame."[45] Zorach lamented the fact that Degas's three-dimensional work had even been brought to public attention: "It is all too suggestive of speculators and exploitation."[46] Despite Zorach's misgivings, pieces from the "B" set were sold to such important collectors as the Hydes of Glens Falls, New York, Lessing Rosenwald of Jenkintown, Pennsylvania, and Mrs. Cornelius Sullivan of New York.

Like the sculptures, Degas's prints should have been something of revelation to American audiences, yet no critics responded when they were exhibited at the Grolier Club in 1922. Perhaps the only early American writing on the prints was a rather brief and uninformative article by Hamilton Easter Field that appeared in 1920.[47] It was written in response to the inclusion of several etchings and lithographs in an exhibition of modern prints at the Keppel Gallery in New York. Field's main point was that Degas was a "versatile master," but he did not seem to know much about the prints nor did he seek to place them into any kind of context. This lack of understanding and of a critical dialogue on the subject of Degas's prints continued well into the twentieth century.

From the 1890s to the 1910s the recurrent characterizations of Degas in the American critical press were as a modernist and as a Realist. The predominant theme in much of the criticism of the conservative 1920s was Degas as "traditionalist." Critics viewed Degas's unsurpassed draftsmanship and his intense study of the old masters as essential virtues of his modernism because they set him apart from those late nineteenth- and early twentieth-century artists and movements that had claimed to break completely with the past. An important article by the French critic Henri Hertz, published in 1923, was one of the first to present this theme to American readers. Hertz's article, "The Great Transitional Artists of the Modern Epoch—Degas," appeared in the monthly *Art in America*. The main point of Hertz's argument was that Degas's work represented a crucial bridge between the old-master tradition and modern art. Hertz wrote, "There was, however, one man [Degas] whom the impressionists loved, whom they could not challenge, who fought in their ranks and who has expressed what they have expressed, but while preserving to line its fundamental function and while remaining the continuator and the fervent pupil of Ingres."[48] Hertz argued that while the Impressionists were undergoing a crisis—presumably Hertz was referring to the period of 1886—Degas

was able at that time to withdraw in order to preserve the "purity" of the movement. "The reason for it is clear: it is because he possessed a technique that the other Impressionists disdained, it is because he was able to reconcile Impressionism with tradition."[49] According to Hertz, Degas was able to shore up the Impressionists' efforts to express "the impetuous and frail aspect of mobility" by giving it substance via drawing, and thus, Hertz predicted, "history will say that he was able to affirm the union between tradition and impressionism so that it will probably be partly due to him that later from age to age the impressionists will remain understood and loved."[50]

American writers of the 1920s picked up on Hertz's theme. In 1925 the critic Royal Cortissoz (1869–1948) published a study of Degas in a book of collected essays titled *Personalities in Art*. Noting the link between past and present in Degas's work, Cortissoz observed, "This intensely modern artist, a progressive of the progressives, the very antithesis of all things academic, was one of the loyalest disciples of the old masters that ever lived."[51] Cortissoz, like a number of critics before him, viewed Degas primarily as a realist: "The actuality of the moment was the object upon which Degas kept his eye. A cool spirit, as of scientific inquiry, presides over practically everything that he ever did, the exceptions to the rule being so few as to be almost negligible."[52] Cortissoz liked Degas's "traditional" work the best—the works mentioned in his essay were almost exclusively early works, and he chose to illustrate such early portraits as that of James Tissot (cat. 22) in the essay. Undoubtedly Cortissoz's taste did not extend to Degas's later pastels and paintings.

In 1927, Frank Jewett Mather Jr. (1868–1953), a Princeton professor, published *Modern Painting*, which included some brief remarks on Degas. Tellingly, Mather included Degas in a chapter entitled "Great Traditionalists," where he concluded: "The eclecticism of Edouard Degas somewhat disguises his essential traditionalism."[53] Both Cortissoz and Mather were conservative critics, and they did not like what they saw when they looked at the work of radical modern artists like Matisse and Picasso or even the work of such late nineteenth-century artists as van Gogh and Monet. Although Degas was by no means viewed as *retardataire,* he represented a temperate artist who did not throw traditional pictorial values out of the window.

By 1936 Degas was widely accepted. The Pennsylvania Museum of Art (now the Philadelphia Museum of Art) mounted

the first major museum retrospective of Degas's work in the world. The showing in Philadelphia preceded the first European retrospective by a year. Simply titled *Degas: 1834–1917,* the exhibition comprised 105 works from all periods of Degas's career and in all media, including paintings, pastels, drawings, sculpture, prints, and even photographs. The exhibition was organized by Henry McIlhenny, who had recently graduated from Harvard College, where he studied with Paul J. Sachs. Sachs, a major lender of drawings to the exhibition, wrote a brief introduction to the exhibition catalogue and his protégé Agnes Mongan (fig. 12) wrote a somewhat longer and more elaborate introduction. These remarks may be viewed as summarizing the critical debate of the previous five decades.

In his preface to the exhibition catalogue, Sachs expressed his appreciation of Degas's work, which derived not only from his knowledge of what had been written about Degas, but also from the pleasure of collecting his work: "As a student and collector of the art of France I have long held the view that, in spite of the vagaries of Paris fashion, Degas is the most sensitive as well as one of the greatest artists of the nineteenth century."[54] Sachs's range of collecting Degas drawings ran the entire gamut from early to late, and although he recognized Degas's roots in the old masters, he was also willing to open his eyes to all of Degas's "modern" innovations.

Agnes Mongan, the first woman to become a director of a major American museum, acknowledged the difficulties of previous generations of American critics in categorizing Degas's work: "He is neither a classicist, a romanticist nor a realist— and yet he is all three."[55] For Mongan, the apparent antithesis between Degas's classicism, realism, and romanticism was unproblematic, and she used the American trope of the "melting pot" to characterize Degas's achievement. She suggested that because of "the mixture of races which ran in his veins," he was able to combine seemingly disparate qualities into a powerful new synthesis.[56] Mongan summarized, "It is this fusion of the best which tradition can offer with a new and vital vision and spirit which makes Degas the last of the old masters and the first of the new."[57]

Sachs's all-embracing appreciation of Degas's drawings and Mongan's all-admiring remarks about the character of Degas's art may have been intended to ease frustrated efforts to categorize Degas, but in fact this critical debate that began in the late

Fig. 12. Agnes Mongan (1905–1996), Harvard University Art Museums.

nineteenth century continues. This is because Degas's work invites categorization, but then stubbornly resists it. Scholars and critics continue to include him and exclude him from studies and exhibitions of Impressionism. They continue to argue over the nature of his Realism and whether or not he was even a Realist. And they continue to debate his place in the genesis of twentieth-century modernism. In this regard, a notable recent effort to present Degas as a seminal figure in the birth of modern painting was Richard Kendall's 1996 exhibition *Degas: Beyond Impressionism,* in which the author felt compelled to demonstrate that Degas's later art carried him "to the heart of early modernism."[58] What is not in question, and apparently never was, is that American collectors, artists, and critics have responded positively to his art from the beginning. Although Americans have had their different reasons for liking Degas's work, in the words of Paul Sachs, "His work has always been received here with well deserved enthusiasm and with true appreciation."[59]

NOTES

1. Some of the European criticism of Degas's work can be found in Berson 1996, vol. 1; and Flint 1984.

2. The early American criticism of Degas has never been the focus of extensive study. See Sutton 1990, p. 37, which describes the American response to Degas as a "tolerant reception." Sutton's conclusion was based on the study of only a few of Degas's American critics.

3. "American Water-Color Society," *New York Times*, February 2, 1878, p. 5.

4. "The Old Cabinet," *Scribner's Monthly*, April 1878, pp. 888–89.

5. Quoted in O'Brien 1986, p. 81.

6. Quoted in ibid., p. 82.

7. For a discussion of the 1886 Durand-Ruel exhibition in New York, see Huth 1946, pp. 237–42.

8. *The [London] Evening Standard*, July 13, 1883, reprinted in American Art Association 1886, p. 7.

9. Ibid., p. 8.

10. "Paintings for Amateurs: The French Impressionists at the American Galleries—Art for Art's sake—Good and Bad Impressionists," *New York Times*, April 10, 1886.

11. Ibid.

12. "The Fine Arts: The French Impressionists," *The Critic*, April 17, 1886, p. 195.

13. *The Studio*, April 17, 1886, quoted in Boggs et al. 1988, p. 432.

14. *The [New York] Mail and Express*, April 21, 1886, quoted in Boggs et al. 1988, p. 433.

15. Brownell 1892, p. 134.

16. Ibid., p. 134.

17. Brownell's remarks on Degas echoed those of certain French critics writing in the later 1880s, including Félix Fénéon and Gustave Geffroy, who stressed the artificial color and the decorative aspects of his work. See Berson 1996, pp. 441–42 and 451–52. I would like to thank Richard Kendall for pointing this out to me.

18. Meier-Graefe 1908, vol. 1, p. 277.

19. Ibid., p. 270.

20. Ibid., p. 278.

21. Meier-Graefe 1923, p. 78. The book was published simultaneously in the United States and England.

22. Ibid., p. 86.

23. A. J. Philpott, "Paintings by Degas," *The Globe*, April 10, 1911. A copy of this review can be found in the archives of the Fogg Art Museum.

24. "The Fine Arts: Loan Exhibition of Pictures by Degas," *Boston Transcript*, April 7, 1911. A copy of this review can be found in the archives of the Fogg Art Museum.

25. D. Ross 1912, p. 81.

26. Ibid., pp. 116–18.

27. Ibid., pp. 135, 172.

28. Wright 1915, pp. 208–9.

29. Ibid., p. 211.

30. Ibid., p. 212.

31. "'Art and Artists,' by Mrs. Havemeyer," *New York Times*, April 7, 1915, p. 7.

32. "Exhibition for Suffrage Cause," *New York Times*, April 4, 1915.

33. Huneker 1910, p. 78.

34. Ibid., p. 80.

35. Ibid., p. 82.

36. "Degas, Famed as a Painter of Dancers, Is Eighty Years Old Today—A Scrupulous Observer of Form," *New York Times*, July 19, 1914, p. 11.

37. "Edgard Degas, Greatest Draftsman of His Century," *New York Times*, October 7, 1917, p. 12.

38. For an excellent discussion of Field as an artist and a critic; see Bolger 1988, pp. 79–107.

39. Field 1921, p. 12.

40. "The World of Art: Degas, Mary Cassatt, and Others," *New York Times*, January 23, 1921, p. 20.

41. Ibid., p. 20.

42. "The World of Art: Degas at the Grolier Club and the Architectural League," *New York Times Book Review and Magazine*, January 29, 1922, p. 20.

43. Ibid., p. 20.

44. Zorach 1925, p. 263.

45. Ibid., p. 264.

46. Ibid., p. 264.

47. Field 1920, pp. 8–11.

48. Hertz 1923, p. 178.

49. Ibid., p. 183.

50. Ibid., p. 184.

51. Cortissoz 1925, p. 223.

52. Ibid., p. 227.

53. Mather 1927, p. 257.

54. McIlhenny, Mongan, and Sachs 1936, p. 5.

55. Agnes Mongan, introduction to Ibid., p. 9.

56. Ibid., p. 9. Mongan's use of the phrase "mixture of races" probably referred to Degas's French and American parentage. She was undoubtedly unaware of the recently disclosed fact that Degas had New Orleans relatives of African descent. See Christopher Benfey, "Degas and New Orleans: Exorcising the Exotic," in Feigenbaum et al. 1999, pp. 23–31.

57. McIlhenny, Mongan, and Sachs 1936, p. 10.

58. Kendall 1996, p. 11.

59. McIlhenny, Mongan, and Sachs 1936, p. 6.

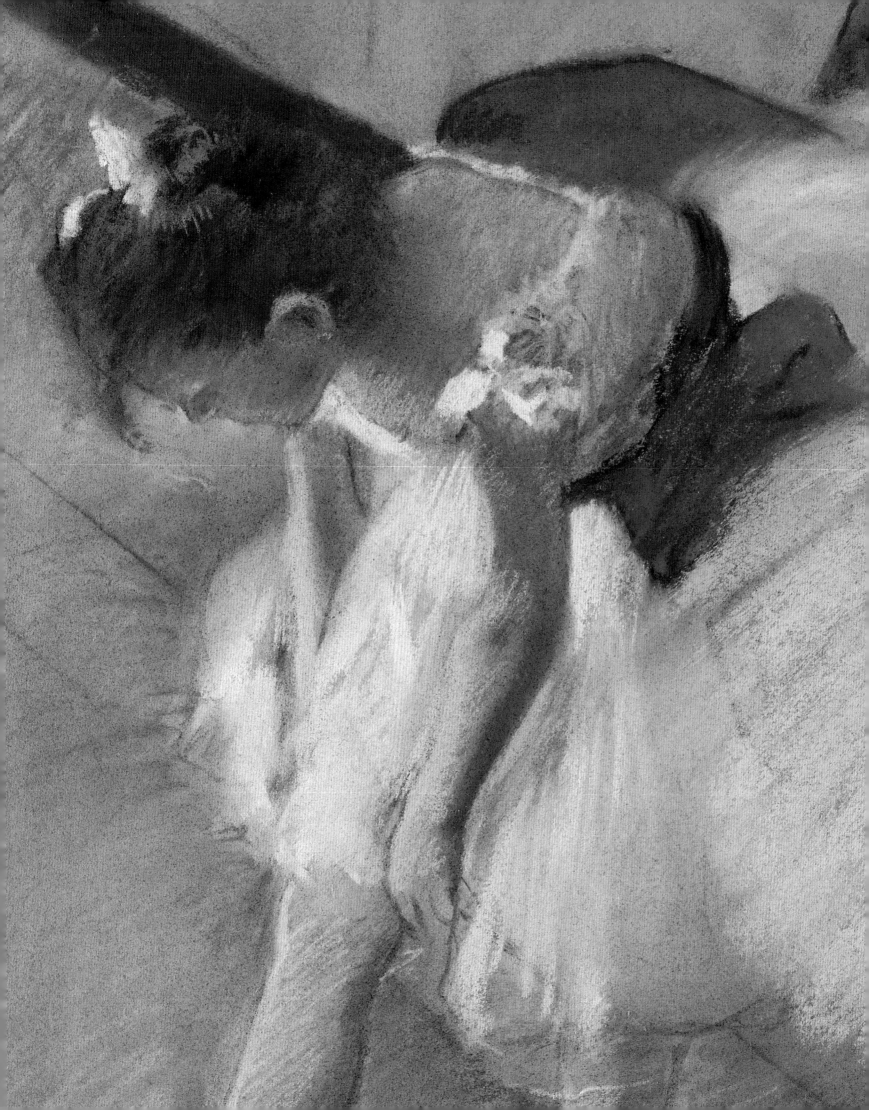

Influence in Low Places:
Degas and the Ashcan Generation

Richard Kendall

*The wave of realism which began with Courbet
and was carried much more convincingly on its way by
men like Manet, Degas and Toulouse-Lautrec reached us
in the works of Robert Henri, George Luks, John Sloan,
Everett Shinn and William Glackens.*

GUY PÈNE DU BOIS, 1931

EDGAR DEGAS IS ONE of the unsung heroes of
early American modernism, not just as a presence in pioneering collections, but as a model of
visual radicalism for many of its leading painters
at the beginning of the twentieth century. His
presence is felt at almost every level, from studio gossip in New
York, Philadelphia, Boston, and elsewhere to the most audacious conceptions of painting and graphic art taking shape in
these cities. We come across Degas's name in artists' letters
and memoirs, in reports of the training they received, and in
the writings of their earliest critics, while his unmistakable imagery echoes throughout the novel subjects they chose and the
innovative compositions they made. We read of Robert Henri's
familiarity with works by Degas in the Luxembourg Gallery in
Paris and of Maurice Sterne's meeting with the elderly French
artist himself in 1905; we learn of William Glackens's purchase
of a Degas canvas on behalf of Dr. Barnes of Philadelphia and
of a visit by John Sloan to a New York exhibition of Degas's pictures on the advice of John Butler Yeats. We find pastels of the
cabaret by Alfred Maurer and canvases of the racetrack by
George Bellows, monotypes of Paris streets by Maurice Prendergast, studies of café life by Guy Pène du Bois, and paintings
of entertainers, such as *Concert Stage* (fig. 1), by Everett Shinn.
Most definitive of all, perhaps, are the numerous depictions of
a subject that Degas had long since made his own—the ballet
dancer—by Henri, Glackens, Luks, Sloan, Shinn, Sterne, Prendergast, Arthur B. Davies, Pène du Bois, and even the young
Edward Hopper (fig. 2).

When, where, and in what form did the painters of the Ashcan generation encounter Degas's art? How wide was their
knowledge of his oeuvre and how considered was their response

61

Fig. 1. Everett Shinn (American, 1876–1953), *Concert Stage,* ca. 1905, oil on canvas, 16½ × 20 inches, Norton Museum of Art, Bequest of R. H. Norton.

to it? Was their interest merely opportunistic, like that of many of Degas's French and other European admirers, or was there a more pondered engagement with his technical and conceptual originality? Both the exhibition *Degas and America: The Early Collectors* and the present catalogue offer some answers to these questions, exploring attitudes toward Degas at the fin de siècle and identifying a number of his pictures known at first hand in the United States during these years. The extent to which such works were seen and remembered by younger painters, however, is often poorly documented, as is their contact with specific examples of Degas's art on their youthful visits to Europe. Other factors enter the equation: notably the development within Degas's own art as he grew older and the alertness of his contemporaries to these changing priorities. In the early years of the century, the septuagenarian Degas was still active in Paris and was arguably as innovative in his manipulations of line, color, and expressive form as at any point in his career. Despite persistent legends to the contrary, some of them circulated by Degas himself, he was also exhibiting recent work and engaging energetically with the art of younger painters in the city.[1] As is often the case, however, there was a measurable time lapse between his output and its public appreciation, and it was the art of his earlier, Impressionist period—principally that of the 1870s—

that still largely defined his professional persona in the first decades of the twentieth century.

The subplot of our story, then, is the functioning of influence itself: the mechanisms of contact and transmission, the exemplary nature of senior figures, teachers, and role models, and the crucial part played by opinion makers, from critics and collectors to studio mythologizers. Elusive in the best of circumstances, these issues are further complicated by the geographical and cultural distance separating the Ashcan generation from the European artists they both revered and feared, and the simultaneous emergence of a powerful new American art, based on "the great ideas native to the country," as Henri put it.[2] Not only were these young American painters responding to a remote and only partially understood Degas, in other words, but also to a contrary drive toward a national (and at times explicitly anti-French) painterly project. Although the situation seems taxing, the virtual neglect of this subject at a critical moment in the evolution of American painting seems inexcusable. While the transatlantic reverberations of American-born artists like Whistler and Cassatt and of European artists such as Manet, Monet, and (in John Rewald's book-length study) Paul Cézanne have now become a matter of record, Degas's case remains virtually unexplored.[3] The aim of this brief essay is merely to open up the territory, to reveal the riches of the landscape rather than to map it comprehensively, confident that others with more local knowledge will develop more refined cartographies. By concentrating on selected painters in and around the Ashcan circle and on the years immediately preceding the Armory Show of 1913, our inquiry finds its focus, but more ambitious studies of the role of Degas in American Impressionism and its aftermath, and in the art of the interwar years, surely wait to be written.

The 1931 statement by Guy Pène du Bois that opens this essay introduces us to several landmarks in this surprisingly uncharted terrain. Pène du Bois was descended from a French family, which, like Degas's, had links with earlier generations in New Orleans. Born in New York, he emerged as a painter in the early years of the century alongside the Ashcan artists, also working as an occasional reporter and art critic. His remarks come from the catalogue of an exhibition of pictures by Glackens, in which Pène du Bois recalled the heroic years that preceded the controversial show of The Eight at the Macbeth Gallery in 1908.[4] What is immediately striking is Pène du Bois's

Fig. 2. Edward Hopper (American, 1882–1967), *Ballerina*, watercolor on paper, 5⅝ × 4 inches, Whitney Museum of American Art, New York, Josephine N. Hopper Bequest.

suggestion that it was a "wave of *realism*"—not of Impressionism, Symbolism, or any of the later, more "advanced" European styles—that reached the Ashcan group and energized its activities. Equally telling is his identification of Degas with this "realist" wave, locating him between the astringent urbanism of Manet on the one hand and the still widely unacceptable decadence of Lautrec on the other. It was the Degas of the 1870s who was foremost in Pène du Bois's mind, the artist of "racehorses, ballerinas and laundresses," of "Cafe-concert singers, Women outside a Cafe, Women at their toilette," as the Parisian critics of the day had characterized him.[5] This same Degas had already become associated in both France and America with another aspect of the same realist impulses—that expressed in contemporary literature. Summarizing this attitude for her readers in 1899, a sympathetic writer in *The House Beautiful: The American Authority on Household Art* explained: "Degas's pictures are instinct with modern life: they are sketches for the great 'Comedie Humaine' . . . the artist is as brilliant a realist as Balzac, and the impressions of stage life which he transcribes

so wonderfully upon canvas are quite as remarkable in character as in art."[6]

Equally illuminating in Pène du Bois's remark is his selection of just five members of the original Eight: Henri, Luks, Sloan, Shinn, and Glackens.[7] This subgroup included some of the most prominent exponents of the aggressively urban art that emerged in and around New York soon after 1900, committed to topical subject matter and a vibrant, often graphically inspired figuration. All of these artists had either spent time in the great European cities or had been caught up in the "wave of realism" flowing from them, and all were now engaged in a similar celebration of their own metropolitan vistas. As Robert Henri wrote in 1907, "The skyscraper is beautiful. Its twenty stories swimming toward you are typical of all that America means, its every line is indicative of our virile young lustiness."[8] In this context the largely rural Impressionist repertoire that had inspired their elders—the light-flooded landscapes of John Twachtman and Childe Hassam, the sun-dappled nudes of Frederick Frieseke, and the domestic tranquilities of William Merritt Chase—now seemed redundant. Though it has been argued that the distinction between American Impressionism and the new urban Realism is often exaggerated, there is no doubt that "the repression of the city" in the earlier phase and its reliance on such European models as Monet, Renoir, and Pissarro, was emphatically reversed by Henri and his colleagues.[9] Instead, the young American painters turned back to what might be called the darker side of Impressionism, the dimly lit backstreets and nighttime entertainments already common to both Montmartre and Manhattan, the restless human dramas of "men like Manet, Degas, and Toulouse-Lautrec," and the graphic outpourings of their predecessors and followers, such as Daumier and Gavarni, Forain and Steinlen (with whom Pène du Bois briefly studied in 1905).

As with much else in the Ashcan story, a crucial conduit for the introduction of Degas's art into America was the personal example of Robert Henri. After studying in Philadelphia, Henri left in 1888 for the first of many sojourns in Europe, soon adding to his early enthrallment with Manet a more general enthusiasm for the new painting. Working in Paris and returning there frequently in the 1890s and early 1900s, Henri became as familiar with the city and its art as any of his American colleagues. By 1895 his interest in Degas had developed sufficiently for him to experiment briefly with a little known series of oil paintings of the

ballet, and we are told that he returned to teach in Philadelphia and New York armed with "photographs and postcards of Rodin, Degas, Manet, Van Gogh."[10] Around 1897, Henri was among the first American artists to see the Caillebotte bequest of Impressionist art installed in the Luxembourg Museum, a remarkable collection of still hotly debated drawings and paintings that included seven pictures by Degas from the 1870s: four dance or theater pastels, two intimate studies of female nudes, and one pastel over monotype of prostitutes in a café.[11] During his visit to the Luxembourg, we are told that Henri "approved of a Monet composition of St. Lazare Railroad Station, together with canvases by Manet, Degas, Sisley and Pissarro."[12]

On later trips to Paris, Henri enjoyed the company of the American expatriates Gertrude and Leo Stein, the latter celebrated for his oratorical defense of the "Big Four": Manet, Renoir, Degas, and Cézanne. According to Leo Stein, "Degas, the third of this quartet, is the most instinctively intellectual. Scarcely anything that he has done is inachieved. He is incomparably the greatest master of composition of our time, the greatest master probably of movement of line with a colossal feeling for form and superb color."[13] Henri too became a proselytizer for Degas's achievement, less through the example of his own painting than by bringing the attention of students and acquaintances to Degas's ideas, methods, and works of art. As a teacher at the Pennsylvania Academy of Art and, from 1902, at the New York School of Art, Henri had a direct impact on several of the younger Ashcan artists, many of whom "first heard the name of Daumier, Manet, Degas, and Goya issue forth from Henri's lips."[14] An unusually liberal educator, Henri was exceptional in his insistence that pupils should learn from the ancient as well as the recent past—by looking at everything from the Sphinx to "the truly decorative and significant work of the Indian"—yet with the explicit aim of fostering their own individuality.[15] Some of his precepts were also close to celebrated aphorisms of Degas's, perhaps picked up in the studio talk of Paris or derived from common sources. Henri noted, for example, "I have often thought of an art school where the model might hold a pose in one room and the work might be done in another," repeating in a similar form a remark attributed to Degas.[16] He also stressed that "it is well to remember that *line* practically does not exist in nature. It is a convention we use," echoing both Degas and the latter's own fount of wisdom, J. A. D. Ingres.[17] But Henri strongly

Fig. 3. Robert Henri (American, 1865–1929), *The Dancer,* ca. 1915, oil on paper, 20 × 12½ inches, private collection.

discouraged imitation ("Don't take me as an authority. You have to settle these matters for yourself."), and he demonstrated in his own work that it was possible to make paintings of American life that resist easy identification with European models, even in such seemingly nostalgic works as *The Dancer* (fig. 3).[18]

William Glackens, Henri's near contemporary and associate during much of this time, presents an intermediate case of artistic indebtedness. Glackens had painted with Henri in France in the 1890s and shared many of his passions and discoveries, evolving his own urban vocabulary that drew strength from both sides of the Atlantic. Studies of the cabaret, horse races, dancers, actresses in their dressing rooms, and trapeze artists all attest to a brash modernity and to a number of wholly or partially digested sources. As Glackens began to exhibit in New York, critics were quick to place him "in the footsteps of the men who were the rage in artistic Paris twenty years ago . . . Manet, Degas

and Monet," and by 1910, when Glackens had already begun his drift toward Renoir, Albert Gallatin could claim him as "a lineal descendant" of Degas and Manet: "But the great difference between Degas and Glackens is that where the former too often seeks for the ugly and repulsive . . . the latter looks only for what gaiety and humor he may discover in the scene."[19]

A well-known picture of this period by Glackens, *At Moquin's* of 1905 (fig. 4), reveals a pronounced ability to fuse his European experiences with a native subject (Moquin's was a New York restaurant), while exploring a vigorous, homegrown technique. Attempts to trace this composition to Degas's celebrated painting *In a Café (The Absinthe Drinker)* (Musée d'Orsay), however, introduce us to a further hazard of our investigation.[20] From the time of its completion in 1876 to the date of its acquisition by the Louvre in 1908 as part of the Camondo bequest, Degas's canvas was in a sequence of private collections in Britain and France, and it seems to have been neither exhibited nor reproduced in contexts where Glackens would have met with it.[21] *At Moquin's,* in other words, was almost certainly created without a knowledge of Degas's picture and presumably results from Glackens's awareness of other works by the artist or from contact with intermediate sources. Several of Glackens's images of this period find him similarly poised between complex referents: an *Outdoor Theater, Paris* of 1895 suggests the kind of magazine illustration that both Degas and Glackens respected; a *Dancer in Pink Dress* of 1902 recalls Whistler as much as Degas; and a painting of *Brighton Beach Race Track* is both unmistakably Degas-like and emphatically American.[22] It is said that Dr. Barnes, for whom Glackens acted as an agent (a 1912 letter from Paris tells us of "a fine Degas" he had acquired for the Philadelphia collector), linked Glackens's draftsmanship with "Goya, Daumier and Degas," while other commentators have compared his work to such diverse admirers of Degas as Carrière-Belleuse and Sickert.[23]

The question of firsthand contact between painters like Henri and Glackens and works of art by Degas in the galleries and museums of Paris deserves careful consideration. Before 1900 the only pictures by the artist on regular public view were those in the Caillebotte bequest, and it was not until a decade later that a further group of pastels and paintings from the Camondo collection were added to this modest total.[24] The state-sponsored retrospective of vanguard art had yet to be invented, and it was

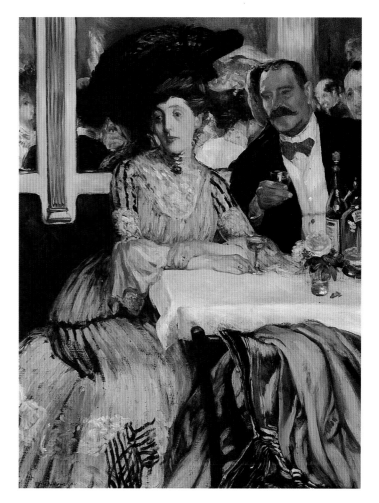

Fig. 4. William J. Glackens (American, 1870–1938), *At Moquin's,* 1905, oil on canvas, 48³⁄₁₆ × 36¼ inches, The Art Institute of Chicago, Friends of American Art Collection.

only by personal contact or fortunate timing that visiting artists discovered the products of their elders, among whom Degas was not the most approachable. Outside the city's institutions, works from earlier periods of Degas's career could occasionally be seen at commercial dealers in the rue Lafitte, the fabled "street of pictures" that had become the haunt of young artists in Paris.[25] Here, also, groups of recent paintings or works on paper might appear, as in the 1892 show of landscape monotypes at Durand-Ruel or the new series of nudes at the same gallery in 1896, as well as a scattering of objects at galleries such as Bernheim-Jeune, Boussod & Valadon, or Vollard.[26] Beyond these limited resources, access to the art of Degas and his Impressionist colleagues was limited in a way that is scarcely

imaginable today. In Degas's case, not a single mass-produced book, catalogue, or color reproduction was available when the first Ashcan artists made the trip to Europe.[27] Though a few black and white photographs, sparsely illustrated articles, and a limited number of prints by and after Degas were in circulation, his admirers had to wait until 1908 for the first cheap monograph on the artist with a substantial number of reproductions to appear.[28] Written by the critic Georges Grappe, it was followed in 1912 by a small but valuable volume (again illustrated in black and white) by Paul-André Lemoisne, who would eventually compile the catalogue raisonné of Degas's pictures.[29] Modest though these books were, their traces are detectable in the histories of the Ashcan circle, and there is reason to believe that they played a wider role in the dissemination of Degas's art to Europe, America, and beyond.

A painter from The Eight who certainly encountered Degas's output in a number of registers was Everett Shinn, arguably the most brazen of the Frenchman's followers in the United States. Shinn first worked as a graphic artist in Philadelphia and then moved in 1897 to New York, where he almost immediately launched his meteoric career. Within two years he was offered a one-man show at the Boussod & Valadon gallery on Fifth Avenue, exhibiting pastels and oil paintings of metropolitan subjects that already revealed the "extremely facile" manner acknowledged by his biographer.[30] After a second successful exhibition at the same gallery in 1900, Shinn left for a tour of several months in England and France, renting a studio in Montmartre—from which he watched Degas pass by—and hiring ballet dancers to pose for his quick-fire sketches.[31] While in Paris, he attracted enough attention for a group of his pastels to be shown at Goupil's, the dealer who had presented an important suite of pastels by Degas a decade earlier.[32] On his return to America, Shinn maintained these European links by presenting his pictures through the network of New York galleries with a Paris base: at Boussod & Valadon in 1901, Knoedler in 1903, Durand-Ruel in 1904, and Gimpel and Wildenstein in 1905. Many of his images from these years were frank adaptations of Degas's repertoire of the early Impressionist period, modified by Shinn's experiences of the theater and music hall in Paris or transposed to the auditoriums of Broadway and including such unlocalized hybrids as *Concert Stage* of 1905 (fig. 1). The works in Shinn's 1901 exhibition read uncomfortably like an

act of homage to his European master: studies from the world of dance, such as *Grand Ballet* and *Behind the Scenes;* themes already inseparable from Degas's reputation, like *Blanchisseuse* and *The Milliner's Shop;* and titles that point to Shinn's admiration for Degas's immediate successors, such as *Back Row, Folies Bergères, The Gaieté Montmartre,* and *Madame L........ of the "Chatelet."*[33] The same year Shinn excelled by painting a picture entitled *Robert le Diable,* borrowing both subject and title from one of Degas's most celebrated early canvases.[34]

A number of factors conspired to heighten Shinn's affinity with Degas's art. Initially, his graphic facility and his experience as an illustrator and pastellist may have propelled him toward what the contemporary American writer James Huneker called "the name of Degas, the pastels of Degas, the miraculous draftsmanship of Degas."[35] Shinn studied at the Pennsylvania Academy, met Robert Henri, and was soon on the receiving end of Henri's wise counsel and his European experience, and presumably his legendary sets of postcards. It was also during this phase that Shinn's energetic involvement with the theater began, both as amateur actor and producer and as a recorder of its backstage turmoil and public spectacle. These ties were evidently strengthened during his brief acquaintance with Paris, where he absorbed not just the work of the senior Impressionists, but that of their younger progeny in the studios and illustrated journals of the French capital. Shinn and his peers would first have come across a number of Degas's characteristic motifs in the work of his followers and associates—in such vicarious forms as the prints of Jean-Louis Forain and Paul Renouard, the paintings of Georges Jeanniot and Jean-François Raffaëlli, the illustrations of Théophile Steinlen, and the multifarious outpourings of Toulouse-Lautrec. New York critics noted Shinn's borrowings from such artists while recognizing his principal adherence: in 1907, Gallatin accepted that Shinn had "learned to see things from Degas's point of view" and that it was from Degas that "he has learned to draw," while Shinn himself claimed that Degas was "the greatest painter France ever turned out."[36]

Shinn's *The Orchestra Pit, Old Procter's Fifth Avenue Theater* of 1906–07 (fig. 5) illuminates both the strengths and weaknesses of his position, as well as the difficulties of negotiating with such a formidable predecessor. Here we see Shinn rising to the challenge of "the greatest master of composition of our time," animating his own canvas with the bold forms, plunging

Fig. 5. Everett Shinn (American, 1876–1953), *The Orchestra Pit, Old Procter's Fifth Avenue Theatre*, 1906–07, oil on canvas, 17⁷⁄₁₆ × 19½ inches, collection of Mr. and Mrs. Arthur G. Altschul.

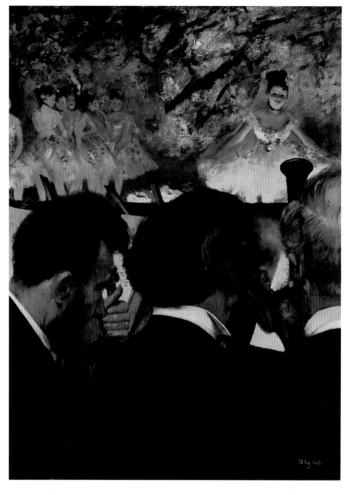

Fig. 6. Edgar Degas, *Orchestra Musicians*, ca. 1870–71, reworked ca. 1874, oil on canvas, 27⅛ × 19¼ inches, Städtische Galerie im Städelschen Kunstinstitut, Frankfurt.

perspectives, and teasing pictorial relationships that so excited him in Degas's work. Openly adopting one of Degas's characteristic theatrical structures—though transposing it from Paris to New York—Shinn seems determined to compete on the older artist's terms and to take his manner to even greater extremes. In Shinn's picture the exaggerated forms of the conductor and curtain almost obliterate the action, as if the artist's visual invention is more significant than the scene it might have enlivened. So blatant is his rivalry that it can be traced to a precise cluster of Degas's canvases, which by this date were already at least thirty years old. If the Musée d'Orsay's *Orchestra of the Opéra* seems the most obvious candidate, we must again note that this work was in private hands throughout the period and was almost certainly unknown in any form to Shinn.[37] A more plausible and ultimately persuasive model is *Orchestra Musicians* (fig. 6), which was included in the *Carnegie International Annual Exhibition* in Pittsburgh in 1900 and was apparently also shown in New York around 1901 at the Durand-Ruel gallery (fig. 7) in precisely the space where Shinn was to exhibit many of his own dance and theater pictures three years later.[38] The looming foreground figures in Degas's canvas were a truly startling invention,

and it is hardly surprising to discover that several artists from the circle of The Eight responded variously to this same composition.[39] But although the vivacity of the thirty-year-old Shinn's picture is undeniable, it set the pattern for hundreds of superficially derivative works produced as late as the 1940s in the intervals of a busy and sometimes scandalous life as a muralist, movie designer, society portraitist, and decorator.

The examples of Henri, Glackens, and Shinn stand for a range of responses to European models, followed in their different and sometimes idiosyncratic ways by other painters in the Ashcan orbit. Younger than all three, Guy Pène du Bois established his inimitable style almost from the beginning, his confident pictures of café and street encounters largely concealing his indebtedness

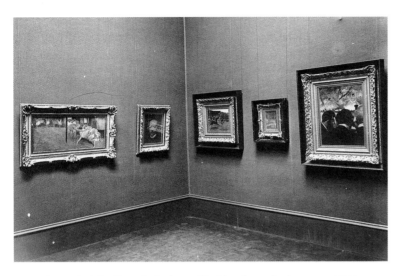

Fig. 7. At right, Degas's *Orchestra Musicians* hangs in the 1901 exhibition at the Durand-Ruel gallery in New York, Archives Durand-Ruel, Paris.

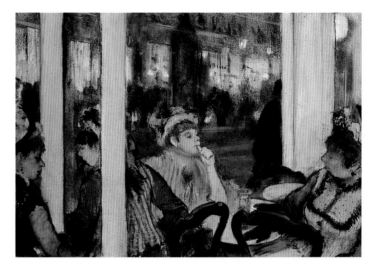

Fig. 8. Edgar Degas, *Women on the Terrace of a Café in the Evening*, 1877, pastel on monotype on paper, 16⅛ × 23⅜ inches, Musée d'Orsay, Paris.

to precursors and contemporaries alike. Pène du Bois's French ancestry and years spent in Paris are often manifest, however, in picture titles and boulevard settings, and in a formal vocabulary that—though integrated into his own elliptical manner—can at times be traced back to Degas. Often choosing to depict his figures from behind or in social spaces divided by largely unexplained vertical accents, Pène du Bois more than once recalls the structure of Degas's *Women on the Terrace of a Café in the Evening* (fig. 8), a picture in the Caillebotte bequest that had already been much reproduced in articles and books such as Lemoisne's of 1912.[40] Pène du Bois's 1919 painting *Social Register* (fig. 9) also makes self-conscious play with the notoriously high viewpoints and areas of empty floor in Degas's work, perhaps combining memories of the latter's audaciously conceived male portraits—such as his *Diego Martelli* (National Gallery of Scotland)—with the bird's-eye view of another Caillebotte bequest picture, *La Toilette* (Musée d'Orsay).[41] And a Pène du Bois canvas of 1926, *Morning Café, Paris* (Whitney Museum of American Art, New York), might finally be regarded as a plausible gesture toward Degas's *In a Café (The Absinthe Drinker)*, a work from the Camondo bequest that was by this date displayed in the Louvre and widely known through illustrations. Above all, perhaps, it was Pène du Bois's detached irony and his fascination with human posturing and pretense, rather than any compositional dependence, that brought him closest to his distant compatriot.

Maurice Sterne's story could hardly be more different. Born in Russia in 1878, he moved to New York with his family and received his first art education at the National Academy of Design. Like Shinn he excelled as a youthful draftsman, but Sterne was equally attracted by the old masters he came across in the Metropolitan Museum and by his first taste of progressive painters such as Whistler and Manet. When he won a traveling scholarship in 1904, Sterne embarked for Europe and the delights of student life in Paris, rapidly digesting the legacy of Impressionism and discovering the work of "a comparatively obscure painter called Paul Cézanne."[42] Initially, however, his reverence for draftsmanship and for the art of the past still dominated, and Sterne recalls that at this time Degas was "the painter I held in the highest esteem."[43] His devotion to Degas is vividly apparent in *Entrance of the Ballet* (fig. 10), an unforgettable—almost alarming—juxtaposition of two phases of the Frenchman's art. The near-monochromatic palette of Degas's early theater paintings provides the setting for a blaze of quasi-Symbolist color, hinting that Sterne may have already made contact in the rue Lafitte with the chromatically strident pastels of his later years. Sterne continued to find himself pulled in many directions, planning (presumably metaphorically) "to spend all the time I could in the Louvre with Degas" and undertaking a copy of Mantegna's *Parnassus* (Louvre), a work of particular importance to Degas at this time.[44] Not only had Degas recommended a companion picture by Mantegna to another copyist some seven or eight years

earlier, but had himself executed a broad study of the painting at the same moment.

During one of his attempts to understand the Cézannes at the 1905 Salon d'Automne, Sterne tells us that he "found two elderly gentlemen intently studying the paintings. One, who looked like an ascetic Burmese monk with thick spectacles, was pointing out passages to his companion, murmuring 'magnificent, excellent.' . . . I wondered who he could be—probably some poor painter, to judge by his shabby old cape. . . . I was shocked and astonished when I learned that the man in the cape was Degas."[45] Sterne immediately turned back with more respect to the Cézanne paintings, eventually acknowledging that "I had not really seen them" and appropriating something of their complex artifice into his brash mature style.[46] Along with Henri and other American visitors to Paris, Sterne also moved in the circle of the Steins, sharing their passion for the work of older and younger artists at Vollard's gallery and experimenting with a range of styles and media. Frequenting the company of Maillol and Rodin, he joined the ranks of the many painter-sculptors in

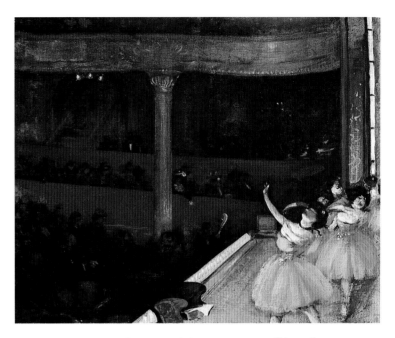

Fig. 10. Maurice Sterne (American, 1878–1957), *Entrance of the Ballet,* ca. 1904, oil on canvas, 26 × 32½ inches, The Detroit Institute of Arts, gift of Ralph Haman Booth.

Fig. 9. Guy Pène du Bois (American, 1884–1958), *Social Register,* 1919, oil on canvas, 20 × 14 inches, The Forbes Magazine Collection, New York.

the city (among whom Degas was already numbered, if largely by reputation), making wax models and later monuments of considerable size and ambition.[47] Further stimulus came from the art of Gauguin, leading to travels in India, Java, and Bali and to pictures that merge a somewhat stylized cubism with the exotic East and fauve color with memories of academic line. His apprenticeship with Degas had been brief, and neither the latter's imagery nor his celebrated restraint left its mark on Sterne's unusually diverse output. But like many painters of his generation, Sterne retained an interest in dance in its many forms, attaching himself for a while to the Isadora Duncan School of Dancing at Tarrytown, New York, and carrying out a number of spirited drawings of the "Isadorables" in action.[48]

The two artists from the Ashcan milieu who most deeply assimilated Degas's art may, paradoxically, have been the two who seem the most uncompromisingly American: John Sloan and Edward Hopper. With both individuals, the operations of influence appear to bypass the obvious channels as well as the most blatant excesses: neither Sloan nor Hopper presumed to become a painter of Parisian high or low life, nor did they affect Degas's practical techniques and stylistic flourishes. To a considerable extent, they also avoided direct quotation from his

Fig. 11. John Sloan (American, 1871–1951), *Kitchen and Bath*, 1912, oil on canvas, 24 × 20 inches, Whitney Museum of American Art, New York, gift of Mr. and Mrs. Albert Hackett.

work or concealed their admiration so thoroughly that only their most astute peers and later cataloguers have detected it. Sloan's is perhaps the extreme case, remote from that of Degas in almost every circumstance of geography, birth, and principle. Unlike many of the group, he did not travel to Paris and was apparently unashamed of the fact: in his 1925 book on the artist, Albert Gallatin announced that "Sloan has never been to Europe and has no wish to go."[49] As instinctively radical as Degas was conservative, Sloan extended his artistic engagement with working class New York to participation in Socialist politics, producing a number of illustrations for such magazines as *The Call* and *The Masses*. Yet, as early as 1927, Hopper would write that "Sloan's design is the simple and unobtrusive tool of his visual reaction. It attempts tenaciously and ever the surprise and unbalance of nature, as did that of Degas."[50]

Sloan shared a number of seminal experiences with friends

among The Eight, spending time as a working illustrator and then as an art student in Philadelphia, enjoying the friendship of Robert Henri, familiarizing himself with European literature, and developing a fascination with prints and printmaking. Recalling this phase in his book *Gist of Art,* Sloan noted, "It was Robert Henri who brought me some Daumier lithographs and also a set of Goya aquatints. . . . Steinlen in *Le Rire* was great in those days, so was Forain."[51] As a teenager in Philadelphia he also read *Modern Painting,* an unillustrated collection of essays on contemporary French art by the Irish novelist George Moore, who had met Degas and mentioned in his text the artist's drawings of "The Ballet Girl, the Washerwoman, the Fat Housewife," adding, in a way that may have appealed to Sloan, "in Degas there is an extraordinary acute criticism of life."[52] Settling in New York in 1904, Sloan continued to make money from his pen, producing illustrations in a variety of styles for a number of publications, including novels recently translated from the French.[53] He used his newly discovered delight in paint to depict the city's poorest streets and housing, specializing in unsentimental views of shops and humble apartments, impromptu gatherings, and scenes of men and women at work. At his best he combined a good-humored concern for his models with the strong, simple design noted by Hopper, along with an informed awareness of other current painting. A picture like *Kitchen and Bath* of 1912 (fig. 11), for example, firmly asserts its place in the tradition of the modern domestic bather, while leaving us in no doubt of its roots beside the Hudson rather than the Seine.

Kitchen and Bath is the product of a mature sensibility, displaying none of the easy eclecticism of certain works by Shinn, Glackens, or Sterne. Yet the powerful form of the bathing figure seems distinctly familiar, and we find ourselves searching for precedents among artists Sloan is known to have admired. For some years, as we have seen, subjects like "Women at their toilette" and Moore's "Fat Housewife" (in reality, a study of a nude beside her bed) had begun to contribute to Degas's often scandalous reputation, now drawing attention to the artist's output in the 1880s rather than to earlier decades. A series of exhibitions in Paris from 1886 onward had featured Degas's recent pictures of bathers in, on, or next to their tubs, some of which had been acquired by courageous American collectors.[54] At least one of these, *After the Bath* (fig. 12), a pastel that remained with the Durand-Ruel family throughout the period and was repro-

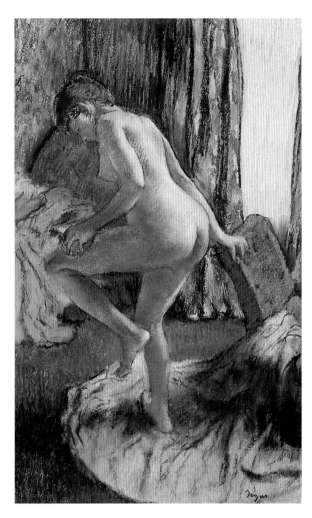

Fig. 12. Edgar Degas, *After the Bath*, 1883–84, pastel on paper, 20½ × 12⅝ inches, private collection.

Fig. 13. John Sloan (American, 1871–1951), *Roof Gossips*, 1913, oil on canvas, 20 × 24 inches, Arizona State University Art Museum, Tempe, gift of Oliver B. James.

duced in such volumes as Grappe's and Lemoisne's, could have provided the visual stimulus for Sloan's painting, while a closely related study belonging to the Havemeyers offered an even more precise model for pose and setting.[55] Both these images capitalize on the angularity of the arms, legs, and torso of the model, and the figure in the latter explicitly perches on her bathtub, just as in Sloan's picture. Whatever his source, however, Sloan has made the bather forcefully his own, clothing her in a suitably chaste shift and emphasizing her grim tenement surroundings, while making few concessions to the limpid light and color of its European precursors. Already mature enough as an artist to have rethought the subject and reimagined it from his own experience, Sloan acknowledged the engagement with human behavior and bodily action that was so fundamental to Degas's art.

That Sloan sustained his interest in Degas's pictures we can deduce from accounts of his friendship with John Butler Yeats, the father of the Irish poet, who was "continually telling Sloan that he 'must not miss' this or that, the Degas at the American Art Galleries, the Monets at Knoedler's," and from other broad affinities between their imagery.[56] Depictions of the opposite sex in intimate moments preoccupied both men, some of Degas's most characteristic themes finding entirely new, emphatically American equivalents in Sloan's *Women Drying Their Hair* (Addison Gallery of American Art) of 1912, *The Cot* (Bowdoin College Museum of Art, Brunswick, Maine) of 1907, and *Hairdresser's Window* (Wadsworth Atheneum Museum of Art) of 1907. Dance in various modern guises also earned its place in Sloan's affections, from his *Isadora Duncan* (Milwaukee Art Center) of 1912 to the *Dancing Nude, Miss Emerson* (John Sloan Trust, Delaware Art Museum, Wilmington) of 1916. In both these works, Sloan largely avoided the compositional clichés that dogged the theatrical scenes of his day—many of them ultimately derived from Degas and his coterie—and generated bolder, less cluttered spaces appropriate to his twentieth-century performers. In *Roof Gossips* (fig. 13), we see another ingenious transposition in which the memory of one of Degas's many

toilette images hovers behind a bold composition that is unmistakably Sloan's. Here again it is possible to point to historical precedents in a lithographic print after a Degas coiffure group in circulation since 1888 and in the pastel *Woman Combing Her Hair* (ca. 1892–96, Private Collection), which was shown in the 1901 Durand-Ruel exhibition of Degas's work in New York.[57] But in each of these cases, Sloan contrives to balance lessons learned with a fresh pictorial solution, a drive toward documentation with his own pictorial energy. As Gallatin pointed out, "if Sloan is an illustrator, if the subject of his picture is scarcely subsidiary to its plastic form, this is only one element in his art, as it was in the illustrative paintings and drawings of Rembrandt, Daumier and Degas."[58]

In later life Edward Hopper was at pains to separate himself and his work from "the so-called 'Ash Can School' with which my name has at times been erroneously associated," yet he studied with several of its members, befriended and admired figures like Pène du Bois and Sloan, and showed his work with other former pupils of Henri just days after the exhibition of The Eight in 1908.[59] He too began as a student of illustration and transferred to the painting class taught by Henri, whose love of all things French stirred a sympathetic response in the bookish young man from Nyack, New York. Soon Hopper was reading French Realist and Symbolist literature, developing a taste for Manet and Millet, and making his first pictures of nocturnal urban events and entertainments. His attitude toward Degas at this date is not recorded, so we must turn to these relatively unknown early pictures in search of clues. If his *Ballerina* of 1900 (fig. 2) shows little acquaintance with the Frenchman's work, *Nude Crawling into Bed* (Whitney Museum of American Art, New York) of 1903–05 has many features in common with monotypes and pastels by Degas that Hopper may conceivably have known first- or secondhand.[60] More immediately recognizable is the dark foreground and high illuminated stage of *Group of Musicians in an Orchestra Pit* of 1904–06 (fig. 14), another work from the Henri milieu that must derive in some way from Degas's theater paintings of the early 1870s.

In her authoritative studies of Hopper's oeuvre, Gail Levin has set out a detailed and largely persuasive case for the influence of Degas on a number of Hopper's mature compositions, quoting both visual sources and his known respect for the artist: in a late interview, after noting his taste for Rembrandt and the

French printmaker Meryon, the famously reticent Hopper added, "I also like Degas very much."[61] With certain of Levin's proposed models, however, there are the same practical doubts about their accessibility in Hopper's early years that we have experienced in studying Glackens, Shinn, and Sloan. The suggestion that Hopper's *Group of Musicians in an Orchestra Pit,* for example, was inspired by the Musée d'Orsay's *Orchestra of the Opéra* does not take account of the latter's obscurity at this period, and we must again turn to the demonstrably available Frankfurt picture (fig. 6).[62] After 1906, when Hopper made the first of several visits to Paris, the situation necessarily changed, as we find him visiting museums and commercial galleries, admiring the graphic work of Steinlen and Forain, and briefly "painting under the influence of Impressionism," to use his own words.[63] But even at this date, he was too single-minded to imitate the art of his seniors for long, beginning instead to relive with caution the life of the French artists he admired: "I used to go to the café at

Fig. 14. Edward Hopper (American, 1882–1967), *Group of Musicians in an Orchestra Pit,* ca. 1904–06, oil on canvas, 15¼ × 12 inches, Whitney Museum of American Art, New York, Josephine N. Hopper Bequest.

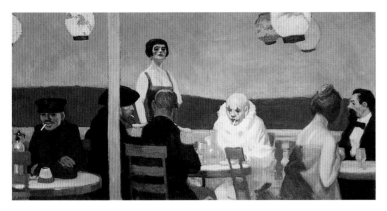

Fig. 15. Edward Hopper (American, 1882–1967), *Soir Bleu*, 1914, oil on canvas, 36 × 72 inches, Whitney Museum of American Art, New York, Josephine N. Hopper Bequest.

Fig. 16. Edward Hopper (American, 1882–1967), *New York Interior*, ca. 1921, oil on canvas, 24¼ × 29¼ inches, Whitney Museum of American Art, New York, Josephine N. Hopper Bequest.

night and sit and watch. I went to the theater a little."[64] Hopper's Paris-based pictures of these years, whether created in France or from recollection in America, already show a sophisticated grasp of the unexpected viewpoints, the visual croppings, and the stark placement of figures characteristic of Degas's earlier manner, while remaining free from the easy pastiche that had bedeviled some of his other young admirers.

For more than a decade after his return to the United States, Hopper clung stubbornly to French themes and to his high-value palette, running counter to the American emphasis of his generation and probably suffering professionally as a result.[65] In the absence of sales he was obliged to earn a living as a magazine and advertising illustrator, until discovering a market for his etchings and watercolors in the early 1920s. Levin argues that many of Hopper's illustrations are "related compositionally to the art of American expatriate James McNeill Whistler, Edgar Degas, and the other French Impressionists who had been influenced by Japanese prints," citing in particular the tilting perspectives and rectilinear commercial interiors of certain of Degas's paintings.[66] By this date Hopper had certainly acquired a basic fluency in Degas's art, presumably enhanced over the years at the 1915 Suffrage Exhibition at Knoedler's and by Hopper's documented visit to the 1916 Degas show at Durand-Ruel in New York, as well as by books he had seen and read.[67] Some of the canvases specified by Levin, such as *The Cotton Office* (Musée des Beaux-Arts, Pau) and *The Interior* (page 21, fig. 7), were not in these exhibitions and were not available to him in the original, but Hopper could conceivably have known both through the

small black and white reproductions in Grappe and Lemoisne.[68] But some of the other works used in Levin's analysis, among them *Mary Cassatt at the Louvre* (cats. 15, 16, 17) and *The Bellelli Family* (see cat. 9), were either incarcerated in Degas's studio or in his dealer's Paris vaults until the artist's death in 1917 and were effectively unknown to the general public.[69] More appropriate, surely, is the sense that Hopper had so thoroughly grasped the character of Degas's art that he was able to create alongside, rather than in subjection to, his predecessor. Certain continuing motifs—such as the picture within a picture—may echo Degas or other sources, but it was Hopper's personal identification with Degas's fractured spaces, unexpected viewpoints, and "use of physical distance to express psychic tension," as Levin so effectively describes it, that is finally more telling.[70]

In this broader sense, Degas is nowhere and everywhere in Hopper's formative work. Hopper's remarkable *Soir Bleu* (fig. 15), painted in New York but unashamedly nostalgic for the Parisian life that lingered in his memory and his reading, already has his own personality stamped upon it. Beneath its subtly syncopated composition, the cluttered tables and abrupt verticals of Degas's *Women on the Terrace of a Café in the Evening* (fig. 8) in the Caillebotte collection may well lurk, merged seamlessly

with the aesthetic of a new century. In *New York Interior* (fig. 16), the scene changes to the American metropolis, a move that was to characterize and ultimately benefit the mature Hopper. Here we peer past dark framing devices into a private space, where a young woman with her back toward us calmly attends to her domestic needs beside a fireplace. All these elements can be found in Degas's toilette pictures, and Hopper seems to tease us further by arranging the girl's sewing into a tutu-like haze around her body. Yet the subject and the handling are entirely Hopper's, and the majority—if not the entirety—of those who first saw the picture may have been oblivious to his solemn playfulness. Later paintings of restaurants, theaters, offices, and solitary nudes in motel bedrooms are equally infused with Hopper's affection for his European hero, a sentiment given pointed form in a wedding gift from his wife, who in 1924 presented him with Jamot's recently published monograph on Degas.[71] Although much of Hopper's later landscape-based output seems remote from the world of Degas, there can be no doubt that the now celebrated American painter persisted in his youthful reverence. Among his last pictures were studies of nudes and of the stage, and a friend of his final years tells us that "the only reproduction in either of the Hopper houses was a Degas nude in the bedroom at Truro."[72]

A brief coda to this study concerns the changed appreciation of Degas's work that followed the great sales of his studio contents soon after the artist's death in 1917. The many hundreds of drawings, prints, pastels, and paintings hoarded in Degas's Montmartre apartment not only became available in a series of profusely illustrated sale catalogues, but found themselves dramatically dispersed among the dealers, collectors, and museums of Europe, America, and elsewhere.[73] For the first time, painters and others could see the full range of Degas's later output with its shift of emphasis toward what Stein had perceptively called his "colossal feeling for form and superb color" and toward repeated images and studio-derived figure compositions. Prominent among the latter were entire sequences of bathing nudes from the 1890s that had never seen the light of day and were soon to become familiar sights in exhibitions and a flood of new publications. It is surely not coincidental, therefore, to find several of the former Ashcan artists turning back in the 1920s to the study of the nude, producing countless variations on the bather, the toilette, and the faintly risqué bedroom

scene, sometimes using pastel and often filling their compositions with the bold limbs and heavy torsos of "the greatest master of composition."[74] There is poignancy here, in the discovery by these aging American painters of the art of Degas's own later years, bringing them face to face with the work he was producing when they had been young and fearless in New York. Unknown to them at the time, these extraordinary statements of mortality were now perhaps closer to their own immediate concerns, as they too looked back on "the wave of realism" that had given buoyancy to their youth.

NOTES

I am much indebted Jim Totis, David A. Brenneman, Jill De Vonyar, and Linda Merrill for readings of my manuscript.

1. For a detailed discussion of this subject, see Kendall 1996, pp. 13–29, 31–55, 159–71.
2. Levin, *Biography*, 1995, p. 75.
3. Rewald 1989. The principal exception is Gail Levin's pioneering examination of Degas's influence on Edward Hopper: Levin 1979; Levin, *Biography*, 1995; Levin, *Catalogue Raisonné*, 1995.
4. Pène du Bois 1931, p. 12.
5. Kendall 1996, p. 125.
6. Pauline King, "A Review of Impressionism," *The House Beautiful: The American Authority on Household Art,* December 1899, pp. 5–6.
7. The remaining three artists who exhibited in 1908—Arthur B. Davies, Maurice B. Prendergast, and Ernest Lawson—emphasized landscape or the more decorative and fanciful elements of their surroundings.
8. Robert Henri in the *New York Sun* (May 15, 1907), quoted in Homer 1969, p. 131.
9. See Weinberg, Bolger, and Curry 1994, pp. 1–13; Gaehtgens and Ickstat 1992, p. 325.
10. Homer 1969, pp. 174, 214.
11. Lemoisne 419, 420, 422, 491, 547, 605, and 658.
12. Perlman 1991, p. 35.
13. Rewald 1989, p. 64.
14. Perlman 1988, p. 93.
15. Henri 1984, p. 128.
16. Ibid., p. 29. Degas's remark is recorded in Hertz 1920, p. 23.
17. Henri 1984, p. 113. For Degas's related statements, see Valéry 1960, pp. 70, 82.
18. Henri 1984, p. 129.
19. Gerdts 1996, pp. 54, 85.
20. Ibid., p. 54; Perlman 1988, p. 105.
21. For a detailed provenance, see Boggs et al. 1988, p. 288.
22. Gerdts 1996, plates 18, 38, 46.
23. Ibid., p. 50; Glackens 1957, pp. 49, 159.
24. For pictures in the Camondo collection, see Loyrette 1991, pp. 605–06.
25. See Kendall 1996, pp. 31–55, 159–71, especially pp. 41–45.
26. Ibid., p. 44.
27. The only significant exceptions were William Thornley's colored lithographic copies of Degas's work exhibited at Boussod & Valadon in 1888 and the sumptuous volume of facsimile drawings, *Degas: vingt dessins, 1861–1896,* masterminded by Michel Manzi in 1898; see Kendall 1996, pp. 41, 50–51.

28. In contrast to standard practice, Degas did not create multiple prints from most of his plates and made few efforts to sell, exhibit, or circulate them, so their importance in spreading his imagery is slight.

29. Grappe 1908; Lemoisne 1912.

30. DeShazo 1974, p. 155.

31. Perlman 1988, pp. 81–82.

32. For Shinn's Paris exhibition, see DeShazo 1974, p. 203. Degas's exhibition at Boussod & Valadon (formerly Goupil's) in Paris is mentioned in Kendall 1996, p. 41.

33. The works in this exhibition are listed in DeShazo 1974, p. 44.

34. Referred to in American Academy of Arts and Letters 1965, no. 51. Degas's 1876 painting *The Ballet from "Robert le Diable"* had attracted attention when it entered the Ionides collection in London in 1881 and again when the owner presented it to the Victoria and Albert Museum in 1900, making it the first work by the artist to enter a museum in Britain; see Boggs et al. 1988, pp. 269–70.

35. Huneker 1910, p. 78. It is also possible that Shinn encountered Degas's work as one of the contemporary painters invited to the home of the Havemeyers.

36. Quoted in Gerdts et al. 1992, pp. 98–99 and Perlman 1988, p. 81.

37. The link between the works is made in Weinberg, Bolger, and Curry 1994, p. 217. A full provenance is in Boggs et al. 1988, pp. 161–62.

38. Photographs of this exhibition in the Durand-Ruel archives are clearly marked 1901, which is consistent with the known histories of the pictures on show, but this date has proved difficult to corroborate. For Shinn's theater pictures, see Linda S. Ferber, "Stagestruck: The Theater Subjects of Everett Shinn," in Bolger and Cikovsky 1990, pp. 51–67.

39. See, for example, Hopper's *Group of Musicians in an Orchestra Pit,* discussed below, and stage scenes by Luks, Glackens, and Sloan.

40. Lemoisne 1912, plate 29. Examples of Degas-like devices or subjects can be found in Cortissoz 1931, pp. 19, 33, 35, 37, 55, and 57.

41. Lemoisne 547, Janis 191.

42. Mayerson 1965, p. 42.

43. Ibid., p. 44.

44. Birnbaum 1919, p. 43. Degas's late interest in Mantegna is considered in Kendall 1996, pp. 112–13.

45. Mayerson 1965, p. 44.

46. Ibid., p. 44.

47. Ibid., pp. 106–09.

48. Ibid., pp. 158–59, 162.

49. Gallatin 1925, p. 12.

50. Quoted in Levin 1979, p. 36.

51. Sloan 1939, p. 1.

52. Moore 1898, pp. 28–29. Sloan's awareness of Moore's book is recorded in Brooks 1955, p. 10. The familiarity of Henri's circle with an earlier Moore volume, *Confessions of a Young Man* (1888), which includes more extensive material on the author's acquaintance with Degas and his art, is mentioned in Perlman 1988, p. 45.

53. Unlike Hopper's illustrations, the bewildering range of hybrid styles in Sloan's graphic output reveals almost no coherent response to the motifs of contemporary painting; see Hawkes 1993, where his illustrations for several novels by De Kock are reproduced.

54. See Kendall 1996, pp. 41, 44, 143.

55. The history of *After the Bath* and related works is discussed in Boggs et al. 1988, pp. 421–24. The picture was reproduced in Grappe 1908 as an unnumbered plate and in Lemoisne 1912 as plate 42. The Havemeyer pastel *The Bath* (Metropolitan Museum of Art) is Lemoisne 1406.

56. Brooks 1955, p. 120.

57. The print was from the 1888 suite by William Thornley and represented *Nude Woman Having Her Hair Combed,* Lemoisne 847. The work shown in New York was Lemoisne 1129.

58. Gallatin 1925, p. 12.

59. Levin, *Biography,* 1995, pp. 74, 138.

60. For *Nude Crawling into Bed,* see Levin, *Catalogue Raisonné,* 1995, no. O-60. A comparable image is represented among Degas's monotypes by the two versions of *Le Coucher* (Janis 129–130). Though at least one of these works was still in Degas's possession at the time of his death, some other monotypes—especially those worked in pastel—were in circulation during his lifetime and a few had been illustrated.

61. Quoted in Kuh 1962, p. 135.

62. For the suggested link between the two pictures, see Levin, *Catalogue Raisonné,* 1995, pp. 44–45.

63. Levin, *Biography,* 1995, p. 67. At this time, Hopper also produced caricatures of Paris street "types" in a somewhat Forain- or Steinlen-like manner; see Levin, *Catalogue Raisonné,* 1995, nos. W-26–W-58.

64. Quoted in O'Doherty 1973, p. 16.

65. See Levin, *Biography,* 1995, pp. 75, 87, 94.

66. Levin 1979, p. 17.

67. Levin, *Biography,* 1995, p. 109. For the 1915 exhibition, see Rebecca Rabinow, "The Suffrage Exhibition of 1915," in Freylinghuysen et al. 1993.

68. Provenances for both works can be found in Boggs et al. 1988, pp. 146, 188. Some of Levin's references to their links with Hopper can be found in Levin 1979, p. 20; and Levin, *Catalogue Raisonné,* 1995, p. 55 and no. O-312.

69. Details of their histories can be found in Boggs et al. 1988, pp. 82, 322. Some etchings related to the latter image were apparently released by the artist.

70. Levin 1979, p. 21.

71. Levin, *Biography,* 1995, p. 183. Hopper also acquired a copy of the catalogue for the 1928 Durand-Ruel Degas exhibition: see Levin, *Catalogue Raisonné,* 1995, no. O-285.

72. Quoted in O'Doherty 1973, p. 23.

73. See *Vente* 1989.

74. Such works are principally found, often in large numbers, in the varied output of this period by Glackens, Shinn, Sloan, and Sterne.

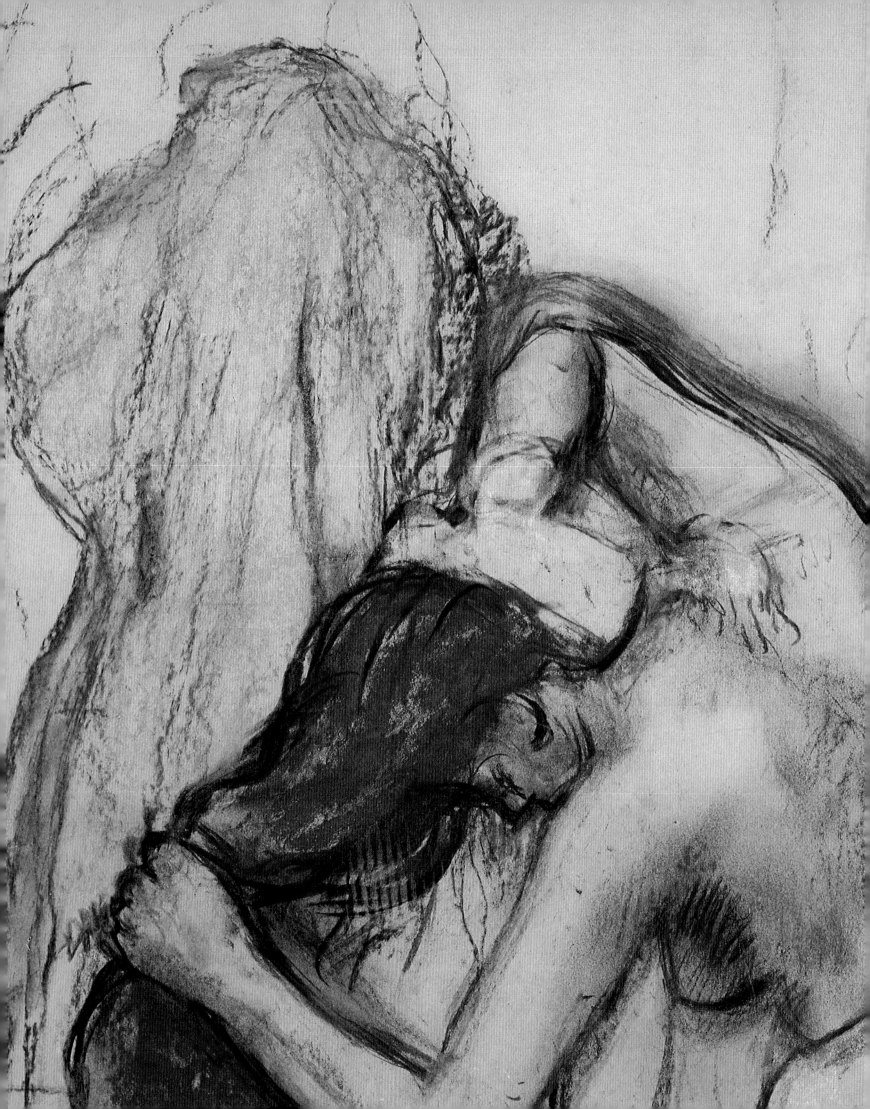

Degas: The Sculptures

Valerie J. Fletcher

UNLIKE HIS PAINTINGS, the sculptures of Edgar Degas were little known during his lifetime. He refused to include any of them in exhibitions, except *Little Dancer of Fourteen Years* (cats. 78, 79). Reclusive by nature, Degas admitted few visitors to his studio, so only selected colleagues actually saw the sculptures prior to the artist's death in 1917. Joseph Durand-Ruel, son of the gallery's founder, noted in 1919 that Degas "spent a good deal of time, not only in the later years of his life but for the past fifty years, in modeling clay. Thus, as far as I can remember—that is to say, perhaps forty years—whenever I called on Degas I was almost as sure to find him modeling in clay as in painting."[1]

The sculptures comprise the same subjects, even identical poses and gestures, found in some of his paintings and prints. Degas seems to have begun working in three-dimensional art as a means of developing his mastery of form in painting, but he gradually became interested in sculpting for its own sake. Evidence from several models who posed for Degas suggests that he focused more on sculpture after 1900, when his eyesight worsened. He apparently ceased working altogether around 1911, after moving into smaller lodgings.

Because of the artist's habit of revising works over many years and his refusal to exhibit the sculptures, experts disagree over their precise dating.[2] Degas never considered his sculptures finished and never cast them in bronze. He told the art dealer Ambroise Vollard that it was a "tremendous responsibility to leave anything behind in bronze—that medium is for eternity."[3] He also told Vollard that "my pleasure consists in beginning over and over again," and he demonstrated by reducing a sculpture to a blob of raw material.[4] Even when approached by

the American collector Louisine Havemeyer in 1903, Degas refused to sell the *Little Dancer* wax.

The total number of Degas's sculptures is not known. About 150 were found in his studio and lodgings after his death; all had deteriorated to some degree. Durand-Ruel described the initial inventory: "Most of them were in pieces, some were almost reduced to dust. We put apart all those that we thought might be seen, which was about one hundred, and we made an inventory of them. Out of these, thirty are about valueless; thirty badly broken up and very sketchy; the remaining thirty are quite fine."[5]

Although thoroughly grounded in traditional painting techniques, Degas had never received technical training in sculpture. Working alone, he used an improvisational method of construction that contributed to the sculptures' deterioration over the years. The originals consisted mostly of wax, sometimes over or mixed with clay or plasticine, which Degas attempted to strengthen by adding household objects (ranging from knitting needles and paintbrushes to cork and candle wick) and external wire armatures.[6] Degas's heirs decided to have many restored, so that seventy-four could be cast into bronze. Mary Cassatt and others who knew of the artist's beliefs disapproved of this decision.[7] Each model was identified by numbers one through seventy-two (apparently the sequence in which they were chosen for casting), plus two unnumbered ones (including the *Little Dancer*). Each was assigned a descriptive title; Degas himself had not named any of his sculptures except the *Little Dancer*.

The Degas family entrusted the works to the Adrien Hébrard foundry (fig. 1). Albert Bartholomé, a sculptor and friend of Degas, restored the fragile waxes, removed the armatures, and prepared the works for casting. In 1919–20, Hébrard's founder, Albino Palazzolo, made a first set of bronzes (which remained unknown until 1977, when they were sold to Norton Simon in Los Angeles). Those "masters" served to make molds for casting the edition of twenty-two bronzes.[8] Technically, all the bronzes except the master set are surmoulages. In general, surmoulages lack the crispness of primary bronzes, but Palazzolo was so skilled that only experts can discern the differences between the master set and the other bronze casts. As was the custom at the time, the foundry added a facsimile of the artist's signature to each work and marked each cast with the foundry stamp, "CIRE PERDUE A. A. HEBRARD." Because the sculptures were identified by numbers, the foundry used letters to

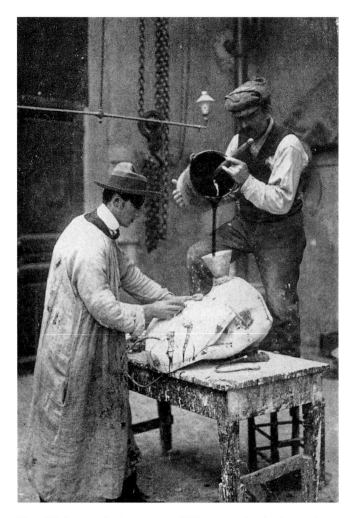

Fig. 1. Workers producing a wax model in preparation for the casting of a Degas bronze at the Hébrard Foundry, Paris, ca. 1920.

indicate the sequence of twenty-two casts of each work (lettered "A" through "T", plus sets for the Degas and Hébrard families lettered "HER" and "HER.D"). Four sets were completed by February 1921, and the complete edition was finished by December 1931. The bronzes were distributed for sale through the Galerie Hébrard in Paris, starting with an exhibition of the "A" set in May through June 1921. One reviewer pronounced Degas "une statuaire de génie,"[9] but the Musée du Louvre refused to accept the "A" set. Louisine Havemeyer—the avid and astute collector of Impressionist paintings by Degas and Cassatt—purchased the entire set on October 15 (see cat. 82).

The first public displays of Degas's sculpture in the United States took place in New York at two different venues in 1922. From January 26 to February 28, the Grolier Club hosted *Prints,*

Drawings, and Bronzes by Degas, featuring Havemeyer's "A" set of bronzes; a highly favorable review was published in the *New York Times*.[10] From December 6 to December 27, the Durand-Ruel Gallery presented *Exhibition of Bronzes by Degas, 1834–1917*, which consisted of the "B" set. That set was shown again at the Ferargil Gallery in New York from October to November 1925 and then was dispersed through the sale of individual works (see cats. 75, 76, and 84). The Ferargil show was helped by an adulatory review by Royal Cortissoz but was evaluated quite negatively by William Zorach (fig. 2) in *The Arts* magazine.[11] A sculptor himself, Zorach knew the history of Degas's waxes. Calling the bronzes "sculptures in reproduction," Zorach said, "They can hardly be considered seriously as sculpture."[12] This criticism arose largely from his adherence to the "direct-carve" aesthetic that had emerged in Europe around 1907 among artists who were repelled by the excess production of bronzes by Auguste Rodin and others in the late nineteenth century (a popular work like Rodin's *The Thinker* was reproduced in hundreds of small bronze casts, for example). Inspired by Paul Gauguin's primitivist wood carvings from Tahiti, which were exhibited in Paris in 1906, a new generation of sculptors repudiated bronze casting in favor of hand-produced stone or wood pieces. In addition to his commitment to carving, Zorach sought to express absolutes in his art; he thus had little appreciation for the aesthetics of the *non-finito*. His own definition of "repose" in art blinded him to how successfully Degas had achieved a new kind of serenity within movement. Zorach's criticisms were not widely shared; The Metropolitan Museum of Art exhibited Havemeyer's entire set of bronzes from 1923 to 1927[13] and two years later received them as a bequest.

That acquisition may have prompted the Musée du Louvre to reconsider their earlier rejection of the "A" set. In 1931 the Louvre purchased the "P" set and included it in *Degas: Portraitiste, Sculpteur* at the Musée de l'Orangerie (July 19–October 1), thus setting the official French stamp of approval on the posthumous surmoulages. In 1935 the art dealer Jacques Seligmann presented an exhibition of Degas bronzes in New York, which sold well. Subsequently, the Great Depression and World War II slowed the art market in general and sculpture in particular. Although individual bronzes were sold, Degas exhibitions at galleries focused on paintings, drawings, and prints—notably the Durand-Ruel Gallery in New York (1932 and 1937), the

Fig. 2. William Zorach, (American, 1887–1966), photographed in 1930 with his sculpture *Mother and Child* (1927–30, Metropolitan Museum of Art)

Galerie Mouradian-Valloton in Paris (1938), and the Galerie André Weil in Paris (1939).

After World War II, as Europe struggled to rebuild, the American economy grew steadily, and many new collectors entered the market, which was centered in New York. Most dealers still focused on two-dimensional works, as in the Durand-Ruel Gallery's *Degas* exhibition in November 1947. In contrast, from 1940 to 1954 the dealer Curt Valentin promoted modern sculpture, which at the time was far less appreciated than painting. His exhibitions attracted many new collectors, including museum curators.[14] Valentin's Buchholz Gallery included several bronzes in an exhibition of Degas drawings in 1945, as well as including a *Little Dancer* in a 1948 sculpture show and ten other Degas bronzes in a 1951 show. Among Valentin's clients was Joseph H. Hirshhorn, who purchased his first Degas bronze, *Dancer Holding Her Right Foot*, from Valentin in 1955.[15] An avid collector, the Latvian-born self-made millionaire had previously acquired a Degas pastel of a dancer but subsequently lost interest in French

Impressionist art.[16] Instead, Hirshhorn had a remarkable affinity for sculpture of all kinds. From 1957 through 1964 he made no attempt to buy any Degas paintings but did purchase twenty-one more Degas bronzes from various sources.[17] In 1966 he donated nearly 6,000 works of art, including 2,660 sculptures, to the Smithsonian Institution to establish a museum of modern and contemporary art. There the Degas bronzes would be seen, not among paintings but as participants in the evolution of international modern sculpture over a span of 150 years.

Coincidentally, by the early 1990s the nation's capital would have another major collection of Degas sculptures. During the same years that Joseph Hirshhorn formed his collection, Paul Mellon was also acquiring. Scion of a wealthy and cultured family, he bought Impressionist and Post-Impressionist paintings, usually from blue-chip art dealers Wildenstein and Knoedler, who dominated the market. In 1955, Knoedler's gallery acquired the original wax sculptures from the Hébrard family and exhibited them for the first time in the United States—a remarkable coup that excited much interest.[18] Mellon purchased the entire group for his private collection. In 1991 he donated them to the National Gallery of Art, where they sparked a new wave of scholarly studies, from technical analyses of the materials to revised theories of chronology. Too fragile to travel, the waxes can only be seen in Washington, D.C., along with ten bronzes also donated by Mellon. The fact that two quite dissimilar collectors, Mellon and Hirshhorn, eagerly sought Degas sculptures testifies to their widespread appeal.

For some collectors Degas's sculptures are appealing as visual documents related to his paintings, or they serve as testaments to one artist's perfectionist obsession with pose and proportion. To modern sculpture historians, the unfinished nature of Degas's forms and surfaces marvelously complement the Romantics' passion for the sketch, Rodin's emotive modeling and use of the partial figure, and Medardo Rosso's evocatively textured Impressionist works. Unlike those contemporaries who saw dramatic gesture and the *non-finito* as metaphors for the tumult and ceaseless change of modern existence, Degas sought the eternal in his little figures. And he sought it the hard way— by pursuing a new definition of beauty within the most ordinary actions in unself-conscious moments: not a glamorous diva onstage but hardworking dancers stretching or checking their costumes; not a goddess with perfect aplomb but anonymous

women drying off after a bath. How utterly mundane to see a tired dancer arching her back in exhaustion or a bather twisting around to rub her hip. Yet Degas perceived the elegance inherent in those seemingly casual postures. His bronzes—devoid of the captivating colors of paintings and pastels—attest to the quiet beauty lurking within the commonplace. Although Degas conceived these works more than one hundred years ago, they have remarkable relevance today, as the reclusive old master from Paris can still remind us to notice and appreciate transient glimpses of grace.

NOTES

1. Joseph Durand-Ruel to Royal Cortissoz, June 7, 1919 (Beineke Library, Yale University), in Cortissoz 1925, p. 245. The Degas chapter in this book was largely based on a 1919 newspaper article by Cortissoz, which included information from Degas's model Pauline. Royal Cortissoz, "Degas as He Was Seen by His Model," *New York Tribune,* October 19, 1919, sec. 4, p. 9. See also Alice Michel, "Degas et son modèle," *Le Mercure de France,* February 16, 1919, p. 634; and Lemoisne 1919.

2. With the lack of documentation on the sculptures, scholars have dated many based on their similarity of pose to various paintings and prints. Connoisseurs have also relied on stylistic arguments, but that method is risky because the sculptures had deteriorated and been restored. Moreover, prior to 1977 most scholars had access only to the bronze surmoulages rather than the master bronzes; the wax originals became public only in 1991. The first monograph was Curt Glaser's 1926 *Das Plastische Werk von Edgar Degas,* a modest publication of twenty pages. John Rewald compiled the first catalogue raisonné in 1944, which was republished in 1956 and again as *Degas's Complete Sculpture* in 1990. Most collectors use Rewald's dates as standard, but he ignored compelling arguments by other scholars for redating works. Charles Millard's 1976 *The Sculpture of Edgar Degas* attempted dates based primarily on stylistic arguments. Ettore Camesasca and Giorgio Cortenova's 1986 *Degas Scultore* identified similarites between poses of sculptures and paintings. Anne Pingeot's 1991 catalogue raisonné contains the most information, including summaries of the various arguments for dating each work. Pingeot also was the first to include specific casting dates based on the Hébrard foundry records. Sara Campbell's 1995 article "A Catalog of Degas Bronzes" identified the location of many casts.

3. Quoted in Vollard 1924, p. 112.

4. Vollard 1936, p. 251.

5. Cortissoz 1925, p. 245. The inventory in the Hébrard archives lists only eighty; see Pingeot, p. 25.

6. See Sturman and Barbour 1995, pp. 49–54. The external armatures are visible in documentary photographs made by Gauthier in 1918 and published in Pingeot, pp. 25, 153–70 and passim. Wax was a common material among sculptors and foundries at the time but not for final works of art. The exception was the Italian Impressionist Medardo Rosso, who worked primarily in wax over a plaster support; his works were first exhibited in Paris in 1886.

7. Mary Cassatt to Louisine Havemeyer, January 1920, cited in Pingeot, p. 189. Degas did have Hébrard make plaster casts of three sculptures around 1900 but never proceeded with bronzes.

8. According to various sources (including Durand-Ruel's June 7, 1919, letter to Cortissoz), the heirs planned an edition of twenty-five. When the "master" set of bronzes and the lettered set for the heirs and founder are included in the count, twenty-five sets were indeed cast. Individual works sometimes have additional casts, as does the *Little Dancer* and *Dancer: Arabesque on Right Leg, Left Arm in Line;* see Campbell 1995. This brings the total number of bronzes to roughly 1,850.

9. Paul Gsell, in *La renaissance de l'art Français* 4 (1921), p. 352. See also François Thiébault-Sisson, "Degas Sculpteur par lui-même," *Le Temps,* Paris, May 23, 1921, p. 3. The bronzes were included in subsequent publications such as Jamot 1924.

10. "The World of Art: Degas at the Grolier Club," *New York Times Book Review and Magazine,* January 29, 1922, p. 20.

11. Royal Cortissoz, "Degas: His Seventy-Two Achievements as a Sculptor," *New York Herald Tribune,* October 25, 1925, sec. 5, p. 8; Zorach 1925, pp. 263–65.

12. By today's standards, Zorach was accurate in his harsh technical assessment of the sculptures as unfinished, deteriorated, posthumously restored surmoulages cast against the artist's wishes. However, those issues were not considered terribly important at the time. Indeed, from the mid-nineteenth through the mid-twentieth century, countless sculptures by many deceased artists were routinely cast by others, sometimes not even by legitimate heirs. It was not until the 1970s that stricter ethical standards and new copyright laws altered casting practices.

13. According to Pingeot, p. 206. There was no publication.

14. Peter Rathbone, director of the Saint Louis Art Museum, acknowledged Valentin's pivotal role in educating many Americans about modern sculpture. See Rathbone 1954. Valentin focused on European sculptors, including Rodin, Degas, Lehmbruck, Maillol, Laurens, Lipchitz, Matisse, Calder, Moore, and Marini.

15. According to the collector's own acquisition records (Hirshhorn Museum and Sculpture Garden Archives), this was his first Degas sculpture purchase. In 1957 he bought three others from different galleries, followed by nine in 1958, two in 1959, two in 1961–62, two in 1963, and three in 1964.

16. Hirshhorn sold the pastel *La Danseuse Fatiguée,* along with other Impressionist paintings at Parke-Bernet in New York on November 10, 1948. See Hyams 1979.

17. Before his death in 1981, Hirshhorn acquired another bronze (a duplicate cast of *Pregnant Woman*), which he bequeathed to the museum. In its effort to create an acquisitions endowment during the late 1980s and early 1990s, the museum deaccessioned and sold five of the Degas bronzes, leaving a total of eighteen in the collection.

18. That year, Jean Adhémar published "Before the Degas Bronzes," and Rewald's catalogue raisonné from 1944 was republished in 1956. Campbell 1995 itemizes which sculptures were acquired by museums: acquisitions notably increase from 1947 (when Valentin intensified his sculpture exhibitions) through the 1950s and 1960s, including major institutions like the Los Angeles County Museum of Art and smaller regional ones like the Shelburne Museum in Vermont.

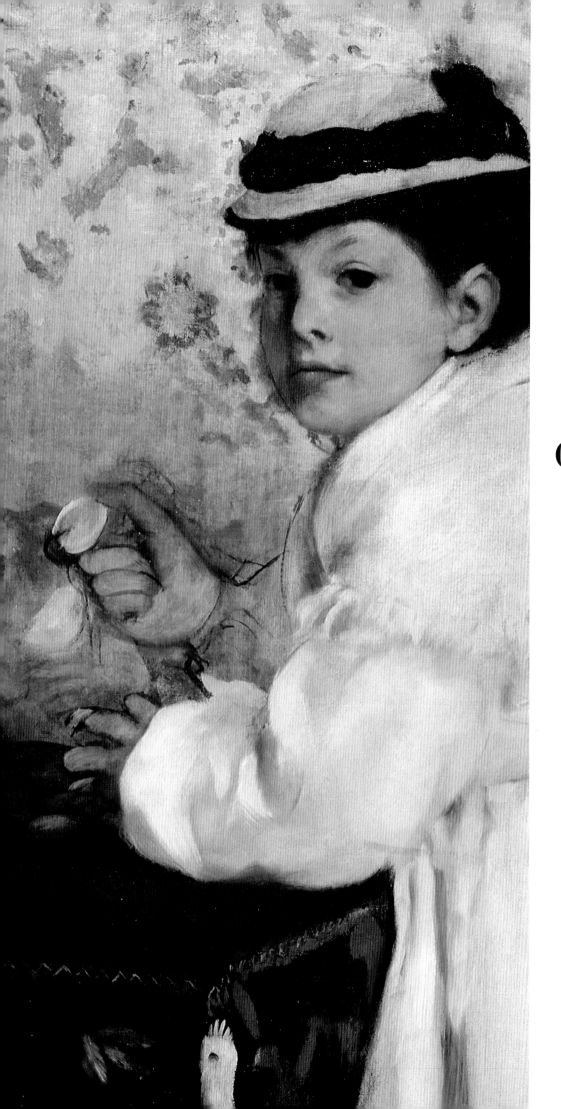

CATALOGUE

1. Portrait of René Degas

1854–55
Pencil on paper
10¾ × 8⅝ inches
Philadelphia Museum of Art
Henry P. McIlhenny Collection
In memory of Frances P. McIlhenney, 1986-26-13

DEGAS MADE SEVERAL STUDIES of his youngest brother René De Gas[1]—eleven years his junior—in the period between his secondary school graduation and his extended trip to Italy.[2] During this time the young artist drew members of his family regularly, presumably because they were the most accessible and least expensive models.[3] It was also during this time that Degas was registered as a copyist at the Louvre and at the Cabinet des Estampes (the print study room) at the Bibliothèque Nationale. Copying works by old masters was one of the traditional methods used to teach young artists to draw in nineteenth-century Paris.

Degas often copied peripheral figures from works of the old masters, a practice he used to build his gestural vocabulary.[4] His early portraits of family members can be seen as independent efforts at employing the expressive vocabulary of the old masters on a familiar subject. If not for the recognizable haircut, soft nose, and family resemblance in the eyes, this early study of René could be a carefully drawn copy of a painting by Holbein or Raphael. In this drawing René is facing left, sleeping, with tousled hair and relaxed mouth. Degas drew another, much younger sleeping child in *Four Studies of a Baby's Head* (cat. 12), a more casual study, drawn about a decade later, that reveals how Degas became more confident as a draftsman. In *Portrait of René Degas,* the sketch is contoured and modeled with line, a method espoused by Ingres that Degas would continue to use late into his career. Ingres's style is also invoked in the light touch the artist used in making his marks on the page, giving René almost translucent skin.

This study remained in Degas's studio until his death. Although the majority of works in Degas's atelier were sold at the Galerie Georges Petit sales, Degas's niece Jeanne Fèvre and his brother René retained several works, including the present drawing. René's son, Jean Nepveu-Degas, inherited *Portrait of René Degas* from his father. By 1966 the drawing had been acquired by the Wildenstein Gallery in New York, whence it was purchased by the Philadelphia collector Henry P. McIlhenny. The McIlhenny family earned its fortune when Henry's grandfather John McIlhenny invented the gas meter. He became a collector, and his family followed suit. Henry McIlhenny attended Harvard, where he had Paul Sachs as a professor. Later, McIlhenny served as the curator of decorative arts at the Philadelphia Museum of Art from 1934 to 1964. His collection of fine and decorative arts was bequeathed to the Philadelphia Museum of Art upon his death in 1986.

PHAEDRA SIEBERT

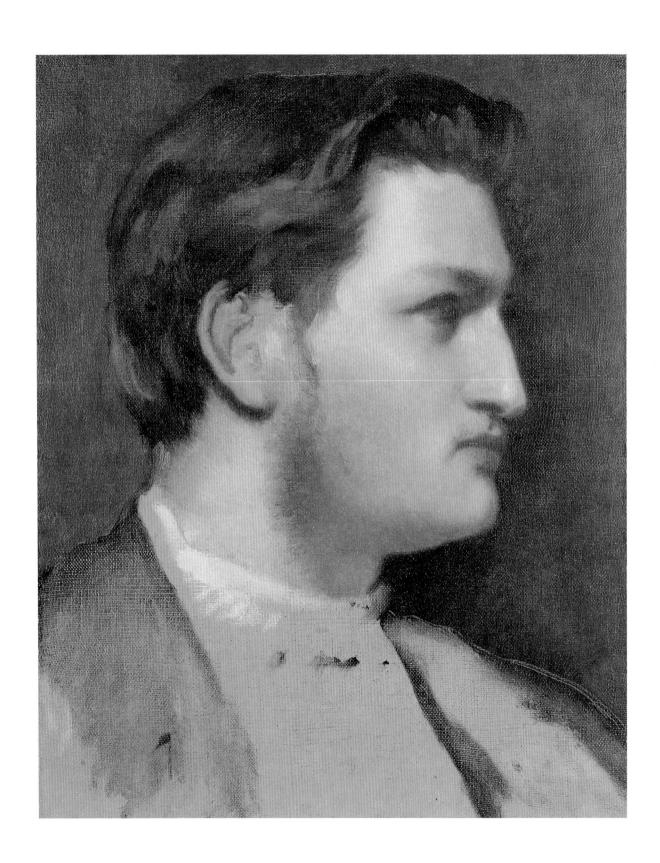

2. PORTRAIT OF PAUL VALPINÇON

1855
Oil on canvas
15⅞ × 12¾ inches
The Minneapolis Institute of Arts
Gift of David M. Daniels in memory of Frances H. Daniels, 74.28
Lemoisne 99
Minneapolis only

DEGAS'S RELATIONSHIP WITH THE MEMBERS of the Valpinçon family ran like a sturdy, unbroken thread throughout the artist's life. It was a friendship between families that probably began well before Edgar Degas and Paul Valpinçon became classmates at Lycée Louis-Le-Grand in 1846.[1] A benefit of the association was the influence of Paul's father, Edouard Valpinçon, whose encouragement of Degas's early interest in Ingres played a vital role in his development as an artist.[2] Significantly, *Portrait of Paul Valpinçon* bears the draftsman-like quality and classic profile that place the painting in 1855, when Degas's interaction with Ingres was at its most pronounced.[3]

Degas portrayed his friend in small portraits on three occasions during his career, and this canvas, which is unsigned and undated on the front, has heretofore been placed between 1861 and 1864. A simple comparison with Paul Valpinçon's features in a dated portrait from 1861 (*M. and Mme. Paul Valpinçon*, pencil, Pierpont Morgan Library, New York), however, clearly locates the Minneapolis painting before 1861 and probably before Degas's departure in 1856 for a three-year sojourn in Italy.[4] The fullness of both Valpinçon's face and facial hair in the pencil drawing denote a stage of maturation well beyond the fresh complexion and scanty sideburns recorded in the painting.[5]

When it was first exhibited in 1931, the portrait—still in the collection of the sitter's daughter, Madame Jacques Fourchy (née Hortense Valpinçon)—was dated ca. 1855 in the exhibition catalogue.[6] By 1939, Lemoisne had dated it around 1861–64 in

his catalogue raisonné of the artist's works. Regardless, both publications noted an inscription on the reverse of the canvas that read, "BI, ns-12, 1ᵉʳ juin 1855. A. Duvivier." Lemoisne essentially dismissed it, describing it as "incomprehensible" and written in an unknown hand; he reasoned that Degas had probably used an old canvas.[7] However, a review of the Valpinçon family history surrounding the painting's creation, as recounted by Hortense in 1936, forges a link between inscription and portrait, which renders comprehensible what had perplexed Lemoisne. After stating that Degas had painted the portrait outdoors in the courtyard of her grandparents' home in Paris, Hortense "translated" the surname on the reverse as that of "Dugommier," a pet name of unknown origin that the two friends had used.[8] She also stated that her father was twenty-one years old at the time—an age that coincides with the date of 1855 inscribed on the painting's reverse.

When Degas's *Portrait of Paul Valpinçon* left the collection of Madame Fourchy is not known. However, by the 1950s the painting was in the possession of Jon Nicolas Streep, a private dealer in New York City, who sold the painting in May of 1955 to David M. Daniels, a noted collector and connoisseur known for his keen appreciation of fine draftsmanship and nineteenth-century French art.[9] In 1974, Daniels, a native of St. Paul, donated the portrait to The Minneapolis Institute of Arts, where it hangs in close proximity to Degas's portrait of Valpinçon's daughter, Hortense (cat. 24).

PATRICIA S. CANTERBURY

3. Two Studies of the Head of a Man

ca. 1856
Pencil heightened with white chalk on rose-brown paper
17⅝ × 8⅞ inches
Sterling and Francine Clark Art Institute, 1955.1393
Minneapolis only

THIS POWERFUL DRAWING dates from the beginning of Degas's sojourn in Italy, which lasted from July 1856 until April 1859. Scholars attribute it to a period Degas spent in Rome in the early months of this important period of training; the careful execution and close observation suggest a student work.[1] Indeed, the model's striking biblical features might have reminded Degas of a project he had begun in Paris the year before his departure: a painting of *John the Baptist and the Angel*.[2] As a student, Degas initially planned to become a history painter; though he chose the path of the *Indépendants,* he retained a lifelong interest in the narrative intricacy and pictorial drama of *la grande peinture*. This drawing combines two exercises crucial to mastering preparatory work on a large composition.

In the catalogue of the fourth Degas atelier sale, the work was erroneously titled *Two Male Heads (After a Painting of the Italian School),* an understandable mistake. Seeing them as two individuals, a viewer might imagine the pair of figures in the background of a larger composition. The gaze of the head at left is countered by the turn of the head on the right, and the positioning of the figures suggests that they share a silent commentary on an action or event happening elsewhere. A slight difference in space is suggested by a subtle shift in tonality, while the repetition of the arch of the eyebrow—one of the features that betrays the fact that both are actually the same model—creates a rhythmic movement that binds the figures together visually. Degas also seems to have used this drawing as a character study, depicting the figure at the right with a stern expression, an angular arm, and a lightly clenched fist. Degas's execution is earnest and disciplined, combining such strong linear elements as the eyebrows and hand with careful shading that includes light touches of white chalk.

Paul Durand-Ruel purchased the drawing from the fourth atelier sale in 1919 (no. 67), and ten years later transferred it to the galleries in New York. Its exhibition there as early as 1935 provided American viewers with an early opportunity to become familiar with Degas's narrative ambitions. This aspect of the work captured the attention of Sterling Clark, who acquired it from Durand-Ruel in 1939. In 1955 it joined the *Standing Nude* (cat. 15) in the museum's charter gift.

DAVID OGAWA

4. STUDY FOR "DANTE AND VIRGIL"

1856

Graphite over black crayon on gray paper

10¾ × 9⅛ inches

Cincinnati Art Museum

Annual Membership Fund, 1920.41

DURING HIS FIRST STAY IN ITALY, from 1856 to 1859, Degas continued his practice of copying classical sculpture and the Renaissance painters as well as contemporary artists, especially the neoclassical master J. A. D. Ingres. This drawing of two nudes was one of several preparatory studies for a painting of clothed figures, *Dante and Virgil* (Louvre), that Degas completed in 1858. Such procedures were often followed at the École des Beaux-Arts in Paris, where Degas had spent only a short time before concluding that independent studies in Italy would be of greater advantage to him.

The subject is drawn from Dante's *Divine Comedy*, in which the Roman poet Virgil guides Dante on a literary journey through the infernal regions. Ingres's line is quite apparent in this sensitive drawing, which nevertheless reveals a youthful insecurity in execution.[1] Interestingly, the profile of Virgil on the left shows a resemblance to Degas himself. He sent the finished painting to his father in Paris, who responded in a letter with generous praise and encouragement.[2]

Ingres's refined neoclassicism began to fade in Degas's artistic program while he was in Italy. Degas had already grasped the complex structure and rich coloration of Eugene Delacroix's dramatic canvases before he left for Italy. There he met the slightly older painter Gustave Moreau, whose originality and inherent romanticism found a ready response in the curious and experimental Degas. The contrast between these influences and the controlled world of Ingres challenged the analytical curiosity of the maturing artist. Degas's use of Ingres's restrained line, evident in this study, gave way to a darkly brooding and loosely brushed execution in the finished painting of Dante and Virgil.

The drawing was in the estate of the artist and sold at the Galerie Georges Petit in Paris in 1919 in the fourth atelier sale (no. 116e). *Study for "Dante and Virgil"* was shown in 1920 (as *Deux Hommes*) at Durand-Ruel in New York in *Exhibition of Pastels and Drawings by Degas*. It entered the collection of the Cincinnati Art Museum in 1920 as part of a group of three drawings purchased directly from the Durand-Ruel Gallery, which had recently acquired a cache of drawings from the atelier sales. Following The Metropolitan Museum of Art's acquisition of several drawings from Degas's estate in 1919, these Cincinnati purchases represented some of the earliest American museum acquisitions of Degas's drawings.

GUDMUND VIGTEL

Roma. 1856

Degas

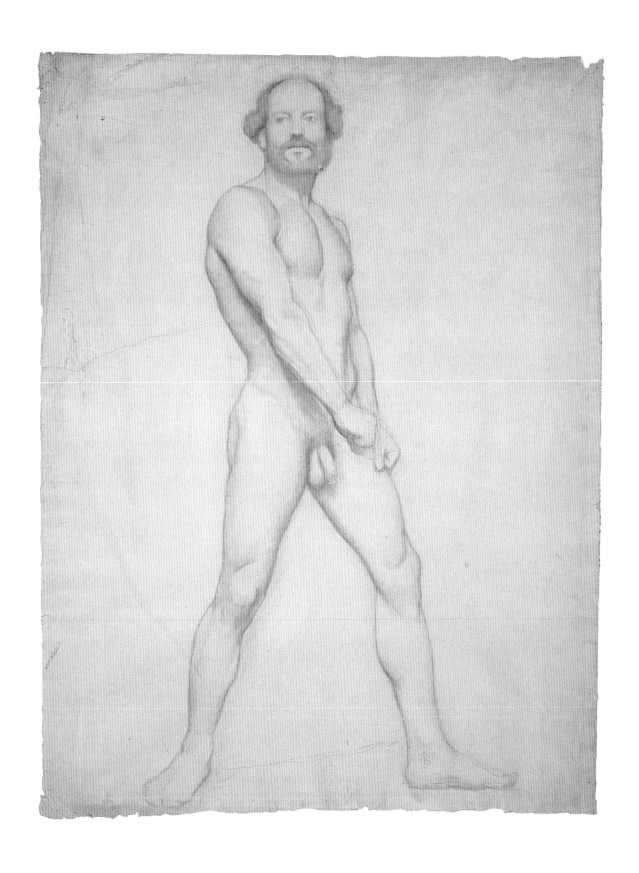

5. ACADEMIC STUDY OF A NUDE MAN

1856–58
Charcoal on pale gray paper
24 × 18⅜ inches
Museum of Fine Arts, Boston
Gift of W. G. Russell Allen, 1938, 38.1653

THIS DRAWING COMES FROM DEGAS'S student years, and like *Standing Nude* from the Clark Art Institute (cat. 15), it is essentially an academic study of a studio model. This work, more than the Clark drawing, reveals the debt that the young Degas owed to the artistic heroes of his younger years: J. A. D. Ingres and Hippolyte Flandrin. The work's tight linear organization and tendency to cling to the picture plane owe a great deal to Ingres, as do certain of the radically simplified areas. The figure's head, with its receding hairline and rounded features, reveals this tendency along with an almost obsessive search for symmetries of both shape and line while studying the live model.

The drawing also reveals Degas's interest in Flandrin, himself a student of Ingres. Though less well known today, Flandrin was one of the leading history painters of the period. He practiced a less rigid classicism than Ingres. The softened contours of this figure and the undulating outline recall Flandrin, giving the work a slightly rubbery yet solid effect. This overall softening is also carried through the delicate shading of the model, which lends the drawing an atmospheric richness that contrasts to the linear discipline of the whole.

Previously unpublished and exhibited only at the Museum of Fine Arts, Boston, the drawing bears a stamp from the atelier on its verso, but lacks the "Degas" signature stamp on its front side. This unusual circumstance indicates that though the drawing remained in the studio after the artist's death, it was not included in any of the four posthumous sales. Such works may have been intended for a fifth atelier sale but seem mostly to have gone to members of Degas's family; many of the works from the collection of Jeanne Fèvre, Degas's niece, bear only the atelier stamp.

This work was acquired in the important early campaign of W. G. Russell Allen of Boston to collect works by Degas—a campaign that included *The Song of the Dog* (cat. 32). Allen's interest in such an early Degas drawing signals not only the collector's acuity in finding accomplished examples of graphic art in all media, but it is also indicative of a broadness of taste among American collectors of Degas in this period. As William Henry Rossiter, the curator who worked with Allen and shepherded his bequest to the Museum of Fine Arts, wrote in 1956, Allen followed the great traditions of early nineteenth-century collecting, forming his collection "with sound knowledge, unremitting care, and an unusually keen eye."[1]

DAVID OGAWA

6. SELF-PORTRAIT

ca. 1857
Red chalk on laid paper
12¼ × 9³⁄₁₆ inches
National Gallery of Art, Washington, D.C.
Woodner Collection, 1991, 91.182.23

THIS DRAWING IS A TIGHTLY FRAMED and delicately executed head study, related, as Jean Sutherland Boggs has noted, to Degas's first painted self-portrait of 1855, now in the Musée d'Orsay.[1] The painting depicts the artist leaning against a console, holding a *porte-fusain* and portfolio.[2] The dark background and sober costume give the work a grave mood, visually relieved only by the light area of the artist's face—that of a serious young man. This expression is the most obvious common ground between the drawing and the painting: in both, the artist looks out of the picture with a gaze of distanced indifference, the impassive eyes separated from his pouting mouth by a long, slender nose. The indications of costume also correspond to those of the painted work. Degas has sketched himself wearing a jacket and hinted at a shirt collar and cravat—similar to the clothing in the painting. The underlying shape of the head and general disposition of the facial features, particularly the left eye, nose, and mouth, provide the most compelling visual evidence of a working relationship between the drawing and painting.

The differences are important, however, and suggest Degas's intentions regarding the finished painting. The drawing shows a face turned more sharply to the right, closer to a profile position. This affords a narrower glimpse of the right side of the face. In conjunction with the light, almost ghostly handling of the chalk, the painter's aloof expression and haughty gaze make the work

less a study in resemblance than an examination of character—a character that is noticeably softened in the final painting. The moody, psychologically intense young Degas in the drawing would have figured more prominently in the imaginations of most American viewers, as the final painting was not exhibited in the United States until 1988. The drawing was included in the 1936 exhibition *Degas: 1834–1917* at the Pennsylvania Museum of Art in Philadelphia and was thus among the first of Degas's self-portraits to become widely known in this country.

As with many of Degas's early family and self-portraits, this drawing (and the painting for which it is a study) was inherited by his brother René, whose 1927 estate sale was the second major opportunity for American collectors to acquire early works by the artist. Bought from the René De Gas sale by Paul Rosenberg & Co., the drawing had entered the collection of John Nicholas Brown of Providence, Rhode Island, by 1929. Brown generously lent the drawing to several important exhibitions, including the 1936 Philadelphia show, and it was thus among the first works from Degas's student years to reach an American audience. Ian Woodner acquired the work from Brown's collection in 1986, and it was included in the important gift of Woodner's collection by his daughters to the National Gallery of Art in 1991.

DAVID OGAWA

7. Self-Portrait

1857

Etching and drypoint on off-white rough wove paper

Fourth state of four

Plate: 9 1/16 × 5 5/8 inches

Sheet: 14 1/2 × 11 inches

Los Angeles County Museum of Art

Purchased with funds provided by The Garrett Corporation, M.81.54

Reed and Shapiro 8

DEGAS PRODUCED THIS PRINT during his years studying in Rome, from 1856 to 1859. He created his first prints in Italy, inspired in part by a printmaker he met there named Joseph Tourny, a copyist chiefly trained as a reproductive engraver.[1] The etchings of Rembrandt, reproduced in a serial monograph published in 1853–58 by Charles Blanc, were the predominant model for nineteenth-century connoisseurs of etching (which Degas, as a focused artist in his early twenties, was rapidly becoming). Rembrandt's influence is evident in the sensitive *chiaroscuro* and psychological depth of this self-portrait. The young artist pictures himself informally attired, turned three-quarters toward the viewer. The wide brim of his hat casts a shadow over his eyes, the gaze of which is direct but reserved and touched with melancholy.

For this fourth and final state, Degas built up the dark tones by gradually biting the copper plate in careful stages.[2] The print closely follows its preparatory drawing (Metropolitan Museum of Art) and resembles Rembrandt's *Young Man in a Velvet Cap* (Museum of Fine Arts, Boston), which Degas sketched and of which he later etched a copy. This is Degas's only self-portrait in the print medium, and he was apparently pleased with the results, for he dispersed several impressions among his friends. They were the only self-portraits to leave his studio during his lifetime.[3]

Degas's interest in printmaking was fairly unusual for an artist in the 1850s. Most artists viewed printmaking solely as a means of reproducing and publishing their more serious painted work. The concept of original printmaking was still at least a decade away, appearing with the "etching revival" of the 1860s and 1870s. In 1853, Degas registered as a copyist at the Cabinet des Estampes in the Bibliothèque Nationale, Paris, and in the late 1850s he studied old-master prints in the collection of the library of Rome's Palazzo Corsini. Throughout his life, but particularly in his later decades, Degas avidly collected prints, creating a significant collection of his own.

This self-portrait was sold at the Degas atelier sale of prints in November 1918 (no. 3). It was purchased by Robert MacDonald in New York and passed to James H. Lockhart Jr., a major American print collector in the 1930s. In the late 1970s the prints and drawings dealer Robert Light of R. M. Light & Co., Santa Barbara, California, bought the print from Lockhart and sold it in 1981 to the Los Angeles County Museum of Art.

MARY MORTON

8. SELF-PORTRAIT

1857–58
Oil on paper, laid down on canvas
8⅛ × 6½ inches
The J. Paul Getty Museum, Los Angeles, 95.GG.43

THIS EARLY SELF-PORTRAIT BY DEGAS reveals the dominating influence of Ingres. Though he was part of the great French tradition of history painting during the early and mid-century, Ingres's most significant financial and artistic success came as a portrait painter. He was the most consistent model for Degas's early portraits, and the ideal of draftsmanship that Ingres represented lived on through Degas's long career.

The Getty Museum self-portrait was painted during Degas's student years in Italy, which lasted from 1856 to 1859. Degas was fresh from the Paris teaching studio of Louis Lamothe, himself a student of Ingres and of Ingres's primary disciple, Hippolyte Flandrin. In Italy, Degas experimented with old-master painting techniques. His exposure to the traditions of Italian painting is evident in the careful linear quality and subtle *chiaroscuro* of this sensitive portrayal.

Degas made at least fifteen self-portraits in various media during his time in Italy. Like his self-portrait of 1855 (Musée d'Orsay), this work shows the influence of Ingres's self-portrait of 1804 (Musée Condé, Chantilly). The Getty work is more intimate than these precedents, however. Whereas Ingres's portrait serves as a public proclamation of the sitter as professional artist, this small work was not intended for exhibition, and in fact it remained in Degas's studio until his death in 1917. It is an informal, private study. Though direct, the gaze is not aggressive but watchful and tentative. Degas turns his face in three-quarter view with his eyes turned even further toward himself as the painter (or toward us as viewers), adding to the sense of a captured moment. The eyes are the focus of the work as they peer searchingly out from under the rim of his felt hat.[1] The image is quite similar to the self-portrait in a hat now at the Sterling and Francine Clark Institute and to the engraved self-portrait from the Los Angeles County Museum of Art (cat. 7).

This painting was among a group of works inherited by Degas's great-niece, Arlette Nepveu-Degas (Mme. Robert Devade). It remained in Degas's family until it was sold at auction at Ader Tajan, Paris, on December 19, 1994, to The J. Paul Getty Museum in Los Angeles.

MARY MORTON

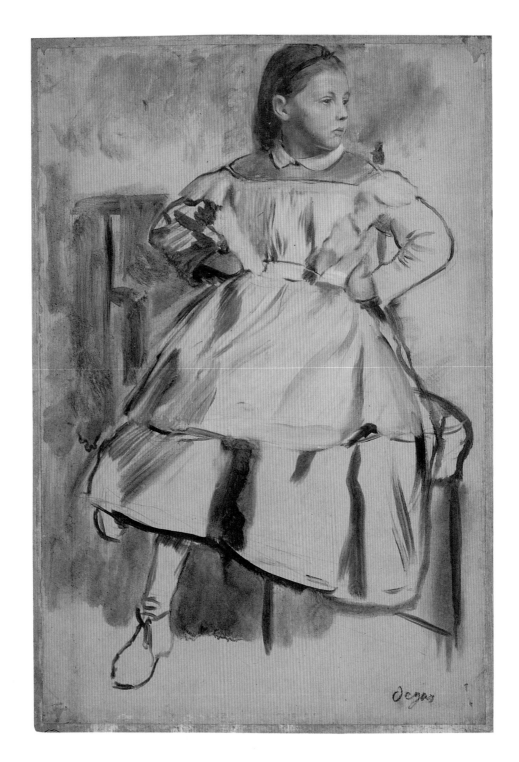

9. GIULIA BELLELLI, STUDY FOR "THE BELLELLI FAMILY"

1858–59

Essence and pencil on cardboard, mounted on panel

14¼ × 9¾ inches

Dumbarton Oaks Research Library and Collection, Washington, D.C.

House Collection, H.C.P.1918.02(0)

Lemoisne 69

In July 1858, Degas began a nine-month visit to Florence with his paternal aunt Laura Bellelli, her husband, and their two daughters, Giovanna and Giulia. In letters written during this visit, Degas expressed eagerness to begin a major work, for which he soon began preparatory studies. On November 27 he wrote enthusiastically to Gustave Moreau, "I am doing [the girls] in their black dresses and their little white pinafores, in which they look delightful."[1] On December 29, Degas began work on the canvas that was to become his first masterpiece, *The Bellelli Family,* now in the Musée d'Orsay.

Back in Florence in the spring of 1860, Degas was still at work on the painting and did several more preparatory drawings. The Dumbarton Oaks study, *Giulia Bellelli,* is the most complete and perhaps the last of the several single-figure studies of her for the painting.[2] In this drawing Giulia sits on the front of a chair in a provocative pose, both defiant and petulant. Placed in the center of the finished painting, she serves as a link between the estranged parents. In his letter to Moreau, Degas described Giulia as having "some of the spirit of a demon and some of the goodness of an angel."[3]

Giulia Bellelli entered the collection of Michel Manzi sometime before 1919, when renowned antiquarian Dikran Kelekian

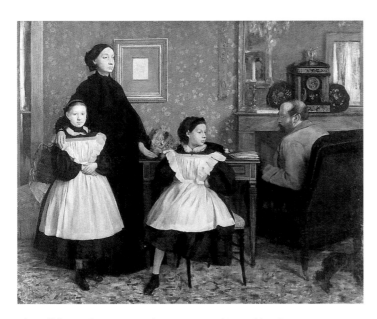

The Bellelli Family, 1858–62, oil on canvas, 78¾ × 99⅜ inches, Musée d'Orsay, Paris.

purchased it. Beginning in 1913, Mildred and Robert Woods Bliss had acquired scores of antiquities from Kelekian's New York City gallery. As Kelekian was also known as a connoisseur of modern French art, in 1937–38 the Blisses turned to him for several important Impressionist and Post-Impressionist works, including the Degas drawing. At this time the Blisses were beginning negotiations to convey their Washington, D.C., property and its collections, library, and gardens to Harvard University to establish the Dumbarton Oaks Research Library and Collection, which occurred in November 1940.[4] It is clear that the Blisses, conscious of the humanist legacy they were creating, desired additional important artworks, even at this crucial juncture in their collecting history.

Correspondence between the Blisses and Kelekian highlights the calculated maneuvers that typified most of their art purchases. Kelekian almost always had "another seriously interested buyer" for pieces the Blisses found interesting, and the Blisses often held pieces for long periods without commitment, even releasing their hold on them, only later to buy them at more advantageous prices. The drawing *Giulia Bellelli* was purchased together with an ancient Egyptian ivory statuette, for which the original combined asking price in 1936 was $37,500 but which Kelekian sold to the Blisses on April 9, 1937, for $20,000. On that date Kelekian wrote to Robert Woods Bliss:

> I am glad that you acquired these two exceptional pieces. I sold them to you at your price for three reasons: first, because you and Mrs. Bliss liked them and I wanted to please you; second, I wanted to have the pride of seeing two other most important objects added to your collection containing already several other first class objects purchased from me; and third, I wanted to hurt myself by making a sacrifice on the price so that I should remember the hardship caused to me by relatives towards whom I had been generous [he was at the time involved in litigation with his nephew]. However, I am a good sport and can stand losses. My only wish is that, since you have such good taste and knowledge, you should not pay attention to the advice of ambulant, so-called experts who are far from being disinterested.[5]

James N. Carder

10. Bust of Young Man, Study for "The Daughter of Jephthah"

1859–60
Pencil on paper
13 × 8⅛ inches
Collection of Irene and Howard Stein, Atlanta, Georgia
Atlanta only

DURING THE EARLY PART OF HIS CAREER, Degas was working in the academic tradition, creating large historical compositions intended for exhibition at the Salon and built up over a period of years from many preparatory drawings and studies. Degas's stated intention in *The Daughter of Jephthah* was to combine the spirit of "Mantegna with the verve and color of Veronese."[1] The top left-hand section of the painting, for which this figure is drawn, was inspired by Mantegna's *The Triumph of Caesar* at Hampton Court. The drawing method for the study,

The Daughter of Jephthah (detail), 1859–60, oil on canvas, 77 × 117½ inches, Smith College Museum of Art, Northampton, Massachusetts, purchased, Drayton Hillyer Fund, 1933.

however, owes far more to Ingres, who exercised a strong influence on the young Degas, especially around this period. Degas used a finely pointed pencil on a smooth surface to create a strong line, supplemented with subtle and carefully nuanced passages of shading.

The Daughter of Jephthah is one of Degas's largest and most ambitious historical compositions. The subject is taken from the Book of Judges (XI:1–40), but Degas may also have been inspired by the long poem of Alfred de Vigny. The story of Jephthah is the biblical equivalent of the tragedy of Iphigenia: Jephthah the Gileadite is recalled from exile by Israel to drive out the Ammonites, who have invaded. Jephthah vows before God that, should he achieve victory over the enemy, he will sacrifice the first person or thing that comes out of his house to greet him. He succeeds in defeating the Ammonites, but when he returns home his joy turns to despair, as the first person to emerge from his house is his daughter and only child. She accepts her fate with stoicism, but the tragedy is compounded by the fact that she must die a virgin, unmarried and childless.

The drawing is a study for a figure on the far left of the painting, but its brilliant draftsmanship and careful observation is lost in the finished work. Degas was anxious to adopt a low viewpoint, since the figure was to be positioned high in the composition. He focuses on the straining arm and neck muscles and the expression of concentration on the young man's face as he reaches up to grab a thin strap or rope. In the finished composition the youth is transformed into a young warrior, returning triumphant from battle and raising a brilliant red standard in celebration. The flag adds a vivid touch of color to the far left of the composition but obscures the young man's carefully rendered right arm.

This is one of several preparatory drawings for *The Daughter of Jephthah*. It was included in the fourth atelier sale (no. 124c) and was acquired by the Parisian collector Jean d'Alayer. By 1960 it had made its way to the United States, where it was shown at the Charles E. Slatkin Galleries in New York in 1961. It was then bought by David Daniels, who owned nineteen works by Degas and a fine collection of drawings and sculpture. It was included in the sale of Daniels's collection on May 11, 1995, from which New York dealer Mark Brady acquired it. It is now in the collection of Irene and Howard Stein of Atlanta.

FRANCES FOWLE

11. LA SAVOISIENNE

ca. 1860

Oil on canvas

24 × 18 inches

The Museum of Art, Rhode Island School of Design

Museum Appropriations Fund, 23.072

Lemoisne 333

THIS PORTRAIT OF A YOUNG WOMAN from Savoy—with its static, symmetrical construction and flat, empty background, so unlike Degas's usual manner—has been the subject of speculation about its place in the artist's body of work. Soon after Degas's death, the work was given an execution date of 1873, which was accepted for decades, until the art historian Theodore Reff demonstrated the similarities between this portrait and neoclassical studies that Degas did of family members in the late 1850s. Opposed to these neoclassical elements are the unorthodox and penetrating narrative portrayals that emerged in Degas's style around 1870.

When Degas drew his young sisters, brothers, and cousins in the 1850s, he showed a predilection for the full, oval faces of the Neoclassicists with delicate outlines and small, well-defined features. These are clearly reflected in the calm, lovely visage of *La Savoisienne*. Her severe, parted hairstyle emphasizes the oval head shape, which is set off by the elaborate ruffles of her native headdress. The body is still and relaxed; there is no sign of the tension shown by Degas's figures in subsequent years.

The young woman's identity—and where Degas might have seen her—is unknown. He could have made drawings of her in 1859 on his way back to Paris from his three-year journey through Italy, which took him across the Alps and through Savoy. It is also possible that she could have been among the Savoyards who were frequently seen in Paris. A war between France and Italy at the time led to the annexation of Savoy by France, and the political implications were of particular interest to the Degas family.[1]

After 1860, neoclassicism and Ingres's subtle line would recur in Degas work, as did the lessons of countless hours spent copying the masters. He saw these influences as central to his artistic development—elements that made his further explorations possible. His preoccupation with incisive depictions of movement, gesture, and specific character led him to analyze his subject from every possible angle under differing light conditions. The effects of this practice would elicit the admiration of his fellow artists and, eventually, of the critics and the public as well.

In 1903 *La Savoisienne* was acquired from the artist by the dealer Bernheim-Jeune, who sold it to Durand-Ruel in 1906. The Museum of Art at the Rhode Island School of Design purchased the canvas in 1923 from Durand-Ruel. Bernheim-Jeune had shown the picture in Paris in 1903, and it was shown in Brussels in 1904. In the United States the painting was exhibited widely. It was shown at the Carnegie Institute, Pittsburgh, in 1908; at the Fogg Museum at Harvard in 1911; at the St. Botolph Club in Boston in 1913; at Knoedler Gallery in New York in 1915; and at Durand-Ruel in New York in 1916.

GUDMUND VIGTEL

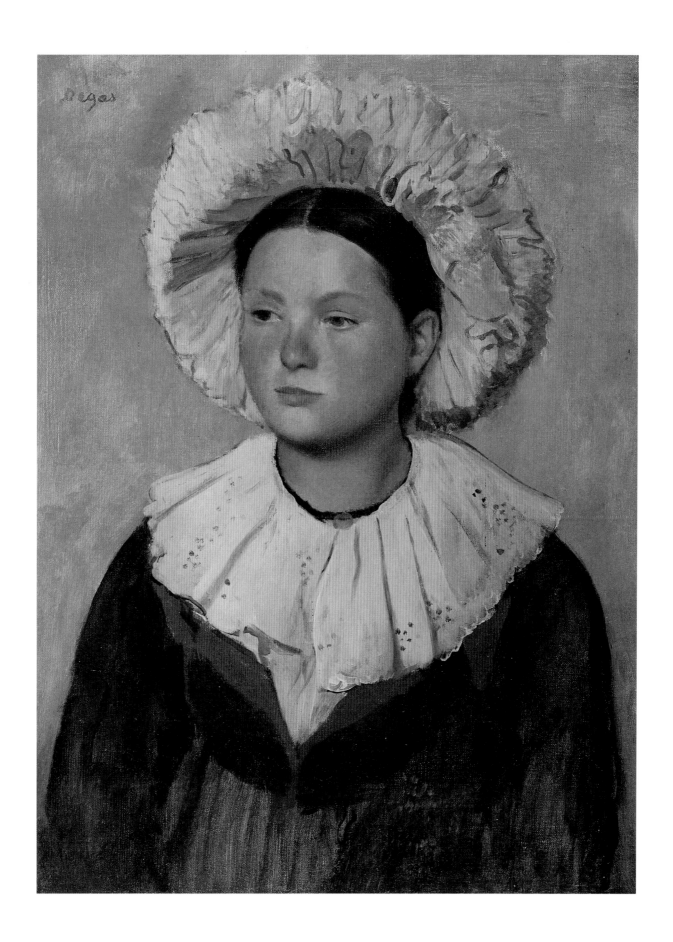

12. FOUR STUDIES OF A BABY'S HEAD

1860s
Charcoal on white, light wove paper
12⅝ × 8½ inches
The Minneapolis Institute of Arts
The John de Laittre Memorial Collection
Gift of Mrs. Horace Ropes, 25.33
Minneapolis only

THAT DEGAS ENJOYED CHILDREN is clear in his many depictions of them throughout his career. The artist seemed to assess their characters with an intuitive understanding. In this sheet of studies Degas seems fascinated with the vulnerability and unfathomable innocence of the small being whose character is yet to be revealed.

The studies—two of the baby in slumber at the top and two in wakefulness at the bottom—pivot in an arc around the paper to display the child's head from four primary views. The firmness of line and degree of finish of the upper sketches reflect the leisure with which Degas could portray his unconscious model. The faint outline of the arm and hand that cradle the baby's form in the uppermost drawing, as well as the skirt that falls away from its head in the second, underscore that such deep, innocent sleep is born of tender protection. The quickly sketched lines in the lower studies exhibit the artist's efforts to capture the likeness of the inquisitive, ceaselessly moving toddler recharged by rest.

Certain dating of this drawing is, unfortunately, loosely tied to the birth date of the unidentified sitter. It has been generally placed in the 1860s.[1] Most recently, it has been suggested that the child may be Josephine ("Joe") Balfour, the daughter of Degas's American cousin, Estelle Musson Balfour (see cat. 27), who was in France beginning in June of 1863[2] and of whom the artist did several sketches in January of 1864.[3] While this is a possible scenario, it remains that Joe was not the only child during this era to whom Degas would have had such intimate access.[4]

Although the atelier stamp on *Four Studies of a Baby's Head* indicates that it was found in Degas's studio at the time of his death, the work does not appear in any of the atelier sales catalogues of 1918. The drawing subsequently came into the possession of the firm founded by Edmond Sagot (died 1917), the publisher and dealer of prints who is generally credited for raising esteem for all forms of original prints.[5] Russell Plimpton, the second director of The Minneapolis Institute of Arts, purchased the drawing in 1925 from Sagot's successor and son-in-law, M. Le Garrec, with funds given by Mrs. Horace Ropes to form a collection in memory of her father, John de Laittre.

PATRICIA S. CANTERBURY

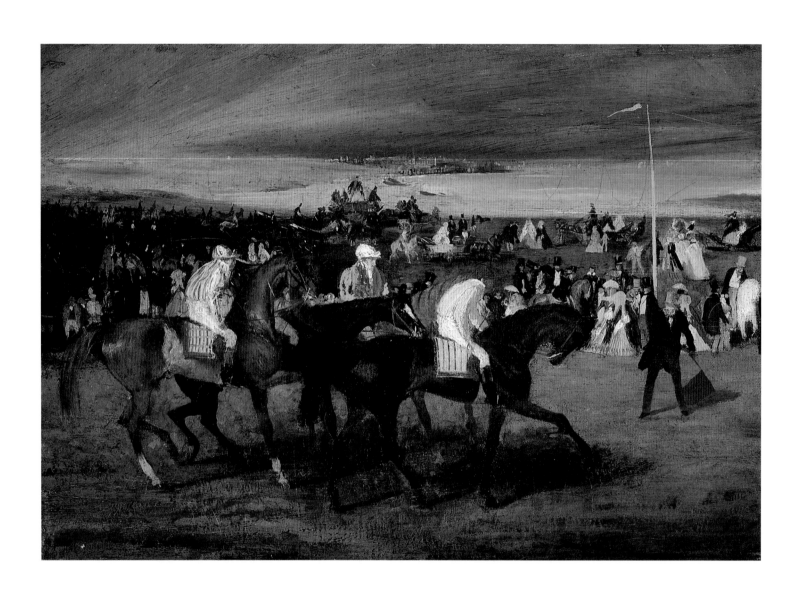

13. At the Races: The Start

ca. 1860–62

Oil on canvas

12⅝ × 18½ inches

Fogg Art Museum

Harvard University Art Museums

Bequest of Annie Swan Coburn, 1934.30

Lemoisne 76

IN THE AUTUMN OF 1861, Degas was staying at Ménil-Hubert in Normandy and may have had the chance to visit the racetrack at nearby Argentan. On his return to Paris, he began a series of pictures of the racecourse, including *At the Races: The Start*. The picture is composed on three horizontal planes: the horses and their jockeys in the foreground proceed toward the start of the race; behind them, rows of spectators and ranks of carriages occupy the middle ground; in the background the scene dissolves into a distant shoreline, a remote and unidentifiable town and a stormy gray sky. Lemoisne proposes that the setting is the Epsom racecourse in England,[1] but Jean Sutherland Boggs asserts that, despite the bay in the background, the racetrack is at Argentan.[2] According to Richard Kendall, however, the location is fantasy, since Degas's early racing scenes were "pure studio confections, remote from, or even innocent of, first-hand experience."[3] He suggests a more likely source for this work is English racing prints and equestrian pictures and draws parallels with the work of one of Degas's favorite artists, James Pollard.[4]

On close observation of the picture it becomes clear that, even if Degas had visited the races by this date, he was not drawing on an intimate knowledge of horses. Although an official is poised to raise his red flag to signal the start of the race and the jockeys appear keyed up and expectant, the high-stepping horse on the far left appears to be participating in a dressage exercise, rather than preparing for the start. Furthermore, a drawing of

ca. 1865, now in the Sterling and Francine Clark Art Institute, which closely resembles this picture, reveals the problems that Degas experienced with clarifying the positions of the horses' sixteen legs. In order to overcome this problem, he took great pains to differentiate the four horses through contrasting hues of light brown, black, chestnut, and reddish roan. Nevertheless, only fourteen legs are visible in the finished picture.

This work was included in the first atelier sale (no. 91) and became part of the Leon Orosdi collection. It was then bought by the French dealer Etienne Bignou, who had a gallery in the rue la Boëtie in Paris. Bignou specialized in nineteenth-century French art, especially Impressionism, and after the First World War, he developed a working relationship with the Lefevre Gallery in London. In 1926 he became a founding director of the newly formed Reid & Lefevre Gallery and three years later, along with Bernheim-Jeune, bought the Paris firm of Georges Petit. After the economic slump of the 1930s, he moved to New York and opened a gallery on East 57th Street. As a result, *At the Races* was sold to an American collector, Howard Young. It was later acquired by Annie Swan Coburn of Chicago, who, with her husband, Lewis Larned Coburn, collected a number of works by Degas—including *The Millinery Shop* (cat. 54) and a portrait of Henri Degas and his niece—which the couple left to The Art Institute of Chicago in 1933. *At the Races: The Start* was bequeathed to the Fogg Art Museum by Mrs. Coburn in 1934.

FRANCES FOWLE

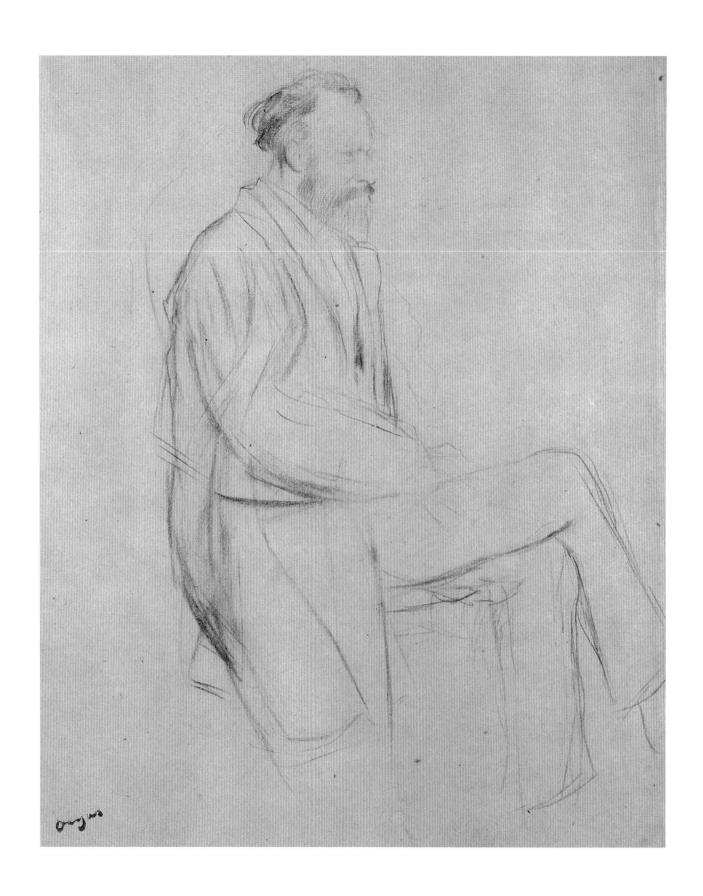

14. STUDY FOR A PORTRAIT OF ÉDOUARD MANET

ca. 1862–64

Black chalk on faded pink paper

14⅛ × 11 inches

The Metropolitan Museum of Art

Rogers Fund, 1918, 19.51.6

Minneapolis only

DEGAS MET ÉDOUARD MANET while copying in the Louvre in 1862, initiating a friendship that was particularly strong in the late 1860s and early 1870s.[1] The unofficial leader of the young painters who would become known as the Impressionists, Manet was the only contemporary artist with whom Degas maintained a consistently competitive relationship.[2] Degas was only two years younger than Manet, and they shared a similar background: upper-middle-class, well educated, and urbane. Degas admired the way in which Manet anchored his contemporary realism in a deep knowledge of old-master techniques and motifs. After Manet's death in 1883, Degas collected an extraordinary group of works by Manet, representing all genres of his oeuvre.[3]

Study for a Portrait of Édouard Manet is part of a series of studies for two etched portraits of Manet sitting in a studio.[4] (Degas also completed a third etched bust portrait of Manet.[5]) Despite the sketchiness of this image and the casualness of Manet's pose—sitting on his coat tails with his legs crossed— Degas succeeds in conveying a sense of strength and alertness in his sitter. Manet sits erect, his head slightly forward, the contours of his strong features set in profile. Degas's crisp line sharply focuses Manet's profile and ear. Bryson Burroughs, The

Metropolitan Museum of Art's curator at the time of the drawing's acquisition, suggested that the drawing portrays Manet aggressively listening to an argument, perched on the edge of rebuttal.[6] Certainly there is the sense of a charged moment captured in this drawing that adds to its modern character.

This drawing is one of three sold as lot 210.2 in the second atelier sale of Degas's work in 1918. The other two drawings in the lot show Manet standing and Manet sitting with his topcoat on and his hat in his hands. The Metropolitan Museum acquired the lot along with several other works, including a drawing of Edmond Duranty (cat. 41) and one of Madame Loubens, through the agency of the French art dealer Jacques Seligmann. Seligmann dealt primarily in *objets d'art* and had served as an advisor to the Metropolitan Museum and to several of its trustees, including George Blumenthal and J. Pierpont Morgan. The museum recognized his service in 1907 with his election as a Fellow for Life. Hindered from sending members of its own staff by wartime transportation difficulties, the Metropolitan commissioned Seligmann to bid from a list of works compiled from the Degas sales catalogue by Bryson Burroughs. The museum's faith in Seligmann's judicious eye paid off in this significant first acquisition of works by Degas.[7]

MARY MORTON

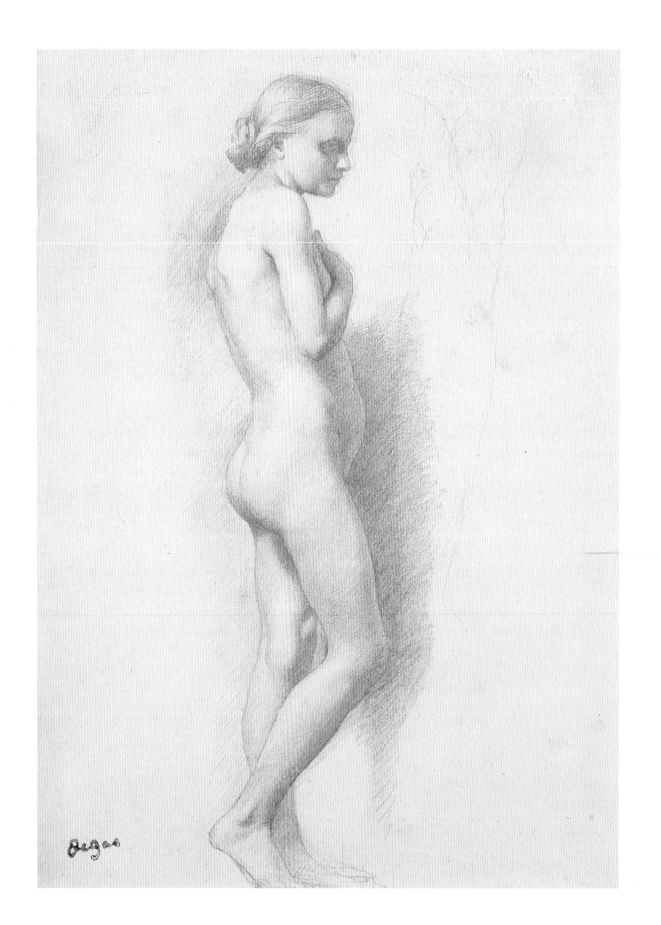

15. STANDING NUDE

ca. 1863
Graphite on paper
11½ × 8⁹⁄₁₆ inches
Sterling and Francine Clark Art Institute, 1955.1847

THIS DRAWING IS A CLASSIC EXAMPLE of the *académie,* a pencil drawing of a nude studio model conceived as an exercise in both anatomy and in handling transitions of light and shade. The pose the model has assumed here is also classical: she stands in *contrapposto,* in which the figure's weight is shifted to one leg and the arms flex or relax on opposite sides of the body. Developed as a pose in Greek sculpture of the fifth century B.C., *contrapposto* endured in traditional art from the Renaissance to Degas's own day as the bodily configuration that communicated a harmoniously balanced asymmetry. In choosing his view of the model from the side, however, Degas simultaneously pays homage to traditional form while stressing his own individual aesthetic. The unified S-curve ordinarily associated with this stance is preserved through the main line of the figure, but Degas encloses it in a pair of tight, undulating lines describing the front and back contours. The effect creates the same sense of balance as a traditionally constructed *contrapposto* but is more energized because of the emphasis on the implied transverse lines of the figure.

The disposition of light and shade adds a strong sculpturesque feel to the drawing. The effect is exaggerated by Degas's use of dark tones across the abdomen of the figure and in part of the background to the right. Close examination reveals that these areas (as well as the shading over the whole figure) are achieved principally through hatching. The extremely fine parallel lines describe not only the areas of light and shadow with great subtlety, but they also follow the projections and recesses of the body itself. The hatching thus reinforces the three-dimensionality of the figure, while it creates an active surface network of lines. As in his variation on a classic pose, Degas puts the hatching to work in an unconventional way. The artist's intimate familiarity with traditional forms and methods combines in this work with his restless experimentation.

Like *Two Studies of the Head of a Man* (cat. 3), this drawing was acquired in the fourth posthumous sale of 1919 (no. 109d), the first opportunity for American collectors to acquire works from Degas's studio. Unable to attend the sale himself, Sterling Clark seems to have simply placed his trust in Knoedler's judgment as to what to buy. A receipt in the Clark Art Institute's records shows that the dealer purchased one painting and eleven drawings on behalf of the collector, among them this early academic figural study.[1] Its purchase is significant for the testimony it provides to the dealer's and the collector's embrace of Degas's early academic training and his ambition to become a history painter—an aspect of his work later downplayed by some critics and art historians, who sought to emphasize his rejection of tradition rather than his connections to it.[2]

DAVID OGAWA

16. PORTRAIT OF EDMONDO MORBILLI

ca. 1865
Charcoal on cream paper
12⅛ × 9 inches
Museum of Fine Arts, Boston
Julia Knight Fox Fund, 1931, 31.433

THIS DRAWING IS A STUDY of the head of the artist's cousin Edmondo Morbilli (1837–1894) executed in preparation for the well-known painting of Edmondo and his wife, Degas's sister Thérèse (page 29, fig. 14). The drawing, done from life, most likely dates to June 1865, when the Morbillis were in Paris for the wedding of Degas's sister Marguerite to the architect Henri Fèvre.[1] The face emerges from a thin layer of wash applied to the paper; the plasticity of the forms is achieved through a series of planes described by quick, bold hatching. The planes of the shaded side of the face, moustache, and beard are similarly articulated by layers of bristly strokes, conveying a sense of visual activity reinforced by the dense, perky curls of hair on the top of the figure's head. At the center of this agitated tonal and linear play is the eye of Edmondo, staring with an intensity matching that of the artist's own gaze. Surrounded by an otherwise expressionless face, the eye is crucial and becomes the psychological center of gravity of the work. The disembodied eye in the upper right corner of the drawing suggests that its form and configuration preoccupied Degas.

Edmondo's left eye is indeed the most carefully rendered part of the drawing, revealing not only a sensitive outline but refined areas of hatching, setting it off from the paler planes of the face. Against the shadowed left side of the sitter's face, it seems to come forward, implying a turn of the head and reinforcing the effect of the sitter's engagement with the viewer. The effect of a strong psychological presence arises from the interaction between the visually steady eye and the expressive lines of beard, hair, and background. In this regard the drawing might also be read as preparatory to the odd psychological configuration of the double portrait. Like the eye in this drawing, in the painting Edmondo is a strong, impassive presence set against Thérèse's quiet agitation.

After Degas's death, both the drawing and the painting went from his studio to his brother René and emerged again at René's 1927 estate sale. Though their paths were slightly different, both works came to the United States through Wildenstein & Co., New York. The gallery acquired them from the René De Gas sale and sold the painting to Robert Treat Paine II of Boston before 1931, when he gave the work to the Museum of Fine Arts, Boston. The drawing, still in Wildenstein's stock, was then purchased by the Museum to complement this important gift. The drawing was exhibited twice in the early 1930s at the Fogg Art Museum in Cambridge and first became known to the public outside of New England when it traveled, along with the painting, to Philadelphia in 1936. Both works were shown separately several times thereafter, until the 1988 retrospective brought them together once again.

DAVID OGAWA

17. HEAD OF A WOMAN, STUDY FOR "A WOMAN SEATED BESIDE A VASE OF FLOWERS"

1865
Graphite on white wove paper
14 × 9¼ inches
Fogg Art Museum, Harvard University Art Museums
Bequest of Meta and Paul J. Sachs, 1965.253

THIS DRAWING IS A STUDY for the painting that is often (mistakenly) referred to as *Woman with Chrysanthemums* (see cat. 18). Previously thought to be a portrait of Madame Hertel, the subject has now been identified as Marguerite Valpinçon (née Bringuant), the wife of Degas's old school friend Paul Valpinçon.[1] Degas made a pencil sketch of the couple in 1861, the year of their marriage, and often stayed at their chateau at Ménil-Hubert in Normandy.

Degas captures the sitter in a moment of contemplation. She leans on her right arm, her hand propping up her chin as she thoughtfully gazes into the distance. Her hair is swept back from her face and enclosed in a lace-trimmed cap, from which a few delicate curls have escaped. One of Marguerite's most distinctive features was her large mouth, which is here partly obscured by the fingers of her right hand. The details of both hand and face—her dark eyes and eyebrows and slender nose—are carefully drawn, while the rest of the body is merely indicated, in the manner of Ingres. The work is signed and dated, a clear indication of its completion.

In the finished painting, the sitter is placed on the far right of the canvas, in front of an open window. She barely has room to lean her elbow on the table, which is dominated by an enormous arrangement of freshly cut, late-summer blooms. The addition of a number of props, such as a half-filled jug of water, a warm scarf, and a pair of gloves, connect the sitter with the task of picking and arranging the flowers and add a narrative element that is missing in the original study.

Head of a Woman was included in the first atelier sale (no. 312) and was bought by the dealer Paul Rosenberg (1881–1959) for 5,300 francs. Rosenberg was an important dealer of Impressionist pictures who ran a gallery in the rue la Boëtie in Paris.[2] He inherited a thriving business from his father, Léonce Rosenberg, and from the outset was able to invest in contemporary art. During the 1920s he supported a number of contemporary artists, giving contracts to Pablo Picasso, Georges Braque, and Fernand Léger. He also kept a large stock of Impressionist paintings, which he often sold for exorbitant sums. For example, in 1923 he offered Manet's *Le Bon Bock* to the Louvre for 1,800,000 francs, but the museum was unable to afford it. The Degas study of Mme. Valpinçon appears to have remained with Rosenberg until 1927, when it was acquired by Paul J. Sachs, associate director of the Fogg Art Museum. Sachs often lent works from his large collection of modern and old-master drawings for exhibition purposes, and the drawing was on loan to Harvard University Museums for several years before becoming part of the permanent collection in 1965.

FRANCES FOWLE

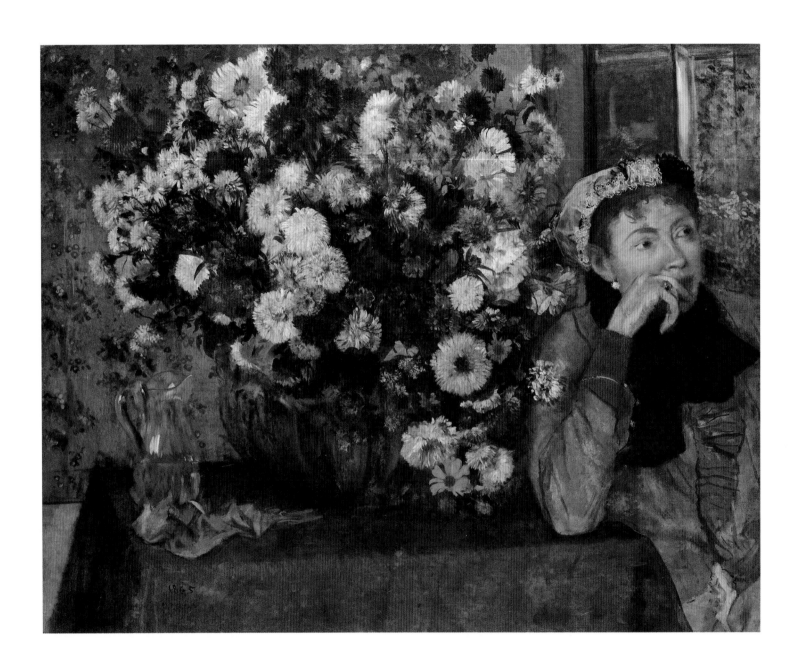

18. A Woman Seated Beside a Vase of Flowers (Madame Paul Valpinçon?)

1865
Oil on canvas
29 × 36½ inches
The Metropolitan Museum of Art
H. O. Havemeyer Collection
Bequest of Mrs. H. O. Havemeyer, 1929, 29.100.128
Lemoisne 125

THIS WORK EVOKES THE COMPLEX ASSOCIATION of women with nature in the nineteenth century. Degas's contemporaries Gustave Courbet, in *The Trellis* of 1862 (Toledo Museum of Art, Ohio), and Jean François Millet, in *Bouquet of Marguerites* of 1871–74 (Musée d'Orsay), created striking juxtapositions of botanical blooms and feminine beauty. Unlike these works, Degas situates his scene in an interior, showing this woman in a private moment. The scale of the floral arrangement seems to undermine the preeminence of the woman who rests beside it. By forcing the viewer to struggle with which element is the desired focus, Degas blurs the boundary between still life and portrait. The cut flowers have been carefully arranged and denaturalized just as the woman will be, once the rigors of public fashion have transformed her from this, her more private self. The glimpse of lush nature through the window at the far right of the painting suggests what unadulterated nature might be.

This work was handled and owned by some of the most important early dealers and collectors of Impressionism. Theo van Gogh, Vincent van Gogh's brother, who worked for the famous French art-dealing firm Goupil and Company, purchased the painting from Degas on July 22, 1887, for 4,000 francs. Van Gogh brought the work to The Hague office, where Emile Boivin purchased it on February 28, 1889. After Boivin's death the painting passed to his wife, whose heirs sold the work to the leading art dealer and patron of the Impressionist circle, Paul Durand-Ruel, on June 10, 1920. One of the most famous and indefatigable early collectors of Impressionist painting, Louisine Havemeyer, purchased the painting on January 28, 1921, for $30,000. It was part of the Havemeyer legacy to The Metropolitan Museum of Art bequeathed in 1929.

Louisine Waldron Elder, guided by her friend Mary Cassatt, purchased her first Degas, a pastel of a ballet rehearsal (page 36, fig. 1) for 500 francs at the age of sixteen. In 1883 Louisine married Henry Osborne Havemeyer. The Havemeyer and Elder families were partners in the sugar refining business. H. O. Havemeyer was an avid Asian art collector, having become fascinated with the displays at the Philadelphia Centennial Exhibition of 1876. The architect of the Sugar Refining Trust of 1887—which amalgamated seventeen interests and in two years rose in value to twenty-five million dollars—Havemeyer began to collect old master paintings, in particular Rembrandt portraits (see page 37, fig. 3), which were displayed in the Havemeyer mansion at 1 East 66th Street in a room designed by Louis Comfort Tiffany. With Cassatt's help, Louisine Havemeyer awakened her husband's interest in modern French paintings, prints, and sculpture as well as in the Spanish masters El Greco and Goya. The Havemeyers owned seventeen Cassatts, twenty-five Corots, forty-five Courbets, sixty-five Degases, twenty-five Manets, and thirty Monets. In her original will, Louisine Havemeyer left 113 works in H. O. Havemeyer's name to the Metropolitan Museum in New York; subsequent codicils and the generosity of herself and her children, Mrs. Adaline Frelinhuysen, Mr. Horace Havemeyer, and Mrs. Electra Webb, raised the bequest to 1,967 works of art.[1]

CLAIRE I. R. O'MAHONY

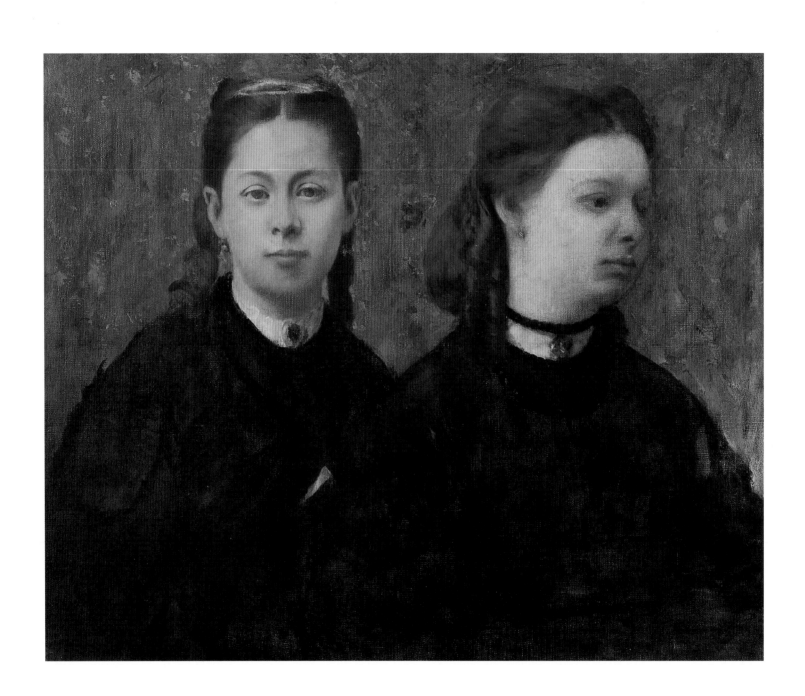

19. DOUBLE PORTRAIT—THE COUSINS OF THE PAINTER

1865–68
Oil on canvas
23½ × 28³⁄₁₆ inches
Wadsworth Atheneum, Hartford, Connecticut
The Ella Gallup Sumner and Mary Catlin Sumner Collection Fund, 1934.36
Lemoisne 169

THE SUBJECTS OF THIS PORTRAIT were the daughters of Stefania, Duchess of Montejasi-Cicerale, one of Degas's three Italian aunts. Elena, on the left, was born in 1855 and Camilla, on the right, in 1857. This portrait of Degas's Neapolitan relations is believed to have been painted between 1865 and 1868.

The composition of this double portrait is similar to that of another set of cousins, Giovanna and Giulia Bellelli (Los Angeles County Museum of Art), which was painted around the same time. The way that Degas closely paired the sisters may have been inspired by the work of Théodore Chassériau, whose painting *The Two Sisters* (Louvre) Degas probably knew.[1] However, unlike Chassériau, who stressed the physical and emotional kinship of his models, Degas created psychological tension by facing the sisters in different directions. Their dark clothing and serious expressions also create a sense of melancholy or mourning. Degas planned to do a series of images on mourning, and perhaps this work was intended as part of that series.[2]

The abstract manner in which Degas painted the background, dabbing and scumbling paint seemingly at random, is highly unusual. Even at this early point in his career, Degas raised the question of finish with such pictorial maneuvers. In other early portraits Degas took a more traditional approach to painting backgrounds. In his portrait of Hortense Valpinçon (cat. 24), for instance, he seemed to revel in the detailed painting of patterned fabrics and wallpapers.

This painting stayed in Degas's family for many years. In the late 1920s or early 1930s, Degas's niece Jeanne Fèvre sold it to New York dealer Henry Reinhardt. The painting apparently also passed through the hands of two other leading dealers of Degas's works, Durand-Ruel and Paul Rosenberg & Co., before it was purchased by the Wadsworth Atheneum in 1934. That year, the Atheneum lent it to one of the earliest monographic exhibitions of Degas's work held at the Marie Harriman Gallery in New York.

DAVID A. BRENNEMAN

20. VICTORIA DUBOURG

1865–68
Oil on canvas
32 × 25½ inches
Toledo Museum of Art
Gift of Mr. and Mrs. William E. Levis, 1963.45
Lemoisne 137

VICTORIA DUBOURG (1840–1926) was a gifted still-life painter whose serene images of fruit and flowers emulated the warm tonalities of the French eighteenth-century master of still life, Jean Baptiste Siméon Chardin (1699–1779). Her paintings were regularly accepted to the Paris Salon starting in 1869, when Degas painted this portrait. Dubourg married the still-life painter Henri Fantin-Latour in 1878. By this time she had achieved a reputation of her own, but appreciation of her art and career has been largely subsumed by her husband's fame until recent years.

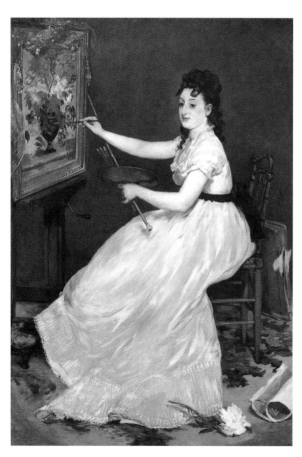

Édouard Manet (French, 1832–1883), *Eva Gonzales,* 1870, oil on canvas, 75¼ × 52½ inches, National Gallery, London, NG3259.

In this portrait Degas creates a subtle evocation of Dubourg as woman and as artist. She is shown not at work but in a bourgeois salon. A comparison with the pretty coquetry of Édouard Manet's 1870 portrait of another woman artist in this intimate circle, *Eva Gonzales,* underlines the vigor and professionalism that Degas accords to Dubourg even in these domestic surroundings. Degas abandoned his initial inclusion of a painting behind Dubourg's head—perhaps a Chardin still life of a pitcher—a device he used in his portrait of James Tissot (cat. 22). Instead, Degas focuses attention upon her intelligent, self-possessed gaze and her powerful hands, which she clasps confidently before her as she leans forward. The elegant sobriety of Dubourg's brown dress is in marked contrast to Gonzales's white flounces. The inclusion of a vase of lilac blossoms and roses and a blue and white Chinese porcelain on the mantelpiece beside her indicates her discerning taste.

Degas kept this painting until his death. It was sold in the first atelier sale in 1918 as *Portrait of a Woman in a Brown Dress* (no. 87); Mrs. Lazare Weiller purchased it for 71,000 francs. It was exhibited in the retrospective of Degas's work held at the Georges Petit Gallery in Paris in 1924. It passed through several collections in the interwar years, first entering Paul Louis Weiller's collection in Paris, before the New York art dealer Paul Rosenberg acquired it. Mr. and Mrs. William E. Levis of Perrysburg, Ohio, purchased the painting from Rosenberg in 1955. Levis (1890–1962) was the third generation of a family of successful glassmakers. Despite having received a law degree from the University of Illinois in 1913, he obeyed his family's wishes and entered the Illinois Glass Company as a car loader. He quickly rose through the ranks, becoming president in 1928. His achievements both in pioneering industrial innovations, such as glass fibers and container design, coupled with his orchestration of a merger with the Owens Bottle Company of Toledo earned him the Horatio Alger Award in 1955.

This painting was part of the Levis 1963 bequest to the Toledo Museum of Art, which included the work of another Impressionist, Cézanne, as well as paintings by Mabuse, Ruysdael, and Bronzino. The gift entered the collection permanently upon Mrs. Levis's death in 1982.

CLAIRE I. R. O'MAHONY

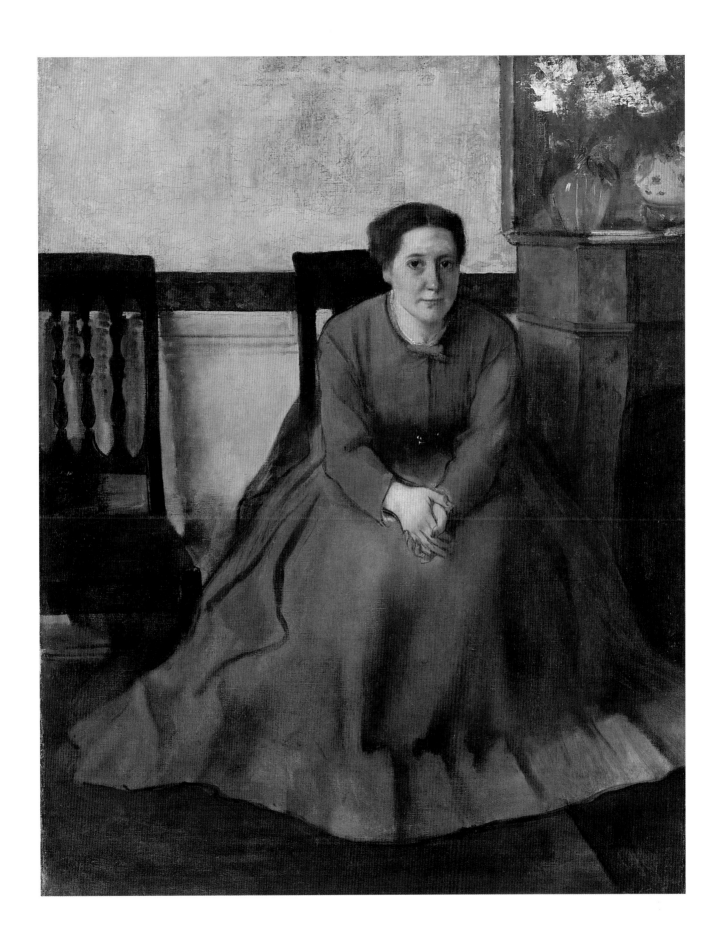

21. Study for "James-Jacques-Joseph Tissot"

1867–68
Black crayon on light brown wove paper
12¼ × 13⅞ inches
Fogg Art Museum, Harvard University Art Museums
Gift of César M. de Hauke, 1930.17

DEGAS DREW, ETCHED, AND PAINTED several portraits of fellow artists, including Édouard Manet (cat. 14), Mary Cassatt (page 16, fig. 1), and Léon Bonnat. This is a study for Degas's portrait of his friend James Tissot (cat. 22), which is now in The Metropolitan Museum of Art in New York. Although in the finished portrait Tissot is shown surrounded on three sides by paintings, in the study Degas gives us no indication of the sitter's profession. He is seated nonchalantly and at an angle, leaning back onto a desk or sideboard, his coat unbuttoned and his top hat discarded to the side. One has the impression that he has only recently entered the room, "a boulevardier who has happened into an artist's studio."[1]

Degas's overall aim was to create an informal portrait of his friend that would effectively capture the character of the artist. By 1869, Tissot was a highly successful artist with distinct social aspirations, who moved among the *beau-monde* and cultivated a style of fashionable, sober elegance. However, beneath his apparent aloofness and confidence, there was a less assured and even melancholic side to Tissot, which Degas sought to capture in the finished portrait. One of Degas's major concerns in the study is the compositional design. Tissot's pose cuts a diagonal line across the picture plane and the figure is positioned slightly off-center. The strong diagonal movement is balanced by a series of verticals, formed by the artist's coat, the back and leg of the chair, and the wall beam. This concern with composition is also seen in the finished painting, especially in the geometric lines of the various canvases in the studio. However, in the painting Tissot no longer dominates the picture space, but is dwarfed and constricted by his surroundings, pushed further into the back of the composition. Degas also alters his pose, which becomes far more awkward and unstable than in the study. He brings the legs together and directly across the side of the chair (which is now at right angles to the back wall) and reduces the height of the chair on which the artist is slumped. The left arm is slung across the back of the chair and the hands, which in the drawing are either clasped or lying across the artist's body, are drawn apart, the right hand toying with a long cane, to give Tissot more the appearance of a dandy. As Emil Maurer comments, "The pose reveals his friend as a dandy, a smart operator, an adaptable artist who has 'arrived.'"[2]

The study was included in the third atelier sale (no. 158a) and acquired by the French dealer Fiquet, a partner in the Paris firm of Nunès et Fiquet, for 1,500 francs. It was then sold to the collector César M. de Hauke, who moved with ease between Paris and New York and had residences in both cities. De Hauke's collection included a large number of Degas drawings and monotypes, some of which were eventually bequeathed to the British Museum in London in 1968. This particular work remained in the de Hauke collection until 1930, when it was given to the Fogg Art Museum.

FRANCES FOWLE

22. JAMES-JACQUES-JOSEPH TISSOT

ca. 1867–68
Oil on canvas
59⅝ × 44 inches
The Metropolitan Museum of Art
Rogers Fund, 1939, 39.161
Lemoisne 175

JAMES-JACQUES-JOSEPH TISSOT's lavish paintings of fashionable society were greatly admired when they were exhibited at the Paris Salon from the 1860s through the 1880s. Tissot (1836–1902) underwent a spiritual awakening around 1890 and devoted himself entirely to religious subjects for the remainder of his career. Degas and Tissot's friendship, captured in this portrait, suggests the inaccuracy of rigid style labels of "Impressionist" and "Salon" painter. Both artists enrolled at the École des Beaux-Arts in Paris as pupils of Louis Lamothe (1822–1869), a follower of Ingres. However, it seems likely that another artist from Tissot's hometown of Nantes, Élie Delaunay, first introduced Degas to Tissot in the early 1860s. Their rich and lengthy correspondence indicates that Degas and Tissot remained intimate friends until the mid-1870s, despite apocryphal anecdotes claiming that their different choices during the Paris Commune of 1871 caused an earlier rupture.

This painting is one of the largest and most elaborate of Degas's 1860s portraits. Degas presents Tissot as the epitome of the Parisian dandy, just as Henri Fantin-Latour presented Édouard Manet (Art Institute of Chicago). In his famous essay "The Painter of Modern Life," poet and art critic Charles Baudelaire championed the Parisian man-about-town, or *flâneur* (from the colloquial word for strolling), a passionate spectator of modern life, anxious yet exhilarated as he roams the boulevards. In Degas's portrait, Tissot, having flung his coat and hat aside, lounges but remains tense, playing with his cane somewhat distractedly. He is surrounded on all sides by a variety of artworks. Theodore Reff has identified the paintings as Cranach's portrait *Frederic III the Wise* (Louvre) in the center, a western copy of a Makimono scroll painting above it, a contemporary genre scene on the easel, and a composition of Moses saved

from the waters leaning against the wall behind the easel. Each work evokes a different genre and style with which Tissot experimented in the 1860s: anecdotal history paintings, *Japonaiseries,* fashionable portraits of contemporary Parisian society, and history subjects reminiscent of the sixteenth- and seventeenth-century Venetian masters, whom both Degas and Tissot admired.

Degas kept this work in his studio until his death. Joseph Hessel, an art dealer and patron of the French Nabi artist Edouard Vuillard, purchased it from the first studio sale in 1918 for 25,700 francs (no. 37). Three years later Hessel consigned the work to Paul Durand-Ruel, who sold it a month later from his New York gallery to financier Adolph Lewisohn for $1,400. Born in Hamburg, Lewisohn made his fortune in copper, gold, and silver mining conglomerates in North and South America. He made huge donations to education, financing the Mining Building and Stadium of Columbia as well as various Jewish charitable institutions. Lewisohn's collection of early nineteenth-century and Impressionist painting was enlarged by his son Samuel to include works by the Post-Impressionists—most notably the study for Seurat's *Grande Jatte*—and contemporary artists such as Picasso and Diego Rivera as well as many American artists. Samuel Lewisohn was an important force in American art and politics of the 1920s and 1930s. He was a founding board member of The Museum of Modern Art, resigning from his post only a year before his death in 1951 in protest of Alfred H. Barr's acquisitions policy. He was also a key force in the prison reforms undertaken during the Roosevelt administration, especially the establishment of the parole system. After Adolph Lewisohn's death in 1938, The Metropolitan Museum of Art acquired this painting from Jacques Seligmann.

CLAIRE I. R. O'MAHONY

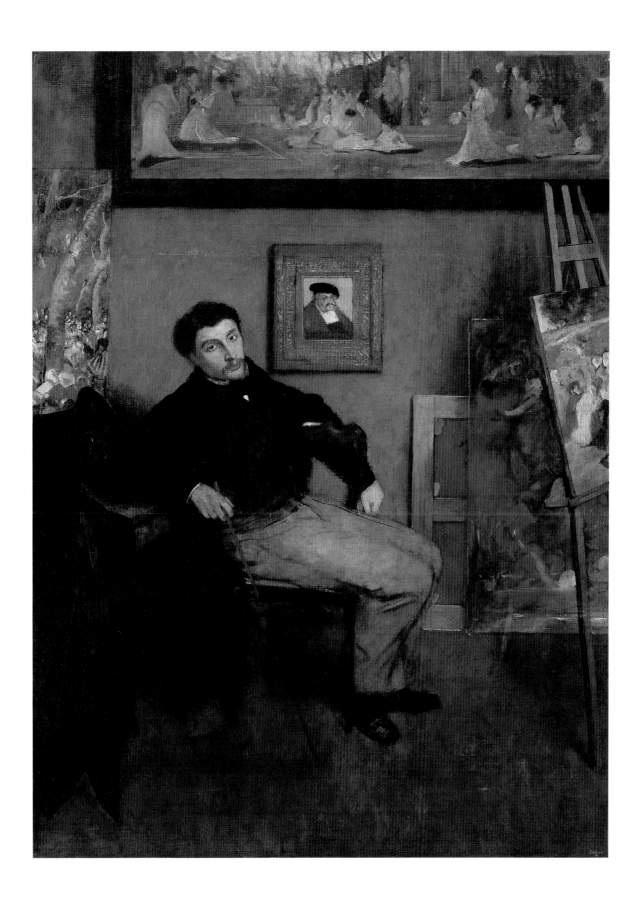

23. ACHILLE DE GAS

1868–72
Oil and graphite on paper, laid down on canvas
14½ × 9¼ inches
The Minneapolis Institute of Arts
Bequest of Putnam Dana McMillan, 1961.36.8
Lemoisne 307

ACHILLE DE GAS (1838–1893), the elder of Degas's two younger brothers, frequently served as a model early in the artist's career. Instances include portrait sketches from the 1850s, a formal portrait,[1] and his inclusion in the group portrait of 1873, *The Cotton Office in New Orleans* (Musée des Beaux-Arts, Pau). However, Degas also employed Achille as a model for figures in his paintings centered upon the world of horse racing.[2] Although the present sketch is a preparatory figure study for *At the Races: The Jockeys* of ca. 1868–72 (Weil Brothers Collection, Montgomery, Alabama), the degree of finish and the assured manner with which Degas portrays the nonchalant elegance of his sibling ranks the work as independent, informal portraiture.[3]

Indeed, the oil and graphite sketch had been considered a work of independent nature until its relationship to *At the Races: The Jockeys* was revealed in 1959 during cleaning of that painting.[4] When Achille's feminine companion with field glasses was also uncovered, the relationship of another preparatory study to the painting, as well as the sequence for the development of the foreground figures, was clearly established, with this preparatory study of Achille being the first the artist realized on canvas.[5] This discovery places the date for the Minneapolis work toward the early part of the period suggested for execution of the painting (ca. 1868–72).[6]

The debonair attitude struck by Achille belies Degas's struggle to establish a pose before achieving a satisfactory reso-

lution. Pencil outlines in the regions of Achille's hat, proper right shoulder, both arms, proper left leg, and the furled umbrella show that the artist adjusted some of these elements as many as four times. Once the form was determined, however, the artist lavished his attention on the face of his brother, framing it in high contrast between the black hat and the bright white pigment of the collar that is flecked throughout with brilliant blue.

At some point this oil and graphite study passed into the possession of René De Gas, the artist's youngest brother, with whom it remained until his death. Following the sale of René's property at the Hôtel Drouot in 1927, the sketch was acquired by Chester Dale of New York. Dale, who had made his fortune on Wall Street, was also an adept collector noted for his holdings of nineteenth-century French art. Eventually, the sketch was sent to auction at Parke-Bernet in 1944 and purchased by Jacques Seligmann and Co. of New York, from which it was acquired by Putnam Dana McMillan on February 11, 1949. McMillan, a Minneapolis native, was vice president of General Mills and the founder of a highly successful real estate company. He was also a keen collector of French art from the late nineteenth and early twentieth century.[7] His loyalty to The Minneapolis Institute of Arts was demonstrated through his long service as a trustee, his frequent acquisitions of objects on its behalf, and, finally, the bequest of his collection in 1961.

PATRICIA S. CANTERBURY

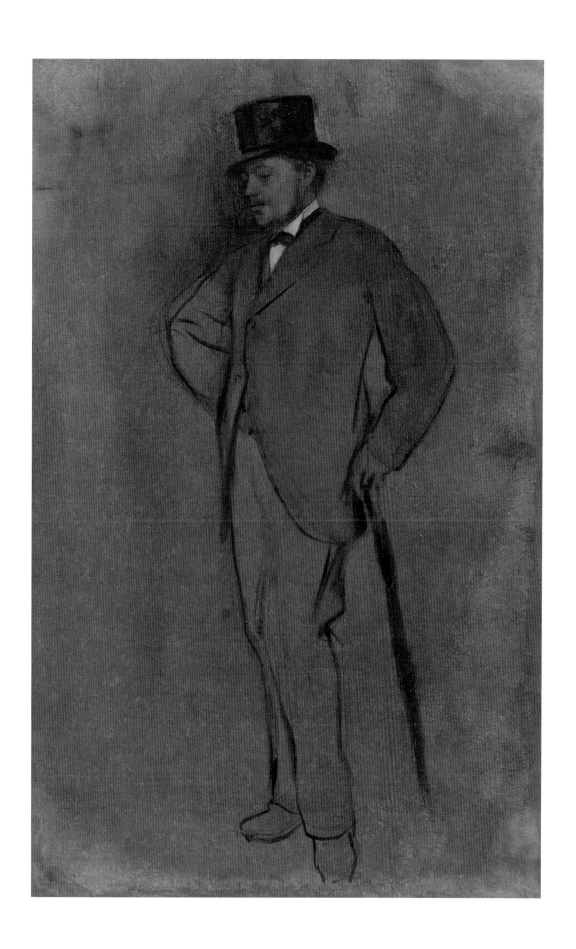

24. PORTRAIT OF MLLE. HORTENSE VALPINÇON

1871
Oil on mattress casing (ticking)
29¹⁵⁄₁₆ × 43⅝ inches
The Minneapolis Institute of Arts
The John R. Van Derlip Fund, 1948.1
Lemoisne 206

THROUGHOUT HIS LIFE, Degas was a frequent guest at Ménil-Hubert, the country estate of his childhood friend Paul Valpinçon (cat. 2). The estate, located at Orne in Normandy, offered the artist a pleasant change of scenery as well as a family of captive yet willing models, whom the artist depicted on numerous occasions. Degas's portrayal of his host's eldest child and only daughter, Hortense, stands as one of the most memorable products of those visits and, perhaps, the most winning depiction of a child from the artist's long career.

Degas's *Portrait of Mlle. Hortense Valpinçon* is a visual recitation of those elements the artist considered essential to modern portraiture. His resolve to explore the expressive possibilities of the genre by depicting people in familiar and typical attitudes[1] resulted in portrayals that were distinguished for their unpretentiousness and psychological directness. Such is Degas's achievement here. Hortense meets the viewer's gaze with an inquisitive, appraising, and almost sagacious air; the result is the evocation of a suspended, spontaneous moment.

Although the unsigned canvas has been variously dated to either 1869 or 1871, based on documented visits by the artist to Ménil-Hubert, the freer handling and simplified background of the portrait all point to the latter date.[2] The compression of forms and patterns into a single visual plane also reflects Degas's growing interest in the aesthetics of Japanese composition and, consequently, also suggests a strong kinship with his works of the 1870s.

The circumstances surrounding the portrait's creation were documented many years later in an interview with the sitter—then Mme. Jacques Fourchy. These recollections have sometimes been discounted as the faded, anecdotal reminiscences of a woman caught in the twilight of her years. However, conservation and technical examination of the painting have proved, to the contrary, the accuracy of Hortense's memory. For instance, her claim that Degas found it necessary to use a remnant of mattress ticking for canvas was substantiated in 1996 when the variegated pattern of blue-and-white striping was discovered at the taped edges of the work.[3] More recent claims that the painting was originally intended as a double portrait[4] (a detail that does not figure in Hortense's story) were contradicted by infrared photography and X-radiography.

The portrait, unfinished and unsigned,[5] became part of the Valpinçon family's substantial holdings of works by Degas, passing from Paul Valpinçon to his daughter, Mme. Jacques Fourchy, with whom it remained until its transfer by purchase, in 1930, to Wildenstein & Co. of Paris.[6] In spite of the painting's beauty, superb provenance, and frequent exposure in numerous high-profile exhibitions, it remained unsold for seventeen years until its acquisition on December 17, 1947, by The Minneapolis Institute of Arts.[7]

PATRICIA S. CANTERBURY

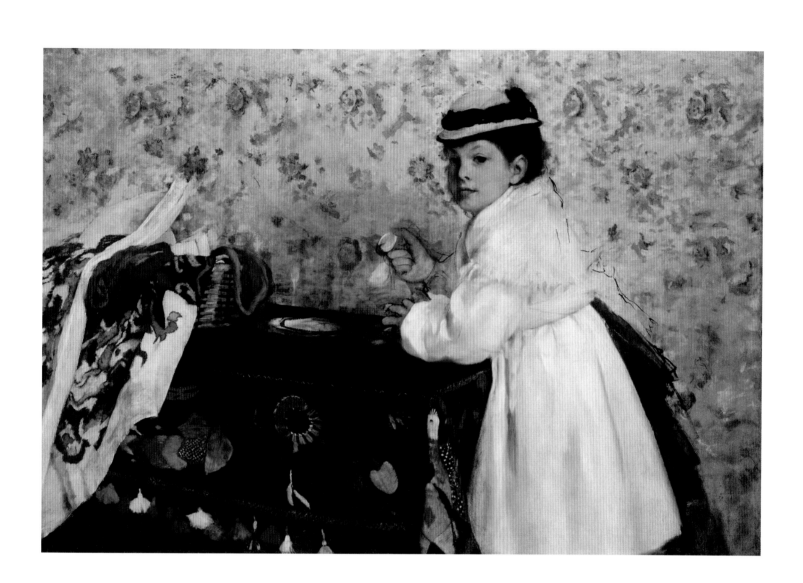

25. THE RACES

Before 1873
Oil on panel
10½ × 13¾ inches
National Gallery of Art, Washington, D.C.
Widener Collection, 1942, 1942.9.18
Lemoisne 317

JUST AS HE PREFERRED to observe ballet dancers offstage, Degas often focused on the moment just before a race, when the jockeys were beginning to line up. *The Races* is one of a series of small panels that the artist produced during the early 1870s. The picture is distinguished by its generally dark palette and low horizon line, and the composition, with the distant sky-line pierced here and there by smokestacks and the towers of a church on a distant hill, is reminiscent of an early Ruisdael. Two-thirds of the canvas is devoted to sky—a vast expanse of blues, violets, and pinks—and the gray, rain-filled clouds that move across its surface recall the skyscapes of Etretat and Villers-sur-Mer, where Degas was sketching in the summer of 1869.

In general, the picture is fairly flat: the horses merge with the dark pigment of the racetrack, and even the jockeys' silks and caps are camouflaged against the backdrop of the city. The red cap of the jockey in pink could double as the sloping roof of a distant house, and the blue sleeves and cap of his neighbor echo the sky above. The most brilliant note of color and movement is provided by the yellow jacket of the jockey in the center of the painting. As he struggles to gain control of his horse, he leans slightly to his right, drawing the eye toward two somber officials in top hats, who are waiting to announce the start of the race. The composition and the landscape open out on the right, where a solitary white fencepost points toward a distant group of galloping horses and beyond them a pair of chimneys, their smoke mingling with the shifting clouds above. To the far right of the picture, another jockey canters toward the waiting group, his black cap rising just above the horizon line.

Degas relied on memory and, often, wooden horses or chessmen to plan his racecourse pictures. Ambroise Vollard described a visit to Degas's studio, when "Degas picked up a little wooden horse from his worktable, and examined it thoughtfully. 'When I come back from the races, I use these as models. I could not get along without them. You can't turn live horses around to get the proper effects of light.'"[1]

This work was bought from the artist by the dealer Paul Durand-Ruel in April 1872 and sold on May 7, 1873, to the famous operatic baritone Jean-Baptiste Faure (1830–1914). Faure was an early collector of Impressionism, and during the 1870s he acquired eleven works by Degas—the largest collection in France at that time—including four scenes at the racetrack.[2] Faure returned the picture to Durand-Ruel in February 1881, and before long it was bought by Jules Féder, a Parisian banker, who supported Durand-Ruel financially in the early 1880s. In the mid-1880s, when Durand-Ruel was promoting the Impressionists in New York, the picture found its way into the collection of Erwin Davis, a New York businessman.[3] Davis began collecting Impressionist pictures in 1881 and owned works by Manet and Degas as well as about twenty works by Monet. He was forced to sell the bulk of his collection, including *The Races*, in New York on March 19, 1889, when the picture was sold to the Scottish dealers Cottier & Co., who had branches in New York, London, Glasgow, and Sydney, Australia. In 1894 the picture was bought by Peter A. B. Widener of Elkins Park, Pennsylvania, and remained in his collection until his death in 1915. It was inherited by Joseph E. Widener and given to the National Gallery of Art, Washington, D.C., in 1942.

FRANCES FOWLE

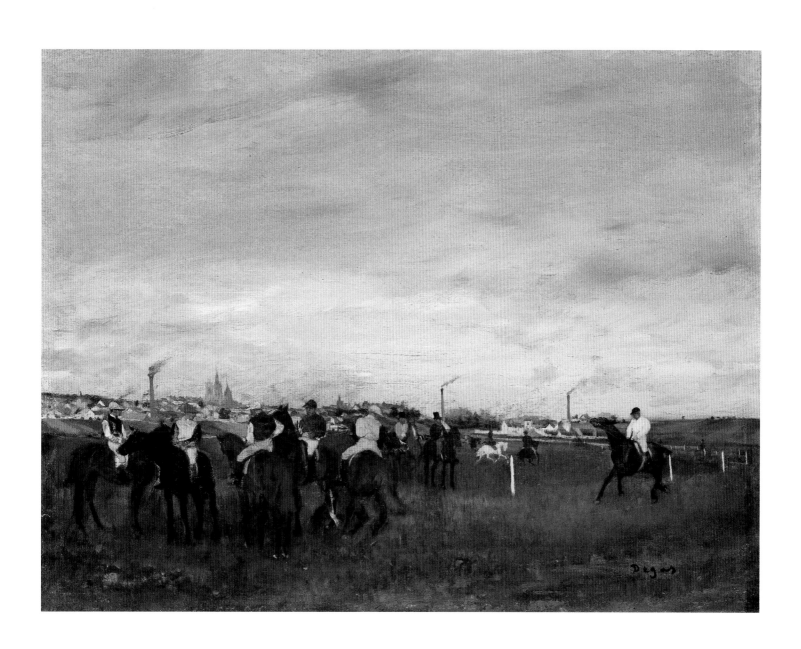

26. SEATED DANCER

1872
Graphite and essence on pink paper
10¹⁵⁄₁₆ × 8¹¹⁄₁₆ inches
The Pierpont Morgan Library, Thaw Collection
Lemoisne 299

THE NAME DEGAS is routinely associated with ballet dancers in popular culture, which has produced innumerable imitations. The artist began to investigate the ballet around 1870 as part of his study of movements and gestures as expressions of the animating force of the human psyche. In previous years he had begun a series of works on horse racing with a similar obsession with detailed observations that he continued parallel to the ballet images. In the process Degas accumulated a store of visual memories that he used to produce a series of images of such extraordinary power that they convey at times a distinct sense of living, breathing reality.

Such a work is the brilliant *Dance Class at the Opéra,* for which Degas made this study. In the study, the seated dancer is turned away from the viewer; her back and limbs seem abandoned to easy repose. In the painting, the dancer is turned slightly, bring-

ing her face into view; she assumes a more dynamic stance with a straight back, her leg outstretched in anticipation of immediate action. The study of the relaxed dancer is brushed swiftly and energetically in diluted oil paint, called *essence.*

Degas was complaining of weakening eyesight at the time he was painting small, detailed pictures such as the *Dance Class.* Letters from his youngest brother René to his uncle in New Orleans report that "his eyes are very weak, and he is forced to use them with the greatest caution."[1] Aggravating problems with his eyes followed Degas into old age and undoubtedly contributed to his stylistic changes over the next decades.

Although his father and two brothers expressed great admiration for his work, Degas had received only scant critical acclaim until the beginning of the 1870s. Nor did he sell much during these early years. It was not until 1872 that the dealer Paul Durand-Ruel bought three paintings from him.

Seated Dancer was sold to Degas's brother René in 1918 at the second estate sale after his death (no. 231). At René's estate sale in 1927, it was bought by the dealer Rodier. Next, Galerie Georges Petit acquired the study, and in 1928 John Nicholas Brown, an important New England collector, purchased it from Wildenstein's in New York. The study was on view in Cambridge, Massachusetts, in 1929, and at the Rhode Island School of Design in 1931. It was included in the Degas exhibition in Philadelphia in 1936. From 1941 to 1946 it was on loan to the Joslyn Art Museum. The heirs of Brown held the study until 1986, when it was sold through the dealer David Tunick to Eugene Victor Thaw, a prominent New York dealer and collector. The drawing is currently on loan to The Pierpont Morgan Library along with other promised gifts.

GUDMUND VIGTEL

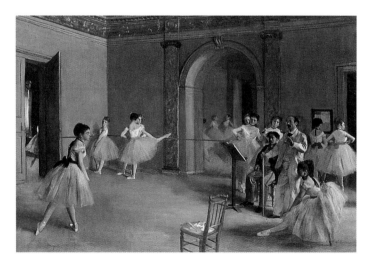

Dance Class at the Opéra, 1872, oil on canvas, 12⅝ × 18⅛ inches, Musée d'Orsay, Paris.

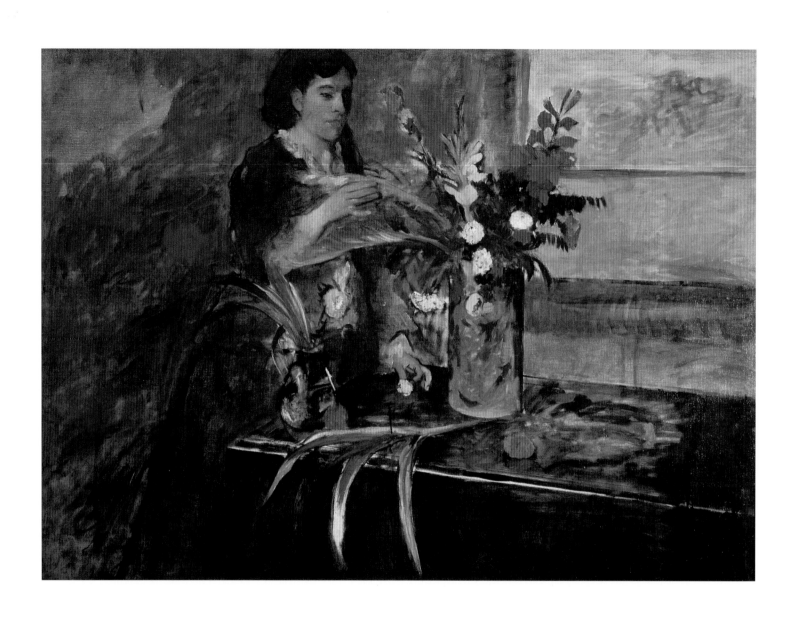

27. Portrait of Mme. René De Gas, née Estelle Musson

1872–73
Oil on canvas
39⅜ × 54 inches
New Orleans Museum of Art
Museum purchase through Public Subscription, 65.1
Lemoisne 306

During the nearly five months Degas spent with his mother's family in New Orleans, from late October 1872 to the middle of March 1873, he painted and drew a number of portraits of his first cousins, none of them larger or finer than that of his brother René's wife Estelle. The painting has a modern sophistication in the free brush strokes, in the unusual contrasts in its coloration, and in the elegant, asymmetrical composition. The boldly painted flowers and foliage, charged with aggressive energy, nearly overwhelm the serene figure blending into the warm darkness of the background, beyond the reach of the light streaming in from the open window. Degas took the painting back with him to Paris, where he added strips of canvas to the top and bottom with the intention, ultimately unrealized, of enlarging the composition. The added strips were removed after the artist's death.

René had gone to New Orleans in 1865 to work in the cotton business for his uncle, Estelle's father. He had met Estelle two years earlier when she came to France with her mother and sister (where Degas did a group portrait of the three) to escape the Civil War and the indignities of Union soldiers' occupation of New Orleans. She had lost her first husband in the war, and she accepted René's proposal after he settled in New Orleans. They were married in 1869.

Degas decided in 1872 to visit his family in New Orleans, traveling with René, who had been in Europe on a business trip. By that time Estelle had developed serious problems with her eyes. Degas, who also suffered from increasing weakness in his eyes, apparently developed a particular affection for Estelle, with whom he shared a love for music. He painted three portraits of her before he returned to Paris.[1]

By the time he arrived in New Orleans, Degas had a highly developed style of portraiture, in which he expressed the personality and experiences of his subject in the pose, demeanor, and surroundings of the individual. Estelle's advancing blindness can be read into her withdrawal within the sheltering darkness of the room from the vibrant flowers and the bright, open window. Her handsome, introverted face could suggest her pregnancy, which the pink flowers almost touching her waist seem to indicate. The portrait is a statement of intimate and affectionate understanding.

The portrait of Estelle De Gas was in the first atelier sale in 1918 (no. 12), where it was purchased by the dealer and collector Jacques Seligmann, who organized the first major American auction of Degas's work in New York in 1921; it was purchased in New York by the Paris dealer Ambroise Vollard, who sold it to Pr. Cremetti of London. The portrait passed through a number of European private collections before it came into the possession of the New York dealer E. V. Thaw. When the painting appeared on the market in 1965, it was acquired by the New Orleans Museum of Art through a broad public appeal for support carried, in part, on national television.

Gudmund Vigtel

28. THE SONG REHEARSAL

1872–73
Oil on canvas
31⅞ × 25⅝ inches
Dumbarton Oaks Research Library and Collection,
Washington, D.C.
House Collection, HC.P.1918.02(O)
Lemoisne 331

EDGAR DEGAS MADE ONE TRIP to America, the only French Impressionist ever to do so. In October 1872 he traveled with his brother René to New Orleans, his mother's birthplace, where he stayed with his uncle Michel Musson and Musson's family. During his five-month stay, the not-yet famous Degas despaired of being equal to the task of capturing "the true character" of the New World on canvas. Nonetheless, Degas quickly established an enjoyable bond with his American family, and it was they who became the sole subjects of his artistic studies and experiments during this period.

The Song Rehearsal is likely the product of Degas's New Orleans visit. Certain elements—the tropical houseplant and white slipcovers on the parlor furniture, for example—suggest a New Orleans setting. Two unusually large, reworked pencil studies for the painting's principal figures (Musée d'Orsay)[1] show that Degas labored over certain figural gestures and expressions as well as over the room's perspective.[2] The same *pentimenti* in the drawings are easily visible in the painting itself. In particular, Degas reconceived the left figure, to whom he gave not only a new commanding gesture in place of the original more imploring one but also a more youthful face.[3] Degas mostly painted out the bottom of a chaise longue, turning it into a *bergère*, thereby opening up the composition and deepening the perspective. The highly dramatic exchange in the painting between the two singers is intently witnessed by the otherwise indistinct figure of the male accompanist. The identity of the original models for these figures is uncertain, and any number of Degas's family members or their friends might have served.[4] The paint-

ing was never signed nor exhibited or offered for sale during Degas's lifetime.

Mildred and Robert Woods Bliss purchased the painting on May 7, 1918, at the first atelier sale (no. 106). In order to protect their anonymity in this purchase, the record price of 100,000 francs was bid by their close friend and advisor, the American expatriate artist Walter Gay. This created some confusion in the press, and on the next day Roger Valbelle reported in the *Excelsior* that Gay was rumored to have made the purchase for the Metropolitan Museum of Art. He added that others believed the painting was to enrich the private collection of an American woman living in France, who had sold her pearl necklace in order to acquire the master's work.[5] According to Hugo Vickers, Gladys, Duchess of Marlborough, recalled the atelier sale "as 'fearfully exciting' and watched in fascination as Mrs. Robert Woods Bliss, of Dumbarton Oaks, climbed 'the ladder of prices' and bought a very good Degas. 'As her purse is castor oil, I should think it must be fat enough to draw upon,' commented Gladys. 'Her expression during the bidding became so rapacious that it stirred even Mr. B. [Walter Berry, then president of the American Chamber of Commerce] into laughter.'"[6] The next day, on May 9, Matilda Gay, the artist's wife, wrote in her diary, "Lunched with Mildred Bliss. . . . Mildred, who has just bought the famous Degas 'La leçon de musique' through the ministrations of Walter Gay, was carrying the picture about the room in her arms like a new toy, and together she and W. G. were studying where to hang it."[7]

JAMES N. CARDER

29. RACE HORSES AT LONGCHAMP

1873–75
Oil on canvas
13⅜ × 16½ inches
Museum of Fine Arts, Boston, S. A. Denio Collection, 03.1034
Lemoisne 334

IN THIS LUMINOUS WORK, Degas captures a rare moment of calm in horse racing, a sport more typically associated with speed and anticipation. Degas arranges the horses and their riders to create a random visual pattern across the plunging, featureless expanse of the course, a device reminiscent of Japanese print compositions. The graceful suspended energy of the horses' desultory movements is disrupted only on the far left of the canvas by one startled horse ridden by a jockey in blue. The painting's gentle color harmonies—the violets and peaches of the twilight sky and the muted browns and blacks of the horses—infuse the composition with a dulcet radiance, while the garish silks of the jockeys' garb create a livelier tempo.

The races were a key motif in Degas's work throughout the 1860s, 1870s, and 1880s. He was fascinated both with the panorama of high and low society among the spectators and the graceful, elongated forms of the human and animal contestants. In the 1830s horse racing was associated with the British aristocracy and, like all things English, it became the vogue among the French upper echelons. The Jockey Club was founded in 1833 and the Société des Steeplechases de France in 1863. This painting depicts the racecourse at Longchamp, which opened in 1857 on the site of a former convent in the Bois de Boulogne, part of the many architectural transformations of Paris supervised by Napoleon III's Prefect of the Seine, Baron Haussmann. In the far distance Degas loosely evokes the village of Suresnes on the slopes of Mont Valérian across the Seine.[1]

Race Horses at Longchamp, purchased by the Museum of Fine Arts, Boston, in 1903, was the first painting by Degas to be acquired by an American museum. Its early provenance remains unclear, but Paul Durand-Ruel purchased the work from the Berheim-Jeune Gallery in Paris on February 10, 1900. Durand-Ruel then deposited the painting with several dealers—first with Cassirer of Berlin and then with Whitaker of Montreal in December 1900—before the work was sent to Durand-Ruel's New York gallery on February 18, 1901. Mrs. William H. Moore held it in her collection for three days before returning the work to the gallery on April 1, 1901. The Museum of Fine Arts, Boston, purchased the painting in 1903 from Durand-Ruel with funds given to the museum by Sylvanus Adams Denio.

Having been housed in cramped quarters in the third floor galleries of the Boston Athenaeum on Beacon Street, the Museum of Fine Arts opened in Copley Square, the new cultural center of Boston, on July 4, 1876, making it one of America's oldest museums. (The 1870s also saw the founding of The Metropolitan Museum of Art in New York and the Corcoran Gallery of Art in Washington, D.C.) The decision to purchase *Race Horses at Longchamp* may have coincided with plans to expand the museum, which, in 1909, moved into a new building, designed by Guy Lowell, in the Fenway district. The initial core of the art collection had been amassed by the Boston Athenaeum but was embellished by many subsequent bequests and financial donations, such as the Denio Fund, which allowed further acquisitions. Many of the Museum of Fine Arts's Impressionist and Post-Impressionist works were bequests made in the 1920s by local collectors, who may have been encouraged in their purchasing of these works by the Museum's foresight in acquiring *Race Horses at Longchamp*.[2]

CLAIRE I. R. O'MAHONY

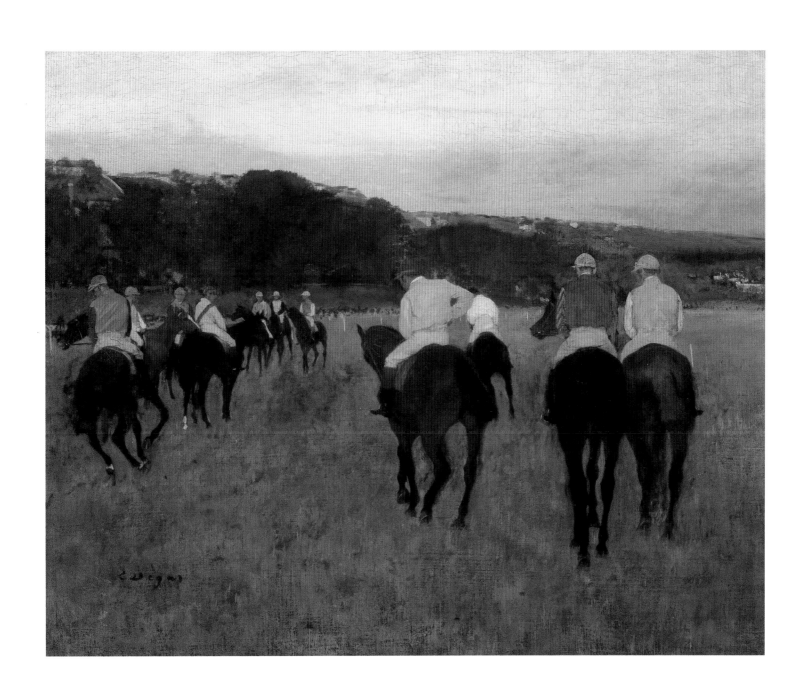

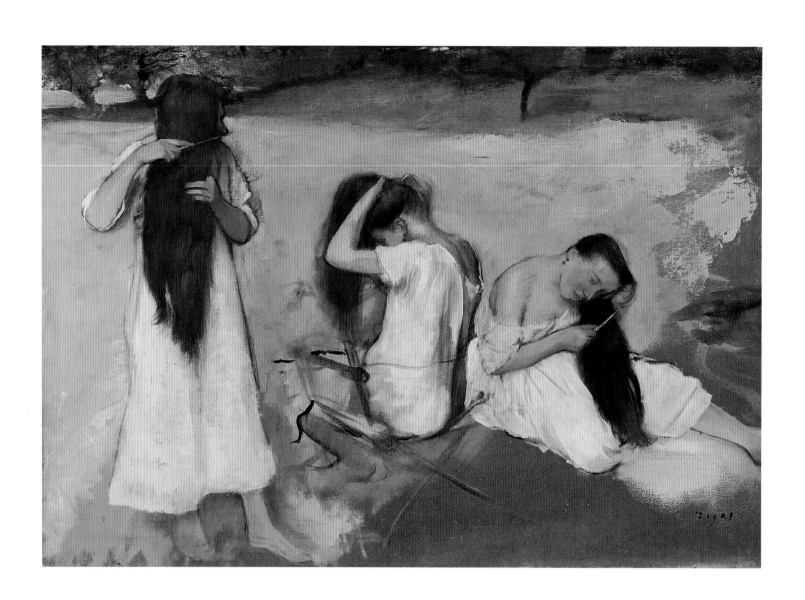

30. WOMEN COMBING THEIR HAIR

1875
Oil on paper mounted on canvas
12¾ × 18⅛ inches
The Phillips Collection, Washington, D.C., 0482
Lemoisne 376

WOMEN'S HAIR HAS OFTEN held a fascination for artists, who have used it to suggest their subjects' sexuality. Fashions of the Victorian age required women's hair to be full and arranged in extravagant coiffures that inspired many a portrait painter. No artist at that time depicted hair in more deliberate ways than Edvard Munch, who used it to indicate woman's seductive guile. Degas, on the other hand, painted hair for its shimmering color and body and used it to describe the flowing rhythms in a woman's form. The subject of women bathing and grooming was to become increasingly prevalent in Degas's art. These subjects gave him the opportunity not merely to describe unconventional movements and poses, but also to give psychological interpretations of women engaged in such private, unselfconscious activities.

Women Combing Their Hair shows three figures involved in their intimate task—unobserved in their easy, sisterly activity—in broad daylight on a sandy beach. In composing this painting, Degas actually used one model in three different poses, arranged in casual placements. Using a design that linked the different stances of the figures and the active play of arms and hands, Degas cunningly brought about the impression of flowing movement.

The figures were apparently drawn in the nude before Degas covered them with white chemises, which create a strong chromatic counterpoint to the auburns, the pinks, and the variations of brown and ochre of the women's hair, skin, and surrounding landscape. Degas's brilliant drawing is evident in the relaxed postures of the figures and in the formation of the arms and hands, a mastery based on his relentless study of nature, the practice that put him at the forefront of his contemporaries who called themselves Realists.

Degas had met Édouard Manet in 1862, and the two artists carried on a friendship marked by friction but also by their similar aims in art. Unlike Manet, who wished to exhibit his work in the Salons, Degas was drawn to the Impressionists. Degas participated in all but one of the eight Impressionist exhibitions. The critics who considered him a leading representative of the Realist movement failed to understand his relationship to the Impressionists' "color daubings." What bound Degas and the Impressionists together was the wish to depict contemporary life and to discard the unreal visions of the academics.

The Parisian composer and painter Henri Lerolle bought the painting from the artist in 1878. Lerolle was a friend of Degas. He later became an important patron of the Symbolist painter Maurice Denis. After Lerolle's death in 1929 the painting remained with his widow. It was with the New York dealer Carstairs after 1936. He sold it to Duncan Phillips in 1940. Phillips had begun to collect art in the teens and in 1921 opened his Washington, D.C., home to display art to the public. By the time of his death in 1966, Phillips had accumulated a distinguished collection of nineteenth- and twentieth-century French and American art for the enjoyment of the public in his museumlike house.

GUDMUND VIGTEL

31. The Singer

1875–80
Pastel over monotype
6¼ × 4½ inches
Reading Public Museum, Reading, Pennsylvania
Bequest of Martha C. Dick, 76.46.1
Lemoisne 462, Janis 43

DEGAS WAS A REGULAR VISITOR to the popular café-concerts situated along the leafy Champs Elysées in Paris. The fluted columns and gas globes in this pastel identify the location as one of Degas's most frequent haunts, the celebrated Café des Ambassadeurs. The singer, on the other hand, is one of the many anonymous female performers whom Degas captured in pastel and monotype.

A contemporary description of the café-concert gives us a sense of the dynamics of these performances:

> The curtain rising reveals a prettily arranged stage, around which are seated a dozen or more young women, some dressed for the ballet, but all extremely bare about the shoulders. Their toilettes are exquisite, and some of the women are pretty, but the majority are barely passably good-looking. They are the performers of the evening, and as they are needed during the progress of the entertainment, retire through a door at the rear before presenting themselves at the footlights. The object of the manager appears to be to keep as many of them as possible constantly before the gaze of the audience, and as soon as a performer is through with her part she returns to her seat on the stage.[1]

In this work Degas has used the monotype process to create strong tonal contrasts, adding touches of pastel to convey the effect of artificial light in an outdoor evening setting. The glowing light of the gas lamps illuminates the fluted columns of the proscenium and the gesturing arms of the singer as she performs on the outdoor stage. The singer is viewed from behind, capturing her rather plain features in profile and allowing us to catch a glimpse of the spectators, seated at their tables in the garden beyond. The audience of the café-concert was generally drawn from the lower-middle classes—the men in their dark suits and top hats, the women in bright dresses with flowers in their hair. The leering countenance of the *chef d'orchestre* or possibly a male admirer appears beneath the singer's extended left arm. Any man wishing to make the acquaintance of one of these "performers of the evening" would send her a bouquet of flowers. If she appeared on stage carrying said bouquet, she was signifying her willingness to accept his advances.

A large number of pastels that Degas produced in the late 1870s and 1880s were developed from monotypes. Degas called his monotype impressions "drawings made with greasy ink and put through a press"[2] and was introduced to the process by the Vicomte Ludovic Napoléon Lepic, who had been experimenting with monotypes since the late 1860s. Although the monotype by definition is limited to a unique impression, there are in fact two impressions of this work, the second (collection of Robert A. Weiner, New York) a much paler "daylight" version, due to the lack of ink remaining on the plate for the second pulling.[3]

By 1947, *The Singer* was in the collection of the Parisian collector Maurice Exsteens, who possessed a similar 1879 work in monotype and pastel, *Mademoiselle Dumay, Chanteuse* of ca. 1879 (cat. 42). Exsteens inherited much of his collection of Impressionist and Post-Impressionist works from his father-in-law, Gustave Pellet, who ran a successful print publishing business in the rue Peletier in Paris. This work was later acquired by Henry Kissinger Dick (1886–1953), a collector from Reading, Pennsylvania. Dick was professor of English at Columbia University in New York. He began collecting French Impressionist pictures and lithographs in the late 1930s and had a special interest in Degas. By 1942 he said his "latest hobby" was "Sung monochromes,"[4] but it must have been toward the end of his life that he acquired *The Singer*. At his death in 1953 he left a painting by Monet and a Degas pastel of a dancer to the Princeton University Art Museum. The bulk of his collection, including *The Singer*, was inherited by his niece, Martha C. Dick, who bequeathed it to the Reading Public Museum in 1976.

FRANCES FOWLE

32. THE SONG OF THE DOG

1876–77
Crayon lithograph (from transfer paper)
One state
Plate: 14 × 9 inches
Sheet: 14½ × 10⅜ inches
Museum of Fine Arts, Boston
Gift of W. G. Russell Allen, 1954, 54.996
Reed and Shapiro 25

THE SONG OF THE DOG is one of Degas's best-known images of Parisian café-concert life. This work brings the viewer on stage beside the singer Thérésa (1837–1913, born Emma Valadon) at the Café des Ambassadeurs. Having made her début in 1864 at the Alcazar d'été, Thérésa was an extremely popular stage star by the time Degas began portraying her around 1876 or 1877.[1] She is shown in the middle of a bawdy number, whose lyrics are suggested by her pawing hands and howling mouth. Degas's strong graphic treatment of the plump curves of her body creates a vibrant figure, fully absorbed in her canine character. Though the painting and print portray the same figure, the composition of the lithograph is more emphatically vertical, an effect Degas strengthened by narrowing the light strip of background near Thérésa's head as well as through a slight repositioning of the glowing gaslight globes of the background. Most significantly, he eliminated in the lithograph any suggestion of the bustling and distracted crowd in the background, substituting the well-defined space of the painting with a series of agitated graphic hatchings. The dark areas they produce set off

Thérésa's dramatically lit face, and individual lines seem to emanate from the singer. By amplifying her song and magnifying her gestures through this treatment of the background, Degas achieves a monumental image—a kind of comic heroine of the café-concert.

This impression is one of only six known to exist and one of the four that left Degas's studio before his death. Although it is not known to whom Degas originally sold or gave this sheet, by 1936 it had entered the collection of W. G. Russell Allen (a trustee of the Museum of Fine Arts, Boston), who lent it—along with a number of other Degas lithographs—to the Philadelphia exhibition that year. This early opportunity to view extremely rare prints by Degas may not have been fully appreciated at the time, however. As with many other Degas prints bequeathed from Allen's collection to the Museum of Fine Arts in 1963,[2] the artist's peculiar use of reproductive media to create singular objects was first fully demonstrated for modern audiences in the Museum's 1984 exhibition *Degas: The Painter as Printmaker.*[3]

DAVID OGAWA

33. PORTRAIT OF A WOMAN (MLLE. MALO?)

1877
Oil on canvas
25½ x 21 inches
The Detroit Institute of Arts
Gift of Ralph Harman Booth, 21.8
Lemoisne 442

BETWEEN 1875 AND 1877, Degas painted some of his most original portraits of individual women. Although many of these were commissioned works, the names of only a few sitters were recorded. The majority were given anonymous titles such as *Woman in Black, Young Woman,* or simply, as here, *Portrait of a Woman.* In this way Degas transforms his sitters into symbols or types; he is concerned less with exterior appearance than with inner truth. To this end, he deliberately blurs or smudges certain features in order to render the details of the sitter's physiognomy imprecise.

Degas painted four portraits of Mlle. Malo, a dancer at the Paris Opéra and René De Gas's mistress. This work bears a close resemblance to the version in the National Gallery of Art, Washington, D.C., painted by Degas around 1877. The woman in the Washington picture adopts a similar stance and is seated in an identical position in front of an arrangement of chrysanthemums. Her features are very close to the Detroit picture, but she is younger and slimmer, with dark hair. An obvious conclusion, therefore, would be that this work represents not Mlle. Malo, but her mother. Another possibility, suggested by Jean Sutherland Boggs, is that Degas was experimenting with the effects of aging, visualizing the young Mlle. Malo as she might appear in middle age.[1] Both women adopt an expression of deep contemplation, and, given Boggs's suggestion, one is tempted to interpret this work as a symbolic evocation of middle age, the older woman contemplating her youth.

Whether or not Degas intended to create an imaginary evocation of Mlle. Malo's old age, it is likely that he painted much of this portrait from memory. This is supported by Degas's observation that "it is all very well to copy what you see, but it is much better to draw only what you still see in your memory."[2] The sitter's face is strongly lit from the side, casting her features into shadow, but Degas has taken care to emphasize the woman's plump cheeks and double chin, her grayish complexion and vain attempts to disguise the ravages of time with lipstick and rouge.

The portrait was included in the first atelier sale (no. 64) and was acquired by Jacques Seligmann. Seligmann was a French dealer of German origin who settled in Paris shortly after the Franco-Prussian war. Along with his two brothers, he developed a flourishing business in the Place Vendôme and established branches in London and New York, where his clients included Benjamin Altman and J. Pierpont Morgan. He later set up on his own at the Hôtel Sagan in the rue St. Dominique. Seligmann's collection included seventy-one works by Degas, which he planned to exhibit in a private gallery attached to his country house outside Paris. The project for the gallery was never realized, and Seligmann sold the entire collection through the American Art Association in New York. The sale took place at the Plaza Hotel on January 27, 1921, and comprised a wide range of subjects, including several portraits. This work was catalogued as *Portrait de femme* and was bought by the dealers Henry Reinhardt & Son on behalf of The Detroit Institute of Arts for $3,800. Reinhardt also bought *Landscape and Dancers* and *Two Seated Women,* as well as one of the most expensive pictures in the sale, *Dancers in the Greenroom,* which sold for a record $10,500.

FRANCES FOWLE

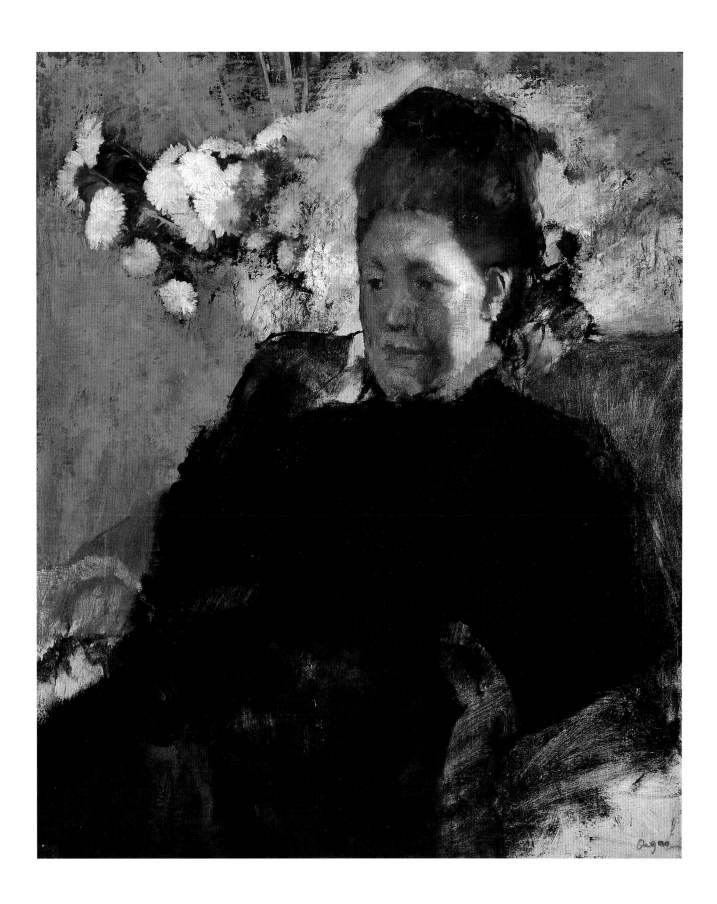

34. Rehearsal Before the Ballet

ca. 1877

Oil on canvas

20 × 24¼ inches

Museum of Fine Arts, Springfield, Massachusetts

James Philip Gray Collection, 41.01

Lemoisne 844

DEGAS WAS A FREQUENT VISITOR to the ballet at the Paris Opéra and often attended the same performance as many as a dozen times. In his pictures, however, he rarely recorded the actual spectacle. Instead, he preferred to capture the dancers relaxed, either practicing their steps, waiting behind the scenes, or even adjusting a shoe. Occasionally Degas painted dancers, sometimes prompted by the *maître de ballet,* in the middle of a dress rehearsal. In this work, members of the *corps de ballet* rehearse onstage, while two other dancers practice arabesques in the wings, and another adjusts her costume on the far right.

The asymmetrical composition and cropped foreground figure reveal the influence of Japanese prints, which, along with photography, gave Degas the impetus to experiment with unusual formats. Indeed, compositional concerns often appear to be of much greater interest to him than accuracy of detail. The dancers in this work appear crudely drawn, their features scarcely indicated, and the dancer on the far left leans at a precarious angle. Degas's painting around the time of the Third Impressionist exhibition sought to capture precise and transient moments. Applying the paint in transparent layers, he conveys the movement of the ballerinas, reducing the second dancer from the right to a shadowy form and the sparkling tutus to a blur of contrasting hues—pink and pale green, violet and yellow, pale blue and orange. The figures are strangely lit, their features flattened and distorted by the effects of artificial illumination, and the overall tone verges on the lugubrious. The eye

is drawn toward the central dancer, her arms raised as she performs an arabesque in the wings of the theater. Her arm movement is echoed by a dancer onstage, resulting in an odd confusion of limbs and tutus, colors and lines, contrasting with the bare expanse of the sloping floor.

A collector called Stettiner bought *Rehearsal Before the Ballet* from the first atelier sale in 1918 (no. 25). It was later bought by Etienne Bignou, who ran the Galerie Bignou in Paris and who sold it to the Glasgow dealer Alexander Reid. Bignou had close associations with Reid from about 1922 onward and in 1926 became a founding director of the Alex Reid & Lefevre Gallery in London.[1] In 1923 the picture was included in an exhibition of Impressionist art entitled *Masterpieces of French Art,* organized by Reid and held at Thomas Agnew & Son in London. One of the buyers at this exhibition was the Scottish collector D. W. T. Cargill, who bought Degas's *Jockeys Before the Race*[2] and later acquired the Springfield picture. Cargill, a director of the Burmah Oil Company, formed one of the finest collections of Impressionist and Post-Impressionist art ever assembled in Scotland, including works by all the main Impressionists as well as Cézanne, Seurat, van Gogh, Gauguin, and Toulouse-Lautrec. Some of Cargill's collection was sold in New York after his death in 1939, when Dr. Theodore Schempp acquired this picture. In 1941 it was purchased by the Museum of Fine Arts, Springfield, Massachusetts, for $9,000.

FRANCES FOWLE

35. MLLE. BÉCAT AT THE AMBASSADEURS

ca. 1877
Lithograph
One state
Plate: 8 1/16 × 7 5/8 inches
Sheet: 13 1/2 × 10 3/8 inches
The Museum of Modern Art, New York
Gift of Abby Aldrich Rockefeller, 276.40
Reed and Shapiro 31

THIS PRINT IS A TOUR DE FORCE of Degas's considerable ability with a hybrid medium: monotype transferred to a lithographic stone. After transferring the image from paper, Degas further worked it on the stone through the addition of crayon and scratching. The resulting light effects range from the delicate and atmospheric to the glaring. The stark white of gaslight globes, the shiny haze of a chandelier, the lurid footlights, the dim glow from the orchestra pit, and the delicate streaks in the sky—thought to represent fireworks—produce a momentary, glittering glimpse of this popular and highly regarded Parisian café-concert.

Like Pierre Ducarre, the impresario of the Café de Ambassadeurs, Degas offers us an evening's entertainment, an ambiance rather than a single event. He places the singer Emélie Bécat, who seems to be taking a bow, at the left side of the composition and frames her with the rectangular indications of the stage. Globe-shaped lights dominate the right side of the work, and the compressed, abbreviated space around the singer opens into a deep view through the café's tree-lined courtyard into the hazy night sky. The artist invites the eye to wander across the image, to admire the singer's powerful presence, to marvel at the artificial lights in the open air, or to squeeze through the dense, darkened crowd of spectators. Degas's control of light and space thus captures both the sight and the sensation of this quintessentially Parisian spectacle.

This lithograph is currently known in fifteen impressions, only five of which were sold or given away before the artist's death.[1] The great American collector Abby Aldrich Rockefeller (1874–1948) bought this impression from the gallery of Frederick Keppel and Co. of New York on October 9, 1928. The acquisition is recorded in a meticulously kept notebook that documented each of Rockefeller's purchases. Rockefeller, a pioneering print collector, assembled a collection of American and European late nineteenth- and early twentieth-century prints between 1925 and 1935. She believed that making her collection of prints accessible to the public could serve to stimulate interest in modern art, and in 1940 she donated her collection to The Museum of Modern Art, followed by an additional bequest of Toulouse-Lautrec prints in 1946.

DAVID OGAWA

36. Mlle. Bécat at the Café des Ambassadeurs: Three Motifs

1877–78
Lithograph transferred from three monotypes
Plates (clockwise from top): 4⅞ × 8¾; 6⅜ × 4⅝;
6⅜ × 4 inches
Sheet: 13⅞ × 10¹¹⁄₁₆ inches
Museum of Fine Arts, Boston
Gift of George Peabody Gardner, 1927, 27.1200
Reed and Shapiro 30

OF ALL THE LITHOGRAPHS by Degas in this exhibition, this work best embodies the artist's unconventional engagement with the medium as well as his restless experimentation with ways of imaging modern life—especially the nocturnal world of the Parisian café-concert. The print was realized as three small monotypes depicting Mlle. Bécat on stage from different angles, all of which were transferred still wet to a lithographic stone. Using crayon, tusche, and a sharp tool for scraping, Degas worked the images further, bringing their tonal ranges into line with one another as well as correcting such linear passages as the performer's costume in the lower right-hand vignette.

Like *The Song of the Dog* (cat. 32), *Mlle. Bécat at the Ambassadeurs* (cat. 35), *At the Café des Ambassadeurs* (cat. 43), and *Mlle. Bécat at the Café des Ambassadeurs* (cat. 56), this work depicts the well-known Parisian café-concert, whose outdoor stage was ringed with trees and globed gas lights. The three scenes here depict Mlle. Bécat's distinctive and popular *style épileptique,* a frenzied dancing style she developed to further enliven her already raucous songs.[1] The artist's fascination with her bodily expressiveness is evident from his concentration on the uncomfortable contortions of her poses, the odd angles of her limbs, and the rubbery turns and twists of her head. His multiplication of the figure across three small compositions, each with a different vantage point, adds to the effect of a dance not reducible to a single movement or gesture.

The small size of each image also compresses and fragments the pictorial space, making the tonal contrasts between the onstage and offstage worlds even more abrupt. In combining these spatial abbreviations of the setting on a single sheet, Degas further exploits their rectilinear qualities to break up the whole into a graphically powerful and rapidly shifting composition, communicating to the viewer the visual energy embodied by Bécat's dance. The bold planes of light, dark, and silhouetted leaves also recall Japanese prints; perhaps Degas also recognized parallels between the imagery of the *ukiyo-e* and his own experience of contemporary Paris, with the Café des Ambassadeurs as an island in that city's own floating world and Mlle. Bécat dancing a modern *kabuki.*

As Reed and Shapiro note, the print is known in only seven impressions, two of which were still in the studio at the time of the artist's death.[2] Documentation on the Museum of Fine Arts's impression is unfortunately scant. It bears none of the stamps marking works remaining in the studio, a sign that the artist himself either sold or gave it away. This impression is documented only as early as 1927, when it was purchased from Maurice Gobin by the museum's enterprising curator, William Henry Rossiter, through funds from George Peabody Gardner.[3] This was one of the first prints acquired by an American museum.

DAVID OGAWA

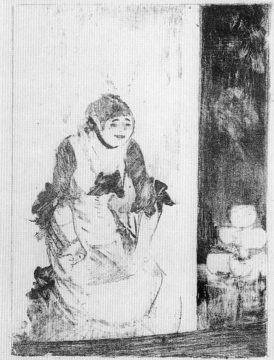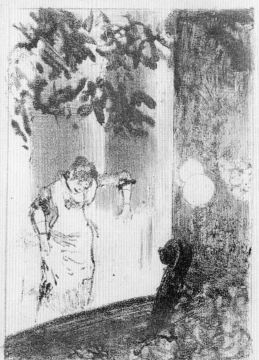

37. At the Theater: Woman Seated in the Balcony

ca. 1877–80
Oil on canvas
9¾ × 13 inches
The Montreal Museum of Fine Arts
Gift of Mr. and Mrs. Michal Hornstein, 1999.18
Lemoisne 466

THIS IS ONE OF A SMALL GROUP of works by Degas that focuses on theater audiences rather than performers. But instead of recording the *haute bourgeoisie* parading themselves in their boxes at the Paris Opéra—in the manner of Renoir or Cassatt—Degas has produced an intimate study of a modest working girl, utterly absorbed by the spectacle and seated in the "peanut gallery." Just as she gazes down toward the stage, we observe her, unnoticed, from above. This slightly elevated viewpoint places her in a position of subservience, while drawing attention to her simple hat with its floral adornments and her intense expression as she leans over the balcony. Degas observes the young woman's dark eyes, pinched face, determined jaw, and button nose, recalling the features of Ellen Andrée, one of the artist's favorite models.

The figure is dressed in black, framed by the red balcony and a green patterned partition. Overall the picture is tonally dark, but it is brought to life by touches of brighter pigment. The white lace collar and cuffs and white lamp provide a counterpoint to the woman's dark clothing. A yellow splash of color on the left, a blue purse or perhaps handkerchief in her hands, and the brilliant turquoise of her hat provide additional notes of color.

Degas probably worked the composition up from an initial sketch, although, being a frequent visitor to the theater, he often relied on memory. A comparable work in pastel, *The Box at the Opéra* of 1880,[1] portrays a single spectator, equally absorbed in the performance but viewed from below.

At the Theater has a distinguished provenance. It was originally owned by the Parisian dealer Jacques Seligmann, who bought it in May of 1918 from the first atelier sale (no. 23). Seligmann acquired seventy-one works by Degas, which he intended to exhibit in a gallery attached to his country house. This project was never realized, and Seligmann took the unusual step of offering the entire collection for sale through the American Art Association in New York. The sale took place at the Plaza Hotel on January 27, 1921. Prior to this date only eighteen works by Degas had appeared at auction in the United States, and record prices were achieved. *At the Theater* was sold for $2,000 to C. W. Kraushaar, who also bought *Visit to the Museum* (Museum of Fine Arts, Boston) from the same sale. The picture changed hands several times until 1943, when it was bought by Erich Maria Remarque, author of *All Quiet on the Western Front,* who exhibited it at the Knoedler Galleries in New York in October of that year. Remarque and his wife, actress Paulette Goddard—the former wife of Charlie Chaplin—amassed an outstanding collection of Impressionist art, especially by Degas and including works by Renoir, Pissarro, Monet, and Cézanne. After her husband's death, Goddard included thirteen works by Degas in a partial sale of the Remarque collection but retained *At the Theater*. In 1986 the picture was bought by Noortman and Brod, who sold it to Mr. and Mrs. Michal Hornstein the same year. The Hornsteins bequeathed it to the Montreal Museum of Fine Arts in 1999.[2]

FRANCES FOWLE

38. THE ROAD

ca. 1878–80

Monotype (black ink) on china paper

Plate: 4⅝ × 6⅝₆ inches

Sheet: 6⅝₆ × 7¼ inches

National Gallery of Art, Washington, D.C.

Rosenwald Collection, 1952, 1952.8.224

Janis 266

DEGAS BEGAN EXPERIMENTING with monotypes in the mid-1870s, when his friend and fellow printmaking amateur, Vicomte Lepic, introduced him to the process. Unlike other printing techniques, monotypes are not adaptable to multiple reproduction. For Degas, making a monotype was more like drawing than printmaking: he referred to monotypes as "drawings made with greasy ink and put through a press."[1] The painterly, tonal character of the monotype forced Degas to set aside his linear skill and concentrate instead on broad compositional design.

For *The Road,* Degas used a subtractive method, covering the plate with dabbed and brushed ink and then wiping with brushes, rags, and his fingers to create a design. The scene shows tracks in a road—perhaps scratched into the design with the end of a brush—disappearing into a distant wooded landscape. Tones range from the saturated black of the trees and other features of the landscape to the white of the sky, achieved by a clean-wiped plate. This print is part of a series of black and white monotype landscapes that Degas started in the late 1870s. Although Degas often pulled two impressions from the plates in

this series, using the weaker one as a potential base for pastel drawings, Richard Kendall has noted that he did not rework any of the landscape monotypes from the 1870s.[2]

The Road was purchased by M. Comiot from the 1918 estate auction of Degas's prints held at Manzi, Joyant & Cie in Paris (no. 309). In 1952 it appeared for sale at one of Kornfeld and Gutekunst's auctions in Bern, Switzerland, where it was purchased by one of America's most important print collectors, Lessing J. Rosenwald of Jenkintown, Pennsylvania, and given to the National Gallery of Art. Rosenwald was chairman of Sears, Roebuck, and Co., headquartered in Philadelphia, until 1939. He assembled a remarkable collection of twenty-two thousand prints, drawings, and rare books. In 1943, Rosenwald bequeathed his collection of prints and drawings to the National Gallery and his rare books to the Library of Congress. He continued to collect, making additional bequests to the National Gallery in 1945, 1946, 1949, 1951, and 1964. The Rosenwald Collection is one of the premier collections of old-master and early modern prints in the world.

MARY MORTON AND DAVID A. BRENNEMAN

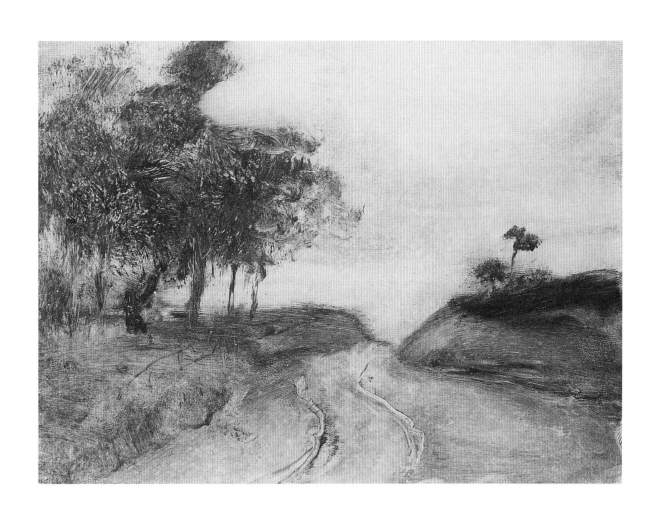

39. TWO WOMEN

ca. 1878–80
Pastel and watercolor on paper
11½ × 17½ inches
The Corcoran Gallery of Art, Washington, D.C.
William A. Clark Collection, 27.73
Lemoisne 505

THIS RADIANT PASTEL HOVERS between two of Degas's favorite themes: theatrical performance and domestic interiors. The plush furnishings—a pair of red armchairs, a table, and a mantelpiece with two large vases of flowers and a loosely evoked clock—dominate half of the image. In the other half, two women wearing similar gowns adopt dramatic postures while performing a song. This is perhaps private, after-dinner entertainment. However, the unusual lighting and the women's theatrical gestures are more reminiscent of the cabaret performers who fascinated Degas than the musical accomplishments of private ladies. The painting is ambiguous about whether this is an entertainment in a society drawing room or a performance in a more public, and perhaps less respectable, space. Lemoisne titled this pastel *Chanteuse de café concert,* interpreting this scene as a performance of a professional singer. By naming the work *Chanteuse* (a singular noun), Lemoisne also suggests that the two women are in fact multiple views of the same performer. Regardless of the specifics of this performance, the sensitivity with which Degas captures the importance of gesture and expression as much as words or music to a song's interpretation is arresting.

The scale of the furnishings solidly ground the picture, while the two women create a contrasting effect of asymmetrical movement. By forcing the viewer into an almost uncomfortable proximity both to the women and their oppressively elegant surroundings, Degas creates a claustrophobic mood. The interior seems too small to accommodate all these disparate elements. Degas often creates a sense of disquiet in interiors that initially appear calm, as in *The Bellelli Family* (see cat. 9) or *The Interior* (page 21, fig. 7).

Two Women entered the Corcoran Gallery of Art as part of the bequest made by Senator William Andrews Clark (1839–1926). Clark was one of the three "Copper Kings" of Montana who amassed enormous fortunes from mining and smelting companies. One of the most cosmopolitan of these entrepreneurs, Clark was a passionate art collector both of decorative arts and old-master painting but especially of nineteenth-century art.[1] As with so many mid-nineteenth-century American collectors, Clark's first loves were the Barbizon School of landscape painters and a later generation of idealized naturalist painters such as Bastien-Lepage and Jules Breton, but he clearly had three favorite artists—Cazin, Corot, and Monticelli—each of whom were represented by more than twenty paintings in his collection.[2] Among Impressionist artists, Clark was drawn to Fantin-Latour, Forain, and Raffaëlli, but he focused particularly upon Degas, acquiring five works: two ballet scenes, a view of a theater box, a cabaret scene, and the present work.

CLAIRE I. R. O'MAHONY

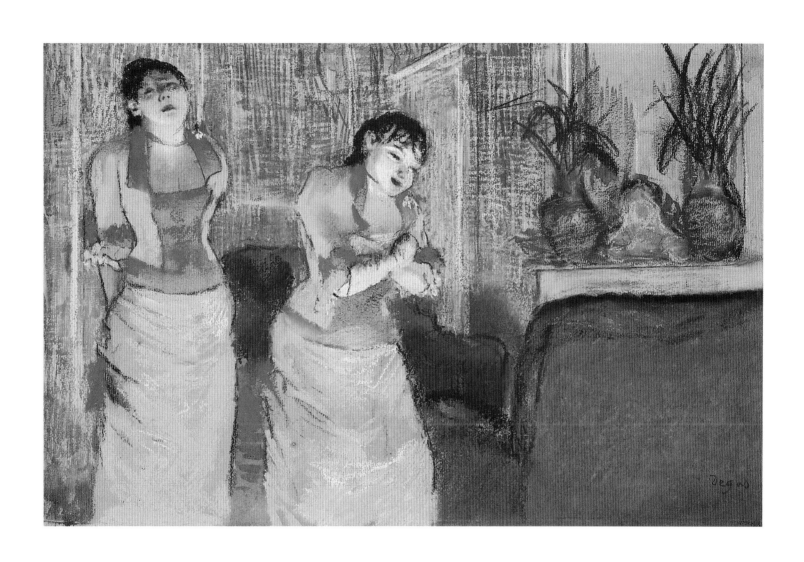

40. Portraits in a Frieze

1879
Black chalk and pastel on gray paper
19¾ × 25⅝ inches
Private Collection
Lemoisne 532

THIS DRAWING CONTAINS A CURIOUS inscription that identifies it as "portraits in a frieze to decorate an apartment." It is closely related to two other drawings executed in the same technique, pastel on gray paper, depicting women in street costume. Although the exact purpose of these drawings is unclear, the inscription indicates that they may have been intended as preparatory studies for a scheme to decorate a domestic interior, an idea that Degas first discussed in a notebook from 1859 to 1864.[1] According to Degas's notes, he wanted to depict two images of a modern family—one in the city and the other in the country. This project, however, was never undertaken.

Degas's models for the middle figure and the figure on the far right have been identified traditionally as Mary Cassatt and the actress Ellen Andrée, who also served as model for one of Degas's most famous images, *The Absinthe Drinker* (Musée d'Orsay). The figure to the left has not been identified. Although the decorative scheme appears not to have materialized, the depictions of the women in the three pastels are also related to a printmaking project that Degas undertook in 1879. Probably in preparation for the failed joint venture with Cassatt and Pissarro to publish a portfolio of prints titled *Le jour et la nuit (Day and Night)*, Degas made two prints of Cassatt in different parts of the Louvre (see cats. 45, 46, 47). Each print includes an image of Cassatt standing from the back. Like the women depicted in the three pastels, who are variously engaged in the activities of looking and reading, the prints of Cassatt in the galleries of the Louvre were part of a concerted effort by Degas to document women engaged in the everyday activities of modern urban life in the late 1870s and early 1880s. Other images undertaken at this time included those of café-concert singers, milliners, and laundresses.

The arrangement of figures in a frieze-like format is considered one of Degas's greatest formal innovations. As Richard Kendall argued in his discussion of Degas's dance imagery, Degas was interested in reviving the simplicity and grandeur of the art of classical antiquity through his depictions of modern ballet dancers.[2] The frieze format, which derives from the sculpted decorations around the exterior of classical buildings, was employed by Degas to imbue his figures with a sense of monumentality that transcended the fleeting nature of urban life.

Portraits in a Frieze first entered the collection of the print publisher Gustave Pellet of Paris, who also purchased a large number of works from the Degas estate sales. The drawing then entered the collection of the distinguished Parisian collector David David-Weill. Dr. Herman J. Abs of Cologne was the next owner. The work is now in a private American collection.

DAVID A. BRENNEMAN

41. PORTRAIT OF EDMOND DURANTY

1879
Black chalk, heightened with white chalk, on blue paper
12⅛ × 18⅝ inches
The Metropolitan Museum of Art
Rogers Fund, 1918, 1919.51.9a
Atlanta only

THIS DYNAMIC DRAWING of Edmond Duranty portrays an intensely active nineteenth-century man of letters. Duranty sits in his library at a desk covered in reviews and magazines before a full bookshelf. His head is slightly sunk between his shoulders, supported by two heavy arms whose contour line quivers with energy. Duranty's forehead is dabbed with a strong white highlight, and he gazes off to the right intently but without focus, deep in thought. The influence on Degas of Ingres's history painting had diminished by this point in his career, but the brilliance of the master's portraits, and his ability to convey personality through gesture and expression with a few decisive

lines, still served as a powerful model for Degas.[1] The sense in this study of Duranty as a fully engaged, cerebral man, with his strange, tense hand gestures (one pressing into his brow, the other grasping something on the desk), is transferred directly and elaborated in the definitive pastel portrait.

Duranty was a Naturalist novelist and art critic, most noted today for penning the first serious publication devoted to the Impressionist aesthetic. His essay "The New Painting" was written in response to the Second Impressionist exhibition in 1876. It tried to articulate the agenda of the young artists: to create fresh images expressive of modern experience in place of the moribund tradition of French painting.[2] Duranty was friendly with the whole group of Impressionists and frequented their hangout, the Café Guerbois. He was closest to Degas, and the contents of his essay are indirectly (if not directly) influenced by the artist.

In addition to this study for the Glasgow portrait of Duranty, Degas completed a pastel study of the full composition (Private Collection, Washington, D.C.), as well as a study of Duranty's bookshelves and desk (Metropolitan Museum of Art). Both Metropolitan Museum studies were purchased from the second Degas atelier sale (no. 242) in December 1918 by Paris art dealer Jacques Seligmann on behalf of the Metropolitan Museum. From the catalogue for the sale, Metropolitan curator Bryson Burroughs had drawn up a request list that included the drawings of Duranty and three drawings of Manet (see cat. 14). In addition to the works on the list, Seligmann purchased two portrait studies of women, two nude studies, and a pastel of a violinist, constituting an extraordinary first group of Degas acquisitions by the Metropolitan Museum.[3]

MARY MORTON

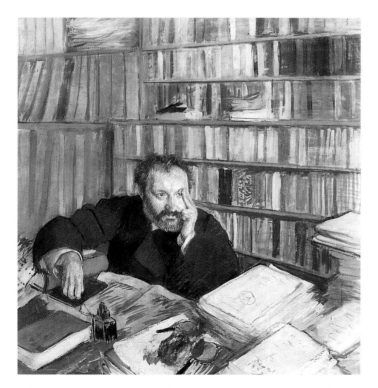

Edmond Duranty, 1879, pastel and tempera on paper, 39⅝ × 39½ inches, Glasgow Museums, The Burrell Collection.

42. MADEMOISELLE DUMAY, CHANTEUSE

ca. 1879
Pastel over monotype on paper
6¼ × 4½ inches
Private Collection
Lemoisne 540, Janis 10

DURING THE LATE 1870S, Degas produced a series of monotypes heightened with pastel that depict a single female singer, focusing in particular on her physical projection and voice. Although Lemoisne identified the singer in this picture as Mlle. Dumay, research has not found any café-concert singer of that name. There was, however, a well-known singer named Victorine Demay, who appeared at the Concert Parisien, Eldorado, Scala, and Alcazar d'Eté in the late 1880s. Although the date does not accord with that of the pastel, contemporary descriptions of Victorine Demay, with her black hair, button nose, and large "elastic" mouth, appear to fit the figure in this picture.[1]

Although Demay was known for her amusing and provocative lyrics, Degas's intention in this work is essentially to create a mood of pathos. The singer, with her pale, oval lips, is lit from below; her dark eyes are closed as she conveys the emotion of the song and her features flattened by the white glow of the gas lamps. Degas has used pastel to intensify the light and to bring out the warmth of the singer's flesh, the curve of her shoulder, and the rich red of her hair decoration. Her plump body is squeezed into a somewhat revealing dress, and one is reminded of Louisine Havemeyer's disparaging description of *The Song of the Dog* (cat. 32), a similar evocation of a *chanteuse* at the café-concert:

> A woman stands upon the stage singing a popular song. . . .
> Look at her and observe the common type. You feel at once
> that she has crowded herself into the uncomfortable gown,

that her gloves are a strange annoyance to her. There is nothing elegant about her pose. . . . The lines of her mouth as she bawls out the vulgar song, her exultant exaggeration, showing she is conscious of her power over her audience, all this and much more shows clearly what a *café-chantant* is, what part it plays in Parisian life, the kind of creature it is that furnishes the amusement.[2]

Developed from an original montoype, this work was included in a sale at the Hôtel Drouot in Paris on December 15, 1917, and was illustrated on the front cover of the catalogue. It was bought by the Parisian collector Maurice Exsteens, who had a particular taste for prints and monotypes. He owned an important collection of Impressionist, Post-Impressionist, and Symbolist art and was the author of two books on the Belgian Symbolist Félicien Rops. New York dealer Carroll Carstairs later acquired *Mademoiselle Dumay, Chanteuse*. Carstairs had close family connections with Knoedler & Co., who had offices in Paris, London, and New York. He exhibited the picture at the Orangerie in Paris in 1937, and the following year it was bought by an American collector John W. Warrington, who exhibited it at the Cincinnati Art Museum in 1939. It was sold at Christie's on May 14, 1997, and is now in a private collection.

FRANCES FOWLE

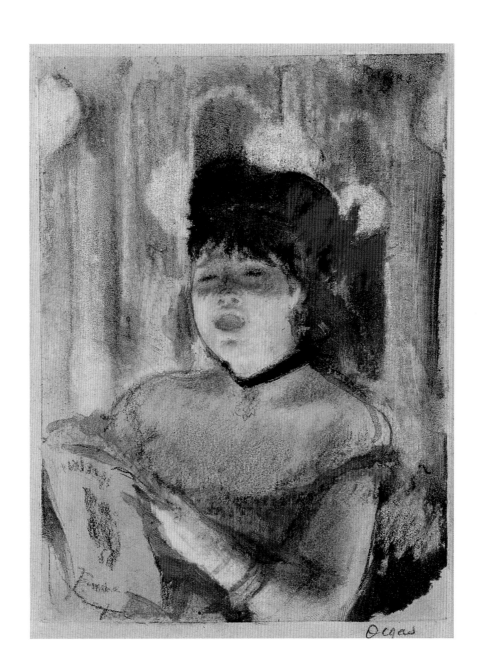

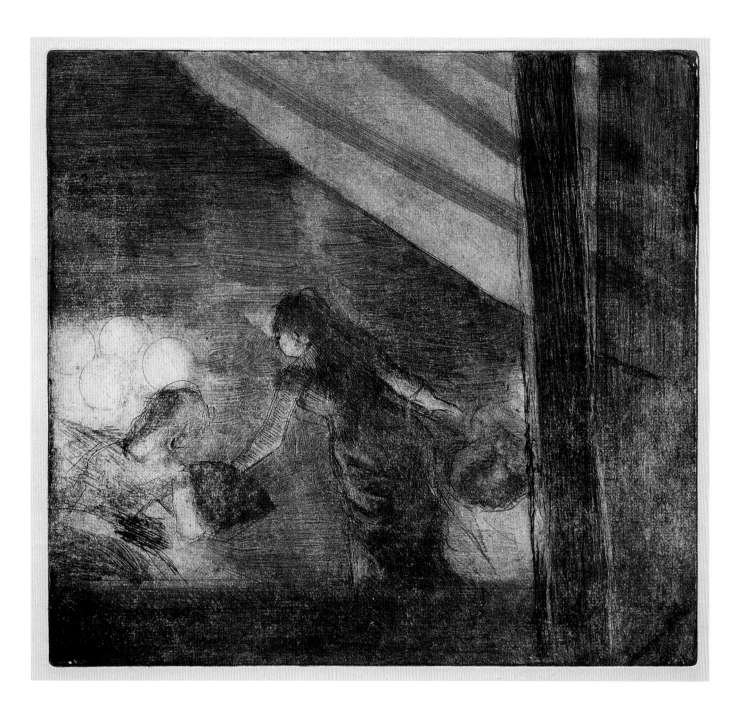

43. AT THE CAFÉ DES AMBASSADEURS

ca. 1879
Etching, softground, drypoint, and aquatint on paper
Third state of five
Plate: 10⅜ × 11½ inches
Sheet: 18½ × 12⅜ inches
Sterling and Francine Clark Art Institute
Williamstown, Massachusetts, 1962.31
Reed and Shapiro 49

A PAINTER OF MODERN LIFE, Degas frequented the many café-concerts of Paris, most of them held in outdoor pavilions along the length of the Champs Elysées. Among his favorite venues was the Café des Ambassadeurs, distinguished by its striped awning, fluted columns, and gas globes that lit the garden beyond.

This is the largest etching that Degas produced and offers an expanded view of an earlier lithograph, *Singer at a Café Concert* of 1876–77.[1] The women are seated in a formation known as the *corbeille,* waiting for their turn to sing.[2] The central figure has been tentatively identified as Mlle. Bécat (cats. 35, 36, 56), who sang for a brief period at the Café des Ambassadeurs and subsequently at the Alcazar d'Eté. She was famous for her *excentricités,* her nonsense songs, which never failed to delight the lower-middle-class audiences of the café-concert. Degas was less fascinated by her looks than by the exaggerated movements and gestures of her performance, which he sought to capture in numerous prints and pastels.[3]

The basic format of the etching is established in the first two states. Degas adopts an unusual vantage point, looking down on the scene from above and behind the stage. The singer stands on an outdoor stage and is framed and enclosed by a railing, two upright features and a striped awning, which echoes and reinforces her unusual pose. In the third state Degas made a number of additions to the plate: he added a second performer on the left, seated in an armchair and holding a fan. Four gas globes glow in the darkening atmosphere, lighting the features of the central singer's face.

An 1885 reworking of this picture in pastel (Musée d'Orsay) considerably aids our reading of the original: the two vertical elements in the right foreground of our picture turn out to be a tree and the fluted column of the proscenium of the Ambassadeurs; a third figure is hinted at on the far right, partially obscured by the tree trunk and clutching a bouquet of flowers. Degas used a variety of tools to create the textures in this work: a broad point to describe the bark of the tree, a stiff brush to make the stripes on the awning, and a double-pointed pen to depict the main singer. A film of ink on the awning and figures emphasizes the smoky, nocturnal atmosphere.

Three impressions of the third state of this etching have been identified. The impression in this exhibition was originally in the collection of the Parisian industrialist Alexis Hubert Rouart (1839–1911),[4] business partner and younger brother of Henri Rouart (1833–1912), one of the earliest and most important collectors of Impressionist works. Degas was a close friend of the Rouart brothers and painted several family portraits. Alexis Rouart was influenced by his older brother in his taste for Impressionist art, and his collection included Degas's painting *Little Milliners* of 1882 (Nelson-Atkins Museum of Art). In general, however, he was more interested in prints, and Reed and Shapiro have identified fifty-three impressions of forty-six Degas prints in the Rouart collection.[5] He also collected Japanese woodcuts and Chinese, Indian, Greek, and Egyptian works of art.

At a later date, this etching was acquired by Herbert Michel, a Chicago physician, who formed an outstanding collection of prints during the 1950s under the guidance of Harold Joachim, curator of prints at The Art Institute of Chicago. In 1962 the Sterling and Francine Clark Art Institute purchased Michel's collection, including *At the Café des Ambassadeurs* and twelve other etchings, lithographs, and monotypes by Degas.

FRANCES FOWLE

44. ACTRESSES IN THEIR DRESSING ROOMS

1879–80

Etching and aquatint

Fourth state of five

Plate: 6⁵⁄₁₆ × 8⅜ inches

Sheet: 8⅞ × 12¹⁵⁄₁₆ inches

The Metrolitan Museum of Art

H. O. Havemeyer Collection

Bequest of Mrs. H. O. Havemeyer, 1929, 29.107.51

Reed and Shaprio 50

ACTRESSES IN THEIR DRESSING ROOMS was produced during the late 1870s, the most productive period of Degas's printmaking career.[1] Degas's lifelong fascination with the technical aspects of making art attracted him to the medium of printmaking. He made most of his prints not for exhibition or publication—they were seen by very few people before the November 1918 atelier sale—but for the sheer excitement of graphic experimentation.

This striking print shows Degas's innovative use of both aquatint and etched lines to represent a spatially complex interior. A harsh light at the left blazes over the figure in the foreground and casts a dark shadow that animates the center of the composition. Just beyond the shadow, a vertical plane leads to an open door, allowing a glimpse of another actress from behind. The variety of lines and textures in this print range from the long, frizzy tresses of the actress in the foreground and the fine lines of her face and bodice to the velvet tones of the shadow at the center and finally to the patchy pattern of the wallpaper on either side of the open door. Through the preceding three states of this print, Degas has stretched the tonal values to an extraordinary degree. In this series he moves beyond the linearity of his earlier prints to explore the tonal effects of aquatint.

Degas took the plate for this print one stage further, for a total of five states. Despite the amount of work he spent on this project, he did not pull an edition; there is only one other known impression of the fourth state (National Gallery of Art, Washington, D.C.) and only eight known impressions of the fifth. That the final states were pulled in such small numbers suggests that Degas's primary interest was less in printmaking's potential for reproduction than for inventive variation.[2]

These years of intense experimentation in printmaking coincide with Degas's preoccupation at this time with contemporary subject matter—in particular with images of working women: laundresses, prostitutes, ballet dancers, and cabaret singers. The effects of artificial light intrigued him, and he sought to capture the strange mood created by gaslight in both interior and outdoor settings. In *Actresses in Their Dressing Rooms*, he creates an image of visual drama infused with a sense of modernity from a mundane moment in the professional life of two performers.

The print was acquired by Mrs. H. O. Havemeyer in Paris soon after its appearance in the posthumous sale of Degas's prints, November 22–23, 1918, at Galerie Manzi-Joyant (no. 57). Louisine Havemeyer's bequest to The Metropolitan Museum of Art, New York, in 1929, which included *Actresses in Their Dressing Rooms*, transformed the museum's collection of nineteenth-century French art into one of the best in the world.

MARY MORTON

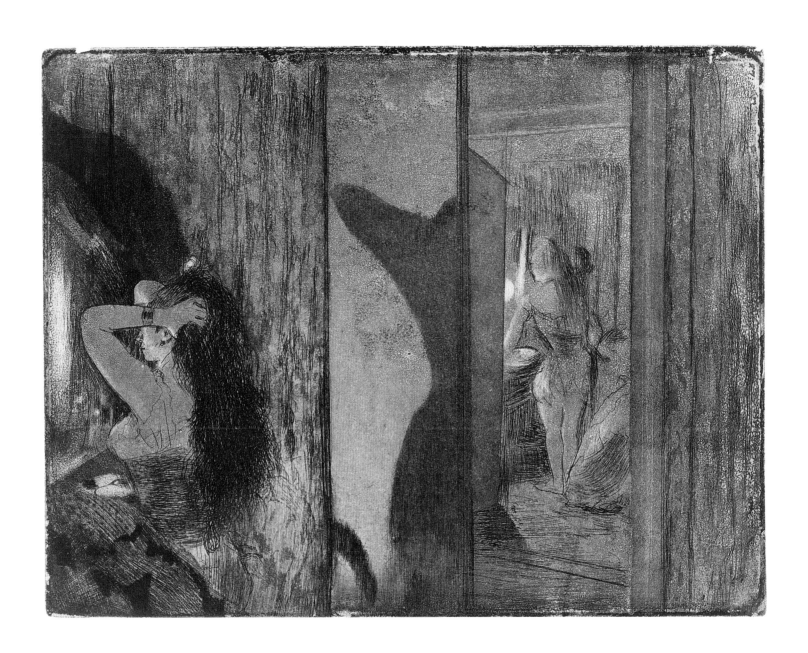

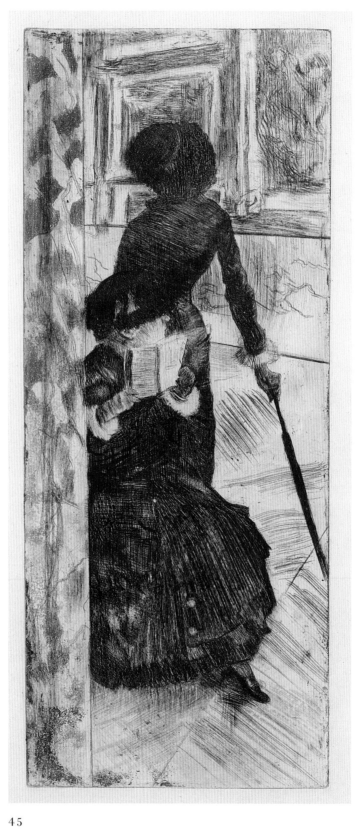

45

45. MARY CASSATT AT THE LOUVRE: THE PAINTINGS GALLERY

1879–80

Etching, soft ground etching, aquatint, and drypoint on cream, medium weight, moderately textured, laid paper

Third state of twenty

Plate: 11⅞ × 5 inches

Sheet: 14⅛ × 10⅜ inches

Yale University Art Gallery, University Purchase, 1949.40

Reed and Shapiro 52

46. MARY CASSATT AT THE LOUVRE: THE PAINTINGS GALLERY

1879–80

Etching, soft ground etching, aquatint, and drypoint on off-white, very thick, wove paper

Eighth state of twenty

Plate: 11⅞ × 5 inches

Sheet: 16³⁄₁₆ × 8³⁄₁₆ inches

The Minneapolis Institute of Arts

The Putnam Dana McMillan Fund, P82.13

Reed and Shapiro 52

47. MARY CASSATT AT THE LOUVRE: THE PAINTINGS GALLERY

1879–80

Etching, soft ground etching, aquatint, and drypoint on buff, moderately thick, smooth, wove paper

Thirteenth state of twenty

Plate: 11⅞ × 5 inches

Sheet: 14⅛ × 8⅛ inches

Philadelphia Museum of Art

Purchased with the John D. McIlhenny Fund, 1941-8-32

Reed and Shapiro 52

DEGAS CREATED A SUITE OF DRAWINGS and etchings in 1879–80 for a new journal of prints, *Le jour et la nuit (Day and Night)*, which he hoped to found. Cassatt, Desboutin, Pissarro, and Raffaëlli all agreed to contribute. Although this periodical was never realized, its proposal encouraged these artists to undertake unprecedented experiments in printmaking. In a print intended for *Le jour et la nuit*, Degas portrayed his friend Mary Cassatt with a companion, possibly her sister Lydia, visiting the Etruscan Gallery in the Louvre. The three prints in this exhibition are part of a second engagement with this motif in which the Cassatt sisters are shown visiting the Paintings Gallery. This composition employs a narrow format used in many of the Japanese prints that both Degas and Cassatt avidly collected. Degas offers a complex image of Cassatt. She is shown looking rather than painting, which might have associated her with the less prestigious identity of the Louvre's lady copyists. He depicts her as a passionate viewer, who does not rely upon a guidebook to shape her appreciation of the old-master paintings before her, as Lydia does, but experiences the beauty directly with elegant but nonetheless deep excitement. Degas depicts her as a connoisseur.

These three prints illustrate the care with which Degas varied his compositions and tonalities over a number of states while developing a print. Through careful examination of the forty-four surviving impressions, scholars have argued persuasively that *Mary Cassatt at the Louvre: The Paintings Gallery* was reworked over a series of twenty states.[1] The three states in this exhibition reflect key stages in the transformation of the print. Degas established the main elements of the composition from the outset: the *Japoniste* verticality and diagonal viewpoint, the placement of the two women, the contrasted poses of guidebook-reading amateur and confident connoisseur. The third state is the earliest in which Degas deepens the overall tonality of the print. He indicates the marble texture of the doorjamb through additions in aquatint and light drypoint and widens the brim of Mary Cassatt's hat. More elaborate hatching and a bold diagonal line suggest parquet flooring, while further demarcations on the wall sharpen the background into three paintings hung above a dado.

By the eighth state much more intricate hatching has been added across all the features of the interior. The doorjamb has been widened, the parquet floor more sharply defined with the addition of a further diagonal division, and the compositions of

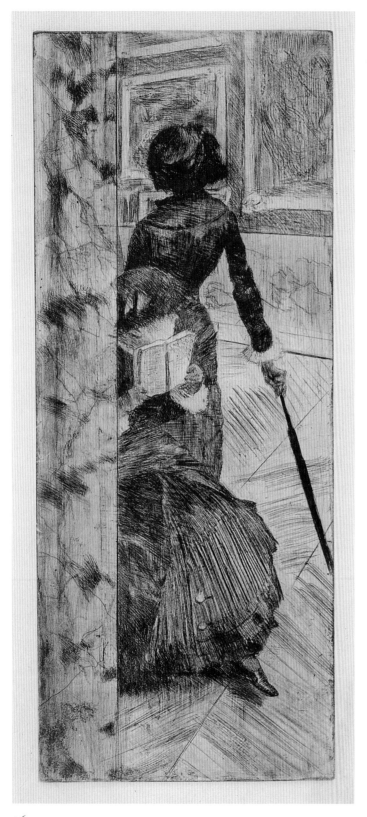

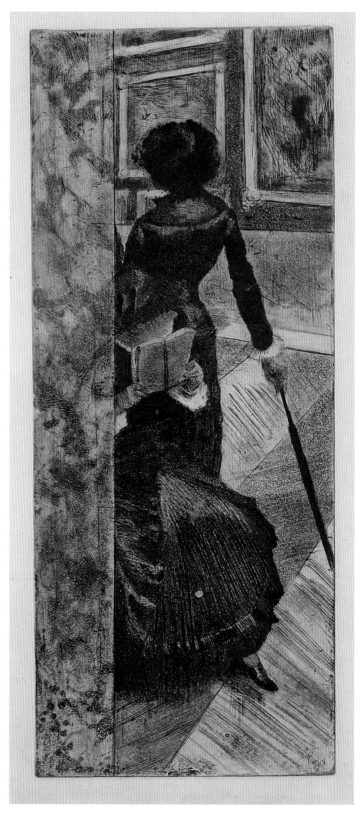

46

47

paintings continue to emerge; Degas hints at a figure painting on the right and a landscape on the left. The women's costumes are much more finely worked; Degas indicates buttons and the sweep of skirts, and he changes the angle of Mary Cassatt's hat.

This angle is abandoned by the thirteenth state in favor of a rounded shape, which survives until the twentieth state. The cascade of pleats in Lydia's skirt is much more finely described by the thirteenth state, and its second button has been covered over. A lighter but more finely detailed evocation of marble texture is added to the doorjamb.

All three of the prints discussed here remained with Degas until his death and were sold in the sale of his prints, November 22–23, 1918, at Galerie Manzi-Joyant. The Yale version was purchased from the atelier print sale by M. Carré (no. 31) and later entered the collection of Charles D. Eddy. Harris Whittemore of Naugatuck, Connecticut, son of the iron tycoon John Horace Whittemore acquired it from an art dealer called Zinser. Whittemore was an important American collector of Impressionism, first acquiring five Monets from the Durand-Ruel Gallery and Boussod & Valadon in 1892. Subsequently, with Mary Cassatt's advice and encouragement, Whittemore also purchased works by Degas (including the present print), Manet, Morisot, Pissarro, and Sisley. The print was acquired by the Yale University Art Gallery in 1949.

The Minneapolis Institute of Arts print was purchased at the print sale (no. 36) by the artist's niece, Mlle. Jeanne Fèvre. It then entered the collection of Arne Isaksen and later the Galleri Haaken, both in Oslo, Norway. It was auctioned at the Galerie Kornfeld, Bern, Switzerland, on June 22–25, 1982. John Ittmann, then curator of prints and drawings, specially sought out this impression through the agency of David Tunick, New York, and purchased it with the Putnam Dana McMillan Fund at the Kornfeld sale.

The Philadelphia print was sold to Loys Delteil at the print sale (no. 40). The Philadelphia Museum purchased it through the John D. McIlhenny Fund in 1941; John D. McIlhenny was the father of Pennsylvania collector Henry P. McIlhenny and was chairman of the Board of Directors of the Philadelphia Museum during the 1920s.

CLAIRE I. R. O'MAHONY

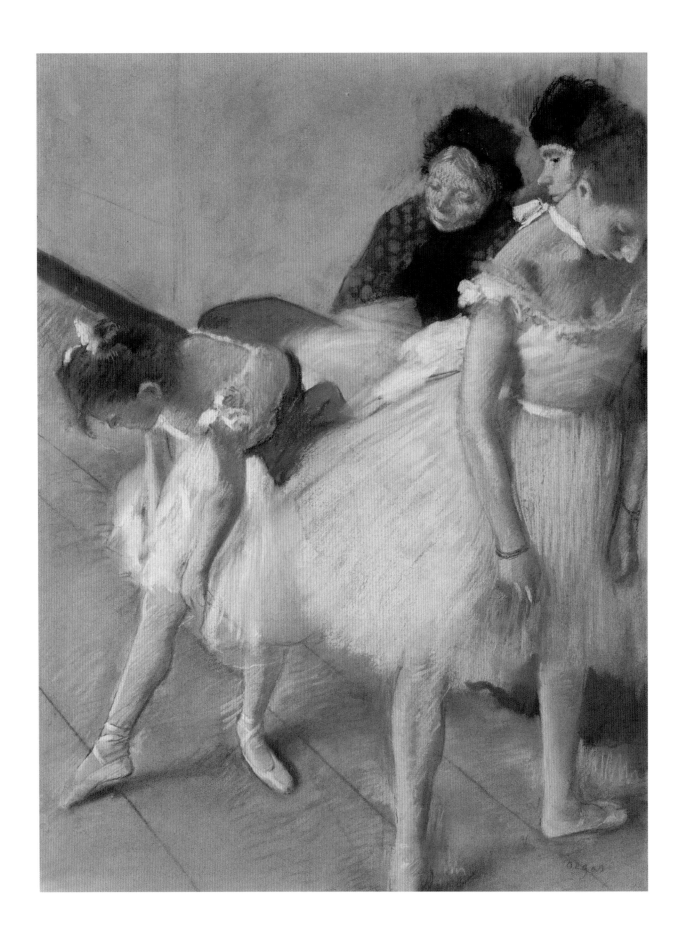

48. The Dance Examination

1880
Pastel on paper
24⅝ x 18½ inches
Denver Art Museum, Anonymous Gift, 1941.6
Lemoisne 576
Atlanta only

THE DANCE EXAMINATION was first shown in 1880 at the Fifth Impressionist exhibition. Organized in large part by Degas, the fifth effort to exhibit works independently of the annual Paris Salon was fraught with internal tension and critical disappointment.[1] Monet was accepted at the Salon that year and chose that venue in the hope of gaining the recognition (and sales) he felt independent shows had failed to bring. This move alone brought a flurry of critics declaring the death of Impressionism. However, among the critics, Degas was held as the standard with which the other exhibitors could not contend.[2] Already known as "the painter of dancers,"[3] Degas received particular attention in 1880 for *The Dance Examination*. The characters in his scene were deemed disagreeable and vulgar yet truthful; his drawing was judged audacious, subtle, and even charming, provided there was enough distance between the work and the viewer.

The work employs the technical vocabulary that made Degas controversial: the unbalanced composition; the unusual cropping of the figures and the enlarging of the girl on the right; the visible hatched strokes of pastel; and the use of contrasting color to create a vibrating surface. At the same time, the draftsmanship of the right-hand dancer's foreshortened head, neck, and shoulders and the modeling of her shoulder girdle demonstrate Degas's unmistakable talent. *The Dance Examination* gave Degas's audience (and prospective patrons) a satisfying representative work that tested the accepted limits of subject matter, color, and composition.

This pastel was lent to the Fifth Impressionist exhibition by Ernest May, who was a member of the Parisian stock exchange and an early collector of Degas and other Impressionists.[4] (May is depicted in Degas's *Portraits at the Stock Exchange,* ca. 1878–79, Musée d'Orsay.) May sold the pastel, along with two other dance scenes, in an 1890 auction held at Galerie Georges Petit, the gallery that would orchestrate the sale of Degas's studio material after his death. In 1898 Paul Durand-Ruel bought the work from Galerie Bernheim-Jeune, who may have acquired it directly from the May sale or through an intermediary owner, and in December he transferred it to his New York gallery. Louisine Havemeyer snatched up the work within two weeks of its arrival.

Mrs. Havemeyer included *The Dance Examination* in an exhibition supporting the woman suffrage movement, organized in 1915 and held at Knoedler's Fifth Avenue gallery. Works by several artists, including Mary Cassatt, were shown; however, critical focus fell on Degas. A quarter-century after its first appearance, *The Dance Examination,* which in the 1880s was a convincing argument for the acceptance of this artist, stood as proof of Degas's incorporation by the educated into the canon of modern masters.[5] Mrs. Havemeyer bequeathed the pastel to her son Horace, who owned the Denver-based Great Western Sugar Company. Horace Havemeyer gave *The Dance Examination* anonymously to the Denver Art Museum in 1941, making it one of the earliest Degas acquisitions by a museum west of the Mississippi.

PHAEDRA SIEBERT

49. THE BALLET CLASS

ca. 1880
Oil on canvas
32⅜ × 30¼ inches
Philadelphia Museum of Art
Purchased with the W. P. Wilstach Fund, W'37-2-1
Lemoisne 479

THIS PAINTING CAPTURES THE CONTRAST of illusion and reality that inspired Degas's lifelong fascination with the world of the ballet. In a mirror reflecting the rehearsal room window, a gray mass of Parisian apartment buildings appears beyond the bare boards of the interior. All appurtenances of scenery and lighting are stripped away; without this contextualizing glamour, the dancers' movements are strangely arresting. The array of dissociated figures exemplifies the oddity of the rehearsal room. The loitering of dancers waiting for their entrance contrasts with the concentration of the performers at work. The juxtaposition of the rigid dancing master and the lounging chaperone awkwardly reading her paper in the foreground enhance this contrast. The illusion of spontaneity in ballet performance must be painstakingly created through repetition. The complexity in this work was carefully orchestrated by Degas's numerous reworkings of the composition. Correspondence with both Mary Cassatt and Louisine Havemeyer as well as X-rays of the painting indicate that the woman in a blue print dress in the foreground was originally a dancer and that almost all of the figures have been repositioned.

Although Cassatt had indicated her intention to purchase this painting for her brother, Degas sold it to Paul Durand-Ruel on June 18, 1881, for 5,000 francs, seemingly in the hopes of securing a higher price (financial haggling was a source of tension in Degas and Cassatt's lifelong friendship). Through his sister, Alexander Johnston Cassatt purchased this work from Durand-Ruel the next day for 6,000 francs, along with paintings by Monet and Pissarro. *The Ballet Class* passed through three generations of the Cassatt family until it was acquired by W. P. Wilstach, whose collection became a part of the Philadelphia Museum of Art in 1937.

Starting as a surveyor in Georgia, by 1880 Alexander Cassatt had risen to third vice president of the Pennsylvania Railway, and the following year he was promoted to first vice president. Although Cassatt retired in 1882, he remained a director of the Pennsylvania Railway and in 1885 took on the presidency of the New York, Philadelphia, and Norfolk Railroad. After the sudden death of a colleague, Cassatt agreed to serve as president of the Pennsylvania Railroad from 1896 until his death in 1906. His tenure was marked by peaks and troughs in railway history: the construction of the Hudson River Tunnel and the Pennsylvania Station in New York (Alexander Weiner's statue of Cassatt was in the Grand Staircase) as well as some of the worst regulation and antitrust battles of the Theodore Roosevelt presidency. Like many of the early American collectors of Impressionism, Cassatt began by acquiring works by Monet. By 1892 he had purchased paintings by Manet, Morisot, Pissarro, Renoir, and Raffaëlli, which were kept in Cheswold, his Victorian Gothic country home in Haverford, Pennsylvania. Cassatt also commissioned Whistler to paint a portrait of his wife, Lois Buchanan Cassatt, a niece of President Buchanan. Cassatt lent his works to many important early exhibitions of Impressionism in America, including the American Art Association 1886 exhibition held in New York, the loan exhibition at the Chicago World's Columbian Exhibition of 1893, organized by Sara Tyson Hallowell, and an exhibition held in Pittsburgh in 1902 (see page 24, fig. 10).

CLAIRE I. R. O'MAHONY

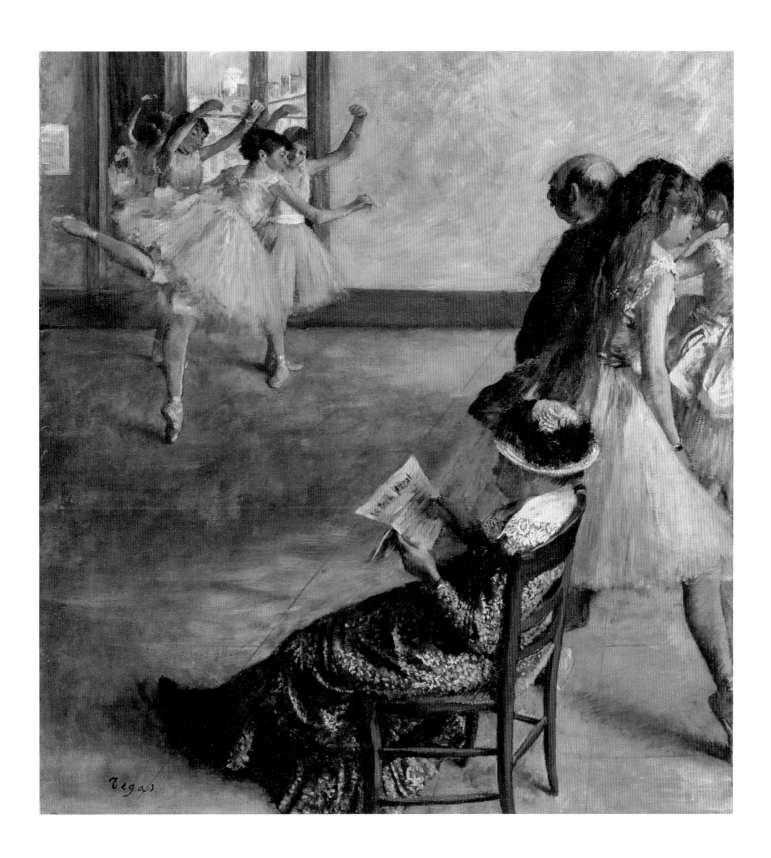

50. BALLET DANCER (DANCER CURTSYING)

ca. 1883
Colored chalk on gray paper
17½ × 12 inches
Wadsworth Atheneum, Hartford, Connecticut
Purchased through the gift of Henry and Walter Keney, 1934.293
Lemoisne 616

ALTHOUGH DEGAS HAD ONLY MINIMAL formal academic training, he never forgot the lessons that he learned in his youth at the teaching studios of Félix-Joseph Barrias and Louis Lamothe and at the École des Beaux-Arts in Paris. This is particularly evident in the number of preparatory studies that he produced throughout his career. In the traditional academic manner, Degas frequently began with studies of nude figures and then progressed to drawn and painted studies of clothed individual figures and groups. In many drawings, Degas also employed the technique of "squaring," drawing a grid onto a study and using an enlarged grid on canvas to transfer the drawing block by block.

Ballet Dancer (Dancer Curtsying) has been squared for transfer. Although it is not entirely clear for which finished work the drawing was originally intended, it appears to be related to a pastel entitled *Dancer in Green* (ca. 1883, Shelburne Museum, Shelburne, Vermont). The position of the dancer's left arm is slightly higher in the pastel. While it is not known how commonly Degas prepared sketches in advance of pastels, there is one documented case from the early 1880s that clearly shows the artist made several preparatory studies for a finished pastel.[1]

When Degas made this drawing, he was becoming known as a painter of dancers. Louisine Havemeyer, Degas's greatest American collector, is reported to have asked the artist why he always painted ballet subjects. The artist responded, "Because, madame, it is all that is left of the combined movement of the Greeks."[2] Richard Kendall has argued persuasively that Degas viewed dance subjects as a means to revive the power and grace of classical Greek art in the late nineteenth century.

Like virtually all of Degas's preparatory studies, *Ballet Dancer* remained in the artist's studio until the posthumous atelier sales. Durand-Ruel, whose New York gallery was a major source of works by Degas for American collectors, bought it in April of 1919 from the third atelier sale (no. 367). Mrs. Cornelius Sullivan of New York purchased it from the gallery sometime during the 1920s or early 1930s. Sullivan assembled a large collection that included several drawings and sculptures by Degas. In 1934 the Wadsworth Atheneum in Hartford, Connecticut, purchased this drawing from Sullivan for $800.

DAVID A. BRENNEMAN

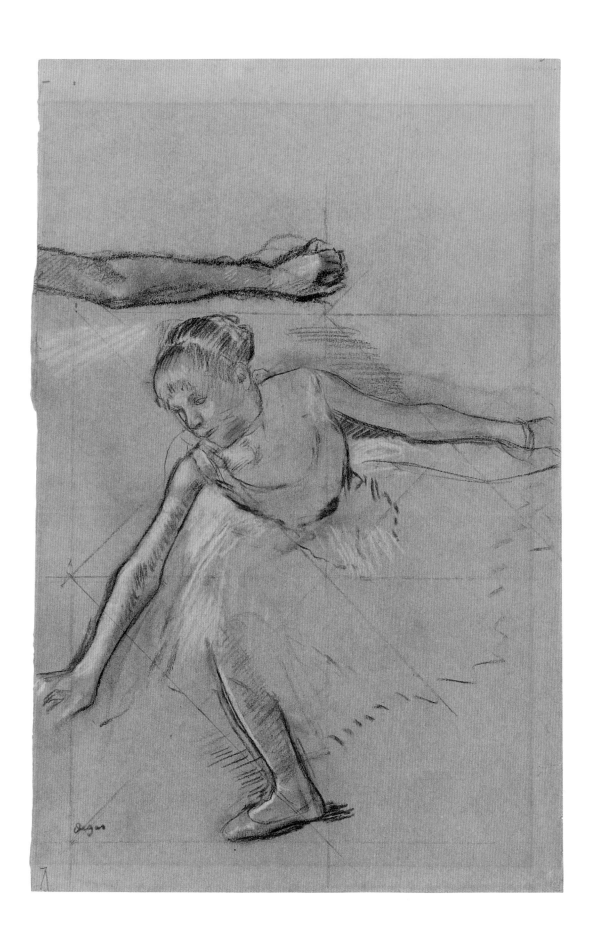

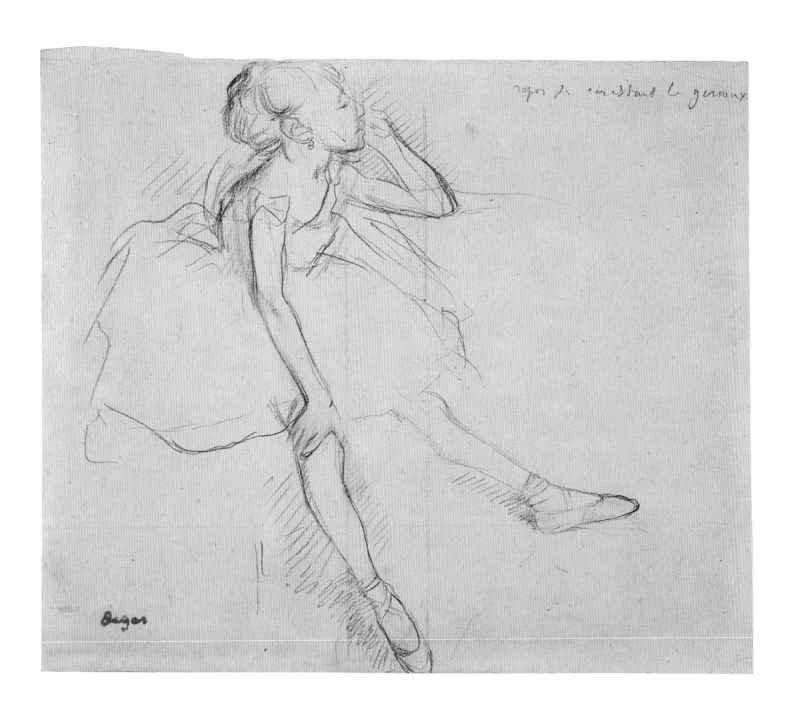

51. BALLET GIRL IN REPOSE

ca. 1880–82
Charcoal on wove paper
9⁹⁄₁₆ × 11⁷⁄₁₆ inches
The Minneapolis Institute of Arts
Gift of Julius Boehler, 1926, 26.10
Minneapolis only

ALTHOUGH SEVERAL ARTISTS had portrayed ballet dancers, none moved beyond superficial observations to capture the artistic form as successfully as Edgar Degas. The dedication with which the artist observed and recorded "every single attitude . . . of a dancer according to her experience" infused his depictions with an accuracy and understanding that made the subject truly his own.[1]

As *Ballet Girl in Repose* confirms, even the youngest dancers, or ballet "rats," were not beyond the scope of Degas's interest. Approximately eight years of age, the young girl is one of many who began their slow climb to accomplished stardom as ungainly apprentices.[2] Her slumped position reveals the inexperience of one whose carriage, even at rest, has not yet been formed by the discipline and rigors of her profession.[3]

The drawing relates to three others that feature a similar fledgling ballerina and that also bear inscriptions describing the dancers' actions.[4] Here, Degas's inscription, *repos se caressant les genoux* (at rest caressing the knees), describes the action of the weary ingenue, who lightly rubs her right knee. The artist's use of the plural "knees," whereas the dancer rubs only one knee, suggests that the inscription was appended at an early stage of the drawing. Faint outlines indicate that Degas altered the placement of her left arm twice before fixing it in its third and final position. In his first approach, he extended her arm downward to her left knee, then more highly placed; in his second, he stretched her relaxed arm forward along the edge of an unseen support. These adjustments, as well as those to her back, reveal how the observant artist kept pace with the shifting posture of his unaware model.

The drawing remained in the artist's possession until his death, as the stamped signature at the lower left indicates. It was sold, along with three other drawings, at the third atelier sale in April of 1919 (no. 109) and passed into the possession of the Galerie Bernheim-Jeune. Shortly thereafter, it was acquired by Julius Boehler, a noted dealer with galleries in Munich and Lucerne, who donated the drawing to The Minneapolis Institute of Arts in 1926.

PATRICIA S. CANTERBURY

52. THE LAUNDRESS IRONING

ca. 1882–86
Oil on canvas
27 × 27 inches
Reading Public Museum, Reading, Pennsylvania
Bequest of Mrs. Martha C. Dick, 76.45.1
Lemoisne 276

ON FEBRUARY 13, 1874, Edmond de Goncourt visited Degas's studio, where the artist was working on a series of pictures featuring laundresses and women ironing. This was a theme that was for some years to preoccupy Degas as well as such writers as Emile Zola, who in 1876 chose a laundress as one of the main characters in *L'Assommoir*.

This picture is typical of Degas's later works, in which he focuses on a single figure with a minimum of props, rather than a busier, more detailed scene inviting some kind of narrative. However, it also shares something with earlier works such as *Woman Ironing* of 1873 (Metropolitan Museum of Art), with its monochrome palette and atmosphere of industry.[1] The figure appears distant and thoroughly absorbed in her task. Her remoteness is emphasized by the high viewpoint and the broad expanse of the ironing table, which extends beyond the limits of the frame and pushes her into the background of the picture. She is further cut off by the strips of washing hanging from an invisible line beyond the edge of the canvas.

The picture is painted with broad brushstrokes and a limited but warm palette, reflecting the heat of the room and the arduous nature of the laundress's task. The soft pink of the woman's shirt is reflected in the white expanse of the table and stands out against the more muted olives and browns of the background. The pastel study for this picture[2] reveals Degas's interest in the movement and position of the laundress's right arm. In the painting, the woman's arms are exposed and bathed in light, drawing attention to their strength, and Degas emphasizes the size of her right hand as it works away with the flatiron. Her face, by contrast, is in shadow and her head half hidden by the hanging washing. The emphasis is on work, not intellect, and she works steadily and quietly, absorbed in her own world.

This painting was included in the second atelier sale (no. 6) in 1918, catalogued as *Blanchisseuse repassant du linge* and bought by a M. Pellé (probably Gustave Pellet) for 7,000 francs. Pellet ran a business at 51 rue Peletier in Paris and was well known as a publisher of prints, specializing in the work of Félicien Rops and Louis Legrand. He also collected works by Impressionist, Post-Impressionist, and Symbolist artists, including Degas, and produced the first editions of color lithographs by Toulouse-Lautrec, Redon, Signac, Luce, and Anquetin. *The Laundress Ironing* remained in Pellet's collection for some time, but by 1949 it had found its way to the United States and was loaned to a New York exhibition by an American collector, Henry Kissinger Dick (1886–1953). Dick was a professor of English at Columbia University, New York. He may have acquired *The Laundress Ironing* in the late 1930s, when he first developed an interest in Impressionism.[3] His collection included works by Monet and Degas as well as a number of lithographs, which he exhibited at the 57th Street Galleries and the Harriman Gallery in New York in 1941. At his death in 1953, some of his collection was bequeathed to the Princeton University Art Museum. The rest, including *The Laundress Ironing*, was inherited by his niece, Martha C. Dick of Reading, Pennsylvania. The picture remained in her collection until 1976, when it was bequeathed to the Reading Public Museum. The Dick estate was auctioned at Sotheby's, New York, in 1977.

FRANCES FOWLE

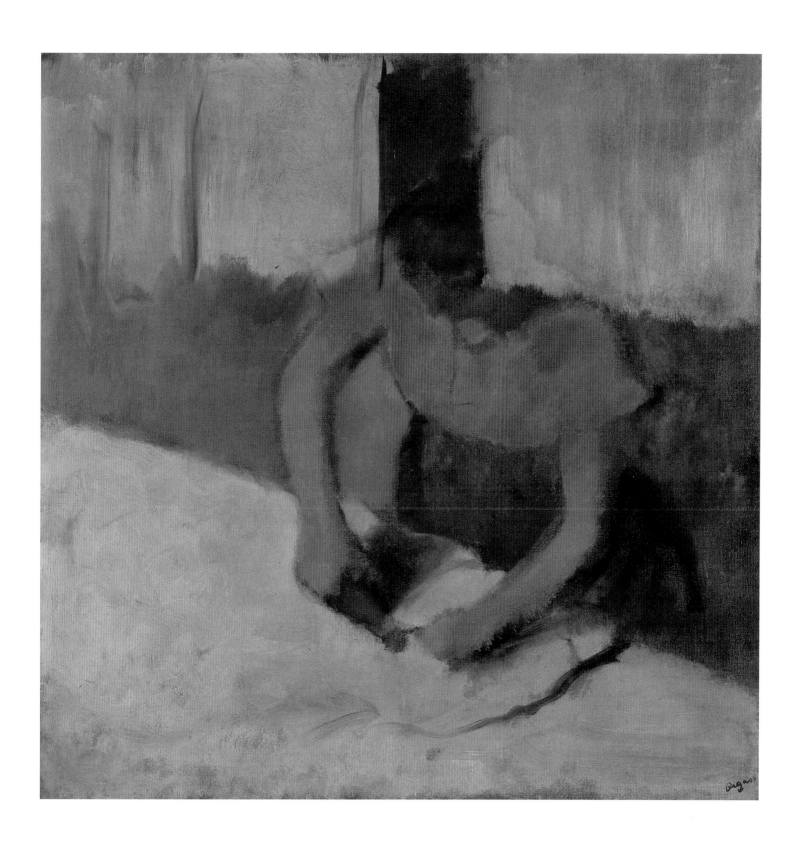

53. DANCER WITH RED STOCKINGS

1883–85
Pastel on pink laid paper
29⅞ × 23⅛ inches
The Hyde Collection, Glens Falls, New York, 1971.65
Lemoisne 760
Minneapolis only

THIS IS LIKELY ONE OF THE FIRST DEGAS pastels shown in the United States. Sent by Durand-Ruel from Paris to New York on February 19, 1886, it figured in an exhibition of Impressionist works held at the Art Association Galleries in the spring of that year. The apparent lack of finish—which drew criticism from American reviewers[1]—was not without precedent in Degas's exhibited works. As early as the Second Impressionist exhibition in 1876, he had shown a series of dancers sketched *à l'essence* on pink paper.[2] The exhibition of the pastel at such an early date gave an American audience a glimpse of well-established yet contemporary Impressionist practice, in which a rapid, sketchy treatment enlivens a carefully developed composition and an extremely complex color structure.

The work depicts two dancers seated beside each other, arranged more or less frontally. Their heads and rounded shoulders give the upper register a harmonic symmetry, which is offset by the sweeping downward lines of the main figure's action and reformulated in the lower half as a bold configuration of angled planes in the form of the dancer's red stockings. The slightly awkward pose resolves itself as Degas brings the eye to the floor with four quick, economical strokes. The space is dynamic yet so shallow there is hardly room for a bench. Degas elaborates the whole through a series of rich layers of pastel: the outlines mix purple and dark green or brick-red and light blue. The vibrant stockings are a mixture of reddish orange and dense pink, providing a strong contrast to the cool blue glow of the dancer's torso. The decisive placement of the signature between her foot and the line of the floor holds the eye suspended in this odd space for a moment, aloft on one of the artist's visual pirouettes.

The drawing is based on a pastel of 1879–80, titled *Before the Ballet*,[3] which depicts uniformly costumed dancers still stretching and moving about in the studio. In addition to altering the point of view of the earlier work, Degas changed the narrative dimensions of the scene. The main figure is dressing to leave the rehearsal or performance and will be ready as soon as she pulls on her stockings and changes her shoes. The artist has chosen a provocative outfit for her and carefully matched her lips to her undergarments. Her poor shivering colleague is transformed into a ghostly presence, only half glimpsed. Degas renders her sympathetically, however, in a warm, glowing brown touched with white.

After its return to Durand-Ruel in Paris in August 1886, the pastel was not shown again until 1935 in Brussels. It had left France by 1937, when it was lent to the Orangerie in Paris from the collection of Lord Ivor Churchill. It came to the United States through Paul Rosenberg in 1944, when it was bought by Charlotte Hyde in December of that year. Sixty-three years after its first exhibition in America, the work was shown again in 1949 in New York.

DAVID OGAWA

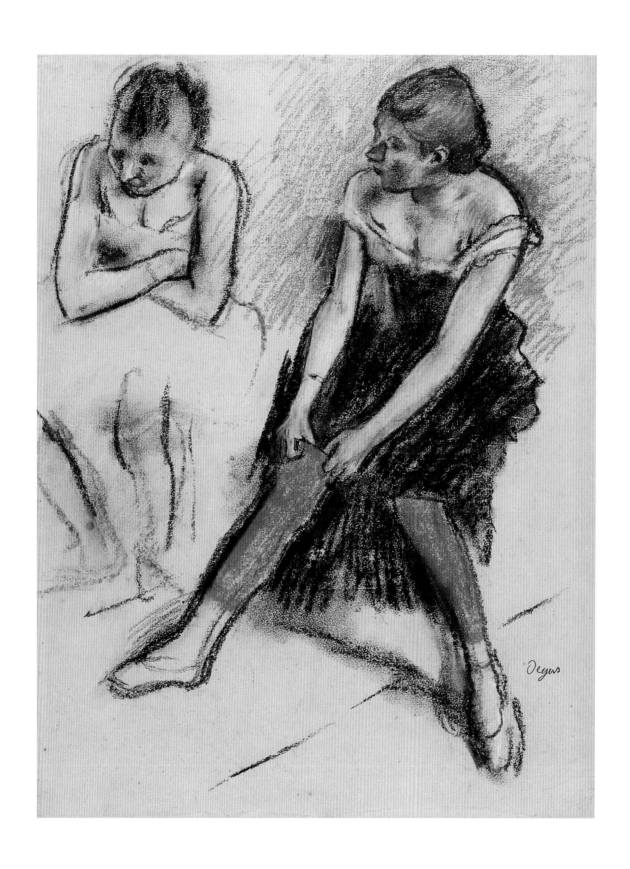

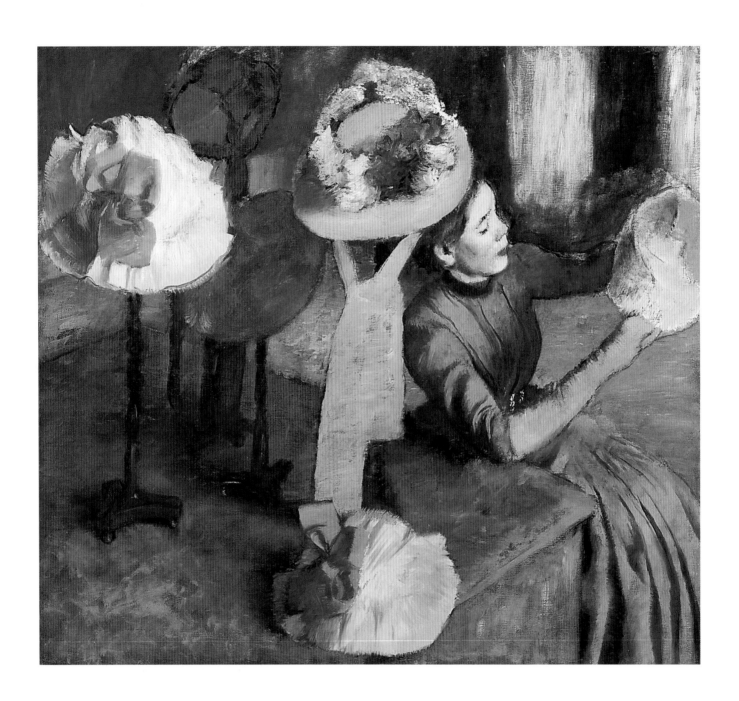

54. THE MILLINERY SHOP

1884–90
Oil on canvas
39⅜ × 43⁹⁄₁₆ inches
The Art Institute of Chicago
Mr. and Mrs. Lewis Larned Coburn Memorial Collection, 1933.428
Lemoisne 832
Minneapolis only

IN THE 1880S AND 1890S Degas often portrayed the world of working women: laundresses and milliners as well as his favorite subject, ballerinas. Whereas Degas often showed the client, attended by the milliner, considering her potential purchases, in *The Millinery Shop* he shows the artisan alone at work with a pin in her mouth. She wears gloves, presumably to protect the delicate fabric from the oils of her skin, while she embellishes the hat's decoration. These gloves create a moment of uncertainty, simultaneously associating her with buyers and with makers. This complexity is enhanced by the curious relationship of the woman to the hats on display. Suspended on stands in midair, the hats seem to have lives of their own, superseding the milliner herself. As early as 1865—in *A Woman Seated Beside a Vase of Flowers* (cat. 18)—Degas had used this compelling yet disorienting device of blurring the boundaries between still life and portraiture.

The success and proliferation of the luxury and fashion trades of France began in the Second Empire but reached new heights in the Third Republic, when *The Millinery Shop* was painted. The advent of Parisian department stores like the Galleries Lafayette and Samaritaine were widely celebrated and critiqued by such authors as Emile Zola in his novel *The Ladies' Paradise*. Later such artists as Georges Seurat and Pablo Picasso would more explicitly represent the absurd yet provocative confinement of women's fashion from suffocating corsetry to unnaturally distended bustles. Degas's focus is on the hat, a more external and thus less problematic element of the feminine toilette. These radiantly colored and multitextured creations nearly replace his need for a living model. Degas's milliner is part of the furniture of the boutique in her neutral brown uniform and with her sidelined placement in the composition. Yet her concentration and dexterity of gesture reveals the admiring pleasure the artist takes in her craft and skill.

Although Degas exhibited this work in New York in 1886, it did not leave his possession until February 22, 1913, when he sold it to Paul Durand-Ruel for 50,000 francs. Durand-Ruel sent it to his New York gallery in 1917, where it remained until January 19, 1932, when Chicago collector Mrs. Lewis Larned Coburn bought it for $36,000. Coburn acquired an important collection of Impressionist works painted principally between 1860 and 1902. Like many American collectors of Impressionism, she began by purchasing the work of Monet, Renoir, and Sisley. Later she also acquired the more contested work of Manet, Degas, and earlier nineteenth-century artists, such as Daumier, as well as examples by the Post-Impressionists Cézanne, van Gogh, Gauguin, and Toulouse-Lautrec. A selection of paintings by Derain and Picasso as well as the work of American contemporary artists reflected the comprehensiveness of the Coburns' taste. Mrs. Coburn bequeathed *The Millinery Shop* with the rest of her collection and a separate gift of watercolors in memory of her mother, Olivia Shaler Swan, to The Art Institute of Chicago. The gift entered the collection in 1933.

CLAIRE I. R. O'MAHONY

55. STUDY OF TWO DANCERS

ca. 1885
Charcoal and chalk on paper
18¼ × 24 inches
High Museum of Art, Anonymous gift, 1979.4
Atlanta only

DEGAS'S DEPICTIONS OF DANCERS and singers differ strikingly from his pictures of women grooming themselves. The dancers and singers are extroverted and mannered performers, while the women in the privacy of their bathing and grooming are totally self-absorbed and oblivious of anything but the tasks at hand. This drawing of two dancers actually crosses the line. The exhausted dancer on the left is lost in thought; the other seems to be concerned only with her left foot. Both seem unaware of their surroundings. To Degas the state of mind of his subject was as important as external forms and accessories.

The right figure in *Study of Two Dancers* appears in a painting of 1890–92, *In a Rehearsal Room* (National Gallery of Art, Washington, D.C.), where the dancer is bent over even more deeply. Both dancers are shown in Yale's *Ballet Rehearsal*. Degas had always made studies of figures and of details and fragments in innumerable positions observed from different viewpoints. He used this accumulated material in developing compositions for final works, which he based not on posed models but on his knowledge and visual memory.

Toward the 1880s, Degas's outlines tended to intensify with repeated strokes that emphasize the forms they enclose. Even if the delicate lines (which he had learned from Ingres) vanished, this emphasis on line continued in these forceful contours. The emphatic lines mark both the studies and the finished paintings of nudes and dancers, jockeys and horses, enhancing the power of these images at the expense of the anecdotal. In a review of the eighth and last exhibition of the Impressionists in 1886, the perceptive critic Félix Fénéon wrote, "Degas does not copy from nature. He accumulates a multitude of sketches, from which he takes the irrefutable veracity that he confers on his work. Never have pictures shown less of the painful image of the 'model' who has 'posed.'"[1]

After his father's death in 1874, Degas found himself in dire straits as creditors descended on the family bank, which, as it turned out, had subsisted on credit. His brothers were of no help in stabilizing the family's finances. René, the youngest, had made a substantial loan from the bank, which he was unable to repay. For a decade Degas was forced to scramble to sell his work in order to meet the monthly payments. He complained about being obliged to produce "saleable" pictures, which he sent to his dealers beseeching them for payments.

By the mid-1880s, Degas's fortunes were picking up. The reviews were, by and large, quite favorable. Degas had become famous, and collectors were buying his work at a gratifying pace, while the artist himself was becoming a major collector, buying numerous works by his contemporaries as well as earlier artists, including Ingres and Delacroix, even canvases by El Greco. By the end of the 1880s his collection had grown so voluminous that he had to move into a very large apartment.

Study of Two Dancers was in the third Degas atelier sale in 1919 at the Georges Petit Gallery, where it was acquired by Georges Viau (no. 223). A successful dentist, Viau had a large and impressive collection of nineteenth- and early twentieth-century French art. Degas was one of the artists whose work he most avidly collected, acquiring pastels and sketches as well as oils. Viau's collection represented all the great movements of French nineteenth-century art, including landscapes of the Barbizon School, Romantic figure pieces, and portraits by Delacroix. All of the leading Impressionists painters—Manet, Monet, Pissarro, and Renoir—were also included more often than not by figural compositions, usually portraits or nudes. A few artists outside the Impressionist circle also appeared, notably works by Puvis de Chavannes, Gauguin, and Toulouse-Lautrec as well as Edouard Vuillard's portrait of Viau in surgery. After Viau owned it, *Study of Two Dancers* was at Adam-Dupré, Paris; the Matthiesen Galleries, London; and the Lilienfeld Galleries, New York. It was then purchased by Mrs. Ralph J. Hines of New York and passed to Mrs. Harry E. T. Thayer and to Mr. Robert S. Pirie of Cambridge, Massachussetts. In 1979 it was given anonymously to the High Museum of Art.

GUDMUND VIGTEL

The Ballet Rehearsal, 1891, oil on canvas, 14⅛ × 34½ inches, Yale University Art Gallery, gift of Duncan Phillips.

56. MLLE. BÉCAT AT THE CAFÉ DES AMBASSADEURS

1885
Pastel over lithograph
9 1/16 × 7 7/8 inches
The Pierpont Morgan Library, Thaw Collection, 1997.88
Lemoisne supplement 121, Reed and Shapiro 31b

DEGAS PRINTED THIS LITHOGRAPH in 1877–78 and drew over it with pastel in 1885. He had begun printmaking in the mid-1870s; the techniques were new to him but offered fresh possibilities for visual exploration. He experimented with intense concentration on monotypes, lithography, and etching.

Degas reworked a number of these prints, drawing over them with such opaque media as pastel, sometimes mixed with oil or gouache for effect. In this example he used pastel to achieve substantial changes, especially in the foreground, where he covered the top hats of spectators and the tops of double bases in the orchestra. In their place he drew faces of female customers, creating a more pronounced division between the foreground and the stage. To give greater depth to the scene, Degas added strips of paper to the right and bottom edge of the image that he incorporated with the use of pastel. In effect, he produced a new image of the theme in the original lithograph.

The Café des Ambassadeurs on the Champs Elysées was one of the better cabarets in Paris and a favorite of Degas. He enjoyed the striking contrasts between the bright stage lights and the murky recesses in the audience, the noisy activities, and especially the antics of the performers. Mlle. Bécat had developed a reputation for her outlandish songs with such titles as "La rose et l'hippopotame," which she performed with jumps and frantic gesticulations popularly known as *le style épileptique*.[1] Degas organized the café-concert's multiple light sources—the moon seen dimly through the clouds, the large gas globe to the

right, the overhead crystal chandelier, the clusters of stage lights, and the fireworks—into an extraordinary dark/light pattern barely held in check by the three verticals of the columns. The glittering contrasts almost overwhelm the slight, pink figure of the singer, who receives the applause as the fireworks outside mark the end of her performance.

Degas, who greatly enjoyed nightlife—attending ballet performances, the theater, and the café-concerts—apparently prepared a number of these prints for a publication, *Le jour et la nuit*, which was to have included prints of daily life by his friends Félix Bracquemond, Mary Cassatt, and Camille Pissarro. Nothing came of the plan, but some of the works that were produced for the printing press appeared in subsequent exhibitions held by the Impressionists between 1874 and 1886.

The dealer Clauzet bought *Mlle. Bécat at the Café des Ambassadeurs* from Degas. In 1891 it was acquired by the British painter Walter Sickert, who greatly admired Degas and was influenced by him in his own work. By 1898, Mrs. Fisher Unwin in London owned it, and by 1908 it went to Mrs. Cobden-Sickert. Much later, the work appeared at Knoedler's in New York and was acquired by Mrs. Ralph King of Cleveland, Ohio, by 1947. Mr. and Mrs. Robert K. Schafer of Mentor, Ohio, owned it until 1982, when it was bought by the dealer David Tunick in New York. Later that same year Mr. and Mrs. Eugene V. Thaw acquired it. It was among the drawings Thaw donated to The Pierpont Morgan Library in New York in 1997.

GUDMUND VIGTEL

57. THREE WOMEN AT THE RACES

ca. 1885
Pastel on paper
27 × 27 inches
Denver Art Museum, Anonymous gift, 1973.234
Lemoisne 825
Minneapolis only

THREE WOMEN AT THE RACES focuses on spectators at a social event, a subject that particularly interested Degas. This pastel was created around the same time that Degas showed several bather pastels at the 1886 Impressionist exhibition— a group of works that inspired a flurry of critical literature and effectively earned Degas his reputation as an unapologetic misogynist. Also exhibited in the 1886 show were two milliner scenes. Much has been written about the brilliantly colored hats and the flirtatious garb in which Degas and other contemporary artists dressed their milliners. Produced alongside his renderings of sexually available hatmakers and his seemingly zoological studies of bathers as animals tending to daily rituals, this work stands in marked contrast.[1]

The pastel technique of the present work is much the same as that employed for the bathers in the 1886 exhibition.[2] However, instead of the pyrotechnic cross-hatchings of color Degas used to model the bathers, this composition is colored soberly; not even the conversing figures' cheeks or the late-afternoon sky is allowed to glow. The mood of the Denver pastel is wholly different from the chattering milliners Degas drew in his *Women on the Terrace of a Café in the Evening* (page 68, fig. 8), made nearly a decade earlier. The women in these works seem to look for (male) companionship and accompany each other only in the meantime. They wear clothing intended to attract attention, and they look outward, engaging passersby.

The tame subject and color of *Three Women at the Races* lend it sobriety and, perhaps, acceptability. Far from being available to male passersby, these women form a closed circle with their bodies. Traces of Degas's original placement of the women are visible. At some point the artist chose to move the outer figures closer to the central figure and to enlarge them slightly. In so doing, he left little room for the background and even less for intruders into their conversation. The women look at each other with intent, wit, and charm, not seeking notice from outsiders. Despite their unavailability, they are not undesirable: their plain frocks are well tailored, revealing figures that conform to the late nineteenth-century feminine ideal.[3]

Three Women at the Races was sold in the first atelier sale in 1918 (no. 309), and it then entered the Trotti collection in Paris. The pastel was part of Durand-Ruel's New York stock by 1932, when it was included in an exhibition of the work of Degas and fellow Impressionist Camille Pissarro. Paul Durand-Ruel was one of the earliest and greatest supporters of Impressionism in Paris and played a crucial role in the dissemination of Degas's work. During the financially difficult 1870s and 1880s in Paris, the dealer opened branches of his gallery in other European cities and eventually in New York, where he exhibited Degas's work as early as 1886. By 1935 the pastel was purchased by a private collector and was given anonymously to the Denver Art Museum in 1973.

PHAEDRA SIEBERT

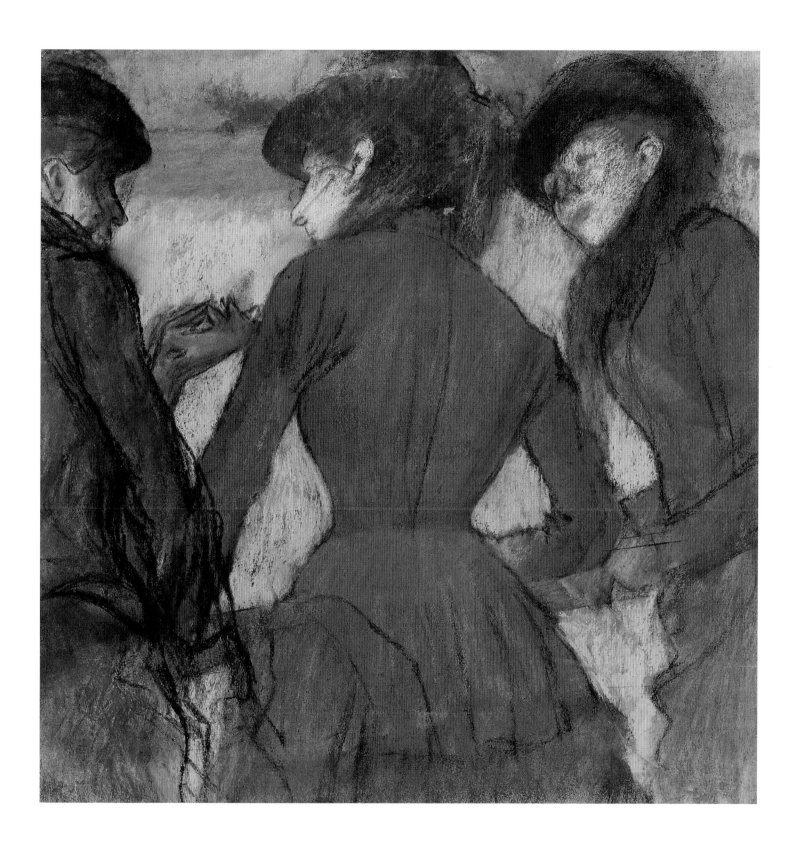

58. DANCER SEEN FROM BEHIND

ca. 1885–90

Black chalk heightened with white chalk on green laid paper

12 × 9½ inches

Art Gallery of Ontario, Toronto

Formerly in the collection of Dr. and Mrs. Harold Murchison
Tovell and purchased from their son, Dr. H. M. M. Tovell of New
York, with the assistance of the Government of Canada through
the Cultural Property Export and Import Act, 1987, 88/85

DANCER SEEN FROM BEHIND is one of several drawings
of dancers in which Degas reinforced his sketched observations
with inscriptions—usually notes regarding technical dance
terms, color, and motifs of particular interest. In this composi-
tion Degas has noted the effect of the light striking the right arm
and the raised leg of the dancer, who is bracing herself against
a wall and executing a *battement* in the second position.

Degas made numerous drawings of dancers in various posi-
tions in order to catalogue the repertoire of ballet movements,
providing him with a virtually inexhaustible source of formal
motifs that he then translated into finished paintings. It is un-
clear whether this drawing served as model for any of the figures
in Degas's paintings.

The drawing is made with black and white chalk on commer-
cially coated green paper. Degas liked to use colored papers,
particularly pink, gray, and green, presumably because they pro-
vided color and served as a middle tint—with white chalk indi-
cating highlights and black chalk creating outlines and shadows.
The relative freedom of Degas's drawing—seen in the swirling
movements of the hair and the curious series of three V-shaped

markings at the lower left—foreshadows the even bolder and
more freely executed large drawings of the 1890s and 1900s,
such as *Two Dancers* (cat. 73).

Dancer Seen from Behind was included in the second sale
of Degas's estate in November of 1918 (no. 219), where Paul
Durand-Ruel purchased it. In 1928, Dr. and Mrs. Harold Mur-
chison Tovell of Toronto purchased the drawing for $600 from
the New York Durand-Ruel gallery, which was a major source
of Degas drawings for North American collections during the
1920s and 1930s. Harold Murchison Tovell was a medical doctor
and his wife, Ruth Matthew, a novelist. Acquired in the 1920s
and 1930s, their collection was one of the most important col-
lections of avant-garde European art in Toronto at the time.
Members of the Canadian avant-garde Group of Seven were
frequent visitors to the Tovell home, where they could see works
by Picasso, Duchamp-Villon, Gauguin, Delacroix, and Degas.
Their son, Dr. Harold Tovell of New York, inherited the drawing,
and in 1987 it returned to Canada when it was purchased by the
Art Gallery of Ontario.

DAVID A. BRENNEMAN

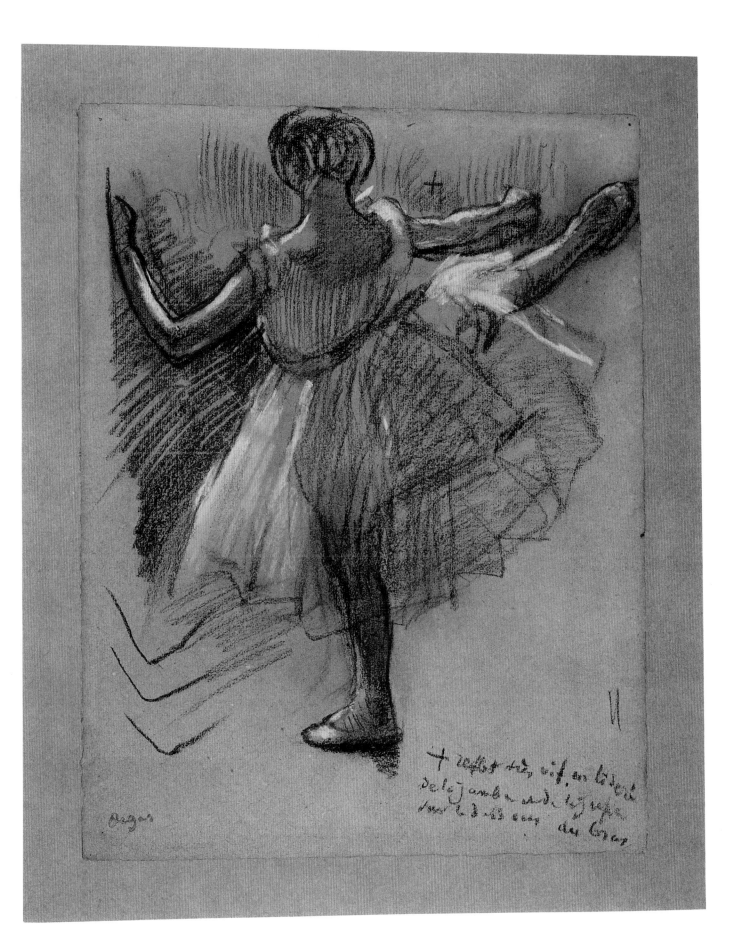

59. Portrait of Rose Caron

ca. 1885–90
Oil on canvas
30 × 32½ inches
Albright-Knox Art Gallery, Buffalo, New York
Charles Clifton, Charles W. Goodyear, and Elisabeth H. Gates Funds, 1943, 1943:1
Lemoisne 862

Rose Caron was a well-known opera singer and acquaintance of Degas. The artist saw her often on the stage in Paris beginning in 1885, dined with her, and composed a sonnet to her. Addressed to "Madame Caron, Brunhilde de Sigurd," the poem evokes the context of a performance by naming both singer and role and describing her body as well as the fictional character she portrays.[1] The concluding couplet reveals the artist's appreciation of her dramatic expression and takes solace in it in the face of his oncoming blindness: "Si mes yeux se perdaient, que me durât l'ouïe,/ Au son, je pourrais voir le geste qu'elle fait." [If my eyes should fade, let my hearing remain,/ In the sound I could see the gesture she makes.]

Caron's gesture—the tense, outstretched arm intersected by the grasp of her glove—declares itself unequivocally as the main subject of the painting. The setting is utterly illegible, the furniture she occupies is unclear, and the costume is only barely suggested. Her face is plunged into a dramatic shadow, silhouetted against a glowing yellow-orange background. Furthermore, the combination of light effect and tonal contrast makes it difficult to decipher her features. The painting thus displaces setting and likeness with the figure's gesture—what Degas sees as he hears Caron sing. His means of conjuring the disembodied sound surrounding her are correspondingly gestural: the painterly strokes, dabs, and scrapes that make up the orchestration of costume, chair, and background are conducted by a single line: the bold, frontal *profile perdu* of the singer. This line is like a pure, clear note that rises above warm, lush harmonies. Caron does not seem to be singing, and her posture implies repose rather than the physical act of performance.[2] Perhaps in choosing to represent her in a private, rather than public moment, Degas intended to eliminate direct, thematic references to musical performance from the painting in order to play it himself with color and line.

This work, one of Degas's best-known and most widely exhibited portraits, remained in the artist's studio until his death. Sold at the third atelier sale in 1919 (no. 17), the work entered the collection of Dr. Georges Viau, where it remained until around 1930. Its whereabouts are undocumented until 1939, when it was acquired by André Weil and Matignon Galleries in New York. Its acquisition by the Albright-Knox Art Gallery represented a strategic moment in American collecting of Degas: recognizing the work's importance, the museum traded its *Two Dancers in Green Skirts*, also by Degas, for the portrait.[3]

David Ogawa

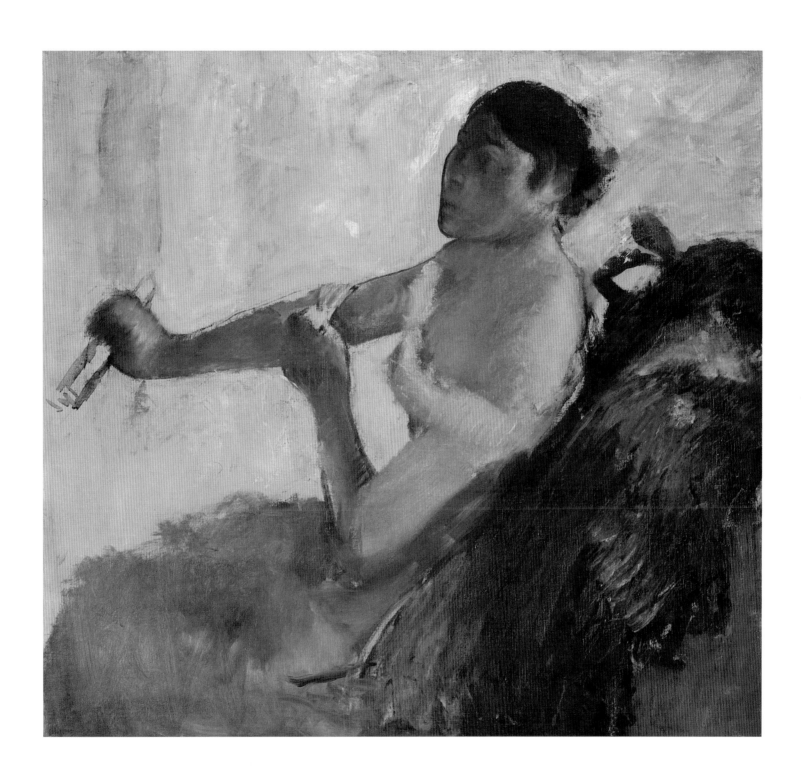

60. PORTRAIT OF MLLE. HÉLÈNE ROUART

1886
Pastel and charcoal on laid paper
19¼ × 12½ inches
Los Angeles County Museum of Art
Mr. and Mrs. William Preston Harrison Collection, 35.18.2
Lemoisne 866

DEGAS CREATED SEVERAL drawn and painted portraits of the family of his boyhood friend, the wealthy engineer and industrialist Henri Rouart. Degas and Rouart shared a passion for art collecting, visiting dealers and attending sales together. Their ambitions as collectors were similar, and both created distinctive collections of what was then considered the modern French tradition of painting. Degas's affection for the Rouart family extended to Henri's wife and children and his brother Alexis. Degas referred to them as "my only family in France."[1]

This pastel was apparently one of three drawings for a planned but never realized double portrait of Mme. Rouart and her daughter Hélène.[2] A drawing from 1884 shows Mme. Rouart seated, contemplating a Tanagra figurine on the table before her, with the standing Hélène set ambiguously in the background. The signs of Mme. Rouart's illness in this drawing—her peaked expressions and slightly slumped form—suggest one reason that she may have been excused from the final painted portrait of Hélène of 1886 (National Gallery, London). The Los Angeles pastel of Hélène cloaked in a shawl and wearing heavy skirts is perhaps inspired by the form of the Tanagra figurines collected by Hélène's uncle Alexis Rouart.[3] Degas himself was interested in small Greek sculptures, having copied many of them in his youth. The classicism of this pastel figure suggests such an antique influence.

Degas made the preliminary outline of this drawing in charcoal, using a firm line to move the position of Hélène's head back, lower her right arm, and draw her shawl close to her body. The application of brilliant blue pastel creates a strong sense of volume and sets off Hélène's auburn hair. The blue, ochre, gray, and white rubbed into the background further establishes the figure in three-dimensional space. Much of the graphic drama is in the drapery, which sweeps to a point of convergence at Hélène's right hip and is held in place by her sharply angled right elbow. The flow of her skirt in the opposite direction at the bottom of the page and the sense of tilting hips beneath the drapery creates a classical sense of motion in the figure.

The pastel was sold in the second Degas atelier sale (no. 329) in December 1918 and was then owned by the Galerie Durand-Ruel and later the Galerie Bernheim-Jeune in Paris. In the late 1920s or early 1930s the drawing was bought by William Preston Harrison, the most active art collector in Los Angeles at the time and a major supporter of the fledgling Los Angeles County Museum of Art.[4] The Mr. and Mrs. William Preston Harrison Gallery of Modern French Art, established at the museum in 1926, was the only public gallery in the city where visitors could see work by such artists as Paul Signac, Henri Matisse, and Pablo Picasso. *Portrait of Mlle. Hélène Rouart* was given to the Museum in 1935, the first work by Degas to enter a West Coast museum.

MARY MORTON

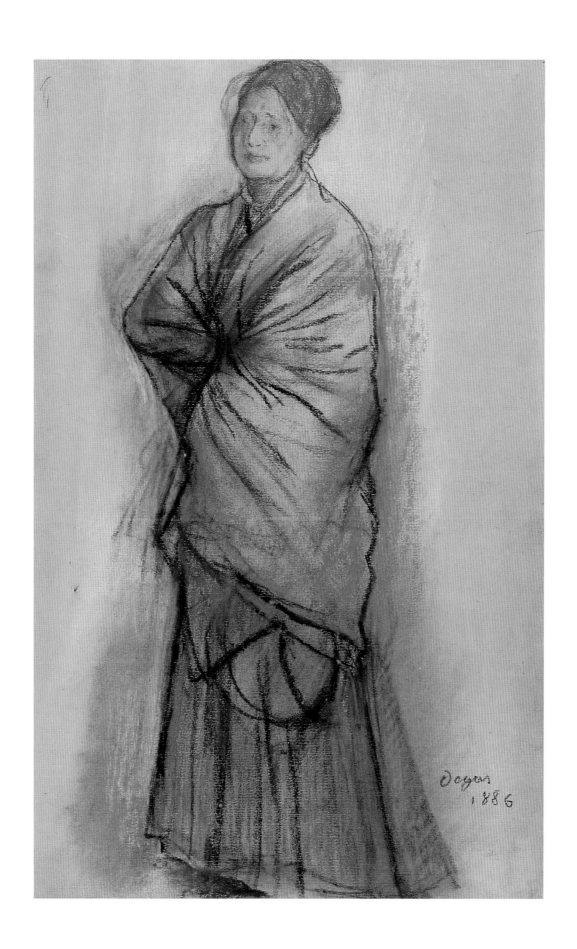

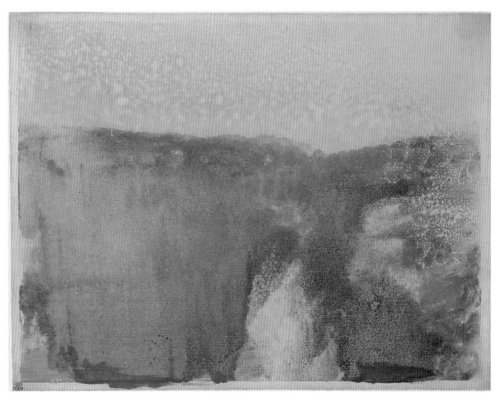

61

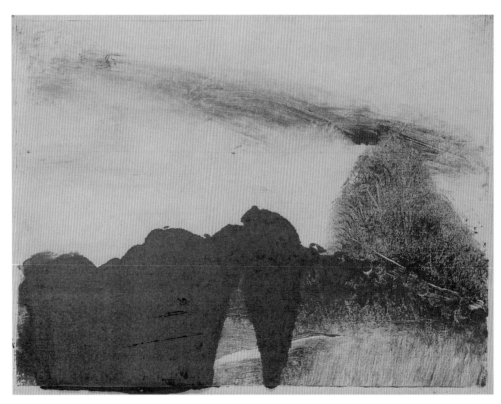

62

61. GREEN LANDSCAPE

ca. 1890
Monotype, printed in color
Plate: 11⅞ × 15¹¹⁄₁₆ inches
Sheet: 12⅜ × 16⅝⁄₁₆ inches
The Museum of Modern Art, New York
The Louise Reinhardt Smith Bequest, 19.96

62. A WOODED LANDSCAPE

ca. 1890
Monotype, printed in color
Plate: 11⅞ × 15¹³⁄₁₆ inches
Sheet: 12⅜ × 16⅝⁄₁₆ inches
The Museum of Modern Art, New York
The Louise Reinhardt Smith Bequest, 20.96
Janis 73

IN SEPTEMBER OF 1892, Degas announced to his friends the Halévys that he had recently completed a group of landscape monotypes. In November, the monotypes went on view at the Galerie Durand-Ruel in Paris. Degas's announcement came as a surprise to those who knew the artist and his low regard for landscape painting, particularly *plein air* landscape.

Degas, however, was not working from nature when he made his landscapes but was creating scenes from memory. In the fall of 1890, Degas traveled with the sculptor Albert Bartholomé to the country home of painter Pierre-Georges Jeanniot. Here Degas experimented with copper or zinc plates, colored inks, and an etching press. The subjects of these experimental prints evidently recalled scenes that he had encountered during a carriage ride through Burgundy. Some of the prints are pure monotypes; others are reworked with pastel.

The landscape monotypes that Degas produced between 1890 and 1892 are notable for their radical abstraction. Degas is reported to have advised his friends in 1890, "Reproduce only what has struck you—that is, the essential; in that way your memories and your imagination are liberated from the tyranny that nature holds over them."[1] Degas smudged and smeared ink over the plates with rags, brushes, and his fingers, imbuing the resulting prints with a sense of improvisatory freshness. In *A Wooded Landscape,* Degas saturated the lower left side with green ink, which blotted under the pressure of the press, further enhancing the impression of artistic sponteneity. Although few critics responded to the group of twenty to thirty prints exhibited at Durand-Ruel in 1892, Arsène Alexandre, a leading critic and supporter of the Impressionists, was enthusiastic: "M. Degas has brought together in these works feelings and reminiscences about that nature that he conveys with great poignancy and power."[2]

Historically, American collectors have been receptive to Degas's landscape prints. Early purchasers included Denman Ross of Boston (see page 25, fig. 11, and page 53, fig. 8) and H. O. and Louisine Havemeyer of New York.[3] *Green Landscape* belonged to the collector and editor of Degas's letters, Marcel Guérin, whose collector's mark appears in the lower left corner of the margin of the print. Guérin published one of the first books on Degas's monotypes. Louise Reinhardt Smith purchased this print from Guérin before 1974.

A Wooded Landscape initially belonged to Maurice Exsteens, the son-in-law of Gustave Pellet, the print publisher with whom Degas had worked on several of his late bather lithographs. It was then purchased by Paul Brame and César de Hauke, the authors of a catalogue raisonné of Degas's paintings and pastels. It was purchased from them by Sir Robert Abdy and descended to Valentine Abdy. It went through two dealers, Galerie de L'Oeil in Paris and E. V. Thaw in New York, before it was purchased by Louise Reinhardt Smith of New York in about 1964. In 1995, Smith gave these two prints as well as outstanding works by Monet, Matisse, and Picasso to The Museum of Modern Art in New York.

DAVID A. BRENNEMAN

63. NUDE WOMAN STANDING, DRYING HERSELF

1890

Lithograph, transfer from monotype, crayon, tusche, and scraping

Third state of six

Plate: 13 × 9⅝ inches

Sheet: 16 × 12⅛ inches

The Baltimore Museum of Art, Gift of Blanche Adler, 1931.39.7

Reed and Shapiro 61

IN EARLY JULY OF 1891, Degas wrote to his friend Evariste de Valernes, "I am hoping to do a suite of lithographs, a first series on nude women at their toilette and a second on nude dancers."[1] The decision to embark on a suite of lithographs may have been prompted by the huge exhibition of lithography that was held earlier that year at the École des Beaux-Arts in Paris. Degas would also have been encouraged by Camille Pissarro and Mary Cassatt's recent interest in printmaking. Once he embarked on the series of bathers, Degas appears to have become utterly absorbed, and the projected series of nude dancers never materialized. Cassatt later commented in a letter to Samuel P. Avery, "[H]e has been talking for some time of doing a series of lithographs but I am afraid it will end in talk."[2]

Reed and Shapiro have identified six series of women bathers, all variations on a set pose: a figure seen from behind, her body leaning over as she dries her hip.[3] Two show the bather facing left, and four show her facing right. The motif of a solitary bather seen from behind derives from images such as Ingres's *Valpinçon Bather* (Louvre), a picture that Degas knew and admired; in choosing to depict this theme, although in a modern context, Degas was drawing on an established tradition. In the early series he depicts the woman by herself, standing in the corner of a room, her only props being a chaise longue and a towel. The space she occupies is constricted and enclosed. Her solitude and apparent vulnerability force the viewer into the position of voyeur; or perhaps Degas merely intended us to take the place of the absent maid, who appears in the later series.

Nude Woman Standing, Drying Herself belongs to the first series of bathers, which began as monotypes and were transferred to lithographic stones. The development of the six states records a gradual process of adjustment, erasure, and addition. In the Baltimore picture, Degas has enlarged the composition using brush, tusche, and crayon. He has extended the patterned wall at the top and the chaise to the left of the model and generally made the details of her surroundings more explicit. He has added brushwork to the model's hair and to the hairpiece lying on the bed, and a dark mass, possibly clothing, appears over the edge of the chaise. Degas has also scraped away part of the dark background to the left of the bath towel and used crayon and scraping to model the figure more carefully, altering the contour of the right arm.

Several impressions of this third state are known to exist—three from the Beurdeley, Fenaille, and Rouart collections and another from the atelier sale—but, apart from this version, only one other (Royal Museum of Fine Arts, Copenhagen) has been located. The Baltimore picture was in the collection of Blanche Adler, who gave it to the museum in 1931. Adler was a pioneering Baltimore print collector, who was advised by Adelyn Breeskin, a Cassatt print scholar and curator at The Baltimore Museum of Art during the 1930s.

FRANCES FOWLE

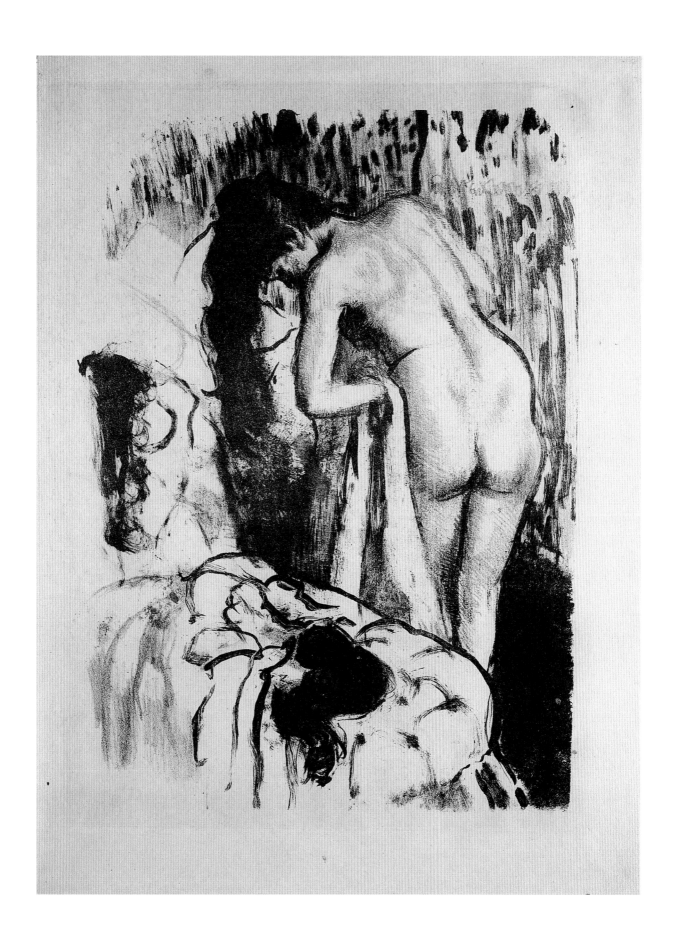

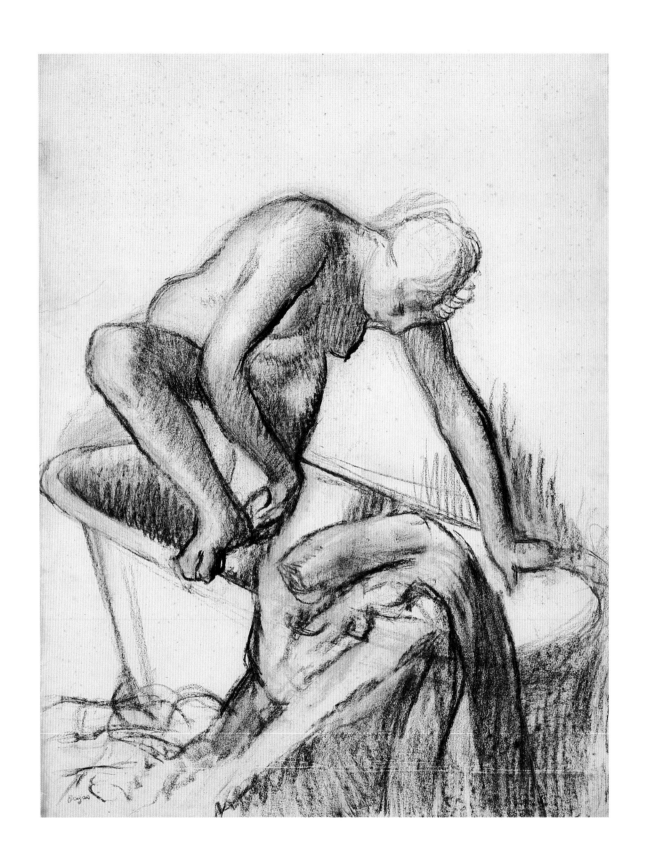

64. A Nude Figure Bathing

ca. 1890–92
Charcoal on white wove paper
25⅝ × 19¾ inches
Fogg Art Museum, Harvard University Art Museums
Bequest of Meta and Paul J. Sachs, 1965.262

ALMOST ALL OF DEGAS'S LATE NUDES are occupied in some way: stepping into or out of a tub, washing or drying themselves, or combing their hair. They are involved in ordinary, everyday routines, devoid of eroticism. In *A Nude Figure Bathing*, Degas is less concerned with the bather's personality than with the formal relationship of figure and bath. Details of physiognomy are left to a minimum and the front of the woman's body is in shadow. The main focus of the drawing is the model's unorthodox pose. She balances precariously on one foot, her right leg propped against the side of the tub and her left arm supporting herself, as she concentrates on the complicated maneuver of scrubbing her right heel. The picture appears to relate more closely to Degas's late nude studies of ballerinas than to his serene bathers. The woman's attitude is similar (although from a different viewpoint) to that of the right-hand dancer in the lithograph *Three Nude Dancers at Rest* (ca. 1891, E. W. Kornfeld, Bern), and produces a satisfying series of parallel lines formed by the figure's arms and right leg. It is not a flattering image: the bather's heavy body is boldly outlined in a continuous curve; her right thigh protrudes from a fold of flesh, giving the impression that she is positively deformed by the awkward pose.

In his later drawings, Degas abandoned pencil for the more flexible medium of charcoal. The unsigned picture is carefully worked, with areas of vigorous hatching. The location, on the other hand, is barely indicated: the room is sparsely furnished and the simple curve of the tub is echoed by the back of the chaise longue, on which a towel or robe has been laid, waiting for the bather to emerge from her tub.

This drawing was included in the second atelier sale (no. 342) in 1918 and bought by the French collector Marcel Bing, who was particularly fond of Degas's graphic work. His collection included many Degas drawings, which he bequeathed to the Louvre in 1922. He also sold several works by Degas, including *A Nude Figure Bathing* and a comparable, but much larger, work in oil, *Nude Woman Drying Herself* (Brooklyn Museum of Art), through the dealers Yamanaka & Co. of New York, who had several branches in the United States. The firm was run by one of its founders, Sadajiro Yamanaka, a specialist in Oriental works of art and a "cultured enthusiast of the arts of . . . Egypt, Greece and Persia."[1] Yamanaka died in 1936 and in the same year the drawing was acquired by Paul J. Sachs, associate director of the Fogg Art Museum, who owned a huge collection of modern and old-master drawings. Sachs often lent pictures from his collection for exhibition purposes, and in 1965 he gave a large number of works, including this drawing, to Harvard University.

FRANCES FOWLE

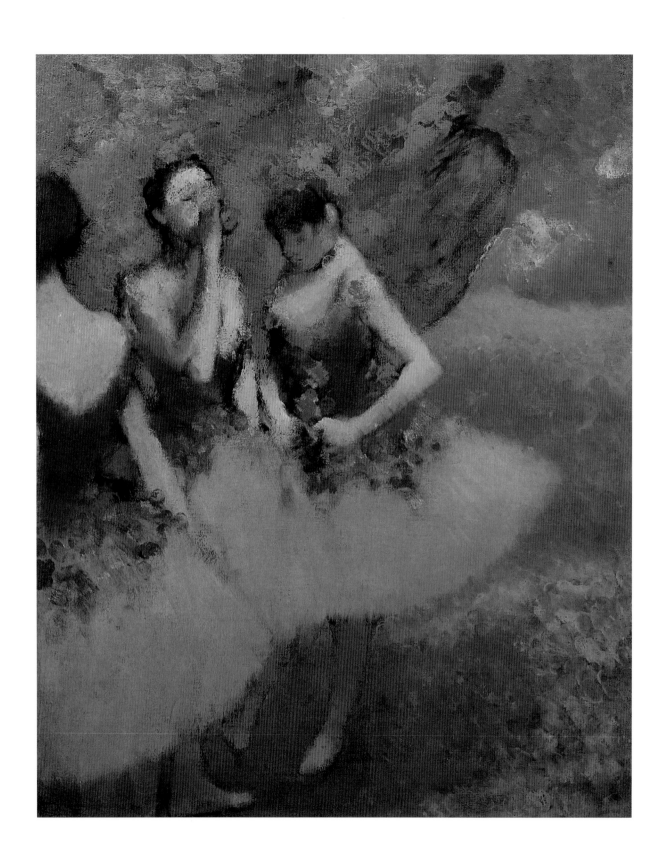

65. THREE DANCERS IN YELLOW SKIRTS

ca. 1891
Oil on canvas
32 × 25⅝ inches
UCLA Hammer Museum, Los Angeles, California
Armand Hammer Collection, AH 90.20
Lemoisne 1100

IN MANY OF HIS PAINTINGS, prints, and drawings and even in his sculptures, Degas sought to capture the unrehearsed moments of trained performers. This brilliant oil painting depicts three ballet dancers offstage, pausing from their performance. Their colorful forms are barely legible against the vivid stage sets. One dancer's back is turned to the viewer, and the other two are unself-consciously absorbed: one drinks water from a glass, and the other tends to her tutu.

Degas's late work is characterized by increasingly intense color and less legible figurative compositions. Here, the intensity of the reds, oranges, and warm yellows is only slightly mitigated by the intermittent application of electric blue and a more muted green. Degas establishes the form of the dancers with dark outlines and then manipulates the canvas surface, using his fingers to apply blue sequins to the dancers' costumes and bright dabs of orange and pink on the sets behind them. He worked this oil painting like a pastel, smudging colors and blurring forms, creating an interlocking pattern of floating color-shapes. The picture is similar in size and composition to *Dancers in Blue* (Musée d'Orsay) and *Dancers in Red and Green* (Metropolitan Museum of Art).[1] The three paintings are coloristic variations on the motif of three similarly posed dancers set at different angles.

This painting was sold in the first Degas atelier sale (no. 82) on May 6–8, 1918, to the Paris gallery of Nunès et Fiquet. It was sold in 1930 by the Galerie René Drouet, Paris, to Caroline and Erwin Swann of Pennsylvania. On December 10, 1969, financier Armand Hammer bought the painting at Sotheby's in London for a price so high (120,000 English pounds) that it was reported in the London *Times* and in papers across the United States. Hammer made his fortune in pharmaceuticals, Russian import-export, and the creation of one of the world's largest multinational corporations, Occidental Petroleum, based in Los Angeles. He also bought and sold art, and in 1967 he established a traveling collection of European and American masterpieces, particularly of the late nineteenth century. During the 1970s and 1980s, *Three Dancers in Yellow Skirts* traveled with Hammer's collection throughout the United States and to museums around the world. In the early 1980s the collection of paintings was intended for the Los Angeles County Museum of Art (with the drawings collection destined for the National Gallery of Art, Washington, D.C.), but Hammer ultimately decided to build his own museum near the University of California at Los Angeles, where the collection serves the university as an independent annex.

MARY MORTON

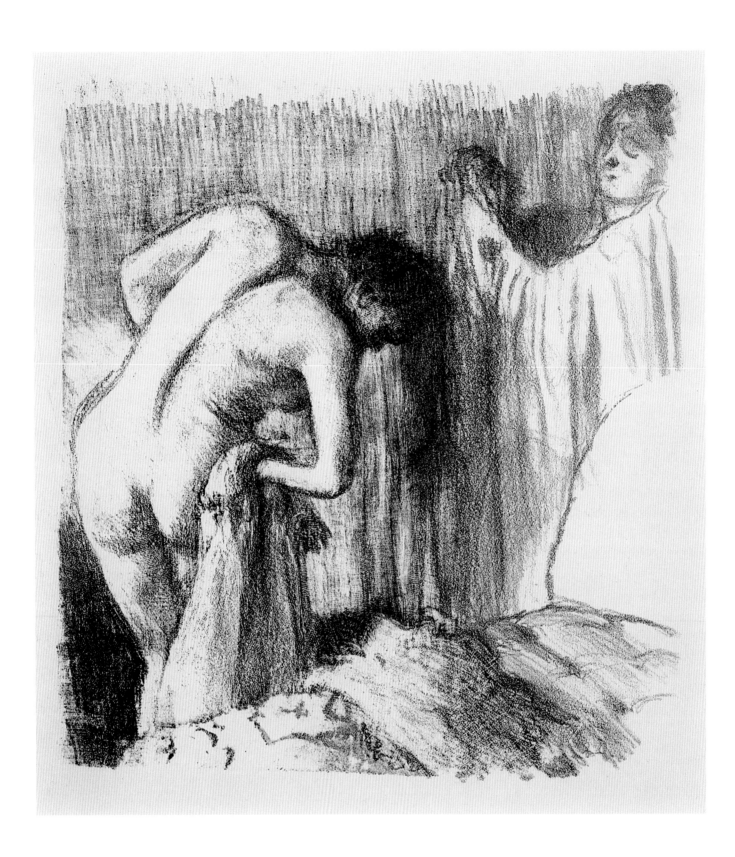

66. AFTER THE BATH III

1891–92
Lithograph, transfer, and crayon
First state of two
Plate: 9 13⁄16 × 9 1⁄16 inches
Sheet: 14 5⁄8 × 12 3⁄8 inches
Collection of Irene and Howard Stein, Atlanta, Georgia
Reed and Shapiro 65
Atlanta only

THE POET AND CRITIC PAUL VALÉRY, a close friend of Degas, once defined the artist's working method: "He is like a writer striving to attain the utmost precision of form, drafting and redrafting, cancelling, advancing by endless recapitulation, never admitting that his work has reached its *final* stage: from sheet to sheet, copy to copy, he continually revises his drawing, deepening, tightening, closing up."[1] This work belongs to a series of six lithographs of female bathers identified by Reed and Shapiro.[2] It is also the last in a suite of three lithographs entitled *After the Bath* and the reverse image of *Nude Woman Standing, Drying Herself* (cat. 63). Degas appears to have been fascinated by this particular pose—a woman seen from behind, leaning forward to dry her hip. As the series progresses, the figure gradually becomes bulkier and more ungainly.

In the earlier versions of *After the Bath*, the nude bather is standing alone at the right of the image, and Degas includes details of the background wall, skirting board, and curtain. In *After the Bath II* (fourth state) he has even drawn patterns on the curtain and added short strokes to indicate the texture of the carpet. In *After the Bath III*, much of this detail has been erased. Transferring the earlier image to a larger lithographic stone, Degas extended the composition of *After the Bath II* and removed the skirting board. He made the background more uniform and added the rounded back of the chaise longue. Finally, he shifted the bather to the left and introduced the figure of the servant holding a towel. He then scraped and redrew the towel and the figure of the bather, enlarging her body and emphasizing the thickness of her waist.

The maid appears as a shadowy figure, only lightly drawn and strangely overdressed in a long robe, which merges with the curtain behind. She disappears again from the second and final state but reappears in various guises in the sixth lithograph of the bathers series, *After the Bath* (large version). A large number of drawings of a female bather and maidservant indicate Degas's interest in this theme. In every case the bather remains unaware of her companion's presence.

The original drawing,[3] from which all three versions of *After the Bath* derive, was made with greasy ink on celluloid and was owned by Michel Manzi (1849–1915), a friend of Degas. Manzi was a specialist in making reproductive prints: from 1881 he was technical director of the printing studios for the Paris dealers Boussod & Valadon. One impression of the second state of *After the Bath I* (Bibliothèque d'Art et d'Archéologie, Foundation Doucet, Paris) is inscribed *Essai chez Manzi* (Experiment made at Manzi's) and signed by Degas. About twenty impressions of *After the Bath III* (first state) have been located. Many of these are signed, but only one (unsigned) version in the Albertina Museum is from the atelier sale. The work in this exhibition may have been one of a group of bather lithographs that the French print dealer Gustave Pellet bought directly from the artist sometime between 1910 and 1915. Pellet is said to have had them signed by Degas and later left them to his son-in-law, Maurice Exsteens, who is known to have owned a large number of impressions of bather lithographs during the 1950s.[4] This impression was later acquired by David Tunick of New York. In 1999 it entered the collection of Irene and Howard Stein in Atlanta.

FRANCES FOWLE

67. LANDSCAPE WITH ROCKS

1892
Pastel over monotype in oil colors on white wove paper
10⅛ × 13⅝ inches
High Museum of Art
Purchase with funds from the High Museum of Art
Enhancement Fund, 2000.200
Lemoisne 1040, Janis 312

IN NOVEMBER OF 1892, Degas exhibited approximately twenty-six monotype prints that were retouched extensively with pastel. The exhibition, at the Galerie Durand-Ruel, came as something of a surprise to contemporaries because the subject was landscape, a genre for which Degas had previously expressed disdain. Despite the apparent eccentricity of Degas's decision to mount such an exhibition, Richard Kendall has argued that Degas's decision was timely.[1] On the one hand, Degas was undoubtedly aware of Monet's recent success in mounting solo exhibitions of landscapes based on a single theme such as poplar trees and grainstacks. On the other, he was also aware of Durand-Ruel's showcasing of the experimental printmaking efforts of his friends and colleagues Mary Cassatt and Camille Pissarro. Degas's decision to mount an exhibition of innovative landscape prints should perhaps be seen as a calculated effort by the artist to regain the limelight and to reposition himself as a leader of the avant-garde.

Certain contemporary critics were intrigued by the extreme freedom of Degas's approach to landscape. They were also struck by the brilliance of Degas's color. They compared the delicate surfaces and exquisite color combinations of his landscapes to the "wings of dragonflies."[2] Degas departed from his earlier practice of working with pastel on a monotype base of black ink by using a variety of oil-based colors that he streaked over the plate with brushes, rags, and his fingers. In this case the artist painted broad swaths of green and olive. He then went over these areas with almost pointillist touches of pink, orange, green, and blue pastel, juxtaposing oranges and greens and pinks and blues in order to heighten their chromatic intensity. In *Landscape with Rocks* the oranges and yellows evoke a feeling of autumn, and in fact, it was titled *Autumn Landscape* when it appeared for sale in New York in 1928.

Motifs in several of the prints included in the 1892 exhibition exhibit a curious anthropomorphism. The rock forms in this print suggest the profile of a face and perhaps also canine teeth.[3] It is not clear whether or not this formation was based on direct observation or was an invention of the artist's imagination. The latter is the most probable, as the working procedure of creating images out of abstract patterns and shapes lent itself to improvisation.

Landscape with Rocks was purchased from Degas by Paul Durand-Ruel in 1892. It was then transferred to Durand-Ruel's New York gallery, where it was purchased by Charles H. Senff of New York. It was purchased from his sale, held at Anderson Galleries in New York in 1928, by Knoedler. It next entered the hands of the New York dealer William H. Schab and then the private collection of Dorothy Edinburg. It sold at a 1987 auction to London-based dealers Browse and Darby, from whom it was purchased by a private collector in Chicago. The High Museum of Art purchased this print from Artemis Fine Arts of New York and London in the summer of 2000.

DAVID A. BRENNEMAN

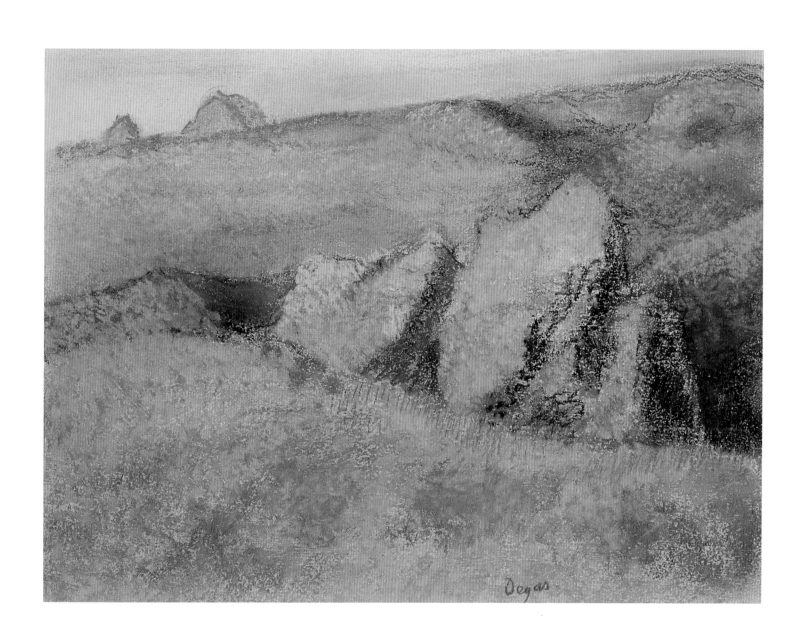

68. THE MORNING BATH

ca. 1892–95
Pastel on tan wove paper
29⅞ × 17 inches
The Art Institute of Chicago
Mr. and Mrs. Potter Palmer Collection, 1922.422
Lemoisne 1028
Atlanta only

THE ART INSTITUTE OF CHICAGO'S *The Morning Bath* includes all the hallmarks of Degas's late bather pastels: a spare, ambiguous setting; a lone subject unaware of any spectator; nearly claustrophobic cropping; and spectacular color. The subject of this pastel expends great effort to lower herself into the tub. When compared with other bathers of the mid-1880s to mid-1890s, however, this figure is much more modest in her gesture (see cat. 64).

Above the bed the picture plane is neatly divided into thirds by the meeting of two walls on the left and the drapery on the right. The bather is placed squarely in the center. Her left arm, the top of her head, and the downward slope of the pillow to her right form a pyramid, which is mirrored in the down-turned corner of the bed sheet.

Degas was careful to balance the color within this rather rigid composition. The strongest color in the pastel is the blue of the drape; however, dollops of cerulean evenly dispersed across the sheet—particularly in the reflection on the bather's side and on the shaded paper decorating the left wall—ensure that the drapery does not dominate the composition. The white in the center wall frames the bather in addition to balancing the mass of bed sheets below. Finally, the light pink of the bather's flesh appears in the towel and pillow, reinforcing the pyramidal line.

The fleshy pink also appears on the exposed bedspread in the lower corners and contrasts with the other color in the cover, sap green. In a nod to old-master technique, Degas uses the same green as the "underglazing" for the bather,[1] and he models her form with fleshy pinks. The green areas that Degas left exposed create contour lines on the bather's flanks. The flat, somewhat awkward S-shaped plane Degas uses to define the subject's back from left buttock to right shoulder is a reference to Michelangelo's rendering of the human body in his late work,[2] as are the strong physicality and exaggerated motion of the woman's precarious entrance into the tub.

Mrs. Potter Palmer of Chicago acquired *The Morning Bath* in 1896—quite early for an American acquisition. Berthe Honoré Palmer was a wealthy philanthropist and socialite and an acquaintance of Mary Cassatt, who actively promoted Degas to her art-collector friends. Palmer bequeathed several works, including *The Morning Bath,* to The Art Institute of Chicago in 1922. The Institute exhibited this work in *A Century of Progress,* the exhibition that accompanied the 1933 World's Fair. This pastel was also in the first American retrospective exhibition, which included just over one hundred works by Degas, held in Philadelphia in 1936.

PHAEDRA SIEBERT

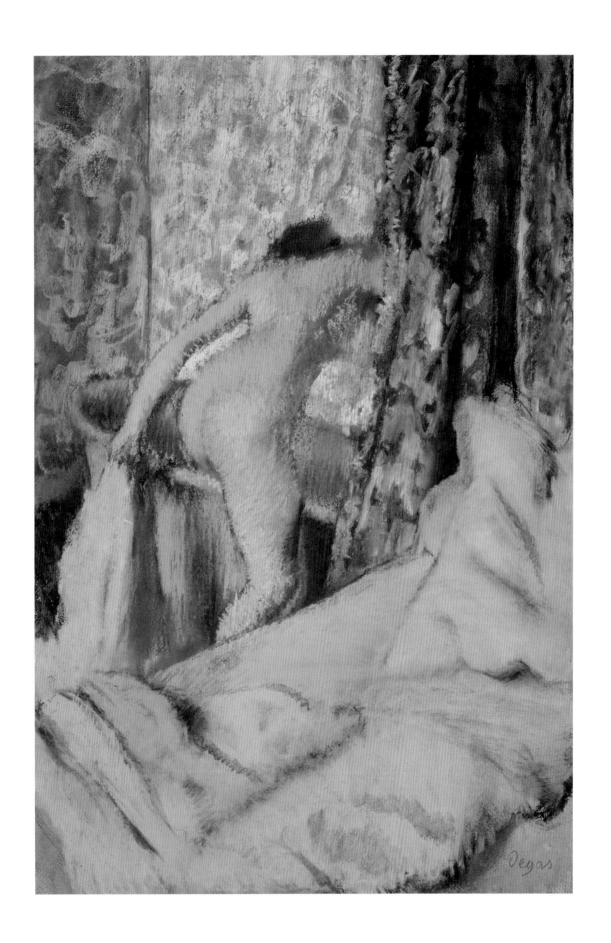

69. AFTER THE BATH

ca. 1895
Pastel on paper
18 × 23¼ inches
The Dayton Art Institute
Gift of Mr. and Mrs. Anthony Haswell, 1952.33
Lemoisne 917

THIS IMAGE CONTAINS most of Degas's favorite bather scene props: tub, armchair, towel, robe, and mirror. Characteristically, Degas has cropped his image close; no single object remains in the composition in its entirety. The bather herself seems in danger of falling right out of the bottom of the composition. Her right foot has already slipped off the edge and her still-damp leg slides downward along the towel. The sense of downward movement is countered by the canary-colored slipper, which braces her firmly against the bottom edge of the composition.

This work has been dated as early as the mid-1880s and as late as 1905. Though Degas had been making bather images since the mid-1880s, the style of the Dayton pastel most resembles works made in the mid-1890s.[1] In works like this one, the artist's renewed emphasis on line is balanced with (and kept distinct from) his ongoing exploration of color.[2] Here, Degas has modeled almost exclusively with line. The color in this composition is decorative though it does, as in the pale blue of the mirror and the slipper's canary blot, describe objects in the composition.

Much recent scholarship has focused on Degas's use of photography.[3] *After the Bath* shows evidence of Degas's attention to photography as a new medium of visual record and source of inspiration.[4] Degas gives the image a depth of field: the tub and the bather's buttocks are sharp, but the focus begins to soften by the bather's shoulders; the armchair and the red robe

are drawn in blurred lines. Mostly, the color is unmodulated and reminiscent of a tinted photograph. The only blending of color occurs around the bather's left forearm, where flesh and towel are smudged with contour line, creating the illusion that the energy with which this woman dries her shin is too vigorous for the viewer's (or the camera's) slow-blinking eye.

After the Bath was made at a time when Degas was financially secure and could afford the luxury of creating works without needing to sell them.[5] Given that it remained in the artist's studio at his death, the Dayton pastel may not have been intended for sale. *After the Bath* was sold in the first of the 1918 atelier sales (no. 222), and it remained in France until Justin K. Thannhauser acquired it for his New York gallery. Justin K. Thannhauser was the son of Heinrich Thannhauser, who founded the Moderne Galerie Thannhauser in Munich. The gallery was instrumental in bringing Impressionism and Post-Impressionism to Germany. Thannhauser escaped Nazi Germany to Paris in 1937 and then to New York in 1939, apparently on the last boat to leave.[6] He reestablished his gallery in New York, where he became one of the most important dealers of Degas's work. By the time of Mr. and Mrs. Anthony Haswell's purchase of *After the Bath* and their gift of it to The Dayton Art Institute in 1952, dealers like Thannhauser had helped to ensure that Degas was thoroughly accepted into the canon of nineteenth-century masters.

PHAEDRA SIEBERT

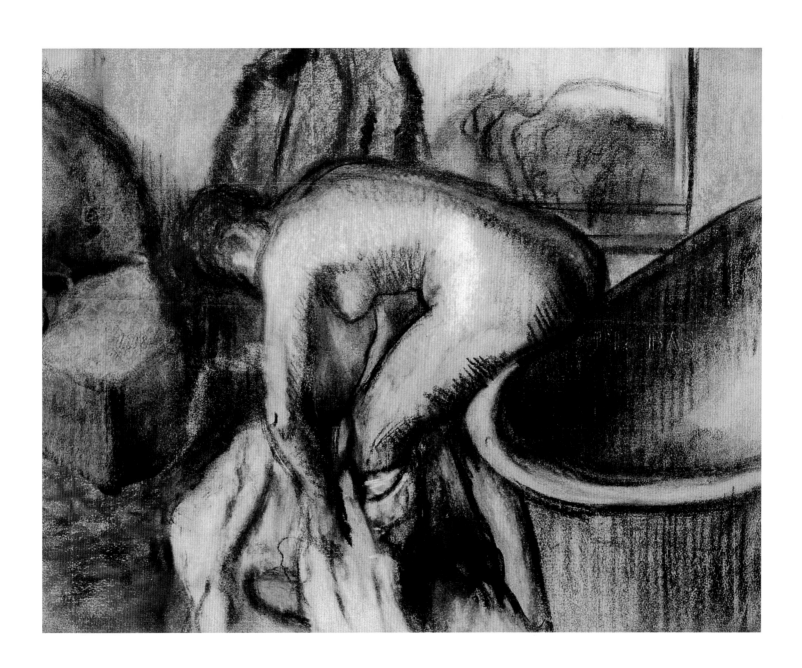

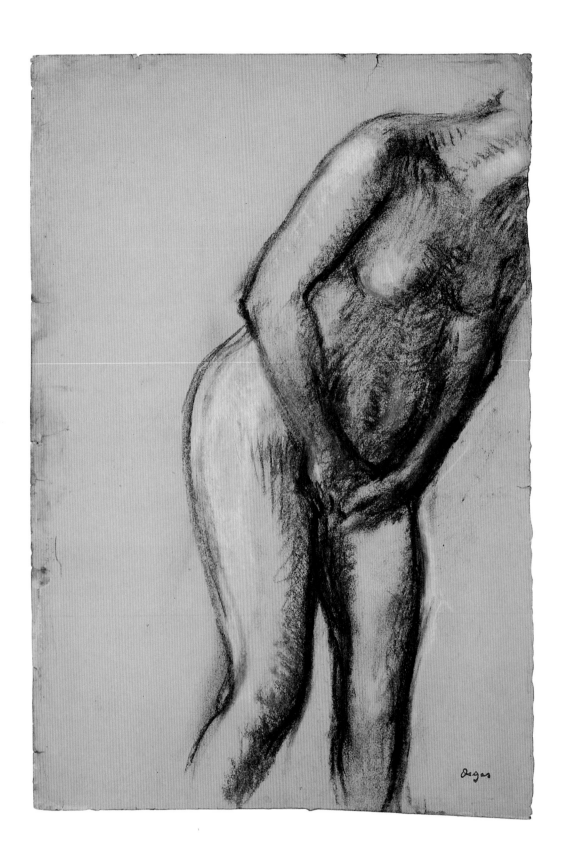

70. STANDING FEMALE NUDE

ca. 1896
Charcoal and pastel on light blue paper
18½ × 12½ inches
The Art Museum, Princeton University
Gift of Frank Jewett Mather Jr., 1943-136
Atlanta only

THIS MOVING DRAWING of a female nude demonstrates how Degas was able to transfer images with facility from one medium to another. The figure is inspired by one of Degas's sculptures, *Woman Taken Unawares* (ca. 1896, Philadelphia Museum of Art).[1] Degas intended it as a preparatory sketch for a larger, never-completed work in pastel, which was to be the culminating image in a series of large-scale pastels of women bathers. We can tell from a charcoal study in the Musée des Arts Décoratifs in Paris that our nude was intended as a foreground figure in a woodland scene with female bathers or nymphs.[2] A large dog or bear is visible to the left of the picture, and Gary Tinterow has suggested that Degas is alluding to the metamorphosis of Callisto, who was transformed into a bear by the goddess Diana as a punishment for allowing herself to be impregnated by the insatiable Jupiter.[3] The protective gesture of the slumped figure, who appears both in the Musée des Arts Décoratifs and the Princeton studies, reinforces this theory. The pose seems to evoke shame rather than modesty and recalls Masaccio's figure of Eve from *The Expulsion of Adam and Eve* (ca. 1425, Brancacci Chapel, Santa Maria del Carmine, Florence). In the Princeton pastel Degas uses streaks of red to highlight the gently swelling abdomen, framed by the figure's arms, as she hides her head in shame beyond the picture's edge. In the charcoal study the figure standing behind our bather gestures in the direction of the bear, perhaps alluding to Callisto's impending transformation.

Tinterow describes the Princeton bather as "retrogressive." It seems to have more in common with Degas's early experiments in this subject—and with the nudes of Titian and Rembrandt—than with Degas's more self-confident nudes of the 1870s and 1880s.[4] Certainly, in producing a series of preparatory drawings for a larger work on a mythological subject, Degas was drawing strongly on the classical tradition. Although he often used different colored papers as supports for his drawings, the choice of blue paper and the limited range of colors recalls the old-master drawings of Renaissance Italy.

Thirteen drawings related to this figure exist, five of which, like the Princeton version, were created in pairs, with an original and a counterproof.[5] In the earlier studies the bather is portrayed as a slim young woman with long hair and an expression of curiosity. As the series progresses, she becomes gradually heavier, older, and more fearful.

In 1919 the Paris dealers Bernheim-Jeune bought the pastel from the third atelier sale (no. 337.1) for 900 francs. It later found its way to the Weyhe Gallery in New York and was sold to Frank Jewett Mather, who bequeathed it to The Art Museum, Princeton University, in 1943. Mather was a scholar of Renaissance art and a professor at Princeton. Although he held a negative view of much late nineteenth- and early twentieth-century art, he particularly admired Degas for his links to the old masters.

FRANCES FOWLE

71. AFTER THE BATH

1899
Pastel on tracing paper
31½ × 23 inches
Columbus Museum of Art, Gift of Ferdinand Howald, 1931.050
Lemoisne 1343

AFTER THE BATH is drawn on tracing paper, a practice that enabled Degas to reuse figures in several compositions. The surface is vigorously worked up, layer upon layer. In parts, Degas used an underglazing of pastel, as in the orange base on the wall and carpet. This sheer, even base of color has been described as Degas's effort to integrate old-masterly painting technique into what was by this time his nearly exclusive use of pastel.[1] Typically, the underlayer of pastel is nearly obliterated by the aggressive scumbling of greens, blues, ochres, and reds.

Particularly in his later work, Degas endeavored to explore color and to remain faithful to his lifelong belief in the importance of line. In this pastel, modeling is achieved in large part through the faint underdrawing for the figure and the thick highlights that Degas has laid on the model's shoulders, hips, knees, and towel. The color in this work is dizzying; nowhere in the pastel has Degas used a single color to describe a single object. The figure of the bather is differentiated from the background by layers of hatchmarks. The artist used smeared, scumbled swirls for the walls, carpet, and upholstery. Although the difference between subject and setting is discernible, the overall patterning blurs the distinction between foreground and background. Furthermore, Degas uses the same ochres, umbers, blues, greens, and reds for the bather's back and for the background elements,

particularly the carpet, further compressing the picture's space. As in The Dayton Art Institute's *After the Bath* (cat. 69), no single object remains in the composition in its entirety, furthering the viewer's impression of the space being pressed ever closer to the surface.

After the Bath remained in Degas's studio until the atelier sales, which suggests that Degas may not have considered the work to be completed or satisfactory. Jacques Seligmann (based in Paris and New York) bought many works, including this one (sale 1, no. 183), at the atelier sales . He also acted as an agent for The Metropolitan Museum of Art in New York at those sales. When he sold his collection at New York's American Art Association in 1921, the American dealer Charles Daniel bought the work on behalf of Ferdinand Howald. A Swiss-born mining engineer, Howald sold his Ohio-based business at a relatively young age and moved to New York, where he began collecting art in earnest. Howald's collection was built primarily through bargain purchases of modern American works. He was partial to watercolors and drawings, so it is not surprising that Daniel would have chosen this very modern pastel for him. At the end of his life, Howald gave a substantial sum of money as well as most of his collection to what would become the Columbus Museum of Art.

PHAEDRA SIEBERT

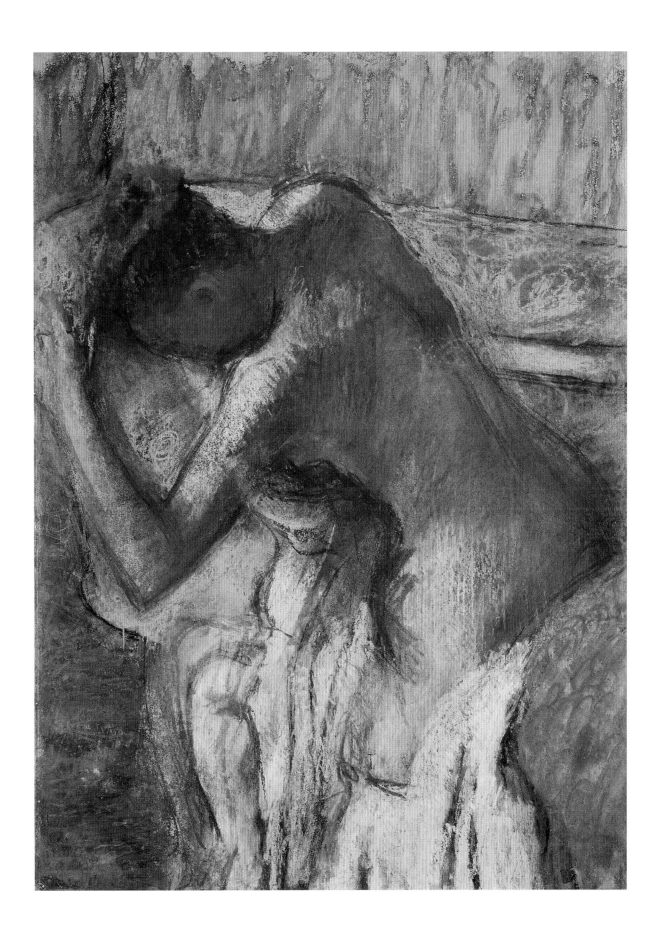

72. THREE DANCERS IN YELLOW SKIRTS

ca. 1900
Chalk and charcoal on tracing paper laid down on board
23⅝ × 19⅝ inches
Cincinnati Art Museum, Gift of Vladimir Horowitz, 1947.542
Lemoisne 1367

DEGAS'S INTEREST IN BALLET and horse racing scenes continued unabated into old age. He came to portray the movements of his dancers and horses with less delicacy but increasing force. In this drawing he emphasizes the contours by repeated tracings, which create a sense of vigorous movement, bringing to mind Ingres's admonition to the young Degas to "draw lines, lots of lines."[1] The striated chalk marks underscore the forceful, restless forms of the dancers, who are now removed from the illusory enchantment of the theater. Instead, these sturdy women, not unlike Degas's bathers or laundresses, radiate what one might be tempted to call primeval energy.

By the late 1870s, Degas began to push his dancers toward the front of his compositions so that the paper or canvas seems barely able to contain their forms, which brim with vitality. Degas's often bold use of color, as in *Three Dancers in Yellow Skirts,* gives the figures even greater force. As he often does with his dancers, Degas shows the three figures in animated movement—not in performance, however, but in conversation, gesticulating vigorously.

Degas, who could create the most lifelike three-dimensional illusions in pencil studies of draperies or horseflesh, produced extraordinary sculptural effects in his bathers, with layers of pastel striations over the underlying drawing and with contours of sensuously descriptive lines. He made wax sculptures as studies initially of horses in the late 1860s and of ballet dancers in the following decades. The sculptures were exercises or studies similar in purpose to his drawings. Wax studies were clearly important for the formation of his full-bodied bathers.

By the mid-1880s, Degas had established himself as a major French artist whose work was widely sought after. He had always been aloof, and when he had achieved financial security he withdrew from society to devote himself to his work and to his family and friends. His eyesight, which had worried him since his thirties, was becoming a severe handicap. By his late seventies he was finally forced to cease active work.

Three Dancers in Yellow Skirts was included in the first estate sale at Galerie Georges Petit in 1918 (no. 302). It was later with the dealer Ambroise Vollard in Paris and with Joseph Hessel in Paris. The pianist Vladimir Horowitz acquired it through the dealer Justin K. Thannhauser and donated the drawing to the Cincinnati Art Museum in 1947.

GUDMUND VIGTEL

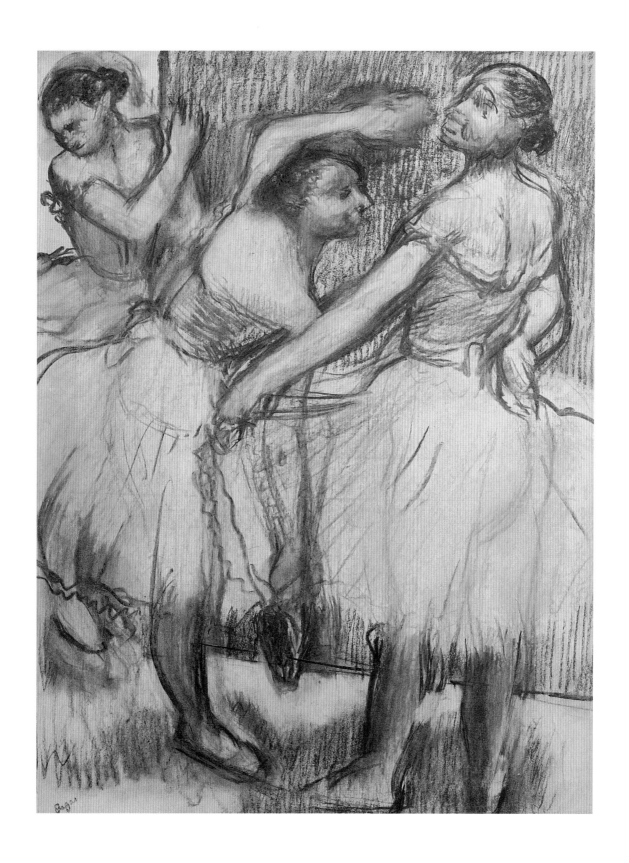

73. Two Dancers

1905[1]
Charcoal and pastel on tracing paper, mounted on wove paper
43 × 32 inches
The Museum of Modern Art, New York
The William S. Paley Collection, BR.149
Lemoisne supplement 149
Atlanta only

In the 1870s and 1880s, Degas almost single-handedly established paintings of ballet dancers as a genre, and by the 1890s the subject of dancers dominated his production. This large drawing of two dancers was produced quite late in the artist's career. It is believed that Degas stopped making works of art around 1910 due to his failing eyesight.

Two Dancers is typical of Degas's late graphic work both in subject matter and technique. It depicts dancers resting or preparing themselves for a performance. The broad, bold application of charcoal and the complex web of erasures, marks, and smudges constitute a radically innovative approach to drawing, one that would later be taken up by twentieth-century artists such as Henri Matisse. With works like this, Degas demonstrated that charcoal drawing could be a grand public art form on par with painting.

Another defining characteristic of Degas's later art is that much of it was produced serially or sequentially. Richard Kendall has shown that Degas's later working habits embraced the notion that figural motifs could be recycled to produce numerous related variants.[2] He used tracing paper to copy and then reprocess existing drawings. As Kendall suggests, *Two Dancers*, which

was executed on tracing paper, is related to at least two pastels that date from the 1890s. One of these may have served as the basis for this drawing.

Degas's drawings of the 1880s and 1890s challenged the contemporary conception of a finished work of art. Although *Two Dancers* appears to be only a preparatory study, Kendall has noted that the drawing was signed, indicating that Degas considered it finished. While Degas rarely signed his drawings, he probably made an exception in this case because it was included in Ambroise Vollard's 1914 publication of photogravure reproductions of twenty-four drawings by Degas.

Although its early history is unclear, this drawing eventually came into the possession of Ambroise Vollard, the Paris dealer and publisher, perhaps at the time of the 1914 publication. In 1935, William S. Paley, the future chairman of the CBS television network, purchased it from Vollard. This drawing was one of the first works to enter Paley's collection along with two works by Cézanne. Paley assembled a remarkable collection of works by modern masters, including Picasso's *Boy Leading a Horse*. In 1992, Paley gave his collection to The Museum of Modern Art.

DAVID A. BRENNEMAN

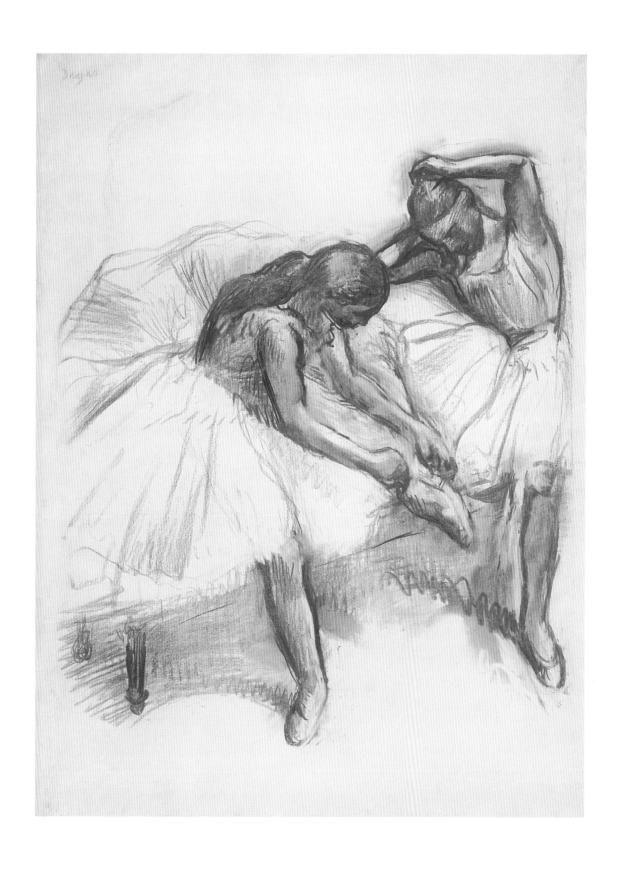

74. WOMAN DRYING HERSELF

ca. 1905
Charcoal and pastel on tracing paper, mounted by the artist on wove paper
31 × 31 inches
The Museum of Fine Arts, Houston
The Robert Lee Blaffer Memorial Collection
Gift of Sarah Campbell Blaffer, 56.21
Lemoisne 1423bis

WOMAN DRYING HERSELF is a variation of one of Degas's favorite bather motifs: a woman seen from behind, bending over as she dries the back of her head while holding out her long, thick hair. Degas found this routine gesture intriguing and produced a series of related compositions on tracing paper in which the pose appears again and again, slightly altered—sometimes a lone figure, sometimes attended. He also sculpted a wax of the pose, which was posthumously cast in bronze (cat. 85). Degas frequently drew on tracing paper in charcoal, transferring posed figures from paper to paper and working them into different groupings and backgrounds. He used tracing paper as no artist had before, pushing the material beyond its preparatory function to serve as the final support for finished work. He explained his serial imagery as follows: "It is essential to do the same subject over again, ten times, a hundred times. Nothing in art must seem to be chance, not even movement."[1]

Like many of Degas's nude and seminude bathers, *Woman Drying Herself* is arresting in its unabashed analysis of a mundane and eminently private moment. Here the woman is utterly unself-conscious as she goes about her business with a graceful vigor. The contours of her body, drawn in heavy charcoal lines

smeared with signs of the artist's reconsideration, compose a vivid form that is convincing and dramatic. The eerily anthropomorphic form of the towel hanging at the left of the composition defines the interior with remarkable economy.

Woman Drying Herself was bought in the second Degas atelier sale (no. 70) in December 1918 by M. Fiquet for 4,950 francs. Fiquet was co-owner of the gallery Nunès et Fiquet of Paris, which was listed in the 1946 catalogue raisonné as the pastel's owner. Fiquet's partner, M. Nunès, was a friend of Renoir and was involved as a dealer and patron in Impressionist circles. Sometime in the next decade, the pastel was acquired by Sarah Campbell Blaffer of Houston. An oil heiress raised in Lampasas, Texas, Blaffer was inspired as a collector by Isabella Stewart Gardner's mansion at Fenway Court, Boston. In 1947 she established the Robert Lee Blaffer Memorial Collection at The Museum of Fine Arts, Houston, in honor of her late husband. The collection includes some two dozen paintings, including major works by Renoir, Cézanne, and Vuillard. *Woman Drying Herself* joined the Blaffer Collection at the Museum in 1956.

MARY MORTON

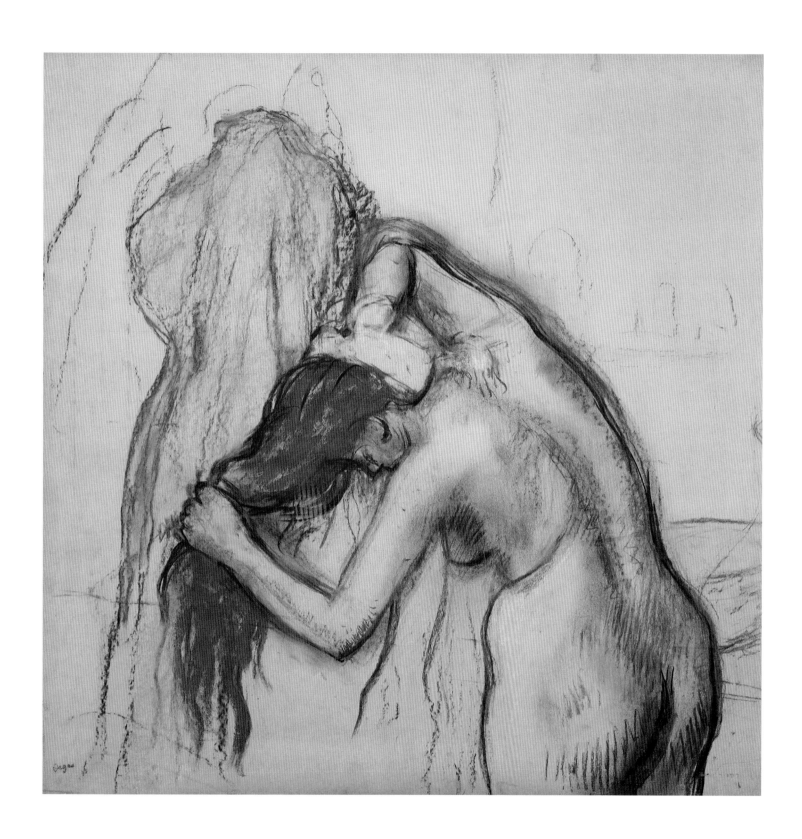

75

76

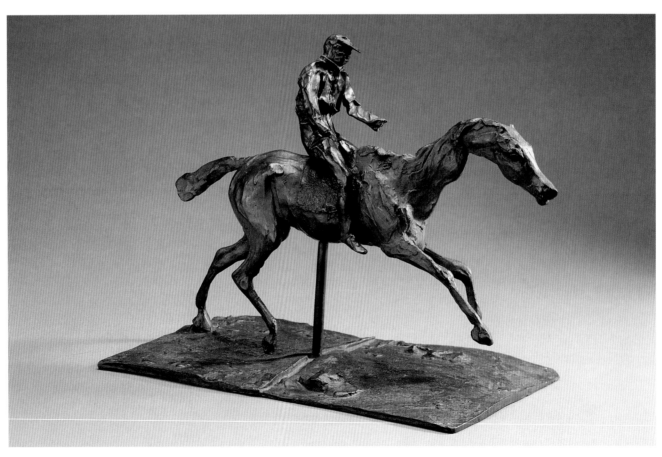

77

75. DRAUGHT HORSE

1866–68, cast 1921[1]
Bronze, 13/B
16½ × 5¼ × 8½ inches
The Hyde Collection, Glens Falls, New York, 1971.92
Rewald 2, Pingeot 42

76. HORSE WALKING

ca. 1860–70, cast 1921[2]
Bronze, 10/B
8⅜ × 10½ × 3⅞ inches
National Gallery of Art, Washington D.C.
Gift of Mrs. Lessing J. Rosenwald, 1989, 89.28.2
Rewald 10, Pingeot 48

77. HORSE WITH JOCKEY

1878–81 or early 1890s, cast 1921[3]
Bronze, 25 and 35/C
9½ × 13¼ × 7 inches
Art Gallery of Ontario, Toronto
Gift of R. W. Finlayson, 1969
Donated by the Ontario Heritage Foundation, 1988, 174.15
Rewald 14–15, Pingeot 49

FIFTEEN OF DEGAS'S ORIGINAL WAX HORSES survive, along with two jockeys. During the late 1850s the young artist studied classical statues of horses in Italy, and scholars believe he sculpted his first around 1860, when horses also appear in several paintings. *Draught Horse,* for example, resembles the horse in Degas's *Mlle. Fiocre in the Ballet "La Source"* (page 26, fig. 12), which was exhibited in the Salon of 1868.

Degas drew and painted many horse images in the mid- and late 1860s; he went to the racetrack and to a breeding farm to study from life. Although he had a good eye for thoroughbreds, he was frustrated by the difficulty of portraying them in motion. In the early 1870s Degas sculpted three horses walking, which seem to progress from a fairly static to a more convincing sense of movement. In the mid-1870s he sculpted a trotting horse and one galloping with its jockey. When he later sculpted another version—the one exhibited here—the pose was more active and more accurately portrays the movement of a horse at full gallop.

The difference between the earlier and later versions owes a clear debt to Eadweard Muybridge's sequential motion-study photographs of horses. Made in 1872 and widely discussed by artists, they were first published in France in the periodical *La Nature* in December 1878. When those photographs were enlarged and republished as *Animal Locomotion* in 1887, they may have inspired Degas to sculpt *Horse with Jockey.*

With their erratic degrees of finish, Degas's horses differ markedly from the detailed realism of *animalier* sculptors such as Jules-Pierre Mène and Emmanuel Frémiet, who specialized in portraits of specific breeds and individual champions. In contrast, Degas was interested primarily in forms rather than description (although he greatly admired Ernest Meissonier's superbly delineated *Horseman in a Storm* of 1881).[4] Nonetheless, Degas's horse sculptures had wide popular appeal and sold readily (some to collectors such as Paul Mellon, who was passionate about both art and horses). As "B" casts, the *Draught Horse* and *Horse Walking* bronzes exhibited here were included in the Durand-Ruel and Ferargil gallery shows in New York in 1922 and 1925. *Draught Horse* was sold from the Ferargil exhibition to Mr. and Mrs. Louis Fiske Hyde. Most of Degas's horse sculptures were sold to individuals rather than museums and remain in private collections to this day.

VALERIE J. FLETCHER

Eadweard Muybridge (1830–1904), *Animal Locomotion Plate 625,* 1887, photo-gravure, private collection.

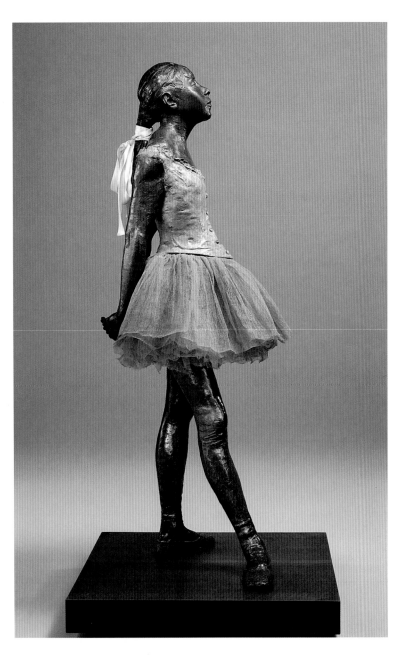

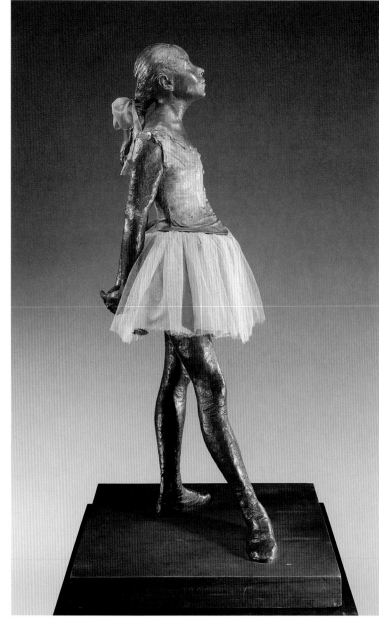

78. LITTLE DANCER OF FOURTEEN YEARS
 1879–81, cast 1921[1]
 Bronze with gauze tutu and silk ribbon,[2] unnumbered/D
 38½ × 14½ × 14¼ inches
 Sterling and Francine Clark Art Institute,
 Williamstown, Massachusetts, 1955.45
 Rewald 20, Pingeot 73
 Atlanta only

79. LITTLE DANCER OF FOURTEEN YEARS
 1879–81, cast 1924–31
 Bronze with gauze tutu and satin ribbon, unnumbered/HER.D
 38½ × 14½ × 14¼ inches
 Virginia Museum of Fine Arts, Richmond
 State Operating Funds and the Art Lover's Society Fund, 1945
 Rewald 20, Pingeot 73
 Minneapolis only

ACCORDING TO THE MODEL FOR THIS WORK, a ballet student named Marie Van Goethem, she started posing for drawings in 1875 and for this sculpture only after she turned fourteen in June 1879.[3] Degas intended to exhibit the wax original of the clothed figure in the Fifth Impressionist exhibition in 1880, but he did not finish it in time. It was included in the Sixth Impressionist exhibition (April 2–May 10, 1881); it was the only Degas sculpture shown in public in the artist's lifetime.

Quite probably Degas's decision not to exhibit any of his other sculptures was prompted by the shock and disapproval elicited by the *Little Dancer* in 1881. Criticisms encompassed the choice of subject, its delineation, and the materials used. Realism in sculpture had been a hotly debated issue from the 1830s through the 1860s, as artists made the transition from Greco-Roman idealism to specific portraiture—describing their subjects with accurate facial features and modern clothing rather than godlike profiles and toga-like robes. But even such realistic portraits celebrated figures of renown, and few artists dared to challenge the centuries-old hierarchy of materials, which approved marble and bronze as "noble," while plaster and wax were considered appropriate only for preliminary studies. From the 1850s onward some Romantic sculptors introduced exotic subjects—such as African and Arab images—and incorporated multihued stones to lend greater verisimilitude (using white marble or alabaster for flesh and red, yellow, and green marbles for clothing).

In *Little Dancer,* Degas went much further in choosing a non-heroic subject and in pursuing lifelike realism. His sculpture portrayed not an adulated prima ballerina but an anonymous student aspiring to become one of the Paris Opéra's *corps de ballet* (known pejoratively as "rats"). Degas sculpted the figure from clay-tinted wax, then clothed it in a white muslin tutu, white linen bodice, satin slippers, and a blue satin ribbon on a wig of real hair; the artist covered the shoes and bodice with wax to blend the surfaces together.[4] That degree of realism offended the defenders of traditional standards in art. Degas's *Little Dancer of Fourteen Years* came uncomfortably close to the famous wax figures by Mme. Tussaud, with their glass eyes and real clothing (which Degas had seen on a trip to London). Those mannequins were considered curiosities, not art, and even Tussaud depicted only celebrities.

As Degas's largest and most finished sculpture, *Little Dancer* was widely appreciated in the United States. Louisine Havemeyer had tried unsuccessfully to buy the wax original from Degas in 1903 and from his heirs in 1919. After she acquired the "A" set of bronzes in 1921, her *Little Dancer* was the first to enter an American museum as part of her bequest to The Metropolitan Museum of Art in 1929—three years after the Dresden Museum purchased their *Little Dancer* and two years before the Louvre bought the "P" set of the bronzes. At least five American collectors bought casts between 1924 and 1941, most of which eventually went to museums. In the early 1920s, Sterling Clark bought casts "C" and "D" and then sold "C" to Grenville Winthrop, who bequeathed it to the Fogg Art Museum in 1943. In 1931, Mrs. James Watson Webb bought the "J" cast; in 1935, Henry McIlhenny bought the "G" cast. In December 1938 the Museum of Fine Arts, Boston, became the first American museum to purchase a *Little Dancer,* followed by The Baltimore Museum of Art in 1943. When Curt Valentin's Buchholz Gallery sold the "HER.D" cast to the Virginia Museum of Fine Arts in June 1945 (it had come from Degas's niece, Jeanne Fèvre, in France), it was the fifth cast to enter an American museum collection. Within ten years Mrs. Webb gave her "J" to the Shelburne Museum in Vermont, and the Clark family donated the "D" cast to the Sterling and Francine Clark Art Institute in Williamstown, Massachusetts. By the time McIlhenny donated the "G" cast to the Philadelphia Museum of Art in 1986, nine bronzes and two plasters of *Little Dancer* were in American museums.

VALERIE J. FLETCHER

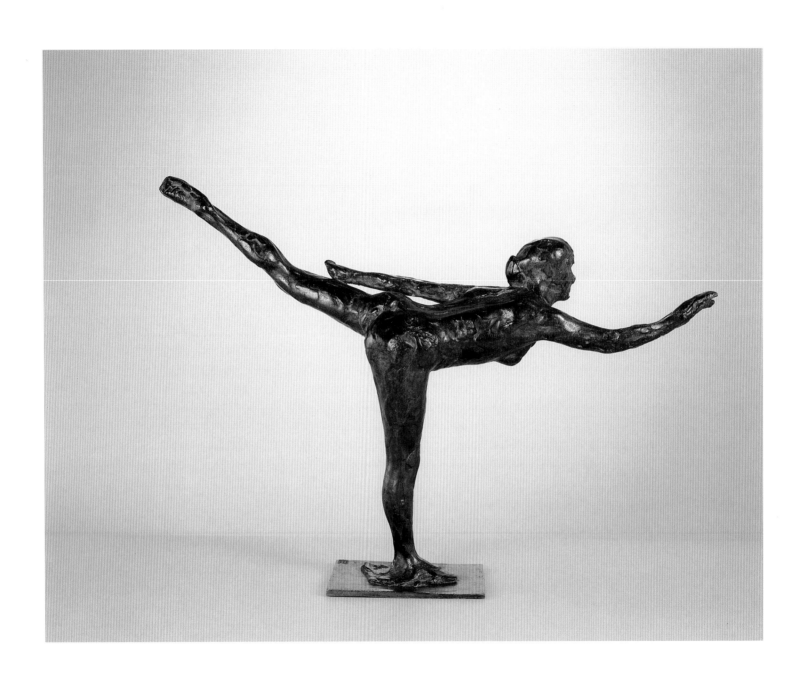

80. DANCER: ARABESQUE ON RIGHT LEG, LEFT ARM IN LINE

1881–85, cast 1919–31[1]
Bronze, 3/unmarked
12 × 16⅞ × 3¾ inches
Hirshhorn Museum and Sculpture Garden
Smithsonian Institution
Gift of Joseph H. Hirshhorn, 1966, 66.1296
Rewald 42, Pingeot 4

UNLIKE MOST OF HIS SCULPTURES of dancers, who are shown in private moments between performances or at practice, this composition illustrates a classic, fully executed ballet movement as it might be performed on stage. As such, *Dancer: Arabesque on Right Leg, Left Arm in Line* expresses Degas's admiration for a ballerina's grace and discipline. An arabesque requires the dancer to exercise formidable control to remain perfectly stable on one foot while she slowly raises one leg straight behind her until horizontal (or sometimes until her foot is as high as possible and her head approaches the floor). The goal of the arabesque is the longest possible extension of the body, from fingertips to toes. Degas sculpted at least eight versions of arabesques, each demonstrating a slightly different attitude, from the leg just leaving the floor to its apogee. The one exhibited here depicts the first of the five basic arabesque postures, considered the most difficult. Degas's model tilted her torso forward in the Russian manner rather than maintaining

the upright torso of the French style (which was probably too demanding a posture for her to sustain). To achieve this precarious posture in the sculpture, Degas had to tie the head, right arm, and left leg to an external armature while he worked. When all eight of Degas's sculptures are seen together, they illustrate not only the range of the arabesque technique but also clearly demonstrate Degas's knowledge of the motion-study photographs of Eadweard Muybridge (see cats. 75, 76, 77).

The arabesque series ranks among Degas's most popular sculptures. Four of them were illustrated in the 1922 Grolier exhibition catalogue, and William Zorach's review of the 1925 Ferargil Gallery exhibition included an arabesque as one of only two works illustrated. The Smithsonian's cast was donated by Joseph Hirshhorn in 1966; he had purchased it in 1958 from Knoedler & Co., who had obtained it from the Hébrard family with the assurance that it came from one of the sets "reserved for the founder."

VALERIE J. FLETCHER

81. Dancer Looking at the Sole of Her Right Foot

1882–95, cast 1921[1]
Bronze, 40/G
18 × 8 9/16 × 7 3/8 inches
The Baltimore Museum of Art, The Cone Collection, formed by
Dr. Claribel Cone and Mrs. Etta Cone of Baltimore, Maryland
BMA 1950.415
Rewald 45, Pingeot 35

EXCEPT FOR A FEW SCULPTURES, such as the arabesque series, that depict formal ballet movements, Degas liked to portray dancers as they prepared for performance, absorbed in ordinary actions. His interest in casual, unself-conscious poses contradicted the academic emphasis on classical postures in art at that time. Instead, the artist sought to find and capture a quiet kind of beauty within the mundane. Degas was fascinated by the pose of a dancer holding her right foot in her right hand; he sculpted at least six versions. The model later recalled how she struggled to maintain this difficult pose for long periods.[2]

In two versions the figure holds her right foot without looking at it, as if stretching or warming up. In four compositions she looks at her foot, as if to discover some imperfection. Perhaps the dancer is searching for a hole in her slipper or a blister on her foot; such an oblique reference to the arduous work required in her supposedly glamorous profession was entirely in keeping with Degas's goal of realism in art. The sculpture exhibited here is usually considered the last of the four versions, in which Degas best captured the model's balance and grace as she stands with consummate ease on one leg.

This "G" bronze was cast in 1921 and sent directly from Hébrard to the dealer Bernheim in Zürich in January 1922. Bernheim sold it to Etta Cone in 1937, who with her sister donated it to The Baltimore Museum of Art in 1950 along with the rest of their collection of early modernist art.

VALERIE J. FLETCHER

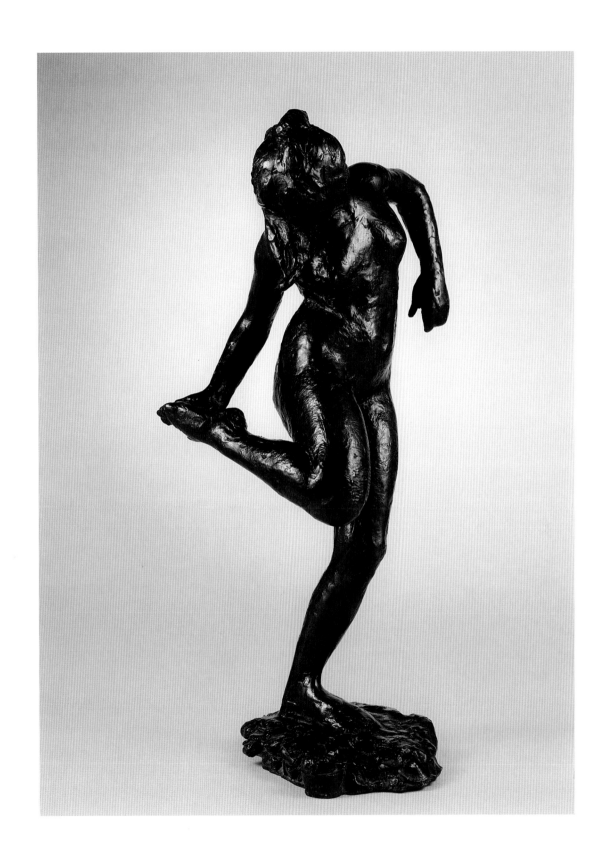

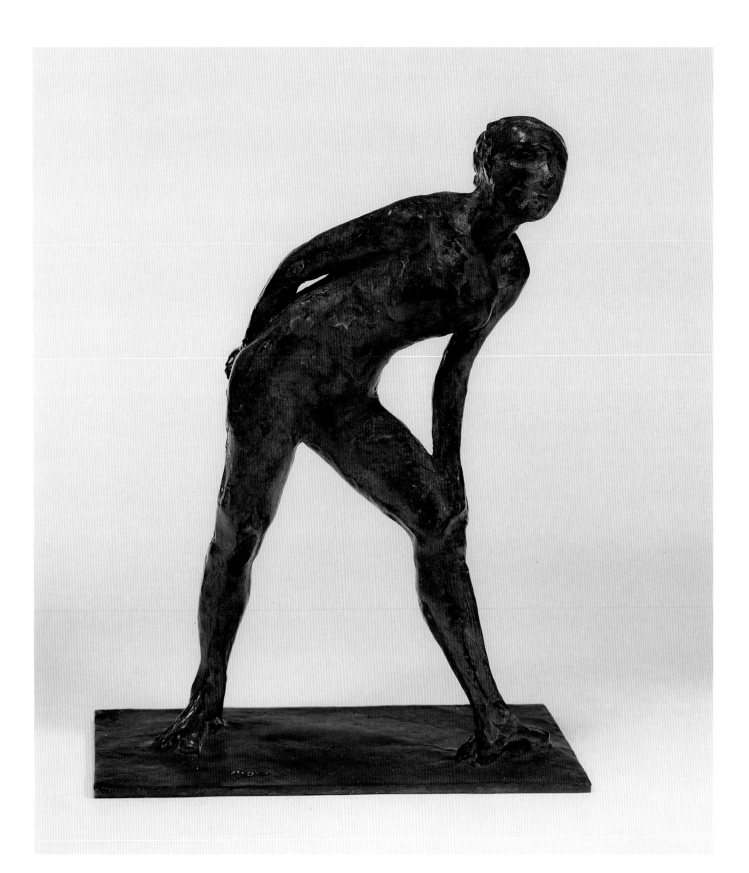

82. Dancer in the Role of Harlequin

1884–85, cast 1921

12¼ × 9⅜ × 5⁹⁄₁₆ inches

Bronze, 39/A

The Metropolitan Museum of Art, H. O. Havemeyer Collection

Bequest of Mrs. H. O. Havemeyer, 1929, 29.100.411

Rewald 48, Pingeot 27

As with so many of Degas's figures, this one combines a timeless elegance with an almost awkward modernity. The pose has few precedents, although Charles Millard has noted an affinity with classical Greek sculptures of a robed woman standing on one leg to adjust her sandal, particularly a relief of *Victory Refastening Her Sandal* that Degas had studied in his youth.[1] In contrast to that source, Degas's figure places her hand on her left knee and looks up as if to speak to an interlocutor.

The sculpture relates to several pastels in Degas's harlequin series, one of which was completed by November 1884 and another by 1885. The latter, the *Harlequin* in The Art Institute of Chicago, shows the rear view of a brightly garbed harlequin in a pose very similar to this sculpture. Gary Tinterow identified the sculpture as the ballerina Mlle. Sanlaville, who danced the role of a harlequin; Degas had attended a rehearsal on July 23, 1885, and was known to admire Sanlaville.[2] The sculpture itself offers no specific allusion to a harlequin; the characteristic costume of the *commedia dell'arte* personage is notably lacking. Rather, the figure shares the anonymity of Degas's other dancers depicted as they warm up in a class or rehearsal (here favoring her left knee as she stands with feet turned in opposite directions). The pose also has affinities with some of Degas's bathers; it is as if the figure were clasping a washcloth in her right hand while rubbing her leg with the left.

This cast came from the "A" set purchased by Louisine Havemeyer in October 1921 and exhibited at the Grolier Club in 1922. It was exhibited at The Metropolitan Museum of Art from 1925 to 1927 (without catalogue) and again in 1931 (with catalogue) and thereafter. Along with the rest of the "A" set, Mrs. Havemeyer bequeathed this work to the Metropolitan in 1929.

VALERIE J. FLETCHER

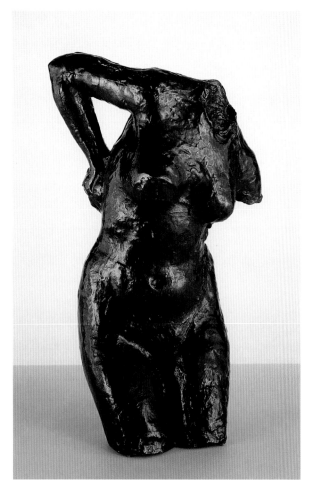

83

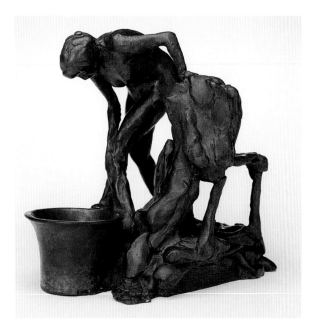

84

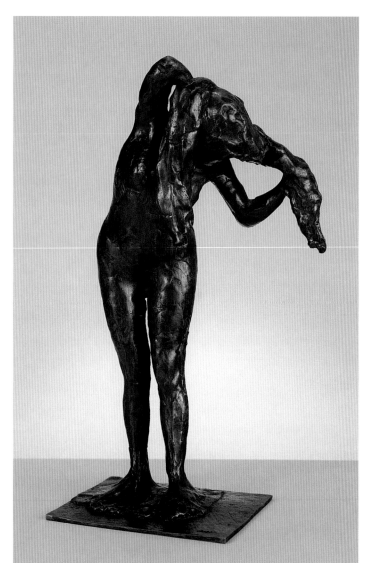

85

83. WOMAN RUBBING BACK WITH A SPONGE (TORSO)

1888–92, cast 1921[1]
Bronze, 28/D
17 × 10½ × 7 inches
Hirshhorn Museum and Sculpture Garden
Smithsonian Institution
Gift of Joseph H. Hirshhorn, 1966, 66.1304
Rewald 51, Pingeot 55

84. WOMAN WASHING LEFT LEG

1896–98, cast 1921[2]
Bronze, 61/B
7¾ × 6 × 7⅝ inches
Hirshhorn Museum and Sculpture Garden
Smithsonian Institution
Gift of Joseph H. Hirshhorn, 1966, 66.1286
Rewald 68, Pingeot 64

85. WOMAN ARRANGING HER HAIR

1896–1911, cast 1931[3]
Bronze, 50/T
18⅜ × 9⅞ × 6⅝ inches
Hirshhorn Museum and Sculpture Garden
Smithsonian Institution
Gift of Joseph H. Hirshhorn, 1966, 66.1305
Rewald 50, Pingeot 62

DEGAS PAINTED AND DREW many compositions of a nude bathing or performing her toilette, particularly after the mid-1880s. The subject descends from classical images of Venus and other goddesses and nymphs portrayed as the epitome of beauty and grace. During the Renaissance the theme symbolized vanity and was associated with female sensuality, particularly in the paintings of Titian. Fully aware of these sources, Degas sculpted his bathers with a different kind of informal grace— sometimes verging on the awkward—as he sought to reveal a new definition of beauty within the mundane.

Woman Rubbing Back with a Sponge (Torso) relates to two pastels of the same title.[4] The motif may have been inspired by a figure in Titian's *Original Sin* of 1550, which Degas saw on a visit to the Prado Museum in Madrid in 1889. The curvature of the body recalls classical torsos, such as the *Aphrodite of Cnidos* by Praxiteles in the Louvre. While some scholars think that Degas removed the head to intensify the evocation of a classical sculpture, most believe that the head fell off as the wax original aged (as happened with at least one other work).

Woman Rubbing Back with a Sponge (Torso) was one of only two illustrations in William Zorach's 1925 review of the Ferargil Gallery exhibition. The "D" cast exhibited here was purchased in 1939 by Justin K. Thannhauser. It later went to Mr. and Mrs. Otto Spaeth in New York, who consigned it to Sotheby's in 1963. Marlborough Gallery (which had been inspired by Curt Valentin in the mid-1950s to promote modern sculpture) purchased it and sold it to Joseph Hirshhorn in April 1964. It was Hirshhorn's twenty-first Degas bronze and became part of his donation to the Smithsonian Institution in May 1966 as part of his gift to establish a new national museum of modern art.

One of Degas's smallest bathers, *Woman Washing Left Leg* occupies a noteworthy niche in the history of modern art as possibly the first sculpture to incorporate a found object. Rather than sculpt a small tub from wax or clay, Degas appropriated a metal inkwell and added it to the composition (clearly visible in Gaulthier's photograph from 1918[5]). As part of the "B" set, the cast of *Woman Washing Left Leg* shown here was exhibited in New York at the Durand-Ruel Gallery in 1922 and at the Ferargil Gallery in 1925, when it was sold to Mr. and Mrs. Cornelius Sullivan. In 1939, possibly after Mrs. Sullivan's death, it was sold at auction by Parke-Bernet in New York to a purchaser identified only as Stone. Joseph Hirshhorn bought it in November 1957 from the Peridot Gallery. It was Hirshhorn's fourth Degas bronze, and was part of his donation to the Smithsonian in 1966.

Woman Arranging Her Hair relates to several drawings and pastels, some from the mid-1880s but most from ca. 1900–05, including *Woman Drying Herself* (cat. 74) and *Woman at Her Toilette* (Art Institute of Chicago). Degas's paintings usually show the figure from the rear, and the back of the sculpture is more fully modeled than the front. This cast belonged to Michel Kellerman in Paris; it then passed through the Marlborough Gallery in London to Robin Howard in London in 1952. When it was sold at auction at Sotheby's in 1964, Joseph Hirshhorn purchased it as his twenty-second Degas bronze, the last purchased before his donation to the Smithsonian.

VALERIE J. FLETCHER

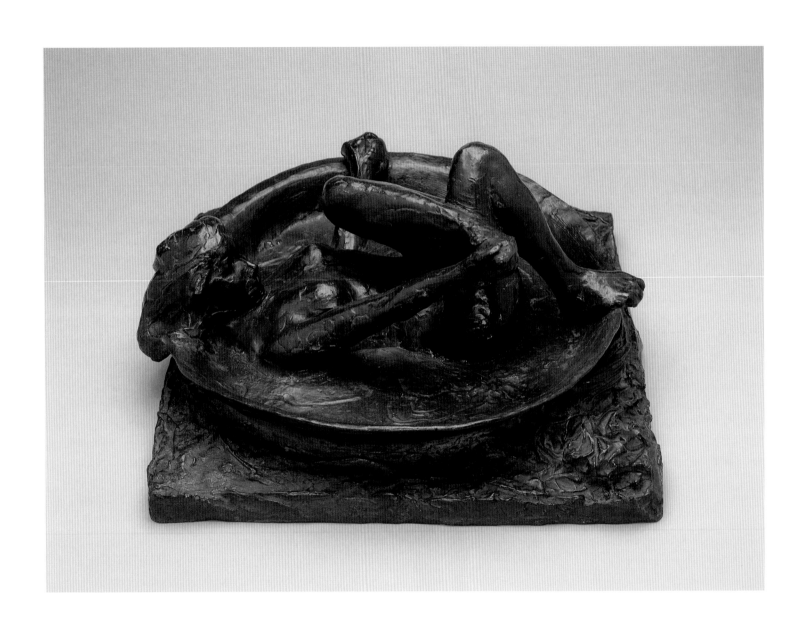

86. THE TUB

1889, cast 1920–21
Bronze, 26/C
8¾ × 16½ × 17¾ inches
The Minneapolis Institute of Arts
Gift of Ruth and Bruce B. Dayton, 1989, 89.99
Rewald 37, Pingeot 56

THE TUB IS WIDELY REGARDED as the most original of Degas's entire sculpted oeuvre. The artist's innovative approach to a traditional theme and his introduction of color through several materials in the original[1] achieved a work of daring that, much like Degas's *Little Dancer of Fourteen Years* (cats. 78, 79), became a touchstone of modernity, confronting the traditional concepts of nineteenth-century sculpture.

The Tub is one of only four sculptures by Degas that can be dated with any certainty.[2] In a letter of June 13, 1889, Degas wrote to the sculptor Bartholemé, "I have worked the little wax a great deal. I have made a base for it with rags soaked in a more or less well-mixed plaster."[3] When the artist first grasped the concept that was realized in the wax original, however, is uncertain. While several pastels from the middle of the decade depict women in a shallow basin in various postures, a two-dimensional work that depicts a reclining nude is not known to exist.[4]

Bronze casting of *The Tub,* as for all of Degas's sculpture, was performed following the artist's death in 1917. Sculptures in which the artist had employed tinted waxes and multiple materials to impart a sense of color presented the greatest challenge for realization in the medium of bronze. It is generally agreed that *The Tub* faired least well in the conversion. The elements so effectively defined through texture, color, and contrast

in the original wax sculpture—the plaster water, the lead rim of the basin, and the plaster soaked draperies that puddle around the basin's outer edge—were unsuccessfully realized in the bronze.

Much of the impact, as well as the charm, of *The Tub* derives from the clever manner in which Degas constructed the viewer's relationship to the sculpture. Because the bather is partially submerged in her shallow basin, a full view can only be obtained from directly overhead. However, the way in which her limbs overlap, and the self-absorption with which she performs her ablutions, achieve an insouciant innocence that foils the most prurient gaze.

Following its casting around 1920–21, this cast of *The Tub* entered a private collection and was eventually acquired by Wildenstein & Co., New York, in 1955. In January of 1957 the sculpture entered the collection of Bruce B. Dayton, a Minneapolis native. Dayton has acted as a trustee of The Minneapolis Institute of Arts for nearly sixty years. His donations to the Institute have ranged from antiquities to twentieth-century art, including a landscape pastel by Degas. *The Tub* remained in Dayton's collection until 1989, at which time the sculpture was donated to The Minneapolis Institute of Arts.

PATRICIA S. CANTERBURY

Catalogue Notes

CAT. 1

1. When Auguste Degas, the father of the painter, moved from Naples to Paris to open a branch of his father's bank, he changed the spelling of his last name to the "more snobbishly acceptable 'De Gas.'" Jean Sutherland Boggs, "New Orleans and the Work of Degas," in Feigenbaum et al. 1999, p. 100. The brothers of the painter, René and Achille, both businessmen like their father, kept the divided spelling, while Edgar eventually reverted to the original spelling of the family name.
2. The only portrait of René in oil is at the Smith College Museum of Art; the pencil study for this portrait is at the National Gallery of Art, Washington, D.C. Other pencil portraits are at The Art Institute of Chicago and in a private American collection (exhibited as no. 14 in the 1994 *Degas Portraits* exhibition in Zürich and Tübingen, Germany). Pencil studies presumed to be of René can be found in a private Basel collection (no. 2 in Adriani 1985; the verso is a sleeping study) as well as on pages from the Bibliothèque Nationale's notebook 5, p. 53, and notebook 6, p. 81, which contains a sleeping study (see Reff 1985). Finally, there is a sleeping study on the verso of a study for Degas's portrait of Achille De Gas in the Musée d'Orsay.
3. Tobia Bezzola, "Family Portraits," in Baumann and Karabelnik 1994, p. 175.
4. Emil Maurer, "Degas's Copies," in ibid., pp. 154–56.

CAT. 2

1. Barrazetti 1936, p. 1. Mme. Jacques Fourchy (née Hortense Valpinçon) recounted that the boys' fathers, Auguste De Gas and Edouard Valpinçon, who held similar interests in common, were friends before their sons became schoolmates. For dates of matriculation at the Lycée, see Boggs et al. 1988, p. 47.
2. Adriani 1985, pp. 23–24. Edouard Valpinçon was a noted collector and connoisseur who owned Ingres's *Bather* of 1808, commonly referred to as the *Valpinçon Bather* (Louvre). It was probably on his advice that Degas took up studies with Louis Lamothe, a pupil of Ingres.
3. See Boggs et al. 1988, p. 48. In early 1855, Edouard Valpinçon took Degas to meet Ingres. In April, Degas registered for studies at the École des Beaux Arts under Louis Lamothe, Ingres's student. In May through July of 1855 he copied several works by Ingres in the Exposition Universelle. It is also worth noting that Degas extensively employed the close-up portrait bust format around this period.
4. The drawing portrays Paul with Marguerite Claire Brinquant shortly after their marriage in 1861. It is reproduced in Boggs et al. 1988, p. 157, fig. 84. See ibid., pp. 47–60, which states that Degas arrived in Naples on July 17, 1856, and did not return to Paris until April 1859.

5. The other undated portrait (E. V. Thaw & Co., New York) clearly portrays Paul at middle age. The portrait (oil on paper laid down on canvas) is reproduced in Sutton 1986, p. 67, fig. 48. The painting was dated in that publication as ca. 1862 but has more recently been dated to 1868–72.
6. Jamot 1931, p. 27, no. 6.
7. Lemoisne 99. Unfortunately, the very delicate, fine-weave canvas was lined at some point before its acquisition by the Minneapolis Institute of Arts. Thus, the inscription, presently concealed, will have to await inspection when, and if, the canvas is ever relined.
8. See Barrazetti 1936, p. 1. The house of M. and Mme. Edouard Valpinçon, originally located at 22 rue Taitbout, was destroyed to make way for Boulevard Haussmann. Whether Hortense correctly recalled and/or interpreted the name cannot be proven, but her testimony as to its nature should not be discounted. It is very probable that the inscription was in her father's hand and therefore would have been more comprehensible to her than to Lemoisne. Furthermore, her memory has proven quite accurate elsewhere.
9. See Reymert 1982, pp. 29–33. Mr. Daniels's first major drawing purchase—a Degas dancer in 1951—was soon followed by several others.

CAT. 3

1. See Boggs et al. 1988, cat. 9, p. 67.
2. See ibid., cat. 10, pp. 67–68.

CAT. 4

1. The hesitant softness of Degas's line at one time suggested that the study could have been drawn for the theme of Dante and Beatrice. See Boggs 1966.
2. Quoted in Boggs et al. 1988, p. 52.

CAT. 5

1. William Henry Rossiter, "W. G. Russell Allen, 1882–1955: Memorial Exhibition," *Bulletin of the Museum of Fine Arts, Boston* 54, no. 296 (Summer 1956), p. 24.

CAT. 6

1. Boggs 1962, p. 9.
2. Boggs et al. 1988, cat. 1, pp. 61–62.

CAT. 7

1. Douglas Druick and Peter Zegers, "Degas and the Printed Image: 1856–1914," in Reed and Shapiro, p. xvii.
2. The plate itself, acquired by the Los Angeles County Museum in 1960, is the heavy kind traditionally used by professional etchers. Ibid., pp. 24, 30.
3. Boggs et al. 1988, pp. 71–72.

CAT. 8

1. See Armstrong 1988.

CAT. 9

1. Reff 1969, p. 283.
2. Illustrations and references to many of the Bellelli studies are in Finsen 1983 and Boggs et al. 1988, pp. 77–85. Although Degas most likely prepared the Dumbarton Oaks drawing in 1858–59, he could conceivably have done it on his visit to Florence in 1860.
3. Reff 1969, p. 283.
4. Whitehill 1967.
5. Kelekian to Bliss, April 9, 1937, House Collection files, K correspondence, Dumbarton Oaks Archives, Washington, D.C.

CAT. 10

1. Quoted from Degas's notebooks, in Boggs et al. 1988, p. 86, n. 7. See also Reff 1985.

CAT. 11

1. Degas's uncle, the Baron Bellelli, had been exiled from Naples since the Revolution of 1848. As a result of the peace agreements, he was permitted to return to Naples with his family. See Rosenfeld 1991, p. 103.

CAT. 12

1. Boggs 1966, p. 88. Boggs dates the drawing ca. 1867.
2. Feigenbaum et al. 1999, p. 135; see also pp. 123–39, 275–88, which thoroughly explore the Musson/Degas familial connections. Estelle and Joe were accompanied to France by Désirée Musson and the family matriarch, Mme. Michel Musson. The women were sent there by Degas's maternal uncle, Michel Musson, to escape the occupation of New Orleans by Union forces.
3. In a letter dated January 5, 1864, Désirée, Estelle's sister, wrote home to New Orleans, "Edgar has made several sketches of little Joe but isn't happy with them. It's impossible to make her be still for more than five minutes." Ibid., p. 135.
4. For instance, Hortense Valpinçon, who was born July 14, 1862, would have been at a stage of development comparable to that in this drawing by late 1863. The shape of the mouth, nose, and brows are echoed in Degas's representation of Hortense in 1871 (cat. 24). Degas's long friendship with the Valpinçon family is general knowledge, and aside from his documented visits to their chateau, Ménil-Hubert, he was probably also a frequent visitor in their Paris home.
5. Lugt 1921, p. 423.

CAT. 13

1. Lemoisne, p. 38.
2. Boggs et al. 1998, p. 43.
3. Kendall 1993, p. 67.
4. Ibid., p. 67.

CAT. 14

1. Boggs et al. 1988, p. 140.
2. Ibid., p. 368.
3. See Dumas et al. 1997, pp. 3–74.
4. Reed and Shapiro 17 and 18.
5. Reed and Shapiro 19.
6. Bryson Burroughs, "Drawings by Degas," *Metropolitan Museum of Art Bulletin* 14, no. 5 (May 1919), p. 115.

7. For Seligmann's role in these purchases, see Susan Alyson Stein, "The Metropolitan Museum's Purchases from the Degas Sales," in Dumas et al. 1997, p. 283. For Seligmann's relationship with the museum, see Seligman 1961, pp. 20–21.

CAT. 15

1. Object files of the Department of Prints, Drawings, and Photographs, Sterling and Francine Clark Art Institute, Williamstown, Massachusetts.
2. See, for instance, Greenberg 1961, p. 39.

CAT. 16

1. See Boggs et al. 1988, p. 55.

CAT. 17

1. See Boggs et al. 1988, cat. 60, pp. 114–15.
2. For information on Paul Rosenberg, see Gee 1981.

CAT. 18

1. See Weitzenhoffer 1986.

CAT. 19

1. Boggs et al. 1988, pp. 120–21.
2. Ibid., p. 253.

CAT. 21

1. Michael Wentworth, "James Tissot, 'cet être complexe,'" in Matyjaskiewicz 1984, p. 12.
2. Emil Maurer, "Portraits as Pictures: Degas between Taking a Likeness and Making a Work of Art (Tableau)," in Baumann and Karabelnik 1994, p. 106.

CAT. 23

1. *Achille De Gas in the Uniform of a Cadet* (National Gallery of Art, Washington, D.C.). The National Gallery dates this painting ca. 1856–57. However, Pickvance 1993, p. 20, assigns a date that would correspond to Achille's term as a naval ensign—an insignia of which rank he wears in the portrait. If correct, that would place the National Gallery's painting between 1862 and 1864, much closer to this work.
2. It is thought that this includes studies for *Scene from the Steeplechase: The Fallen Jockey* (ca. 1866, National Gallery of Art, Washington, D.C.). Whether or not Achille was actually a *habitué* of the racetrack is explored briefly in Jean Sutherland Boggs, "Horses and People," in Feigenbaum et al. 1999, p. 165.
3. This view is supported by the manner in which the sketch has been presented over the years—essentially as a painting. At some point in its provenance, the paper support was mounted onto canvas and subsequently varnished. This type of treatment has, no doubt, contributed to the confusion over the actual nature of media and support (i.e., oil and/or oil wash on paper; oil on paper laid down on canvas; oil on oiled card; oil on parchment; oil on parchment on canvas). However, infrared and microscopic inspection in early 1999 at the Upper Midwest Conservation Association confirmed the presence of graphite and oil on paper, which is laid down on canvas.
4. Nicholson 1960, pp. 536–37. The painting was acquired at auction from Sotheby's on July 1, 1959, by dealers Arthur Tooth & Sons. X-rays of the painting revealed the presence of a different composition beneath. Degas had intermittently altered elements of the painting between ca. 1868 (the approximate date of the original composition) and his death in 1917. He had changed certain aspects while completely obliterating others. The composition, as it appeared before cleaning (illustrated in Nicholson

1960, fig. 39; and in Pickvance 1993, p. 31), had not been resolved. A conservator (Dr. Ruhemann) removed several layers of paint to reach the original composition, at which time the figure that is based upon the Institute's preparatory study was revealed. The woman with field glasses who appears with Achille in the painting was also uncovered at that time. The male figure that had overlaid Achille (which was removed during the cleaning) relates to another sketch, *Achille De Gas* (Lemoisne 308, Private Collection, Switzerland). It should be noted that Boggs is misleading, implying that the painting was cleaned around 1950, rather than in 1959. See Feigenbaum et al. 1999, p. 173, n. 3

5. It is generally recognized that the drawing of *Manet at the Races* (ca. 1868–70, Metropolitan Museum of Art), which includes the faint impression of the woman with field glasses to his left, was Degas's first exploratory sketch for the foreground figures of the painting. For the canvas, however, the artist chose to substitute the more elegant figure of his brother as developed in the Institute's oil and graphite sketch.

6. As the relationship of the Institute's sketch to the painting was unknown until 1959, it had been variously dated. Lemoisne assigned a date of ca. 1872–73 (a date that has been most frequently repeated). However, it was Nicholson who, in 1960, first suggested an earlier date for the Institute's sketch. Pickvance 1993, who relied on revelations of the 1959 cleaning, first declared ca. 1868 as the most plausible. Adriani 1985 opted for a date as early as 1865–66. Most recently, however, Boggs assigns the sketch the same dates ascribed to the painting, ca. 1868–72. (Degas's departure for New Orleans serves as the terminus to this time frame.) See Feigenbaum et al. 1999, p. 172.

7. McMillan's older sister, Emily, had studied painting with Whistler in Paris during the 1890s, and she encouraged and guided her brother's taste for modern art.

CAT. 24

1. See Degas's *Carnets de notes, 1868–83,* Carnet 21, 1869 [formerly R], pp. 46–47, Bibliothèque Nationale, Paris.

2. For a thorough review of the facts and circumstantial evidence connected with the dating of this painting, see Boggs et al. 1988, cat. 101, p. 168.

3. Treatment was performed in July 1996 by the Upper Midwest Conservation Association, Minneapolis, Minnesota. A vertical, striped pattern is also discernible in infrared photographs. The weave of the support is consistent with a herringbone twill.

4. "At an earlier stage the painting appears to have been a double portrait . . . where the portrait of an adult woman leaning on her elbow was scraped down . . . [and] replaced by her attribute, a sewing-basket." Brettell 1983, p. 238.

5. Hortense recalled that her father feared the freshness of the portrait would be sacrificed to Degas's relentless perfectionism. Thus he declared it perfect as it was, and wrested it from the painter's hands unfinished and unsigned. Barrazzetti 1936, p. 3.

6. While Chester Dale has long appeared at this point in the provenance, research in the Wildenstein & Co. files reveals that he never purchased it. Instead Wildenstein's files indicate that Mr. and Mrs. Dale viewed and passed over the portrait on at least six separate occasions between 1930 and 1944.

7. For a possible explanation as to why American collectors passed over such an important painting, see Visson 1986, p. 168. Visson observed in some American collectors a tendency to buy paintings as if they were blue-chip investments. He wrote of one collector, possibly Chester Dale, "with paintings worth several million [who] frequently came to check out our new acquisitions. . . . He looked at the marvelous painting [*Portrait

of Mlle. Hortense Valpinçon] for a few moments and then, greatly disappointed, sighed, 'But, Vladimir, it's not even signed.' No amount of explanation that this was one of Degas' most famous paintings could dispel his doubts regarding this 'share of stock.'"

CAT. 25

1. Vollard 1986, p. 56.

2. Boggs et al. 1988, p. 221.

3. For information on Erwin Davis (and other early collectors of Impressionism), see Distel 1990.

CAT. 26

1. Quoted in Boggs et al. 1988, p. 58.

CAT. 27

1. Estelle would eventually become totally blind. Her string of tragedies culminated in René abandoning her and their children in 1878 and eloping with their neighbor. It led to a break between the two families, and Degas himself refused to have anything to do with his brother until they had grown old. See Feigenbaum et al. 1999, p. 18.

CAT. 28

1. For reproductions and commentary, see Feigenbaum et al. 1999, cats. 35–36, pp. 238–42.

2. X-radiographic and infrared examinations of the painting also suggest a number of changes to the structure of the space. I am indebted to Ann Hoenigswald, painting conservator, National Gallery of Art, Washington, D.C., for undertaking these examinations and sharing her results. She summarizes: "The architectural lines have been redrawn over and over again, and Degas seems to have had a great deal of trouble making it work. Clearly the doorway has been shifted over to the left significantly and the reworking at the left may have been done to accommodate the reorientation of the viewer to the interior. The shift in the doorway is visible to the naked eye. All of the drawing for the paneling in the doorway appears in the infrared to suggest that the [pianist's] head was painted over the already completed architecture. One may assume that the piano itself existed initially, whereas the piano player was added."

3. This figure was possibly modeled in Paris after his youngest sister, Marguerite. Henri Loyrette traces this identification to the unpublished memoirs of Marguerite's friend Louise Bréguet-Halévy. Boggs et al. 1988, p. 189, n. 4.

4. The right-hand female figure can plausibly be identified as the blind and possibly pregnant Estelle De Gas, an accomplished singer, who gave birth to her third child on December 20, 1872, during Degas's visit. Her painted visage remains fairly true to the pencil study, and both compare favorably to other representations of Estelle. Jean Sutherland Boggs has tentatively suggested that the left-hand figure be identified as Mme. Millaudon, a friend of the Musson-Degas family. Boggs and Brown 1999, p. 30.

5. Roger Valbelle, "La Deuxième Journée de la Vente Edgar Degas," *Excelsior,* May 8, 1918.

6. Hugo Vickers, "Gladys, Duchess of Marlborough," in J. Herbert 1978, p. 144.

7. Quoted in Rieder 2000, p. 213; I am indebted to Mr. Rieder for making the reference in the privately owned, unpublished Matilda Gay diary available to me.

CAT. 29

1. Shackelford and Wissman 2000, p. 212

2. Troyen and Tabbaa 1984.

CAT. 31

1. McCabe 1869, pp. 692–93.
2. Janis, p. xvii.
3. See Janis 42.
4. *The Princeton Alumni Weekly,* September 25, 1942.

CAT. 32

1. See R. Herbert 1988, p. 83. On the painting, see also Boggs et al. 1988, cat. 175, pp. 290–92.
2. According to curatorial records at the Museum of Fine Arts, Allen died intestate in 1956. The seven-year gap between his death and the bequest date testifies to the museum's negotiation for his collection.
3. Both *The Song of the Dog* and *Mlle. Bécat at the Ambassadeurs* (cat. 35) figured in this exhibition. Reed and Shapiro 25, 31.

CAT. 33

1. Jean Sutherland Boggs, "Degas as Portraitist," in Baumann and Karabelnik 1994, pp. 45–46.
2. Cited in ibid., p. 227.

CAT. 34

1. See Cooper 1976, pp. 17–19.
2. Location unknown. Lemoisne 649.

CAT. 35

1. Reed and Shapiro, pp. 94–97.

CAT. 36

1. R. Herbert 1988, p. 81.
2. Reed and Shapiro, pp. 90–91.
3. Curatorial files, Department of Prints, Drawings, and Photographs, Museum of Fine Arts, Boston.

CAT. 37

1. Location unknown. Lemoisne 584.
2. I am grateful to Nathalie Bondil-Poupard, curator of European Art at the Montreal Museum of Fine Arts, for providing information on this picture.

CAT. 38

1. Janis, p. xvii.
2. Kendall 1993, p. 130.

CAT. 39

1. Hall 1978. I am grateful to Laura Coyle, assistant curator, Corcoran Gallery of Art, for forwarding me excerpts from this catalogue and a list of all the works in the Clark bequest. Clark's painting purchases varied from old masters like Correggio, Van Dyck, Ghirlandaio, Van Goyen, Rembrandt, Rubens, Ruisdael, Terborch, and Velde to a selection of eighteenth-century French painters, including Boucher, Chardin, Fragonard, and Pater.
2. Clark may have been guided in his favoring of Cazin, Corot, Degas, and Monticelli by an influential contemporary book, W. C. Brownwell's *French Art.* See Aaron Sheon, "Nineteenth Century French Art in the Clark Collection," in Hall 1978, pp. 117–27.

CAT. 40

1. Boggs et al. 1988, p. 320.
2. Kendall 1996, p. 134.

CAT. 41

1. Theodore Reff, *The Metropolitan Museum of Art Bulletin* 34, no. 4 (Spring 1977), p. 33.

2. For more on Duranty's essay and his relationship with the Impressionists, see Moffett 1986.
3. See Bryson Burroughs, "Drawings by Degas," *The Metropolitan Museum of Art Bulletin* 14, no. 5 (May 1919), pp. 115–17. See also Susan Alyson Stein, "The Metropolitan Museum's Purchases from the Degas Sales," in Dumas et al. 1997, p. 283.

CAT. 42

1. Shapiro 1980, p. 161.
2. Havemeyer 1993, p. 245.

CAT. 43

1. Reed and Shapiro 26.
2. Shapiro 1980, p. 153.
3. Ibid., pp. 156–57.
4. For information on Alexis Rouart, see Distel 1990.
5. See Reed and Shapiro, pp. 262–63.

CAT. 44

1. See Clifford Ackley, "Edgar Degas: Painter as Printmaker," in Reed and Shapiro, p. x.
2. For a discussion of Degas's attitude toward printmaking as a purely reproductive medium, see Douglas Druick and Peter Zegers, "Degas and the Printed Image: 1856–1914," in ibid., pp. xv–lxxii. For a discussion of each of the five states of this print, see ibid., pp. 161–63.

CATS. 45–47

1. Reed and Shapiro, pp. 184–97

CAT. 48

1. Charles S. Moffett, "The Fifth Exhibition, 1880: Disarray and Disappointment," in Berson 1996, pp. 292–314.
2. "Why does a man like Degas dally with this pack of incompetents?" Albert Wolff, "Beaux-Arts: Les Impressionistes," *Le Figaro,* April 9, 1880, pp. 1–2, cited in Berson 1996, p. 318
3. Joris-Karl Huysmans, "Exposition des artistes indépendants en 1880," *L'art moderne* (Paris: G. Cherpentier, 1883), pp. 85–123, cited in Berson 1996, pp. 284–93.
4. Distel 1990, pp. 223–30.
5. "Exhibition For Suffrage Cause: Art at Home and Abroad" *New York Times,* April 4, 1915, sec. N, p. 2.

CAT. 50

1. Maheux 1988, pp. 52–56.
2. Kendall 1996, p. 134.

CAT. 51

1. Browse 1949, p. 59.
2. See Kendall 1998, p. 17, wherein the life and training of the ballet "rat" in relation to the creation and reception of *Little Dancer of Fourteen Years* (cats. 78, 79) is thoroughly explored.
3. Browse notes that an experienced dancer, "even in moments of repose cannot allow herself to relax" but instead unconsciously stretches her instep, forces her *pointes,* and continues to pull back her shoulders. Browse 1949, p. 59.
4. *Battements sur les Pointes à la Barre,* ca. 1880 (location unknown); *Battements à la Seconde à la Barre,* ca. 1880 (Metropolitan Museum of Art); *Rondes-de-Jambe-à-Terre à la Barre,* ca. 1880 (Fitzwilliam Museum, Cambridge, England). Illustrated in Browse 1949, nos. 76–78.

CAT. 52

1. The location of *Woman Ironing* (Lemoisne 361) is unknown. See discussion in Boggs et al. 1988, cat. 258, pp. 428–29.
2. Location unknown. Lemoisne 277.
3. A Princeton alumni publication records Dick's "new hobbies" as "collecting paintings by French Impressionists (especially Degas)." *Thirty Year Record, Class of 1909,* Princeton University, January 1, 1939.

CAT. 53

1. See Boggs et al. 1988, cat. 261, pp. 432–33.
2. Not unusually, these works were not listed in the catalogue of the Second Impressionist exhibition. On their inclusion, see ibid., cat. 137, p. 243.
3. Private collection. Lemoisne 530.

CAT. 55

1. Quoted in Boggs et al. 1988, p. 368.

CAT. 56

1. Boggs et al. 1988, cat. 176, p. 292.

CAT. 57

1. Gary Tinterow, "The 1880s: Synthesis and Change," in Boggs et al. 1988, p. 366.
2. For a technical description of *Three Women at the Races,* see Harris, Chambers, and Story 1996, p. 176.
3. Hollander 1986, pp. 131–35.

CAT. 59

1. The opera *Sigurd* was composed by Degas's friend Ernest Reyer and premiered in Paris in 1885.
2. On the basis of the costume, Jean Sutherland Boggs proposes that the painting depicts a performance of another opera of Reyer's: an adaptation of Flaubert's *Sallambô.* Boggs et al. 1988, cat. 326, pp. 533–34.
3. *Two Dancers in Green Skirts* was in the first atelier sale and had been acquired by Albright-Knox in 1928 from Durand-Ruel. Curatorial files, Albright-Knox Art Gallery, Buffalo, N.Y.

CAT. 60

1. Quoted in Dumas et al. 1997, p. 114.
2. Jean Sutherland Boggs, "Mme. Henri Rouart and Hélène by Edgar Degas," *Los Angeles County Museum Bulletin of Art* 8, no. 2 (Spring 1956), pp. 13–17. See also Boggs 1962, p. 67.
3. Boggs 1966, p. 67. See also Millard 1976, p. 58.
4. Harris 1993, p. 13.

CATS. 61–62

1. Quoted in Boggs et al. 1988, p. 502.
2. Quoted in ibid., p. 502.
3. Kendall 1993, p. 231.

CAT. 63

1. Degas to de Valernes, July 6, 1891, in Guérin 1945, no. 159. Author's translation.
2. Cassatt to Avery, March 2 [1893], in Mathews 1984, p. 246.
3. Reed and Shapiro 61–66.

CAT. 64

1. Obituary in *Connoisseur* 98 (December 1936), p. 365.

CAT. 65

1. Walker 1980, p. 110

CAT. 66

1. Valéry 1960, p. 39.
2. Reed and Shapiro 61–66.
3. Location unknown. See illustration in ibid.
4. Ibid., p. 220. Exsteens owned impressions of Reed and Shapiro 61 (fourth and sixth state), 65 (first and second state), and 66 (fifth state).

CAT. 67

1. Kendall 1993, pp. 185–88.
2. Quoted in ibid., p. 183.
3. I would like to thank Richard Kendall for sharing this observation in conversation with me in June of 2000.

CAT. 68

1. See Kendall 1996, p. 101, for further discussion of Degas's use of undercolor in his late pastels.
2. For a discussion and list of Degas's interest in Michelangelo and other old masters, see Walker 1933, pp. 173–85. For a list of Degas's copies after Michelangelo, see Reff 1985.

CAT. 69

1. See *After the Bath,* ca. 1893–98, Bayerische Staatsgemäldesammlung, Munich (Lemoisne 964). For a color reproduction of this work, see Kendall 1996, p. 49. Kendall, however, dates Dayton's *After the Bath* 1900–05. Ibid., p. 97, fig. 99.
2. See Guérin 1947, p. 247. In a note dated Saturday, February 14, 1892, Degas is quoted as saying, "At last I shall be able to devote myself to black and white, which is my passion."
3. See Daniel, Parry, and Reff 1998; and Vaizey 1982.
4. Kendall 1996, p. 97.
5. Boggs et al. 1988, pp. 370–72.
6. Krens 1992, p. 11.

CAT. 70

1. See Kendall 1996, p. 256.
2. See illustration in Boggs et al. 1988, p. 558, fig. 314.
3. See ibid., cat. 348, pp. 558–59.
4. Ibid., cat. 348, p. 558.
5. See Lemoisne 1020bis.

CAT. 71

1. This technique is described in Kendall 1996, p. 101. However, Kendall discusses Degas's use of a colored composition base over an entire work, not just part of a composition.

CAT. 72

1. Regarding this apocryphal admonition, see Theodore Reff, "'Three Great Draftsman': Ingres, Delacroix, and Daumier," in Dumas et al. 1997, pp. 137–75.

CAT. 73

1. Kendall 1996, p. 74, dates this drawing to ca. 1898–1903.
2. Ibid., pp. 74–75.

CAT. 74

1. Quoted in Kendall 1996, p. 81.

CATS. 75–77

1. For dating arguments on all of the horse sculptures, see Daphne S. Barbour and Shelley G. Sturman, "The Horse in Wax and Bronze," in Boggs et al. 1998, pp. 180–207. Rewald dates *Draught Horse* as 1866–68 because of the affinity with the horse depicted in Degas's painting *Mlle. Fiocre in the Ballet "La Source"* (page 26, fig. 12), which was exhibited in mid-1868. Barbour and Sturman date the sculpture to the early 1860s, believing that it may have inspired the horse in the painting.
2. Rewald dates it as 1865–81; and Pingeot as 1866 because it served as model for a painting of racehorses from 1866–68. Camesasca and Cortenova 1986, pp. 120, 183, date it as 1866 as well.
3. Rewald dates it as 1865–81 because the horse may be related to a painting of 1869–71 and the jockey to a painting from 1866–68. Millard 1976, p. 23, dates it as 1881–90. Barbour and Sturman in Boggs et al. 1998, p. 198, date it to the 1890s, based on the improved accuracy of the galloping pose and the simpler armature of this work compared with the other version. At the very least this composition should date from after 1878, when Degas saw Eadweard Muybridge's photographs. Degas originally made the jockey as a separate figure; one wonders if he played with adding the figure to different horses at different times. The figure also incorporated cloth but not as obviously as in the *Little Dancer.*
4. François Thiébault-Sisson, "Degas sculpteur par lui-même," *Le Temps* (Paris, May 23, 1921), p. 3; and Valéry 1938.

CATS. 78–79

1. Degas's title indicates that he started working on the wax original in 1879. He had hoped to include it in the Impressionist exhibition the following year but did not finish it until spring 1881, when it was exhibited. These facts make *Little Dancer of Fourteen Years* the only finished and securely dated sculpture by Degas. The wax was not shown again in public until April 1920 at the Galerie Hébrard just before casting began. According to Pingeot, p. 190, the first bronze was finished in November 1922, followed a month later by the second; the next ten were completed by January 1924, but subsequent casts were not documented. It is possible that in recent years an additional cast may have been made (in a photograph documenting a new cast of Rodin's *Thinker* at the Valsuani foundry in Paris in late 1999 or early 2000, an unclothed *Little Dancer* appears in the background).
2. Some or all of the casts originally had subtle surface colorations added by the foundry to make the bronze resemble the original: beeswax tinted pink on the lips and in the ears, beeswax tinted dark brown on the upper shoulders and on the hair, and golden beeswax on other areas of flesh, as well as the pigments on the bodice. See Rolfe 1999, pp. 14–25.
3. The model's correct fourteenth birthday (formerly thought to be February 1878) was established by Anne Pingeot and Theodore Reff, "Positioning Degas," symposium at Joslyn Art Museum, Omaha, Nebraska, April 1998. For a comprehensive source on this sculpture, see Kendall 1998.
4. The coloration of the bronze *Little Dancer* does not accurately reproduce the original. The artist's niece, Jeanne Fèvre, decided to have the bodice, shoes, and hair cast in bronze rather than use real cloth, and she chose a shorter grayish-green tutu.

CAT. 80

1. Although scholars have ascribed dates from 1877 to 1895, most experts believe the original in yellow-brown wax was made in the early 1880s. The casting date is less clear because this bronze has no legible letter; the founder may have omitted the letter for this cast by accident or may have made an extra cast (as happened with two other sculptures).

CAT. 81

1. Rewald dates it as 1882–95. Beaulieu 1969, p. 374, dates it as 1890–95. The original sculpture must have been completed by 1900, when Degas had Hébrard make a plaster cast, illustrated in Pingeot, p. 170.
2. Alice Michel, "Degas et son modèle," *Le Mercure de France* (February 16, 1919), p. 634.

CAT. 82

1. See Millard 1976, pp. 67–68, figs. 77–79.
2. Gary Tinterow in Boggs et al. 1988, cat. 262, pp. 433–34. Scholars disagree on whether this work should differ from Degas's other sculptures of dancers by having such a specific and literal title simply because the sculpture relates to a few pastels with that subject. Neither title was assigned by Degas himself. The connection with the *Harlequin* pastel caused most scholars to redate the sculpture (Rewald had dated it to 1882–95).

CATS. 83–85

1. Rewald dates it as 1888–92. Thomson 1987, pp. 194–95, dates it as 1889–90. It must have been completed before 1900, when Degas had Hébrard make a plaster cast, illustrated in Pingeot, p. 178.
2. Rewald dates it as 1896–1911. Beaulieu 1969 dates it as 1883; and Camesasca and Cortenova 1986, pp. 158, 204, as ca. 1898.
3. Rewald dates it as 1896–1911. Beaulieu 1969, p. 380, dates it as ca. 1903; Thomson 1987, p. 128, as 1890–95; Boggs et al. 1998 as 1900–10; Camesasca and Cortenova 1986, pp. 147, 199, as 1900–08.
4. Lemoisne 967 and 968.
5. See illustrations in Pingeot, p. 184.

CAT. 86

1. Thorough technical analysis of the original wax sculpture identified colored beeswax, plaster, cloth, cork, wood, wire, and a lead alloy strip for the sides of the shallow basin. See Sturman and Barbour 1995, pp. 49–54.
2. Millard 1976, p. 10.
3. Boggs et al. 1988, cat. 287, p. 469; quoted from Guérin 1947, no. 119, p. 132. (Guérin erroneously linked this comment to *Little Dancer of Fourteen Years.* Boggs et al. 1988, p. 470, n. 2.)
4. Ibid, cat. 287, p. 470.

Appendix: Selected Degas Exhibitions in America, 1878–1936

COMPILED BY PHAEDRA SIEBERT

Unless noted, catalogues accompanying the exhibitions were published.

1878

(February 3–March 3) New York, National Academy of Design, *American Water Color Society, Eleventh Annual Exhibition*. One work exhibited: *Rehearsal of the Ballet* (page 36, fig. 1), Louisine Havemeyer's first Degas acquisition, the first exhibition of a work by Degas in the United States.

1883

New York, National Academy of Design, *Pedestal Fund Art Loan Exhibition*. One work exhibited: *Dancers in Pink* (page 48, fig. 1).

1886

New York, American Art Association and National Academy of Design, *Special Exhibition: Works in Oil and Pastel by the Impressionists of Paris*. Twenty-five works by Degas exhibited, including *Dancer with Red Stockings* (cat. 53) and *The Ballet Class* (cat. 49).

1892

New York, Durand-Ruel Galleries, *Exhibition of Impressionist Paintings* (no catalogue).

1893

Chicago, World's Columbian Exposition, *Loan Exhibition of Foreign Master-pieces*. Two works exhibited: *The Ballet Class* (cat. 49), lent by Alexander Cassatt, and *Race Horses* (Detroit Institute of Arts).

1894

Cleveland, Ohio, Cleveland Museum of Art, *Art Loan Exhibition*. One work exhibited: *Dancers in Pink* (page 48, fig. 1).

1895

St. Louis, Missouri, St. Louis Exposition and Music Hall, *Twelfth Annual Exhibition*. One work exhibited.

1896

Pittsburgh, *Carnegie International Annual Exhibition*. Two works exhibited: *Race Horses* (page 23, fig. 9) and a dance rehearsal scene.

1897

Pittsburgh, *Carnegie International Annual Exhibition*. One work exhibited: *The Ballet from "Robert le Diable"* (Metropolitan Museum of Art).

1898

Pittsburgh, *Carnegie International Annual Exhibition*. One ballet scene exhibited.

1899

Pittsburgh, *Carnegie International Annual Exhibition*. One ballet scene exhibited.

1900

Pittsburgh, *Carnegie International Annual Exhibition*. One work exhibited: *Orchestra Musicians* (page 67, fig. 6)

1901

Pittsburgh, *Carnegie International Annual Exhibition*. One horseracing scene exhibited.

New York, Durand-Ruel Galleries. In the Durand-Ruel archive, there are photographs of an exhibition labeled 1901 (page 68, fig. 7). However, there is no other evidence that this exhibition was mounted.

1902

Pittsburgh, Carnegie Museum, *Loan Exhibition of 1902* (no catalogue). One work exhibited: *The Ballet Class* (cat. 49), lent by Alexander Cassatt.

1905

Toledo, Ohio, Toledo Museum of Art, *Exhibition of One Hundred Paintings by the Impressionists, from the Collection of Durand-Ruel & Sons, Paris*. Five works exhibited. Traveled to Buffalo, New York, and St. Louis, Missouri, through 1907.

1908

(February 10–March 10) Pittsburgh, Carnegie Institute, *An Exhibition of Paintings by the French Impressionists*. Five works exhibited, including *La Savoisienne* (cat. 11). Traveled to Cincinnati, Ohio (March 18–April 12), and St. Paul, Minnesota (May 13–23).

1911

(April 5–14) Cambridge, Massachusetts, Fogg Art Museum, *A Loan Exhibition of Paintings and Pastels by H. G. E. Degas*. Twelve works exhibited, including *Dancers in Pink* (page 48, fig. 1), *La Savoisienne* (cat. 11), *The Interior* (page 21, fig. 7), *The Tub* (page 18, fig. 3), and *Race Horses at Longchamp* (cat. 29).

1913

New York, Sale of the Tadamasa Hayashi Collection. Ten objects sold.

(January 20–31) Boston, Saint Botolph Club, *Impressionist Paintings Lent by Messrs. Durand-Ruel and Sons*. Two works exhibited: a bather and *La Savoisienne* (cat. 11).

(February 15–March 17) New York, The Armory Show International Exhibition of Modern Art. Three works exhibited.

1915

(April 6–24) New York, M. Knoedler & Co., *A Loan Exhibition of Masterpieces by Old and Modern Painters*. Twenty-seven works exhibited (of which four were not catalogued), including *The Mante Family* (page 18, fig. 4), *La Savoisienne* (cat. 11), *The Dance Examination* (cat. 48), *After the Bath* (page 17, fig. 2), and *Race Horses at Longchamp* (cat. 29).

1916

(April 5–29) New York, Durand-Ruel Galleries, *Manet and Degas*. Thirteen works exhibited, including *La Saviosienne* (cat. 11) and *The Lowering of the Curtain* (page 49, fig. 3).

1918

(January 9–26) New York, Durand-Ruel Galleries, Degas Memorial Exhibition.

1919

Cambridge, Massachusetts, Fogg Art Museum, *French Painting from the Ninth Century to the Present*. Nine works exhibited.

New York, Marius de Zayas Gallery, *Exhibition of Paintings by Courbet, Manet, Degas, Renoir, Cézanne, Seurat, Matisse*. Five works exhibited.

1920

Pittsburgh, *Carnegie International Annual Exhibition*. One work exhibited.

(March 11–27) New York, Durand-Ruel Galleries, *Exhibition of Pastels and Drawings by Degas (1834–1917)*. Eighty-six works exhibited, including *Study for "Dante and Virgil"* (cat. 4).

(April 17–May 9) Philadelphia, Academy of Fine Arts, *Paintings and Drawings by Representative Foreign Masters*. Ten works exhibited.

1921

(January 27) New York, American Art Association, Sale of the Jacques Seligmann Collection. Seventy-one works exhibited, including *After the Bath* (cat. 71), *Portrait of a Woman (Mlle. Malo?)* (cat. 33), *Portrait of Mme. René De Gas, née Estelle Musson* (cat. 27), and *At the Theater: Woman Seated in the Balcony* (cat. 37).

(March 16–April 3) New York, Museum of French Art, *Loan Exhibition of Works by Cézanne, Rodin, Redon, Gauguin, Degas, Derain, and Others*. Six works exhibited.

(May 3–September 15) New York, The Metropolitan Museum of Art, *Loan Exhibition of Impressionist and Post-Impressionist Paintings*. Twelve works exhibited, including *The False Start* (page 31, fig. 16) and *The Interior* (page 21, fig. 7).

(February 8–14) Brooklyn, Brooklyn Museum of Art, *Painting by Modern French Masters Representing the Post-Impressionists and Their Predecessors*. Fifteen works exhibited, including *Mlle. Fiocre in the Ballet "La Source"* (page 26, fig. 12).

1922

(January 26–February 28) New York, The Grolier Club, *Prints, Drawings, and Bronzes by Degas*. One hundred and thirty-four works exhibited, featuring Louisine Havemeyer's "A" set of the bronzes, now at The Metropolitan Museum of Art, including *Dancer in the Role of Harlequin* (cat. 82).

(March 1–18) New York, Durand-Ruel Galleries, *Exhibition of Pastels and Drawings by Degas (1834–1917)*. Twenty-two works exhibited.

(December 6–27) New York, Durand-Ruel Galleries, *Exhibition of Bronzes by Degas (1834–1917)*. Seventy-two works exhibited: the "B" set of bronzes, first purchased by the painter and art critic Walther Halvorsen, including *Horse Walking* (cat. 76).

1923

(opened February) New York, The Metropolitan Museum of Art, *Sculptures by Degas* (no catalogue). Through December 1927.

1925

(October–November) New York, Ferargil Gallery, *Degas Bronzes*. Most of the "B" set of bronzes, first purchased by the painter and art critic Walther Halvorsen, was exhibited, including *Draught Horse* (cat. 75), which was purchased at this exhibition by the Hyde family.

1926

(December 18–31) New York, Durand-Ruel Galleries, *Exhibition of Paintings by the Impressionists*. Three works exhibited.

1928

(November 12–December 8) New York, M. Knoedler & Co., *A Century of French Painting*. Two works exhibited, including *The False Start* (page 31, fig. 16).

1929

(February 3–24) Toledo, Ohio, Toledo Museum of Art, *Exhibition of French Paintings*. One work exhibited: Toledo's recently acquired pastel *The Dancers*.

(March 6–April 6) Cambridge, Massachusetts, Fogg Art Museum, *Exhibition of French Painting of the Nineteenth and Twentieth Centuries*. Twenty-one works exhibited, including *The Song of the Dog* (cat. 32), *Head of a Woman* (cat. 17), *Seated Dancer* (cat. 26), and *Race Horses at Longchamp* (cat. 29).

1930

(February) Toledo, Ohio, Toledo Museum of Art, *French Paintings*. One work exhibited.

(March 10–November 2) New York, The Metropolitan Museum of Art, *The H. O. Havemeyer Collection*. One hundred and five works exhibited, including Mrs. Havemeyer's "A" set of the bronze sculptures.

New York, Jacques Seligmann & Co., *Drawings by Degas*. Sixty-three works exhibited, including *Study for "James-Jacques-Joseph Tissot"* (cat. 21).

1931

(May 9–30) Cambridge, Massachusetts, Fogg Art Museum, *Degas*. Twenty-five works exhibited, including *James-Jacques-Joseph Tissot* (cat. 22) and *Study for "James-Jacques-Joseph Tissot"* (cat. 21).

1932

(February) Toledo, Ohio, Toledo Museum of Art, *Sculpture and Drawing by Sculptors.* Three works exhibited.

(April 6–October 9) Chicago, The Art Institute of Chicago Antiquarian Society, *Exhibition of the Mrs. L. L. Coburn Collection: Modern Paintings and Watercolors.* Five works exhibited, including *The Millinery Shop* (cat. 54) and *At the Races: The Start* (cat. 13).

New York, Durand-Ruel Galleries, *Exhibition of Gouaches and Pastels by Edgar Degas and Camille Pissarro.* One work exhibited: *Three Women at the Races* (cat. 57).

1933

(January) St. Louis, Missouri, Saint Louis City Art Museum, *Drawings by Nineteenth Century French Masters from the Collection of Paul J. Sachs,* loaned by the Fogg Art Museum. Twelve drawings exhibited.

(June 1–November 1) Chicago, The Art Institute of Chicago, *A Century of Progress: Exhibition of Paintings and Sculpture.* Twelve works exhibited, including *The Morning Bath* (cat. 68).

(November–December) New York, M. Knoedler & Co., *Paintings from the Ambroise Vollard Collection.* Four works exhibited.

(November 28–December 18) Northampton, Massachusetts, Smith College Museum of Art, *Edgar Degas: Paintings, Drawings, Pastels, Sculpture.* Thirty-seven works exhibited, including *The Millinery Shop* (cat. 54), *The Lowering of the Curtain* (page 49, fig. 3), *Mlle. Fiocre in the Ballet "La Source"* (page 26, fig. 12), and *Edmondo and Thérèse Morbilli* (page 29, fig. 14).

1934

New York, Museum of Modern Art, *Memorial Exhibition: The Collection of the Late Miss Lillie P. Bliss.* Eight works exhibited.

Philadelphia, Philadelphia Museum of Art, *Impressionist Figure Painting* (catalogue not located). Seven works exhibited.

Toledo, Ohio, Toledo Museum of Art, *French Impressionists and Post-Impressionists.* Four works exhibited.

(March 21–April 28) Cambridge, Massachusetts, Fogg Art Museum, *Drawings and Prints of the Nineteenth Century.* Seventeen works exhibited, including *Study for "James-Jacques-Joseph Tissot"* (cat. 21) and *After the Bath* (page 17, fig. 2).

(June 8–July 8) San Francisco, The California Palace of the Legion of Honor, *Exhibition of French Painting from the Fifteenth Century to the Present Day.* Five works exhibited, including *Mlle. Fiocre in the Ballet "La Source"* (page 26, fig. 12).

(October 15–November 10) New York, Durand-Ruel Galleries, *Exhibition of Important Paintings by Great French Masters.* Five works exhibited, including *Race Horses* (page 23, fig. 9)

(November 5–December 1) New York, Marie Harriman Gallery, *Degas.* Fifteen works exhibited, including *Double Portrait—The Cousins of the Painter* (cat. 19).

1935

(January) Buffalo, New York, Buffalo Fine Arts Academy, *Master Drawings, Selected from the Museums and Private Collections of America, January 1935.* Four works exhibited, including *Self-Portrait* (cat. 6).

(March 31–April 28) Kansas City, Missouri, William Rockhill Nelson Gallery of Art and Mary Atkins Museum of Fine Arts, *One Hundred Years of French Painting.* Six paintings exhibited, including *Race Horses at Longchamp* (cat. 29).

(March 8–April 30) Boston, Museum of Fine Arts, Boston, *Independent Painters of Nineteenth Century Paris.* Thirty-eight works exhibited, including *At the Races: The Start* (cat. 13).

(April 22–May 11) New York, Durand-Ruel Galleries, *Exhibition of Gouaches and Pastels by Degas, Renoir, Cassatt, Pissarro.* One work exhibited: *Two Studies of the Head of a Man* (cat. 3).

(April 29–May 18) New York, Jacques Seligmann & Co., *Exhibition of Bronzes and Drawings by Degas.*

1936

New York, The Century Club, *French Masterpieces.* One work exhibited: *The Singer in Green* (Metropolitan Museum of Art).

(March 15–April 28) Philadelphia, Pennsylvania Museum of Art *Degas, 1834–1917.* One hundred and five works exhibited, including *At the Races: The Start* (cat. 13), *A Woman Seated Beside a Vase of Flowers* (cat. 18), *The Ballet Class* (cat. 49), and *The Morning Bath* (cat. 68).

Bibliography

Catalogues Raisonnés

Janis
Janis, Eugenia Parry. *Degas Monotypes*. Cambridge: Fogg Art Museum, Harvard University, 1968.

Lemoisne
Lemoisne, Paul-André. *Degas et Son Oeuvre*. 1946. Reprint, with a supplement compiled by Phillipe Brame and Theodore Reff, with the assistance of Arlene Reff. New York: Garland, 1984.

Pingeot
Pingeot, Anne. *Degas Sculptures*. Paris: Imprimerie Nationale Éditions; Réunion des Musées Nationaux, 1991.

Reed and Shapiro
Reed, Sue Welsh, and Barbara Stern Shapiro; with contributions by Clifford S. Ackley and Roy L. Perkinson; essay by Douglas Druick and Peter Zegers. *Edgar Degas: The Painter as Printmaker*. Boston: Little, Brown, 1984.

Rewald
Rewald, John. *Degas's Complete Sculpture: Catalogue Raisonné*. Originally published 1944 as *Degas: Works in Sculpture*. San Francisco: Alan Wofsy, 1990.

References

Adriani 1985
Adriani, Götz. *Degas: Pastels, Oil Sketches, Drawings*. Translated by Alexander Lieven. New York: Abbeville, 1985.

Adhémar 1955
Adhémar, Jean. "Before the Degas Bronzes." *Art News* (November 1955), pp. 34–35, 70.

American Academy of Arts and Letters 1965
American Academy of Arts and Letters. *Robert Henri and His Circle*. New York: Spiral Press, 1965.

American Art Association 1886
American Art Association. *Works in Oil and Pastel by the Impressionists of Paris*. New York: American Art Association, 1886.

Armstrong 1988
Armstrong, Carol. "Reflections on the Mirror: Painting, Photography, and the Self-Portraits of Edgar Degas." *Representations* 22 (Spring 1988), pp. 108–41.

Barrazetti 1936
Barrazetti, S. "Degas et ses amis Valpinçon." *Beaux Arts* 190 (August 21, 1936), pp. 1, 3.

Barter et al. 1998
Barter, Judith A., Erica E. Hirshler, George T. M. Shackelford, Kevin Sharp, Harriet K. Stratis, and Andrew J. Walker. *Mary Cassatt: Modern Woman*. New York: Art Institute of Chicago in association with Abrams, 1998.

Baumann and Karabelnik 1994
Baumann, Felix, and Marianne Karabelnik, eds. *Degas: Portraits*. London: Merrell Holberton, 1994.

Beaulieu 1969
Beaulieu, Michèle. "Les sculptures de Degas." *La revue du Louvre et des Musées de France*, no. 6 (1969), pp. 369–80.

Berson 1996
Berson, Ruth, ed. *The New Painting: Impressionism, 1874–1886: Documentation*. San Francisco: Fine Arts Museums of San Francisco, 1996; distributed by the University of Washington Press.

Birnbaum 1919
Birnbaum, Martin. *Introductions: Painters, Sculptors, and Graphic Artists*. New York: F. F. Sherman, 1919.

Blanche 1919
Blanche, Jacques-Emile. *Propos de peintre*. Vol. 1, *De David à Delacroix*. Paris: Émil-Paul, 1919.

Boggs 1962
Boggs, Jean Sutherland. *Portraits by Degas*. Berkeley: University of California Press, 1962.

Boggs 1966
———. *Drawings by Degas*. St. Louis, Mo.: City Museum of St. Louis, 1966.

Boggs and Brown 1999
Boggs, Jean Sutherland, and Marilyn R. Brown. *Degas et la Nouvelle-Orléans*. Copenhagen: Ordrupgaard, 1999.

Boggs et al. 1988
Boggs, Jean Sutherland, Douglas W. Druick, Henri Loyrette, Michael Pantazzi, and Gary Tinterow. *Degas*. New York: The Metropolitan Museum of Art, 1988.

Boggs et al. 1998
 Boggs, Jean Sutherland; with contributions by Shelley Sturman, Daphne Barbour, and Kimberly Jones. *Degas at the Races*. Washington, D.C.: National Gallery of Art; New Haven: Yale University Press, 1998.

Bolger 1988
 Bolger, Doreen. "Hamilton Easter Field and His Contribution to American Modernism." *The American Art Journal* 20, no. 2 (1988), pp. 79–107.

Bolger and Cikovsky 1990
 Bolger, Doreen, and Nicolai Cikovsky, eds. *American Art around 1900*. Washington, D.C.: National Gallery of Art, 1990; distributed by the University Press of New England.

Brettell 1983
 Brettell, Richard. "The Diversity of French Nineteenth-Century Painting," *Apollo* 117, no. 253 (March 1983), pp. 234–43.

Brooks 1955
 Brooks, Van Wyck. *John Sloan: A Painter's Life*. New York: Dutton, 1955.

Brownell 1892
 Brownell, W. C. *French Art: Classic and Contemporary Painting and Sculpture*. New York: Scribner's, 1892.

Browse 1949
 Browse, Lillian. *Degas Dancers*. London: Faber and Faber, 1949.

Callen 1995
 Callen, Anthea. *The Spectacular Body: Science, Method, and Meaning in the Work of Degas*. New Haven: Yale University Press, 1995.

Camesasca and Cortenova 1986
 Camesasca, Ettore, and Giorgio Cortenova. *Degas Scultore*. Milan: Mazzotta, 1986.

Campbell 1995
 Campbell, Sara. "A Catalog of Degas Bronzes." *Apollo* 142, no. 402 (August 1995), pp. 10–48.

Cooper 1976
 Cooper, Douglas. *Alex Reid & Lefevre, 1926–1976*. London: Lefevre Gallery, 1976.

Cortissoz 1925
 Cortissoz, Royal. *Personalities in Art*. New York: Scribner's, 1925.

Cortissoz 1931
 ———. *Guy Péne du Bois*. New York: Whitney Museum of American Art, 1931.

Daniel, Parry, and Reff 1998
 Daniel, Malcolm, Eugenia Parry, and Theodore Reff. *Edgar Degas, Photographer*. New York: The Metropolitan Museum of Art, 1998.

Davis 1978
 Davis, Patricia Talbot. *The End of the Line: Alexander J. Cassatt and the Pennsylvania Railroad*. New York: Neale Watson Academic, 1978.

DeShazo 1974
 DeShazo, Edith. *Everett Shinn, 1876–1953, A Figure in His Time*. New York: C. N. Potter, 1974.

Distel 1990
 Distel, Anne. *Impressionism: The First Collectors*. Translated by Barbara Perrond-Benson. New York: Abrams, 1990.

Dumas et al. 1997
 Dumas, Ann, Colta Ives, Susan Alyson Stein, and Gary Tinterow. *The Private Collection of Edgar Degas*. New York: The Metropolitan Museum of Art, 1997; distributed by Abrams.

Dumas et al. 1998
 Dumas, Ann, Görel Cavalli-Björkman, Caroline Durand-Ruel Godfroy, Judit Geskó, Lukas Gloor, Christopher Lloyd, Monique Nonne, and Stefan Pucks. *Impressionism: Paintings Collected by European Museums*. Atlanta: High Museum of Art, 1998; distributed by Abrams.

Erens 1979
 Erens, Patricia. *Masterpieces: Famous Chicagoans and Their Paintings*. Chicago: Art Institute of Chicago, 1979; distributed by Chicago Review Press.

Faulkner 1972
 Faulkner, Joseph W. "Painters at the Hall of Expositions: 1890." *Chicago History* 2, no. 1 (Spring 1972), p. 14.

Feigenbaum et al. 1999
 Feigenbaum, Gail; catalogue by Jean Sutherland Boggs; essays by Christopher Benfey, Marilyn R. Brown, and Christina Vella. *Degas and New Orleans*. New Orleans: New Orleans Museum of Art, 1999.

Fernandez and Murphy 1987
 Fernandez, Rafael, and Alexandra R. Murphy. *Degas in the Clark Collection*. Williamstown, Mass.: Sterling and Francine Clark Art Institute, 1987.

Field 1920
 Field, Hamilton Easter. "Edgar Degas, Painter-graver." *The Arts* 1, no. 1 (December 4, 1920), pp. 8–11.

Field 1921
 ———. "Edgar Degas, Painter." *The Arts* 1, no. 2 (January 1921), pp. 8–15.

Finsen 1983
 Finsen, Hanne. *Degas og familien Bellelli/Degas et la famille Bellelli*. Copenhagen: Ordrupgaard, 1983.

Flint 1984
 Flint, Kate, ed. *Impressionists in England: The Critical Reception*. London: Routledge and Kegan Paul, 1984.

Frelinghuysen et al. 1993
 Frelinghuysen, Alice Cooney, Gary Tinterow, Susan Alyson Stein, Gretchen Wold, and Julia Meech. *Splendid Legacy: The Havermeyer Collection*. New York: The Metropolitan Museum of Art, 1993.

Gaehtgens and Ickstat 1992
 Gaehtgens, Thomas W., and Heinz Ickstat, eds. *American Icons: Transatlantic Perspectives on Eighteenth- and Nineteenth-Century American Art*. Santa Monica, Calif.: Getty Center for the History of Art and Humanities, 1992; distributed by the University of Chicago Press.

Gallatin 1925
 Gallatin, A. E. *John Sloan*. New York: Dutton, 1925.

Gee 1981
 Gee, Malcolm. *Dealers, Critics, and Collectors of Modern Painting: Aspects of the Parisian Art Market between 1910 and 1930*. New York: Garland, 1981.

Gerdts 1996
 Gerdts, William H. *William Glackens*. New York: Abbeville, 1996.

Gerdts et al. 1992
 Gerdts, William, D. Scott Atkinson, Carole L. Shelby, and Jochen Wierich. *Lasting Impressions: American Painters in France, 1865–1915*. Evanstown, Ill.: Terra Foundation for the Arts, 1992.

Gerstein 1989
 Gerstein, Marc S. *Impressionism: Selections from Five American Museums*. New York: The Carnegie Museum of Art; New York: Hudson Hills, 1989; distributed by Rizzoli.

Gimpel 1966
Gimpel, René. *Diary of an Art Dealer*. Translated by John Rosenberg. New York: Farrar, Straus and Giroux, 1966.

Glackens 1957
Glackens, Ira. *William Glackens and the Ashcan Group: The Emergence of Realism in American Art*. New York: Grosset and Dunlap, 1957.

Glaser 1926
Glaser, Curt. *Das Plastisches Werk von Edgar Degas*. Berlin: Kunstarchiv, 1926.

Grappe 1908
Grappe, Georges. *Edgar Degas*. Paris: Librarie Artistique et Littéraire, 1908.

Greenberg 1961
Greenberg, Clement. *Art and Culture: Critical Essays*. Boston: Beacon, 1961.

Guérin 1945
Guérin, Marcel, ed. *Lettres de Degas*. Paris: B. Grasset, 1945.

Guérin 1947
———, ed. *Edgar Germain Hilaire Degas: Letters*. Translated by Marguerite Kay. Oxford: Bruno Cassirer, 1947.

Hall 1978
Hall, Lewis. *The William A. Clark Collection*. Washington, D.C.: Corcoran Gallery of Art, 1978.

Harris 1993
Harris, Neil. "William Preston Harrison: The Disappointed Collector." *The Archives of American Art Journal* 33, no. 3 (1993), pp. 13–28.

Harris, Chambers, and Story 1996
Harris, Neil, Marlene Chambers, Lewis Wingfield Story. *The First Hundred Years: The Denver Art Museum*. Denver: The Denver Art Museum, 1996.

Havemeyer 1915
Havemeyer, Louisine. "Mrs. H. O. Havemeyer's Remarks on Edgar Degas and Mary Cassatt." Lecture at M. Knoedler and Co., New York, April 6, 1915, privately printed.

Havemeyer 1993
———. *Sixteen to Sixty: Memoirs of a Collector*. Edited by Susan Alyson Stein. New York: Ursus Press, 1993.

Hawkes 1993
Hawkes, Elizabeth H. *John Sloan's Illustrations in Magazines and Books*. Wilmington: Delaware Art Museum, 1993.

Henri 1984
Henri, Robert. *The Art Spirit*. Compiled by Margery Rayerson. 1923. Reprint, New York: Harper & Row, 1984.

J. Herbert 1978
Herbert, John, ed. *Christie's Review of the Season 1978*. London: Studio Vista, 1978.

R. Herbert 1988
Herbert, Robert. *Impressionism: Art, Leisure, and Parisian Society*. New Haven: Yale University Press, 1988.

Hertz 1920
Hertz, Henri. *Degas*. Paris: F. Alcan, 1920.

Hertz 1923
———. "The Great Transitional Artists of the Modern Epoch–Degas." Translated by Catherine Beach Ely. *Art in America* 11, no. 4 (June 1923), pp. 178–87.

Hollander 1986
Hollander, Anne. *Seeing Through Clothes*. Berkeley: University of California Press, 1986.

Homer 1969
Homer, William Innes. *Robert Henri and His Circle*. Ithaca: Cornell University Press, 1969.

Huneker 1910
Huneker, James. *Promenades of an Impressionist*. New York: Scribner's, 1910.

Huth 1946
Huth, Hans. "Impressionism Comes to America." *Gazette des Beaux-Arts* 29 (April 1946), pp. 225–52.

Huysmans 1883
Huysmans, J. K. *L'Art Moderne*. Paris: G. Charpentier, 1883.

Hyams 1979
Hyams, Barry. *Hirshhorn: Medici from Brooklyn*. New York: Dutton, 1979.

Jamot 1924
Jamot, Paul. *Degas*. Paris: Éditions de la Gazette des Beaux-Arts, 1924.

Jamot 1931
———. *Degas: portraitiste, sculpteur*. Paris: Musée de l'Orangerie, 1931.

Kendall 1993
Kendall, Richard. *Degas Landscapes*. New Haven: Yale University Press, 1993.

Kendall 1996
———. *Degas: Beyond Impressionism*. London: National Gallery, 1996.

Kendall 1998
———. *Degas and the Little Dancer*. New Haven: Yale University Press, 1998.

Krens 1992
Krens, Thomas. *Thannhauser Collection*. New York: Guggenheim Museum, 1992.

Kuh 1962
Kuh, Katherine. *The Artist's Voice: Talks with Seventeen Artists*. New York: Harper & Row, 1962.

Kysela 1964
Kysela, John D. "Sara Hallowell Brings Modern Art to the Midwest." *Art Quarterly* 27, no. 2 (1964).

Lemoisne 1912
Lemoisne, Paul-André. *Degas*. Paris: Librarie Centrale des Beaux-Arts, 1912.

Lemoisne 1919
———. "Les Statuettes de Degas." *Arts et Décoration* (September–October 1919), pp. 109–17

Levin 1979
Levin, Gail. *Edward Hopper as Illustrator*. New York: Norton, 1979.

Levin, *Biography*, 1995
———. *Edward Hopper: An Intimate Biography*. Berkeley: University of California Press, 1995.

Levin, *Catalogue Raisonné*, 1995
———. *Edward Hopper: A Catalogue Raisonné*. New York: Whitney Museum of American Art, 1995.

Loyrette 1991
Loyrette, Henri. *Degas*. Paris: Fayard, 1991.

Lugt 1921
Lugt, Frits. *Les marques de collections de dessins et d'estampes.* Amsterdam: Vereenigde Drukkerijen, 1921.

Maheux 1988
Maheux, Anne F. *Degas Pastels.* Ottawa: National Gallery of Canada. 1988.

Mather 1927
Mather Jr., Frank Jewett. *Modern Painting.* Garden City, N.Y.: Garden City Publishing, 1927.

Mathews 1984
Mathews, Nancy Mowll, ed. *Cassatt and Her Circle: Selected Letters.* New York: Abbeville, 1984.

Matyjaskiewicz 1984
Matyjaskiewicz, Krystyna, ed. *James Tissot.* Oxford: Phaidon Press and Barbican Art Gallery, 1984.

Mayerson 1965
Mayerson, Charlotte Leon, ed. *Shadow and Light: The Life, Friends, and Opinions of Maurice Sterne.* New York: Harcourt, Brace, 1965.

McCabe 1869
McCabe, James Dabney. *Paris by Sunlight and Gaslight.* Philadelphia: National Publishing, 1869.

McIlhenny, Mongan, and Sachs 1936
McIlhenny, Henry P., Agnes Mongan, and Paul Sachs. *Degas: 1834–1917.* Philadelphia: Pennsylvania Museum of Art, 1936.

Meier-Graefe 1908
Meier-Graefe, Julius. *Modern Art: A Contribution to a New System of Aesthetics,* 2 vols. Translated by Florence Simmonds and George W. Chrystal. London: Heinemann; New York: Putnam's, 1908.

Meier-Graefe 1923
———. *Degas.* Translated by J. Holroyd-Reece. London: Ernest Benn, 1923.

Millard 1976
Millard, Charles W. *The Sculpture of Edgar Degas.* Princeton: Princeton University Press, 1976.

Moffett 1986
Moffet, Charles S., ed. *The New Painting: Impressionism, 1874–1886.* Geneva, Switzerland: R. Burton, 1986; distributed in the United States by the University of Washington Press.

Mongan 1965
Mongan, Agnes, comp. *Memorial Exhibition: Works of Art from the Collection of Paul J. Sachs Given and Bequeathed to the Fogg Art Museum, Harvard University.* Cambridge: Fogg Art Museum, 1965.

Moore 1888
Moore, George. *Confessions of a Young Man.* London: S. Sonnenschein, Lowrey, 1888.

Moore 1898
———. *Modern Painting.* Enlarged ed. London: W. Scott, 1898.

Nicholson 1960
Nicholson, Benedict. "The Recovery of a Degas Race Course Scene." *The Burlington Magazine* 102, no. 693 (December 1960), pp. 536–37.

O'Brien 1986
O'Brien, Maureen C. *In Support of Liberty: European Paintings at the 1883 Pedestal Fund Art Loan Exhibition.* Southampton, N.Y.: Parrish Art Musuem, 1986.

O'Doherty 1973
O'Doherty, Brian, *American Masters: The Voice and the Myth.* New York: Random House, 1973.

Pène du Bois 1931
Pène du Bois, Guy. *William J. Glackens.* New York: Whitney Museum of American Art, 1931.

Perlman 1988
Perlman, Bennard B. *Painters of the Ashcan School: The Immortal Eight.* 1979. Reprint, New York: Dover, 1988.

Perlman 1991
———. *Robert Henri: His Life and Art.* New York: Dover, 1991.

Perlman and Leeds 1998
Perlman, Bennard B., and Valerie Ann Leeds. *Robert Henri, American Icon: Exhibition of Important Paintings Including a Selection from the Estate of Robert Henri.* New York: Owen Gallery, 1998.

Pickvance 1993
Pickvance, Ronald. *Degas.* Martigny, Switzerland: Fondation Pierre Gianadda, 1993.

Rathbone 1954
Rathbone, Perry Townsend. *In Memory of Curt Valentin.* New York: Curt Valentin Gallery, 1954.

Reff 1969
Reff, Theodore. "More Unpublished Letters of Degas." *Art Bulletin* 51, no. 3 (September 1969).

Reff 1976
———. *Degas: The Artist's Mind.* New York: Harper, 1976.

Reff 1985
———. *The Notebooks of Edgar Degas: A Catalogue of the Thirty-Eight Notebooks in the Bibliotèque Nationale and Other Collections.* Rev. ed. New York: Hacker Art Books, 1985.

Reid 1968
Reid, B. L. *The Man from New York: John Quinn and His Friends.* New York: Oxford University Press, 1968.

Rewald 1950
Rewald, John, ed., with the assistance of Lucien Pissaro. *Camille Pissaro: Lettres à son Fils Lucien.* Paris: Albin Michel, 1950.

Rewald 1989
———. *Cézanne and America.* Princeton: Princeton University Press, 1989.

Reymert 1982
Reymert, Martin L. H. "The Evolution of Major Collections Part I: David Daniel's Drawings." *Nineteenth Century* 7, no. 4 (Winter/Spring 1982).

Rieder 2000
Rieder, William. *A Charmed Couple: The Art and Life of Walter and Matilda Gay.* New York: Abrams, 2000.

Rishel 1987
Rishel, Joseph R. *The Henry P. McIlhenny Collection.* Philadelphia: Philadelphia Museum of Art, 1987.

Rolfe 1999
Rolfe, Melanie. "Little Dancer Aged Fourteen." In *Material Matters: The Conservation Of Modern Sculpture.* Edited by Jackie Heuman. London: Tate Gallery, 1999, pp. 14–25.

Rosenfeld 1991
 Daniel Rosenfeld, ed. *European Painting and Sculpture, ca. 1770–1937, in the Museum of Art, Rhode Island School of Design.* Providence: Rhode Island School of Design, 1991.

D. Ross 1912
 Ross, Denman Waldo. *On Drawing and Painting.* Boston: Houghton Mifflin, 1912.

I. Ross 1960
 Ross, Ishbel. *Silhouette in Diamonds: The Life of Mrs. Potter Palmer.* New York: Harper, 1960.

Rouart 1957
 Rouart, Denis, comp. and ed. *The Correspondence of Berthe Morisot, with Family and Friends.* Translated by Betty W. Hubbard. London: Lund, Humphries, 1957.

Saarinen 1958
 Saarinen, Aline B. *The Proud Possessors: The Lives, Times, and Tastes of Some Adventurous American Art Collectors.* New York: Random House, 1958.

Seligman 1961
 Seligman, Germain. *Merchants of Art: 1880–1960; Eighty Years of Professional Collecting.* New York: Appleton-Century-Crofts, 1961.

Shackelford 1984
 Shackelford, George T. M. *Degas: The Dancers.* Washington, D.C.: National Gallery of Art, 1984.

Shackelford and Wissman 2000
 Shackelford, George T. M., and Fronia E. Wissman. *Monet, Renoir, and the Impressionist Landscape.* Ottawa: National Gallery of Canada, 2000.

Shapiro 1980
 Shapiro, Michael. "Degas and the Siamese Twins of the Café-Concert." *Gazette des Beaux-Arts* 95 (1980).

Sloan 1939
 ———. *Gist of Art.* Recorded with the assistance of Helen Farr. New York: American Artists Group, 1939.

Smyth and Lukehart 1993
 Smyth, Craig Hugh, and Peter M. Lukehart, eds. *The Early Years of Art History in the United States.* Princeton: Princeton University, 1993.

Sturman and Barbour 1995
 Sturman, Shelley, and Daphne Barbour. "The Materials of the Sculptor: Degas' Techniques." *Apollo* 142, no. 402 (August 1995), pp. 49–54.

Sutton 1986
 Sutton, Denys. *Edgar Degas: Life and Work.* New York: Rizzoli, 1986.

Sutton 1990
 ———. "Degas and America." *Gazette des Beaux-Arts* 116 (July–August 1990), pp. 29–40.

Thomson 1987
 Thomson, Richard. *The Private Degas.* New York: Thames and Hudson, 1987.

Troyen and Tabbaa 1984
 Troyen, Carol, and Pamela S. Tabbaa. *The Great Boston Collectors: Paintings from the Museum of Fine Arts, Boston.* Boston: The Museum of Fine Arts, 1984.

Vaizey 1982
 Vaizey, Marina. *Painter as Photographer.* London: Arts Council of Great Britain, 1982.

Valéry 1938
 Valéry, Paul. *Degas danse dessin.* Paris: Gallimard, 1938.

Valéry 1960
 ———. *Degas, Manet, Morisot.* Translated by David Paul. New York: Pantheon, 1960.

Van Hadley 1987
 Van Hadley, Rollin, ed. and ann. *The Letters of Bernard Berenson and Isabella Stewart Gardner, 1887–1924, with Correspondence by Mary Berenson.* Boston: Northeastern University Press, 1987.

Venturi 1939
 Venturi, Lionello, ed. *Les archives de l'impressionisme.* Paris: Durand-Ruel, 1939.

Vente 1989
 Vente atelier Edgar Degas. 1918–19. Reprint. San Francisco: Alan Wofsy, 1989.

Visson 1986
 Visson, Vladimir. *Fair Warning: Memoirs of a New York Art Dealer.* Edited by Lynn Visson. Tenafly, N.J.: Hermitage, 1986.

Vollard 1924
 Vollard, Ambroise. *Degas (1834–1917).* Paris: G. Crés, 1924.

Vollard 1936
 ———. *Recollections of a Picture Dealer.* Translated by Violet M. Macdonald. Boston: Little, Brown, 1936.

Vollard 1986
 ———. *Degas: An Intimate Portrait.* Translated by Randolph T. Weaver. New York: Dover, 1986.

Waldman 1910
 Waldman, E. "Modern French Pictures: Some American Collections." *Burlington Magazine* 17 (April 1910).

Walker 1933
 Walker, John. "Degas et les maîtres anciens." *Gazette des Beaux-Arts,* ser. 6, v. 10 (September 1933), pp. 173–85.

Walker 1980
 ———, ed. *The Armand Hammer Collection: Five Centuries of Masterpieces.* New York: Abrams, 1980.

Weinberg, Bolger, and Curry 1994
 Weinberg, H. Barbara, Doreen Bolger, and David Park Curry. *American Impressionism and Realism: The Painting of Modern Life, 1885–1915.* New York: The Metropolitan Museum of Art, 1994.

Weitzenhoffer 1986
 Weitzenhoffer, Frances. *The Havemeyers: Impressionism Comes to America.* New York: Abrams, 1986.

Whitehill 1967
 Whitehill, Walter Muir. *Dumbarton Oaks: The History of a Georgetown House and Garden, 1800–1966.* Cambridge: Belknap Press of Harvard University Press, 1967.

Wright 1915
 Wright, Willard Huntington. *Modern Painting: Its Tendency and Meaning.* New York: John Lane, 1915.

Zorach 1925
 Zorach, William. "The Sculpture of Edgar Degas." *The Arts* 8, no. 5 (November 1925), pp. 263–65.

Notes on Contributors

David A. Brenneman is the Frances B. Bunzl Family Curator of European Art at the High Museum of Art.

Patricia Sue Canterbury is Assistant Curator in the Department of Paintings and Modern Sculpture at The Minneapolis Institute of Arts.

James N. Carder is Archivist and House Collection Manager at Dumbarton Oaks Research Library and Collection, Washington, D.C.

Ann Dumas is an independent scholar, co-curator of *The Private Collection of Edgar Degas,* The Metropolitan Museum of Art, 1997, curator of *Impressionism: Paintings Collected by European Museums,* High Museum of Art, 1999, and co-curator of *1900: Art at the Crossroads,* Royal Academy of Arts, London, 2000.

Valerie J. Fletcher is Curator of Sculpture at the Hirshhorn Museum and Sculpture Garden.

Frances Fowle is Honorary Research Fellow in the Department of Fine Art at the University of Edinburgh, Scotland.

Richard Kendall is an independent Degas scholar, curator, and author of *Degas Landscapes, Degas: Beyond Impressionism,* and *Degas and the Little Dancer.*

Mary G. Morton is Associate Curator of European Art at The Museum of Fine Arts, Houston.

David C. Ogawa is Visiting Assistant Professor in the Department of Visual Arts at Union College in Schenectady, New York.

Claire I. R. O'Mahony is Curator for Nineteenth- to Early Twentieth-Century Painting at the Richard Green Gallery, London, and Education Officer and Visiting Lecturer at the Courtauld Institute of Art.

Rebecca A. Rabinow is Assistant Curator, specializing in nineteenth-century art, in the Department of European Paintings at The Metropolitan Museum of Art, New York.

Phaedra Siebert is the Curatorial Assistant in European Art at the High Museum of Art.

Gudmund Vigtel is Director Emeritus of the High Museum of Art.

Index

Wright, Willard Huntington, 53–54
 Modern Art: Its Tendency and Meaning, 53
 portrait of, 54 fig. 9

Yamanaka, Sadajiro, 207
Yeats, John Butler, 71

Zola, Emile, 184, 189
Zorach, William, 56–57, 79, 81 n. 12
 photograph of, 79 fig. 2
Zorn, Anders, *Mrs. Potter Palmer,* 19, 20 fig. 5

PHOTO CREDITS